A History of
ILLUMINATED MANUSCRIPTS

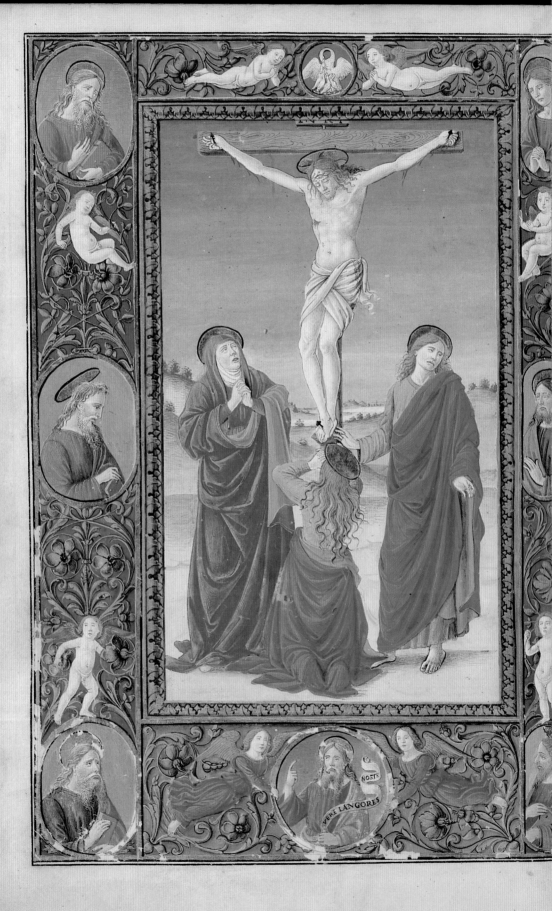

VERI LANGORES NOSTR

EIGI TUR

Clementissime pr per i
iesum christum filium tuuz
dominum nrm supplices i
rogamus ac petimus. uti
accepta beas i benedica
bec + dona + bec mune
ra + bec sca sacrificia il
libata. in primisque tibi
offerimus pro ecclesia
tua sca catholica. quam
pacificare. custodire. o
adunare. et regere digni
ris. toto orbe terrarum
una cum famulo tuo pa
pa nro .N. et antistite o
nro. .N. et omnibus orth
voxis atque catholice et
apostolice fidei cultoribus.
 ¶ Oratio pro rruis.

Memento dne fami
lorum famularumque
tuarum .N. et omniuz
circumstantium quorum
tibi fides cognita e i no
ta deuotio. pro quibus
tibi offerimus. uel q offe
runt boc sacrificium lau
dis pro se suisque omni
bus pro redemptione ani
suarum p spe salutis.
et i colunitatis sue tibi
que reddunt uota sua et
no deo uiuo i uero.
 ¶ Infra actionem.
Communicantes i me
moriam uenerantes
in primis gloriose se
perque uirginis Marie.

A History of

ILLUMINATED

MANUSCRIPTS

CHRISTOPHER DE HAMEL

BCA

LONDON NEW YORK SYDNEY TORONTO

Frontispiece

Paris, Bibliothèque Nationale, ms. lat. 17323, fols. 177v–178r

This is the opening of the Canon of the Mass in a luxurious Missal made in Florence for Leo X, pope 1513–21. On the left is the Crucifixion, and on the right the opening initial 'T' encloses a figure of Christ displaying his wounds, as seen by St Gregory (one of Leo X's predecessors as pope), miraculously appearing in person during the recitation of the Mass.

This edition published 1994 by BCA by arrangement with Phaidon Press Limited

© 1994 Phaidon Press Limited

CN 6977

Printed in Hong Kong

The following abbreviations have been used:

B.L.	London, British Library
Paris, B.N.	Paris, Bibliothèque Nationale

Contents

Introduction 8

I *Books for Missionaries* 14

7th–9th centuries: the written word as an essential tool for the early missionaries of Britain and Ireland, who produced books of extraordinary sophistication

II *Books for Emperors* 42

8th–11th centuries: books as treasure and as luxurious objects of display and diplomatic gifts in the courts of Charlemagne and his successors

III *Books for Monks* 74

12th century: the golden age of the monastic book, when monks in their *scriptoria* produced manuscripts for their libraries

IV *Books for Students* 108

13th century: the rise of the universities and the emergence of a professional book trade to meet the new need for textbooks

V *Books for Aristocrats* 142

14th century: the Age of Chivalry – a wealthy and newly literate aristocracy generating a new type of book, the secular romance

VI *Books for Everybody* 168

15th century: the emergence of the Book of Hours as a devotional book for ordinary households as well as the aristocracy

VII *Books for Priests* 200

13th–16th centuries: the Bibles, Missals, Breviaries, Psalters and other service books and handbooks that sustained the life of the Church

VIII *Books for Collectors* 232

15th–16th centuries: the revival of classical learning and the creation of de luxe manuscripts for wealthy humanist patrons

Bibliography 258

Index of Manuscripts 264

General Index 267

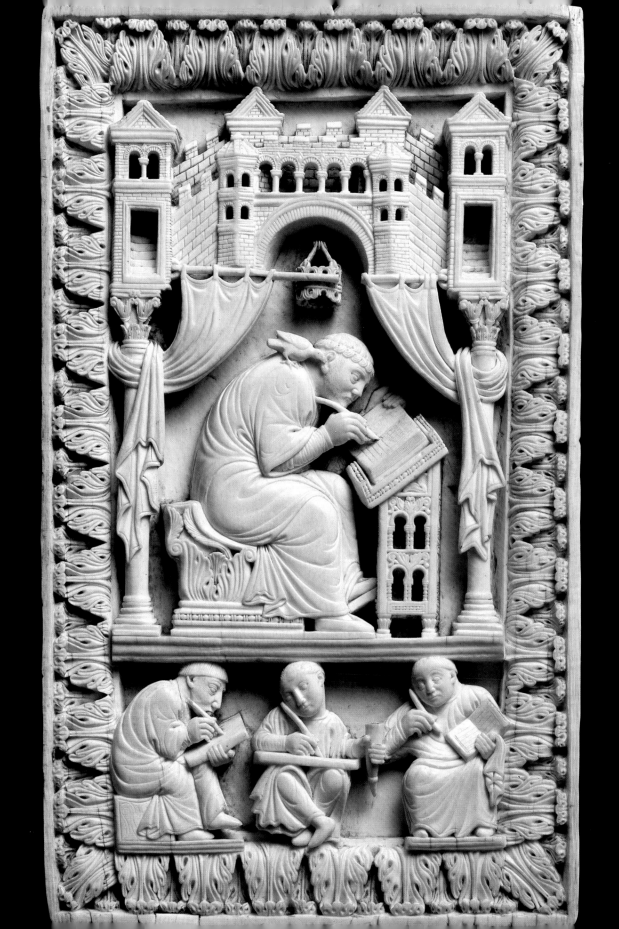

Introduction

The word 'manuscript' literally means 'written by hand'. When we talk about medieval manuscripts we usually mean the books produced by hand in Europe between about the fifth century and the Renaissance of the late fifteenth century. The books are all written by hand and are sometimes beautifully decorated. It happens that the Middle Ages form a neatly defined historical period, but the outside limits for medieval manuscripts are determined by two crucial changes in the methods of book production. The first was the invention of the book as a more or less rectangular object with pages. There had been various forms of writing from the earliest periods of recorded history: scratched impressions in clay, chiselled stone inscriptions, ephemeral wax tablets, and the long-lasting papyrus scroll. Most ancient Roman literature was first written down on scrolls. The great change took place in the first centuries AD. The scroll gradually gave way to the book, or *codex*, in the modern sense with separate pages that can be turned and read one after the other. Scribes began to use prepared animal skin (parchment or vellum — the terms are interchangeable) rather than papyrus because vellum leaves are less likely to break off if they are frequently turned. Scrolls are practical for reciting a continuous literary text and are convenient to store (and are perhaps enjoying a revival in the modern microfilm), but they are difficult to handle for works such as the Bible or law books in which the reader often needs to refer backwards or forwards. As Christianity overtook classical culture from the fourth century and as the old Roman law was finally collected and codified (a word which refers directly to the new type of book), so the scroll evolved into the vellum *codex* in the last years of the Roman empire. This development coincides with the beginning of what are called the Middle Ages. It marks the opening of our story.

The end of our period is indicated by the invention of printing. This began with experiments in the Rhineland in the 1440s, and sophisticated printing with movable type was introduced from Germany into Italy (1465) and France (1470), followed rapidly by the Low Countries, Spain, and England. By about 1510 most European books were being made on printing presses. The invention had an enormous impact on literature and on the written word, as has often been stressed; it represents the end of the production of illuminated manuscripts and coincides with the close of the medieval period. Not all scribes regretted the passing of the handwritten book. Many welcomed printing. At last books could be made more quickly and with greater accuracy than ever before. We shall see how scribes had tried to devise methods of doing this centuries before. Printing was a tremendous boon, and some scribes themselves became printers, doing what they had always done but with greater efficiency and profit. Book production was a very practical business.

We are concerned therefore with the books made in Europe in the Middle Ages. The period covered is vast, more than a thousand years (twice as long as the history of the printed book), and it covers all countries of western Europe. Manuscripts are the medium for the entirety of the Scriptures, liturgy, history, literature, law, philosophy and science from the classical and medieval ages. They preserve the major portion of medieval painting and all the arts of handwriting, bookbinding, and publishing. If the field is huge, the

2 *Above*

**Malibu, J. Paul Getty Museum,
MS. Ludwig XV.5, folio 148r, detail**

The *Roman du Bon Chevalier Tristan* is
a prose romance about the knights
of King Arthur. The miniature here
shows Tristan leading a maiden into
the forest where they find King
Arthur held prisoner by two knights
at the foot of a tower. The manu-
script was made probably in Paris,
*c.*1330, for a wealthy secular patron.

1 *Previous page*

**Vienna, Kunsthistorisches Museum,
ivory panel**

This panel for a book cover depicts
St Gregory at his writing desk.
Inspired by the Holy Spirit (symbol-
ized by the dove on his shoulder),
he is writing the Canon of the Mass.
Three scribes below carry on the
copying of liturgical texts. One of a
group of three produced by the
same artist, the panel was made in
northern Europe between 850 and
1000, doubtless for a liturgical book
such as a Sacramentary.

number of surviving books is enormous. Illuminated manuscripts
are often included in that general (and pleasantly deceptive) cate-
gory of 'rare books'. Rarity is not their most obvious characteris-
tic, and there is no doubt that more books survive than any other
artefact from the Middle Ages. Books have a knack of surviving. In
a limited way we can see this survival against all odds reflected in
our own households today: the items we still possess from child-
hood are not the long-gone toy aeroplanes and tricycles, but the
books, battered perhaps and often repaired, but still with us.
Books from the distant past can survive in the same way, just
because they were never thrown out. St Augustine's Abbey in
Canterbury, the first monastery in England, has been an utter ruin
for centuries, but over 250 of its medieval books have passed from
owner to owner and still exist today. We shall be meeting some of
them in chapters 1 and 3. What private possessions still survive
from the great figures of European history, such as St Boniface,
Charlemagne, Otto III, Thomas Becket, St Louis, Boccaccio, and
Erasmus? Books survive, handled and read by all of them.

Medieval books are now preserved in all parts of the world.
Hundreds of thousands exist, and energetic collectors can still
acquire them. Many are concentrated in the great national collec-
tions such as the British Library in London, the Bibliothèque
Nationale in Paris, and the Bayerische Staatsbibliothek in Munich,
but there are great holdings of medieval books in universities,
museums, and libraries in many cities and countries. I myself
began to look at them in Dunedin, New Zealand. Most people live
somewhere near at least a few medieval manuscripts. Almost any-
one, with a little patience and tactful persuasion, can get to handle
one. It can be a fascinating experience.

The breadth of the subject makes it very difficult to synthesize
into a single volume. Manuscripts are so different from each other.
A small grammatical treatise written out by a priest in Verona in
the seventh century, for instance, has little in common with an
illustrated Book of Hours ordered by a Parisian cloth merchant's
wife around 1480, except that they are both manuscripts. A
Carolingian imperial Gospel Book, to take another example, not
only looks quite different from a fourteenth-century Bohemian
song book, but its original purpose was quite different and the cir-
cumstances of its production share almost nothing except that
scribes were involved. Even in the same period, the mechanics of
illuminating a Livy for Cosimo de' Medici, for example, are alto-
gether unlike the methods used the same year by a student at
Erfurt University to make his own commentary on the Psalms.
This should surprise nobody. The function of the student's book
was quite different. To try to account for all kinds of medieval
book in a single all-embracing narrative would not only be imprac-
tical but infinitely confusing, as one style and category of book
would run parallel with countless others and diverge and rejoin
and cross the main threads in a tangled web of copies and
influences as wide and diverse as the whole of medieval culture.

This book, at the genial suggestion of the publishers, is called *A History of Illuminated Manuscripts*. The word '*illuminated*' bothered some reviewers of the first edition. The term strictly means with decoration that includes metallic gold or silver, which reflect and sparkle when they catch the light. Many medieval manuscripts have almost no decoration, and even many richly decorated manuscripts do not, as it happens, include gold. The term 'illuminated manuscripts' for all European medieval books is a convenient and evocative one, if not absolutely accurate, and is used here only in its general sense. This is most certainly not a history of manuscript illumination, but is a history of medieval books which, because there was almost no other known way of making them, happen to be manuscripts.

There are several ways of coming to terms with the vast mass of historical information about medieval books and the great number of medieval manuscripts themselves. The traditional method is to take the high spots only and to consider the very famous manuscripts on their own. We would jump from one masterpiece to another, but, to re-use a famous metaphor, we cannot explore a mountain range by looking only at the peaks. The *Très Riches Heures* of the Duc de Berry (PL. 151) is great because it is so exceptional, and even if we knew everything about it (which we do not), it would add little to our understanding of the fifteenth-century book trade. It would be like writing a social history entirely by means of biographies of kings.

A second method would be to follow right through certain characteristics of manuscripts, such as handwriting and decoration. This approach is often successful over a short period or limited geographical area. However, many manuscripts are not decorated at all, and are no less valuable. All manuscripts include handwriting, of course, but script does not evolve with a fixed and universal regularity. Nor does the reader now want 80,000 words on the shape of the letter 'g' (a subject I rather recommend, incidentally). The brilliant attempts by Belgian manuscript historians to classify medieval script with the precision of botanists are fascinating in the classroom but are difficult to apply in the library. Medieval scribes were human too. A bad scribe followed few rules. A skilful one could produce a dozen different kinds of handwriting according to the kind of book he was making.

If one were really faced with contrasting the Book of Kells (PLS. 17 AND 18) and the *Très Riches Heures* of the Duc de Berry, the difference would not be in the text (by chance, parts are identical) or even in the decorative style (of course that is not the same – the books are six hundred years apart) but in the purpose in making the book. Monks in a tiny Northumbro-Irish island monastery had a reason for making the Book of Kells that was completely different from that of the rich, secular Limbourg brothers who undertook a prestigious commission in the court of the king's brother in the early fifteenth century. This difference of purpose is reflected in the material, size, colour, layout, decoration, and binding of the two manuscripts. Only when we can see what they were trying to do can we stand back and try to judge the work of art in its own right.

Therefore it seems appropriate to try to isolate some of the principal reasons for making books in the Middle Ages. Each forms a separate chapter. Each is only part of the whole subject of medieval manuscripts. If we can look at certain groups of books from the point of view of the people who needed them, we can conveniently cover a much wider range and can jump centuries and styles without losing track of the theme. By examining a few manuscripts we may be able to apply general observations to others sharing the same purpose. Of course no classification can be exact and one theme overlaps another, but some chronological sequence emerges and one angle of inquiry represents each period. Briefly, we can take the subjects in turn.

The first theme is the need for books for missionaries. Christianity is the religion of written revelation. As early parties of missionaries moved across northern Europe preaching to heathen tribes, they offered literacy and a civilization founded in Judea and polished in Rome. Their books were the tangible proof of their message. They exhibited them, read the services from them, and taught civilization from them. We shall see something of how this must have been done. The missionary movement chosen to illustrate the theme took place in Britain and among the British missions to Germany. This is a useful choice. England and Ireland were never really engulfed in the Dark Ages and, while tribes were ravaging seventh-century Europe, monks in Northumberland and Ireland were producing Latin manuscripts of an extraordinary sophistication. It was from Britain that Christianity was re-exported to the Low Countries and to Germany. Britain produced two of the world's great works of art, the Lindisfarne Gospels and the Book of Kells. But it must be stressed that this is only a sample of what was going on in the *scriptoria* of Europe between about AD 650 and the ninth century. There was literacy in Italy and in North Africa and in great parts of Spain and southern France. It is convenient for us, in asking the question of where Benedict Biscop of Northumbria obtained his books, to say that he got them in Italy, but that only puts the problem back one stage. The reader must take for granted the vast cultural legacy of ancient Rome. If we have to exclude such celebrated monuments as the two fifth-century Virgil manuscripts now in the Vatican or the classical texts from Bobbio and Verona, this is because it is simpler to plot the advance of literacy (and Roman literacy too, expressed in the Roman script known as uncial) as it moves with the missionaries across pagan countries far from the Mediterranean.

The court of Charlemagne brings us into a fascinating blend of the rough free-for-all Germanic traditions of the north and the newly imported southern civilization of Rome, where Charlemagne was crowned by the pope in AD 800. The new Holy Roman Emperor deliberately imitated classical culture and used

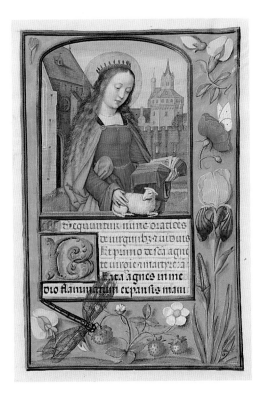

3 *Above*

The Netherlands, private collection, s.n., Vol.II, fol. 76r

This miniature is from a Book of Hours made for a Renaissance statesman and prince of the Church, Cardinal Albrecht of Brandenburg (1490–1545). It was illuminated in Bruges, *c.*1522–3, by the well-known artist Simon Bening. The miniature here shows St Agnes, who is holding her own book wrapped in a blue chemise cover.

the imperial purple for the pages of manuscripts. But his subjects were brought up in the traditions of warfare rewarded by booty and of allegiance rewarded by protection. Now, however, golden manuscripts replaced barbarian loot. Books were treasure. They were deliberately valuable. They were almost part of the fiscal resources of the empire. Again this is a specific theme which can carry us for four centuries through the imperial treasuries of France and Germany to admire the manuscripts of Charlemagne, Otto III, Henry II, and Henry the Lion. These books are some of the very grandest ever produced, and that is why they were made.

It is stating the obvious to stress again that of course imperial manuscripts are not the only books written during those centuries. They are merely one very remarkable type. At the same time books were being made all over Europe. The greatest contribution comes from the monasteries. This will be no surprise: the association of monks and old manuscripts comes easily to mind. What is less well known is that the great period of monastic book production came to an end around 1200 and that for the last three hundred years of the Middle Ages manuscripts were usually made by professionals rather than by monks. For this reason, the theme of making books for monastic libraries focuses here on the twelfth century. We can watch the change from the old to the new methods of supplying books for the needs of monks. The country chosen to illustrate this phenomenon is England. The choice could perfectly well have been France, but Germany or Italy would probably have furnished fewer really great monastic books. Craftsmanship and the monastic life are commonly linked, and probably never again were such fine books made in England. It is in the monastic context that we can follow through most simply the general aspects of making vellum, ruling, writing, mixing paints, and applying gold. In this chapter we see the unhurried book production of the cloister.

The phenomenon which marked the end of the monks' monopoly of learning was the dramatic rise of the universities. Students need books, and universities need a great number of books. We must look primarily at Paris. Here from the early thirteenth century there were organized professional stationers who devised and marketed textbooks. The university book trade gives a fascinating insight into the needs of scholarship and into the mechanics of publishing. There were clear rules about the purpose of books in a university, and this is directly reflected in the manuscripts made and decorated for students. It is a subject curiously neglected in general studies of medieval manuscripts, but it takes us right back to the beginning of the profession of making books for sale.

When I was at school, two neat explanations for any historical event always seemed available: one was the rise of nationalism (probably they do not teach this one any more) and the other was the rise of the middle classes. One or other was cited to explain almost everything from the Peloponnesian War to the Weimar Republic. Both themes emerge in the fifth chapter. Secular

literature is the most enduring monument of the Middle Ages. The great national epics of the Trojan War, King Arthur, Roland, and the Nibelungenlied, and the works of the first modern authors, Dante, Jean de Meun and Chaucer, all come into prominence with the emergence of a wealthy literate laity (or nearly literate, as we shall see, helped by pictures). There was now a market for simple vernacular stories, and books were produced for this purpose. The theme is most striking in the fourteenth century, but it goes back to the twelfth century and forwards indefinitely, since it is still a feature of book production.

By the fifteenth century the number of people wanting and using books seems almost unlimited. While we must not neglect the famous patronage of such collectors as the French and Burgundian royal families, it is the extreme popularization of books which forms so distinctive a feature of the end of the Middle Ages, and which eventually gave way to printing with little change in the book trade. The most popular text of all was the Book of Hours. These are by far the most common surviving manuscripts, and one might sometimes imagine that everyone in the fifteenth century owned a copy. It is a standard series of prayers and psalms intended for recitation at the eight canonical 'hours' of the day, from Matins to Compline. How much they were actually used is a different question altogether. The need for quite unprecedented numbers of copies led to many new methods of mass-producing and selling Books of Hours. The examples must be mainly French, but they take us through the wealthy bourgeois towns of Flanders and the Low Countries. Books of Hours were rare in Germany and usually of poor quality in England. If the image of a virtual production line in cheap Books of Hours is distressing to those of us who liked to dream of old monks painstakingly labouring in ivy-clad cloisters, it is an important historical fact with significance for the study not only of art but also of popular education. Most people learned to read from Books of Hours. The word 'primer' reflects the office of Prime which they read in a Book of Hours each morning.

Although a Book of Hours was a prayer-book, it was intended for use at home rather than in a church. Priests had their own manuscripts for use during Mass and for the daily round of services which took place in parish churches all across Europe. The Reformation had not yet taken place, and all countries of western Europe belonged to the Catholic Church. Priests used Missals and Breviaries as well as Graduals, Antiphoners, Psalters, Manuals, Processionals, model sermons and handbooks on parish duties. A great many such manuscripts still survive. They are not all beautifully decorated as many were utilitarian copies. The function of the books would have been very familiar in the late Middle Ages but those who handle them today often find the texts difficult to distinguish. Nineteenth-century owners used to call all these manuscripts 'Missals', a title which is often far from correct. Chapter 7 examines the books which a priest would have used in his church, focusing on the fifteenth century.

The Middle Ages came to an end with the Renaissance. This started in southern Europe. While Parisian workshops were still undertaking thoroughly Gothic Books of Hours for contemporaries of the Duc de Berry, the scribes of Florence and Rome were already producing elegant classical texts in what they thought was the ancient Roman manner. They devised neat round scripts and pretty white vine initials. A whole new generation of humanistic collectors was swept into the excitement of rediscovering the classics (and the booksellers neatly met this demand, enriching themselves in the process). By the time that printing offered a more accurate alternative to manuscripts, there was an efficient and professional network of decorators, binders, and booksellers. The change was straightforward. The first printers in Italy copied the small round script (which, for this reason, we still call 'Roman' type). Classical culture was re-exported from Italy all over again, taking us back to what the missionaries had started a thousand years before. Printing was here to stay. Books were no longer manuscripts.

This is the second edition of this book. The first was published in 1986 and since then research on the history of manuscripts has progressed. This revised text follows the structure of the earlier version, but many sections have been modified and updated and others redrafted. Many illustrations are new and the bibliography has been extended.

I

Books for Missionaries

When St Augustine and his fellow missionaries landed in south-east England in AD 597, they asked for an interview with King Ethelberht of Kent, saying they had important news of eternal life to announce. Bede recounts that an audience was arranged in the open air and that, as the missionaries approached the king, they held up a silver cross and the image of the Saviour painted on a board. A few days later the monks reached Canterbury, where Ethelberht had assigned a house to them, and once again it is related by Bede that, according to their custom, they came for the first time towards the city bearing aloft the cross and the image of Christ. It was evidently very important that right from the outset the monks should exhibit a visual image of the new religion which could be seen and wondered over even before they began explaining the message of Scripture.

After Augustine had reported his successes back to Rome, a further delegation of missionaries was sent out to consolidate the newly founded church. In 601 the party arrived, led by Mellitus, and brought with them, Bede says, 'all such things as were generally necessary for the worship and ministry of the Church, such as sacred vessels, altar cloths and church ornaments, vestments for priests and clerks, relics of the holy apostles and martyrs, and very many books' ('codices plurimos', in his words). It is these books which are of interest. Christianity is the religion of the book and its message goes with literacy, a concept new to many of its British converts. Missionaries, then as now, could face sceptical audiences with the Gospels under their arms – a specific manual for salvation in debate against a religion based on oral tradition – and the scarcely literate are quite rightly impressed by the written word.

We do not know exactly what manuscripts were brought in 601. Alfred the Great says that St Augustine owned a copy of the *Pastoral Rule* of Gregory the Great, the pope who sent the mission,

and this is more than likely. Bede calls it a remarkable book, and it was of great value for missionaries. The late medieval library catalogue of St Augustine's Abbey in Canterbury recorded ten copies of the *Pastoral Rule* and many other texts by Gregory the Great, some described as old, imperfect and worn out through use. St Augustine's copy, sent to him by the author, would have been an exciting relic if it had survived. It would have looked something like the ancient copy now in Troyes (Bibliothèque Municipale, ms. 504), written almost certainly in St Gregory's own scriptorium in Rome about AD 600 in splendid uncial script without division between words and with penwork initials in dark red, dark green, and brownish yellow. The Troyes volume has been cruelly repaired in modern times but is still a heavy and noble manuscript. It is the just kind of book the missionaries from Rome would have used in England.

The late medieval monks of St Augustine's Abbey believed they had some books acquired from St Augustine himself, and these were carefully examined by Thomas of Elmham between 1414 and 1418. He drew a sketch of the high altar in the abbey church showing that the books were kept there propped up in two rows among other relics of saints (PL. 5). In the text he describes a two-volume Bible with inserted purple leaves, a Psalter and hymnal, a Gospel Book (known as the Text of St Mildrid – Elmham says a certain peasant in Thanet swore falsely on it and was said to have been

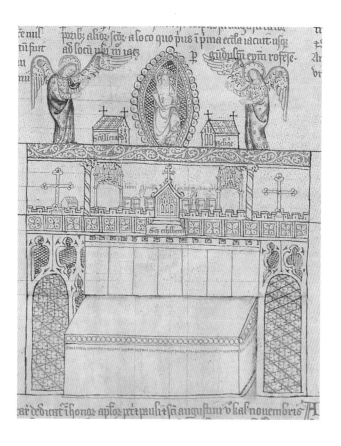

struck blind), and another Psalter with a silver binding showing Christ and the Evangelists. The two-volume Bible was preserved until at least 1604, when it was apparently kept concealed as a miraculous relic in the hands of the English Catholics. It has since disappeared. The Psalter, described as once having been bound in silver, does survive. It is now MS. Cotton Vespasian A.I in the British Library in London (PL. 7). The book had passed after the suppression of St Augustine's Abbey to William Cecil, Lord Burghley (1520–98), and from him to Sir Robert Cotton (1571–1631), whose magnificent library entered the newly-founded British Museum in 1753. It is disappointing to find that the ancient tradition does not stand up to investigation. The manuscript is of superb quality, in uncial script rather like that of the Troyes St Gregory, but it is English in execution and must be assigned to a decade or so around 730. St Augustine himself had died in 604. The Vespasian Psalter, as it is called, is almost certainly based on some Italian models, but it is a local production. The important point is that the monks remembered St Augustine as bringing books to Britain and they associated this square uncial manuscript with the earliest mission. We need not blame them because after eight hundred years they were venerating the wrong volume.

4 *Previous page*

London, British Library, Cotton MS. Nero D.IV, fol. 211r

The Lindisfarne Gospels was made about the year 698 in the island abbey of Lindisfarne off the north-east coast of England. This is the opening page of the text of St John's Gospel. The script was written out by Eadfrith, bishop of the island, and the tiny interlinear translation into Anglo-Saxon was added almost three centuries later by Aldred, provost of Chester-le-Street.

5 *Left above*

Cambridge, Trinity Hall, MS. 1, detail of fol. 77r

Thomas of Elmham, chronicler of St Augustine's Abbey, Canterbury, in 1414–18 made a drawing of the High Altar of his monastery as it was in his own time. Displayed on a little shelf above the altar, on either side of the relics of Ethelberht, king of Kent, are the six manuscripts, drawn here in red ink, which St Augustine himself was reputed to have been sent by Pope Gregory in 601 AD.

6 *Left below*

Cambridge, Corpus Christi College, MS. 286, fol. 125r

Two full-page miniatures remain in a sixth-century Italian Gospel Book which may very well have been brought to England with St Augustine's mission. The book survives among an important group of manuscripts from St Augustine's Abbey which are now in Corpus Christi College in Cambridge. The twelve little scenes here illustrate the Passion of Christ from the Entry into Jerusalem until the Carrying of the Cross, and are the kind of picture which the first missionaries would have used to explain the Gospel story to pagan and illiterate audiences.

7 *Opposite*

London, British Library, Cotton MS. Vespasian A.1, fols. 30v–31r

This luxurious Psalter, written in uncial script, was believed by the monks of Canterbury to have been one of the books which had belonged to St Augustine himself. In fact, the book must have been made in the first half of the eighth century, certainly in England and perhaps in Canterbury, over a hundred years after Augustine had died. The miniature on the left shows King David.

There may be an actual candidate, however, for one of St Augustine's books. This is a Gospel Book which belonged to Matthew Parker (1504–75), Archbishop of Canterbury, and which is still in the library that Parker gave to Corpus Christi College in Cambridge (MS. 286, PL. 6). It too comes from St Augustine's Abbey and was certainly there at least a thousand years ago. The book itself, however, was made in Italy in the sixth century, a date quite consistent with the first missions. In the late seventh or early eighth century numerous corrections were made to the text in an English hand. The book has been much thumbed, and it is still used in fact for the swearing-in of new archbishops of Canterbury. The manuscript preserves two full-page miniatures of at least six which it must once have contained (there are faint offsets from at least four others). The first shows twelve scenes from the life of Christ and the second depicts St Luke holding an open book and is surrounded by six further scenes from Christ's life. If all the miniatures had survived there would have been a very extensive cycle of pictures from the story of Christ. Those that remain are simple and dramatically explicit in their message. It was the custom of St Augustine's missionaries, as we have just seen, to exhibit the painted image of Christ as a prelude to preaching, and no doubt the

technique was very effective. They could have held up this book too. The illustrations had a very simple and very practical function.

The 'very many books' which arrived with St Augustine's mission were certainly not the only Italian manuscripts brought to Britain in the early generations of Christianity. There is an Italian seventh-century Gospel Book in the Bodleian Library in Oxford which was in England by the eighth century, perhaps at Lichfield (MS. Auct. D.11.14). An 'innumerable quantity of books of all kinds', according to Bede (using a similar phrase to that about Canterbury), came to Wearmouth and Hexham in Northumbria. These are important. Both Bede and an anonymous monk wrote lives of abbots of Wearmouth and Jarrow, and we are well informed about Benedict Biscop and his successor Ceolfrith, two exceptional Northumbrian administrators and bibliophiles. Benedict (c.628–90) travelled to Rome five times. On his third visit, Bede says, he acquired 'no inconsiderable number of books'. In 674 he was given land by Egfrith, King of Northumbria, for a monastery to be built at Wearmouth, in the extreme north-eastern corner of England. His library, temporarily on deposit at Vienne in France, now went to form the nucleus of the Wearmouth collection. Once again Benedict set off for Rome in the company of

Ceolfrith in 678. They returned with relics and pictures for the new abbey, including panel paintings of Christ, perhaps something like the one held aloft by St Augustine, and above all they seem to have brought back manuscripts. We have a few clues about these forays into the book collections of Italy. Bede recounts that many books were acquired on one of Benedict Biscop's visits to Italy, 'and these he had either bought at a price, or received as presents from his friends'. This too is important. The reference to purchasing at a price is tantalizing, as it suggests there was a market for books in Italy. It would be fascinating to have details of how this worked in practice. Were there still some kinds of bookshops as there had been in late classical Rome? However it was achieved, Benedict Biscop and Ceolfrith may actually have brought off one of the greatest book-collecting *coups* of all time. It seems very possible that they purchased second-hand the library of Cassiodorus (*c*.485–*c*.580), the great Roman patristic author and scholar. When he retired from public life, Cassiodorus had set up two monastic communities at Vivarium in the far south of Italy and he had formed there a kind of academy for the promotion of both religious and secular learning. Cassiodorus mentions in his *Institutes* that he furnished the foundation with different kinds of scriptural

manuscripts which he describes in some detail. These included what was known as the Codex Grandior, a huge one-volume 'pandect' (that is, a Bible in a single volume) in the old Latin version from before the time of St Jerome. This actual book, Cassiodorus's copy, was certainly in Northumbria in the time of Bede.

Probably Ceolfrith and Benedict acquired all or some of Cassiodorus's Bible in nine volumes (the *Novem Codices*), which we know to have been at Vivarium too, and they may have obtained a third Bible which Cassiodorus described as being in tiny script. Not impossibly the purchase included copies of Cassiodorus's own commentaries (of which Durham Cathedral Library MS. B.11.30 may be some echo) and perhaps even the old Latin version of Josephus and other classical texts. We know that, one way or another, the resources of Wearmouth and of Benedict's second foundation of Jarrow became exceptionally rich.

Bede himself, working in Jarrow *c*.690–*c*.735 and never travelling out of the north of England, cites some eighty different authors whose works he must have seen. The importance of the Christian missions to Britain cannot be overstated, and it is noteworthy that the learning which went hand in hand with Christianity brought the civilized Latin literature of ancient Rome

8 *Left*

**Oxford, Bodleian Library,
MS. Hatton 48, fols. 38v–39r**

St Benedict (*c*.480–*c*.547) was the founding father of western monastic life. This manuscript, which was written in England, *c*.700, is the oldest surviving copy of his book of rules for monks. It is written in a very fine uncial script, on the model of Italian manuscripts, and it must have belonged to one of the earliest communities of Roman monks in England.

9 *Opposite left*

**Florence, Biblioteca Medicea-
Laurenziana, MS. Am. I, fol. Iv**

The dedication page of the Codex Amiatinus, written in Northumberland, *c*.700–16, offers the huge book as a gift from the ends of the earth. In the fifth line the name of the donor 'Petrus Langobardorum' has been falsely inserted over an erasure: the original and rightful name, just decipherable underneath, is 'Ceolfridus Anglorum', for the book was intended as a gift to the pope from Ceolfrith, abbot of Wearmouth and Jarrow (690–716), who died on the journey to Rome, before the volume could be presented.

10 *Opposite right*

**Florence, Biblioteca Medicea-
Laurenziana, MS. Am. I, fol. Vr**

The Codex Amiatinus is illustrated with this vast frontispiece which has excited much curiosity. Its caption declares that it shows the Old Testament prophet Ezra, but it is likely that the whole image was copied from an Italian model, perhaps originally a frontispiece of the 9-volume Bible which had once belonged to Cassiodorus. The picture shows an author writing out a manuscript on his lap in front of a classical book cupboard with nine books laid out on the shelves.

and of the early Christian writers to the very edge of the known world.

Once furnished with exemplars to copy, monks began making their own books (PL. 8). An important documented record of book production occurs also in the lives of the abbots of Wearmouth and Jarrow. The biography of Ceolfrith (642–716) ends with an account of his works and says that he commissioned three huge Bible manuscripts ('tres pandectes novae translationis'), one each for use in the churches at Wearmouth and Jarrow, and one which Ceolfrith eventually announced was to be offered as a present to the pope. One could imagine that Ceolfrith wished to demonstrate to the Roman See (through whom Cassiodorus's Codex Grandior and its fellow volumes had possibly come) that even remote England was now able to reproduce great books and was worthy of housing the exemplars. He may even have been fulfilling a business arrangement: perhaps the Cassiodoran library was released only on the understanding that a copy of the great pandect was returned to Rome for reference. The chronicle quotes a dedication inscription added to the presentation manuscript, naming Abbot Ceolfrith as offering the book in token of faith from the furthest ends of the earth, as indeed it then was ('extremis de

finibus'). Abbot Ceolfrith himself accompanied the expedition to carry the manuscript to the pope. They set out on 4 June 716. This is the earliest date known to us for the export of a book made in England. Unfortunately Ceolfrith never arrived. He died on the road at Langres on 25 September. The book is not known to have reached Rome, and that, until a little over hundred years ago, was the end of the story.

In the Laurentian Library in Florence is a celebrated Latin Bible of the very early eighth century – in fact, the oldest complete Latin Bible known – which was used as a source for the revision of the Latin Bible published in 1590 (Florence, Biblioteca Medicea-Laurenziana, MS. Amiatino 1). It had come to Florence from the abbey of Monte Amiata, and is known as the Codex Amiatinus (PLS. 9–10). It has a presentation inscription from a 'Petrus Langobardorum' and the volume was always thought to be Italian work. In 1886, however, G.B. de Rossi observed that several names in the inscription had been tampered with and were written over erasures and, without at first linking this with Wearmouth/Jarrow, he pieced out the original donor's name as 'Ceolfridus Anglorum'. The next year, F.J.A. Hort noted that this newly recovered dedication exactly matched the one quoted in the

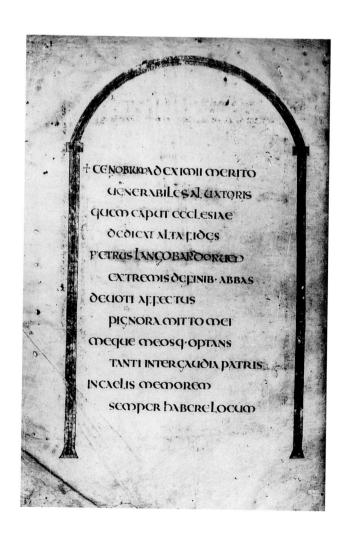

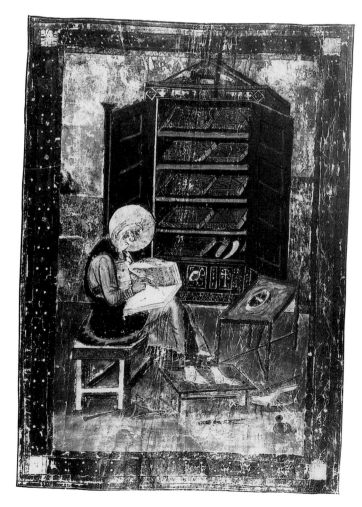

ET NON MINUAS PRIMITIAS
 MANUUM TUARUM
IN OMNI DATO HILAREM
 FAC UULTUM TUUM
ET IN EXULTATIONE STIFICA
 DECIMAS TUAS
DA ALTISSIMO SECUNDUM
 DATUM EIUS
ET IN BONO OCULO ADINUENTIONE
 FAC MANUUM TUARUM
QUONIAM DNS RETRIBUENS EST
ET SEPTIES TANTO REDDET TIBI
NOLI OFFERRE MUNERA PRAUA
 NON ENIM SUSCIPIET ILLA
ET NOLI INSPICERE SACRIFICIUM
 INIUSTUM
QUONIAM DNS IUDEX EST ET NON
 EST APUD ILLUM GLORIA
 PERSONAE
NON ACCIPIET DNS PERSONAM
 IN PAUPEREM
ET PRAECATIONEM LAESI EXAUDIET
NON DISPICIET PRAECES PUPILLI
 NEC UIDUAM SI EFFUNDAT
 LOQUELLAM GEMITUS
NONNE LACRIMAE UIDUAE
 AD MAXILLAM DESCENDUNT
EXCLAMATIO EIUS SUPER
 DEDUCENTEM EAS
A MAXILLA ENIM ASCENDUNT
 USQUE AD CAELUM
ET DNS EXAUDITOR NON DELEC
 TABITUR IN ILLIS
QUI ADORAT DM IN OBLECTATIONE
 SUSCIPIETUR
ET PRAECATIO ILLIUS USQUE
 AD NUBES PROPINQUAUIT
ORATIO HUMILIANTIS
 SE NUBES PENETRAUIT
ET DONEC PROPINQUET
 NON CONSOLABITUR
ET NON DISCEDIT DONEC
 ASPICIAT ALTISSIMUS
ET DNS NON ELONGAUIT

SED IUDICABIT IUSTO ET FACIET
 IUDICIUM
ET FORTISSIMUS NON HABEBIT
 IN ILLIS PATIENTIAM
UT CONTRIBULET DORSUM IPSORU
 ET GENTIBUS REDDET UINDICTA
DONEC TOLLAT PLENITUDINEM
 SUPERBORUM ET SCEPTRA
 INIQUORUM CONTRIBULET
DONEC REDDAT HOMINIBUS
 SECUNDUM ACTUS SUOS
ET SECUNDUM OPERA ADAE
 ET SECUNDUM PRAESUMPTIONE ILLIUS
DONEC IUDICET IUDICIUM
 PLEBIS SUAE
ET OBLECTAUIT IUSTOS
 MISERICORDIA SUA
DE PRAECATIO AD DM
SPECIOSA MISERICORDIA DI
 IN TEMPORE TRIBULATIONIS
QUASI NUBES PLUUIAE
 IN TEMPORE SICCITATIS
MISERERE NOSTRI DS
 OMNIUM ET RESPICE NOS
ET OSTENDE NOBIS LUCEM
 MISERATIONUM TUARUM
ET IMMITTE TIMOREM TUUM
 SUPER GENTES QUAE NON
 EXQUISIERUNT TE
ET COGNOSCANT QUIA NON EST DS
 NISI TU UT ENARRENT
 MAGNALIA TUA
ALLEUA MANUM TUAM SUPER
 GENTES ALIENAS UT UIDEANT
 POTENTIAM TUAM
SICUT ENIM IN CONSPECTU EORU
 STIFICATUS ES IN NOBIS
SIC IN CONSPECTU NOSTRO
 MAGNIFICABERIS IN ILLIS
¢ UT COGNOSCANT TE SICUT
 ET NOS AGNOUIMUS
QUONIAM NON EST DS PRAETER
 TE DNE
INNOUA SIGNA ET IMMUTA MIRABILIA

life of Ceolfrith. The Codex Amiatinus is quite simply the actual volume written at Wearmouth or Jarrow by English scribes in imitation of the Codex Grandior. As Ceolfrith died on the journey, the book never reached Rome. The diagrammatic illustrations reproduce precisely those described by Cassiodorus in the Codex Grandior itself. The strange frontispiece shows the aged prophet Ezra (or Cassiodorus or, more probably, both as the same man) seated before an open cupboard containing the carefully labelled nine volumes of the *Novem Codices* which Cassiodorus gave to the Vivarium community. This picture too is no doubt copied from the sixth-century Italian original.

The identification of the Codex Amiatinus as Ceolfrith's copy created great excitement in the late nineteenth century, especially among patriotic antiquarians glad to learn that the earliest known complete Latin Bible was made in England. In 1889 Canon William Greenwell of Durham bought an old register from a bookseller in Newcastle and found that its binding was made up of an ancient leaf of vellum with part of the Latin Book of Kings in script almost identical to that of the Codex Amiatinus. He gave his find to the British Museum (now B.L., Add. MS. 37777). Soon afterwards, ten leaves (and scraps of an eleventh) were sorted out from among the archives of Lord Middleton. On the publication of the Greenwell leaf in 1909 it became quite clear that they came from the same dismembered manuscript. They were acquired by the British Museum in 1937 (now B.L., Add. MS. 45025). In July 1982, yet another leaf was found forming a binding at Kingston Lacy House, then just acquired by the National Trust (PL. 11). Possibly there are others still to be discovered. The significance of these leaves is that they must be from one of the other two matching Bibles ordered by Ceolfrith and assigned by him to the use of Wearmouth and Jarrow. Both monasteries were destroyed by the Vikings in the late ninth century and remained as ruins for two hundred years. Relics from the sites were rescued for Durham Cathedral, whose monks later claimed to own several manuscripts

in Bede's own hand ('de manu Bede', in fact, an over-optimistic attribution). After the Reformation at least one Durham Cathedral manuscript Bible migrated into the library of the Willoughby family, later Lords Middleton, and very probably the Willoughbys owned a substantial portion of the Ceolfrith manuscript and used its huge pages centuries ago for binding their books at Wollaton Hall, near Nottingham, or Middleton Hall, near Tamworth.

An even smaller fragment, still in Durham Cathedral, links in with the story too. There is a tiny scrap of part of the Bible (bits of I Maccabees 6–7) reused as a flyleaf in Durham Cathedral Library, MS. B.IV.6. It is only 8½ x 5 inches (217 by 127 mm), about the size of a postcard, but is certainly Italian work of the sixth century. Could it be a relic from Cassiodorus's nine-volume Bible? It shares two extremely rare readings – one of them unique, in fact – with the Codex Amiatinus, and was doubtless the model used by Ceolfrith's scribes. These copyists used both the Codex Grandior and the *Novem Codices* at least. By calculating the amount of text that the scribe of the Durham fragment could have fitted onto a single page, one can conclude that the whole Bible, if indeed it was a whole Bible, would have been well over two thousand leaves thick. If divided into nine volumes, on the other hand, each part would have averaged about 240 leaves, which would be quite manageable. Beyond that, we hardly dare speculate.

All the manuscripts mentioned so far in this chapter, whether British or Italian, are written in uncial script. This is the late classical handwriting made up of capital letters formed with graceful curved strokes (PLS. 8, 9 and 11). The dependence of the Kentish missionaries on their Roman origins and the fierce allegiance of the Wearmouth/Jarrow communities to the papacy are demonstrated not only by historical record but, most graphically, by the use of this handwriting. It is a script specifically associated with Rome. The very earliest library catalogues describe uncial manuscripts as 'Romana litera scriptum'.

We must now introduce a whole new element into the story.

11 *Opposite*

**Kingston Lacy House,
National Trust, Bankes Collection,
single leaf, recto**

This large manuscript leaf was discovered in 1982 reused as a wrapper around a much later book. It is from part of the book of Ecclesiasticus and is one of several surviving fragments from one of the huge Latin Bible manuscripts described by Bede as having been commissioned by Ceolfrith for the use of the monasteries of Wearmouth and Jarrow in Northumberland in *c.*700–16.

To the embarrassment and confusion of the Roman-based apostles in England, theirs was not the only or even the first Christian mission to Britain. Christianity had flourished in Ireland since the mid-fifth century, led by St Patrick and others, and in 563, more than thirty years before St Augustine landed, St Columba founded the famous island monastery at Iona off the west coast of Scotland. It was the beginning of a great missionary movement. By 635 St Aidan had brought this Celtic Christianity right across the country to another offshore foundation at Lindisfarne on the east coast of Northumbria. The Irish liked islands. Ceolfrith, dedicating his Bible to the pope, thought he lived in a remote place, but it was nothing to the extreme and literal insularity of the tiny primitive Irish communities. The image of Benedict Biscop thoughtfully purchasing classical texts in Rome sounds supremely civilized. It contrasts dramatically with the legends of the earliest Irish books. St Columba (c.521–97) is said to have borrowed a manuscript from St Finnian (c.495–579) and stayed on in the church at night copying it out while his fingers shone like candles and filled the church with light. Finnian contested that his manuscript should never have been used in this way. His messenger, interrupting the illegal copying, had his eyes pecked out by St Columba's pet crane, we are told. The feuding saints appealed to the local king who declared against Columba, making him hand over his pirated copy ('to every cow her offspring, and to every book its transcript'). Columba in retaliation then marshalled the king's enemies against Finnian and defeated him at the Battle of Cul Dremhe in 561. The actual manuscript made by Columba in the legend used to be identified with the so-called Cathach of St Columba, a seventh-century manuscript now kept at the Royal Irish Academy (PL. 12). It is as different from the Codex Amiatinus as one can imagine. It is small and decorated with spiralling penwork initials, and it survived in the early medieval shrine or *cumdach* in which its owners took it into battle shouting for victory. Even the name 'Cathach' means 'battler' in Old Irish. We are in a different world.

Historians from the time of Bede onwards have described the distressing rivalry and differing emphases of the early Irish Christians and the first Roman missionaries, and the disputes were made no easier by the absolute sincerity of the protagonists. A major difference of tradition was represented by contrasting methods for calculating the date of Easter, and no doubt the arguments were watched with sly amusement by any still pagan British, a race famous for carefully regulated festivals and seasons. Finally in 664 the Christians came together for their great synod at Whitby in Yorkshire when King Oswy chaired the debate between Colman for the Irish and Wilfrid for Rome. In the event, the argument came to hinge on whether St Peter or St Columba had greater authority in heaven, and the claims of the Roman Church triumphed. Almost all adherents of the Irish cause, including the king, now declared their new allegiance to the universal Church, but Colman himself returned unconvinced to Ireland.

Literacy and a belief in written revelation were the most fundamental tenets of both Irish and Roman Christians, and they all owned books. We see something of their politics reflected in the surviving manuscripts. The Irish – isolated, holy, ascetic, independent of Rome – produced no uncial manuscripts at all, and wrote entirely in their eccentric Irish majuscule and minuscule scripts. Their books were at first generally cramped and irregular and on poor-quality vellum, consistent with the primitive nature of the communities. The Cathach of St Columba is Irish work dating from well before the Synod of Whitby. The leaves are crooked and the lines uneven, but there is something deeply venerable about this relic. The Bangor Antiphonary (Milan, Biblioteca Ambrosiana, MS. C.5.inf.) was written at Bangor in northern Ireland during the abbacy of Colman (680–91) and is an unorthodox volume full of original holes. The same ascetic roughness can still be seen in the eighth-century Irish pocket-sized Gospel Books like the Book of Dimma, probably made in County Tipperary (Dublin, Trinity College, MS. A.IV.23), and in the Book of Mulling, which has a colophon associating it with the name of St Moling (d.692–7) and which was probably made by his eighth-century successors at the monastery of Tech-Moling in County Carlow (Dublin, Trinity College, MS. A.I.15).

Somewhere in this misty early period too belongs the controversial Book of Durrow. This great Gospel Book, now in Trinity College, Dublin (MS. A.IV.5, PLS. 13 and 15), is tall and narrow, about 9½ by 5½ inches (245 by 145 mm) and includes twelve interlaced initials, five full-page emblematic figures symbolizing the Evangelists, and six 'carpet' pages, an evocative term used to describe those entire sheets of multicoloured abstract interlace patterns so characteristic of early Irish art. Anyone can see that it is a fine manuscript and it has attracted much speculation. It ends with an invocation asking that whoever holds this book in his hands should remember Columba its scribe, who copied it in twelve days, but this inscription has been altered and rewritten and if it actually refers to St Columba himself, founder of Iona, it is at best a copy made a century later from one made by the missionary saint. It is very possible that the book comes from one of St Columba's foundations (of which Durrow is one) some time in the second half of the seventh century. Scholars have argued for origins in Ireland (c.650), Iona itself (c.665), or even right across at Lindisfarne (c.680). The size of the book suggests it could easily slip into a traveller's saddle-pack, and perhaps it was used in several missionary outposts. It was back in Ireland when King Flan (d.916) commissioned a *cumdach* for it, and it seems to have been at Durrow, about fifty miles west of Dublin, from at least the early twelfth century.

After 664 and the merging of Irish and Roman interests, many manuscripts graphically reflect their double pedigree. The term 'insular manuscripts' is used to describe books made in the British Isles (as distinct from the Continent), but whether in England or

**Dublin, Royal Irish Academy,
s.n., fol. 48r**

The Cathach of St Columba is
one of the earliest of all Irish manu-
scripts, perhaps of the early seventh
century. It is a Psalter, and the term
'Cathach' (battler) reflects the fact
that it was carried as a magic talis-
man into battle. The manuscript
is now incomplete and damaged
around its edges, but shows the
characteristic Irish feature of succes-
sive letters at the start of each Psalm
diminishing in size from the large
decorated opening initial down to
the small scale of the script itself.

Ireland may not be clear. Another general term is 'Northumbro-Irish'. We have already mentioned the Vespasian Psalter from St Augustine's Abbey in Canterbury, written in uncials so Roman in type that the late medieval monks kept it on the high altar as St Augustine's own copy. It is true that its miniature of King David and his musicians must be copied, perhaps directly, from a sixth-century Italian original but the broad arched top of the picture is thoroughly Irish with its delicate swirling interlaced patterns (PL. 7). It is very closely related to a Gospel Book now in Stockholm (Kungliga Biblioteket, MS. A.135), known as the Codex Aureus, the golden book (PL. 16). This manuscript is also in uncial script, partly in gold ink on leaves stained in purple, and the book is ascribed to the mid-eighth century. It too has delicate Irish inter-laced and animal-filled initials. Like the Vespasian Psalter, it was almost certainly made in Canterbury, right in the centre of the Roman tradition. There were clearly Northumbro-Irish models there by the eighth century. Indeed the Codex Aureus itself nearly disappeared, carrying the style far away, in a most dramatic man-ner. In the mid-ninth century the volume was stolen in a raid by the pagan Norsemen. It was then ransomed for gold by Aldorman Aelfred and his wife Werburg and presented to Christ Church, Canterbury, probably between 871 and 889, a famous donation recorded in Anglo-Saxon on the upper and lower margins of folio 11r. By the sixteenth century the book was in Spain, belonging in turn to the historian Jerónimo Zurita (1512–80), the Carthusians of Aula Dei near Saragossa, and members of the Guzmán family. In 1690 it was bought in Madrid by John Gabriel Sparwenfeldt for the Swedish royal collections. After eight hundred years, therefore, it fell back into Scandinavian hands, now duly Christian and biblio-graphically minded.

But if Celtic decoration edged its way quietly into uncial manu-scripts, the losing faction at Whitby achieved a far more enduring monument in the victory of their script. This is the period of the great insular Gospel Books. They are all written in Irish half uncial script, like the Book of Durrow, and Irish minuscule, like the Book of Armagh. The most famous is certainly the Book of Kells, but this is really the last in a long line and was preceded by such out-standing manuscripts as the Lindisfarne Gospels (c.698), the Echternach Gospels, the Durham Gospels (both c.700 and proba-bly Northumbrian), the Book of St Chad or Lichfield Gospels (eighth century, possibly Welsh, PLS. 14 and 30), the Hereford Cathedral Gospel Book (perhaps the west of England or Wales, late eighth century), the Book of Armagh (Ireland, c.807), and a good many other splendid books of this class.

The Book of Kells is a problem. No study of manuscripts can exclude it, a giant among giants (Trinity College, Dublin, MS. A.I.6, PLS. 17–18). There are signposts through the streets of Dublin directing tourists to where it may be seen, an honour paid to no other manuscript in the world. Around its glass case in Trinity College there stands an almost permanent circle of

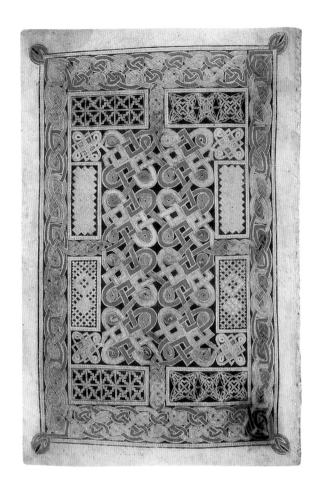

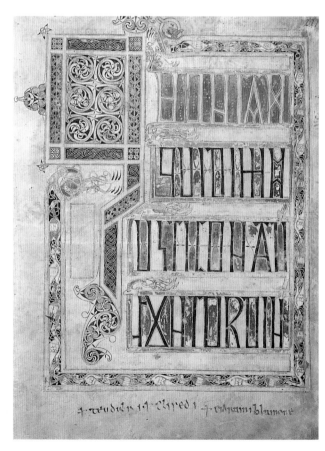

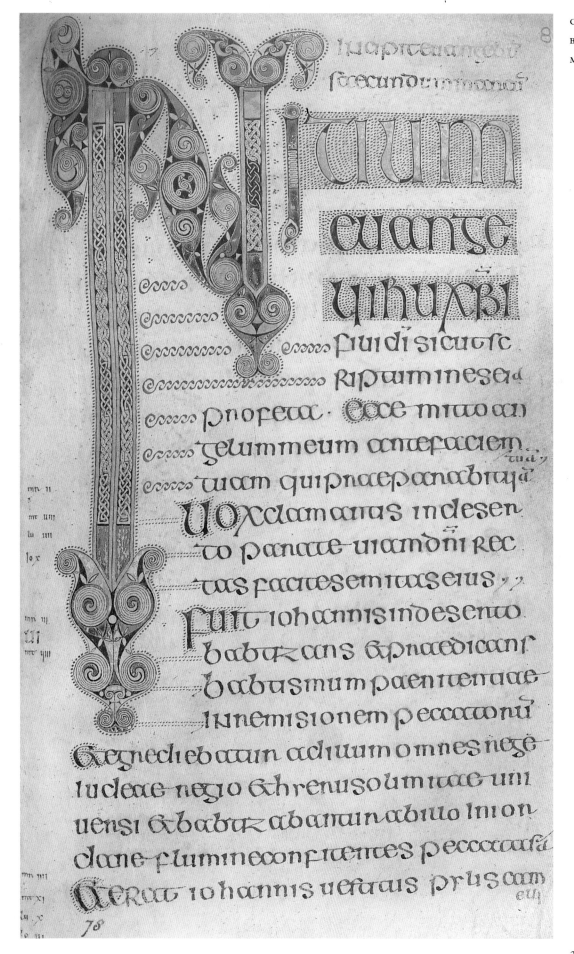

13 *Opposite above*

**Dublin, Trinity College,
MS. A.4.5, fol. 125v**

The Book of Durrow dates from the
second half of the seventh century.
It has six elaborate 'carpet' pages of
interlaced patterns, such as this
which precedes the Gospel of St
Luke. The manuscript was certainly
at Durrow Abbey by the late
eleventh or early twelfth century.

14 *Opposite below*

**Lichfield, Cathedral Library,
MS. I, p. 221**

The Book of St Chad, or Lichfield
Gospels, probably dates from the
second quarter of the eighth century.
It may have been made in what is
now Wales, and in the ninth century
it was exchanged for his best horse
by Gelhi, son of Arihtiud. For the
last thousand years, at least, it has
been in the Cathedral at Lichfield.

15 *Right*

**Dublin, Trinity College,
MS. A.4.5, fol. 86r**

The opening of St Mark's Gospel in
the Book of Durrow shows the elab-
oration of early Irish art in its most
refined, infinitely more complex
than that of the Cathach of St
Columba (PL. 12) of less than a
century earlier. The letters 'I' and
'N' merge together ('Initium
evangelii …', 'The beginning of
the Gospel …') in a design which
resembles Celtic metalwork.

16 *Overleaf*

**Stockholm, Kungliga Biblioteket,
MS. A. 135, fols. 9v and 11r**

The Codex Aureus, a spectacular
Gospel Book, dates from the mid-
eighth century. It was presumably
made in Canterbury, and the general
style of the miniature of St Matthew
on the left here can be compared
with that of David in the Vespasian
Psalter (PL. 7 above). In the upper
and lower margin of the right-hand
page here is an inscription in Anglo-
Saxon recording how the precious
book was ransomed for gold from
the pagan Norsemen by one Aldor-
man Aelfred in the ninth century.

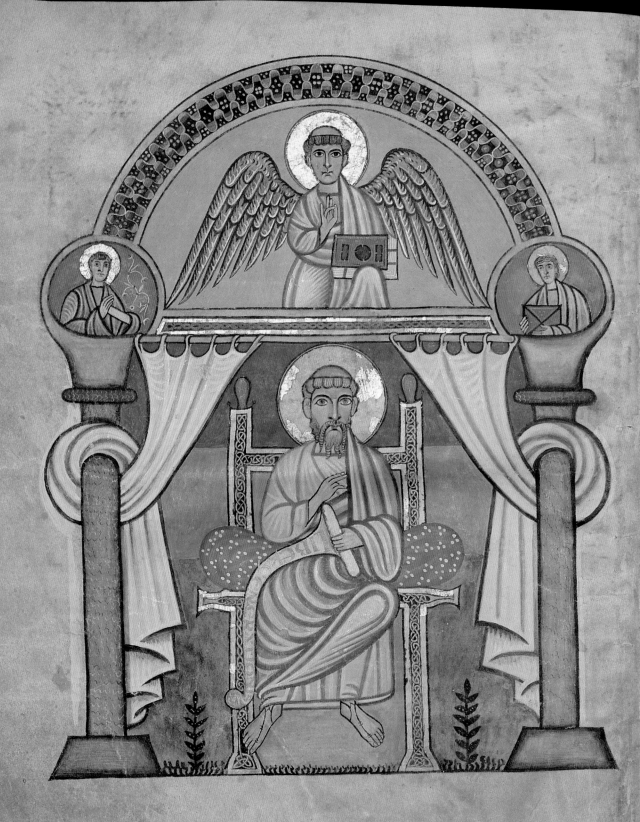

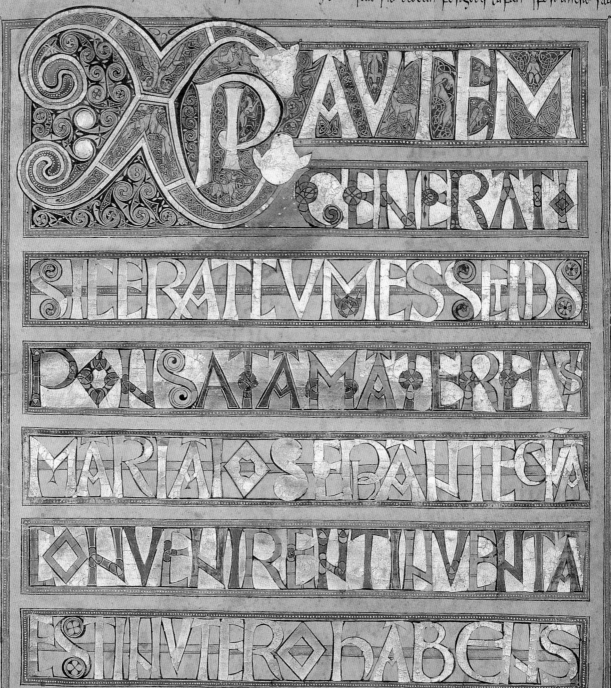

In nomine dni nri ihu xpi. Ic ælfred aldormon ⁊ wærburg min gefera begetan ðas bec æt hæðnum herge mid uncre claene feo ðæt ðonne wæs mid clæne golde ⁊ ðæt wit deodan for godes lufan ⁊ for uncre saule ðearf

XP
AVTEM
GENERATI
SIC ERAT CVM ESSET D̄S
PONSATA MATER EIVS
MARIA IOSEPH ANTEQ'A
CONVENIRENT INVENTA
EST IN VTERO HABENS

Ond forðon ðe wit noldan ðæt ðas hal gan beoc lencg in ðære hæðenysse wunaden, ⁊ nu willað heo gesellan inn to cristes circan gode to lofe ⁊ to wuldre ⁊ to weorðunga ⁊ his ðrowunga to ðoncunga, ⁊ ðæm godcundan geferscipe to brucon ne de in cristes circan dæghwamlice godes lof rærað, to ðæm gerade ðæt heo mon arede ælce monaðe for ælfred ⁊ for wærburg ⁊ for alhðryðe heora saulum to ecum lecedome, ða hwile ðe god gesegen hæbbe ðæt fulwiht æt ðeosse stowe beon mote. Ec swelce ic ælfred dux ⁊ wærburg biddað ⁊ halsiað on godes almæhtiges noman ⁊ on allra his haligra ðæt nænig mon seo to ðon gedyrstig ðætte ðas halgan beoc aselle oððe aðeode from cristes circan ða hwile

admirers. Its decoration is of extreme lavishness and the imaginative quality of its workmanship is quite exceptional. It was probably this book which Giraldus Cambrensis in about 1185 called 'the work of an angel, not of a man'. But in the general history of medieval book production the Book of Kells has an uncomfortable position because (despite much investigation, not all of it free from zealous patriotism) really very little is known about its origin or date. It may be Irish or Scottish or English. It has been assigned to various dates between the early eighth and the early ninth century, quite late (in any case) in the story of insular manuscripts. It is sometimes suggested that it was made at Iona and that the monks fled with it back to Ireland when in 806 Iona was sacked by the Vikings and sixty-eight members of the community were killed. The survivors escaped to Kells, about thirty miles north-west of Dublin, and the abbot of Iona, Cellach, was buried there in 815. All that is known for certain is that the Book of Kells was there by the twelfth century.

In the case of the Lindisfarne Gospels (B.L., Cotton MS. Nero D.IV) which may be up to a hundred years earlier, the documentation is, by contrast, almost overwhelmingly rich (PLS. 4 and 19). We know where it was made, who wrote it, why, who bound it,

who decorated the binding, and who glossed the text. We know enough about the craftsmen to be able to date the manuscript fairly closely. Although the colophon was added in the tenth century by the priest who filled in translations of words into the Anglo-Saxon language long after the volume was first made in Latin, there is no reason to doubt the accuracy of his information. In translation, it reads: 'Eadfrith, bishop of the Lindisfarne Church, originally wrote this book, for God and for St Cuthbert and – jointly – for all the saints whose relics are in the island. And Ethelwald, bishop of the Lindisfarne islanders, impressed it on the outside and covered it – as well he knew how to do. And Billfrith, the anchorite, forged the ornaments which are on the outside and adorned it with gold and with gems and also with gilded-over silver – pure metal. And Aldred, unworthy and most miserable priest, glossed it in English between the lines with the help of God and St Cuthbert …'

Eadfrith, said to be the scribe, became bishop in 698 and was succeeded in 721 by Ethelwald who (according to the colophon) first bound the book. Ethelwald himself was a novice at Lindisfarne, but between about 699/705 and his return as bishop in 721 he held office as prior and then abbot at Melrose Abbey. Therefore if the two men worked together at Lindisfarne, a date

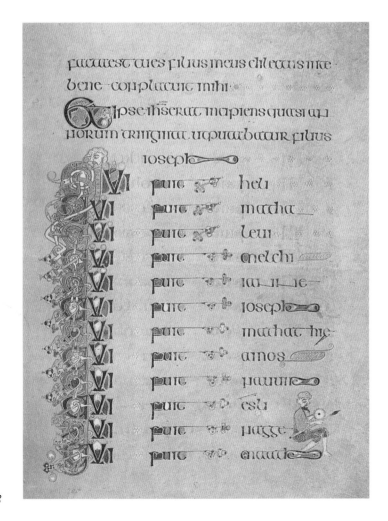

17 *Opposite left*

**Dublin, Trinity College,
MS. A.I.6, fol. 200r**

The Book of Kells is perhaps the
most famous manuscript in the
world, probably made in the early
ninth century. The page here shows
the names of the ancestors of Christ
(Luke 3:23–6) with the opening let-
ter of every line filled with intricate
ornament.

18 *Opposite right*

**Dublin, Trinity College,
MS. A.I.6, fol. 124r**

The decoration of the Book of Kells
is so rich that important passages in
many parts of the Gospels are
marked with full-page ornament.
Here the text of St Matthew 27:38
('Tunc crucifixebant duo latrones
…', 'Then they crucified two
thieves …') is transformed into a
carpet-like design with little fair-
headed men crowded into the edges.

19 *Right*

**London, British Library, Cotton
MS. Nero D.IV, fol. 25v**

The portrait of the evangelist
St Matthew in the Lindisfarne
Gospels is clearly derived from the
same model as the portrait of Ezra
in the Codex Amiatinus, which was
made in Northumbria at almost
exactly the same date (PL. 10
above). In the upper corner is St
Matthew's symbol in art, the man
with wings, captioned here 'Imago
hominis' and blowing a trumpet.

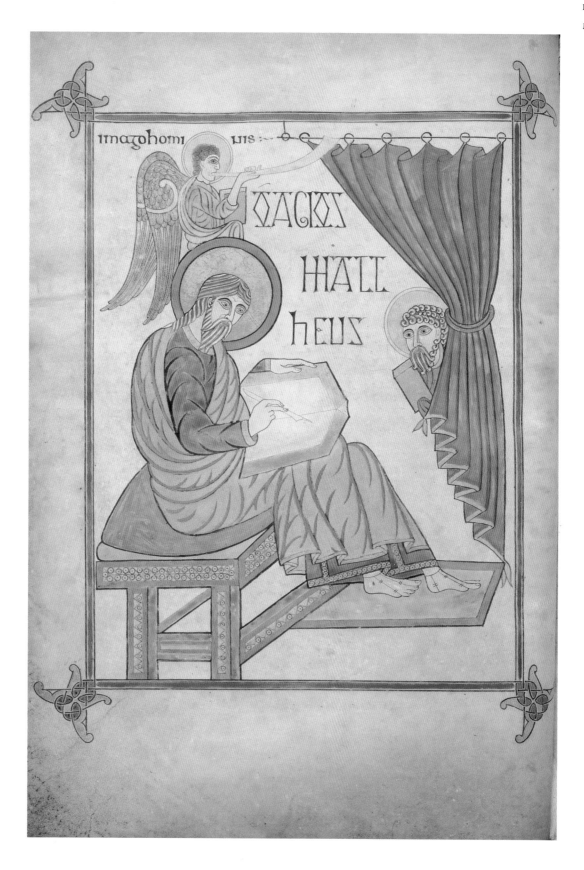

around 698 must be about right for the manuscript. The miniature of St Matthew writing is clearly modelled on the same source as the Ezra portrait in the Codex Amiatinus, painted in Northumbria *c*.700–16 (PLS. 10 and 19). The Lindisfarne Gospels was intended to be a showpiece. In 698 the monks of Lindisfarne reburied the body of St Cuthbert in an elaborate wooden shrine, an event which brought many pilgrims to the monastery. The manuscript belongs exactly to this period and the colophon names St Cuthbert as co-patron. The volume was probably on display for about a hundred years. But, at about the time of the raids on Iona, Lindisfarne too came under attack from the Vikings. In 793 the island community was sacked by the invaders, and eventually in 875 the monks fled to the mainland taking with them their most precious possessions, including the relics of St Cuthbert and the Lindisfarne Gospels. There is a tale recorded in the early twelfth century by Symeon of Durham that the refugees intended to cross to Ireland (as the Iona monks had done), but that, as they put out to sea, a terrible storm arose and a copy of the four Gospels, richly bound in gold and jewels, was swept overboard and lost. The monks quickly abandoned their voyage and, through the miraculous intervention of St Cuthbert, their precious manuscript was restored to them at low tide, still perfectly preserved. This story very probably refers to the Lindisfarne Gospels. If there had been no storm and the refugees had brought the book safely to Ireland, of course, Aldred would never have been there to add his detailed colophon and we might

never have known the Lindisfarne provenance. In that case, students could still be debating whether the book was English or Irish.

Though the monks had tried to take the Lindisfarne Gospels westwards to Ireland, many more books were by this date being carried for quite different reasons eastwards across the North Sea. One of the great achievements of the insular Church was to carry the Word of God to the Continent. After the Synod of Whitby, Colman had retreated to Ireland but the champion Wilfrid had turned his zeal to Frisia in 677, and Wihtberht preached there in 690. The missions gained momentum at the extreme end of the seventh century. While the Lindisfarne islanders were making their Gospel Book at home, St Willibrord (658–739) and his younger contemporary St Boniface (680–754) set forth from Britain across Germany. Willibrord founded the famous monastery at Echternach in 698. Before 742 the missionaries had established dioceses at Utrecht, Würzburg, Erfurt, Eichstätt, and elsewhere; in 744 Boniface founded the great abbey of Fulda and in 747 he adopted Mainz as his cathedral. With St Willibald and others, they evangelized most of Frisia, Saxony, Thuringia, Bavaria, and part of Denmark.

To return then to the theme of this chapter, Christian missionaries need books. These are essential tools for impressing the pagans and educating the converts. It is hardly possible to think of a more striking way of illustrating the impact of the Anglo-Saxon missionaries on German cultural life than by looking at their

20 *Right*

Paris, Bibliothèque Nationale, ms. lat. 9389, fol. 18v

'Imago hominis', the image of a man, the evangelist's symbol for St Matthew (as in PL. 19 above), appears here in the Echternach Gospels. The man in the picture, like the Anglo-Saxon missionaries themselves who brought this volume across Europe, is exhibiting the words of the Gospel by holding up an open manuscript.

21 *Opposite*

Paris, Bibliothèque Nationale, ms. lat. 9389, fol. 116r

The Echternach Gospels was also made in Northumbria around the year 700 and was probably among the books brought from England to Echternach Abbey in Luxembourg by St Willibrord (658–739) and his fellow missionaries. This is the opening of the text of St Luke's Gospel.

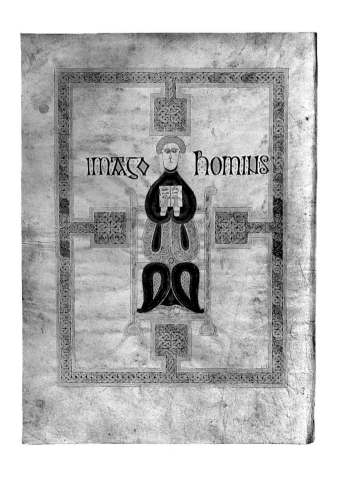

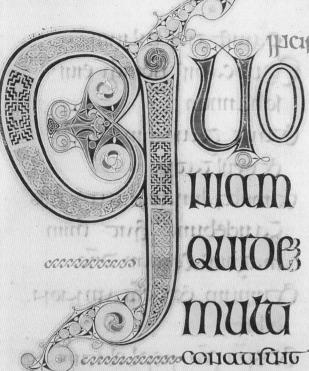

QUO

niam
quidem
multa

conati sunt

Ordinare narrationē
quae innobis conple
tae sunt rerum
Sicut tradiderunt
nobis
Qui abinitio ipsi uiderunt
et ministri fuerunt
sermonis
Uisum est & mihi
adsecuto á principio
omnibus
Diligenter exordine
tibi scribere optime
Theofile

Ut cognoscas eorum
uerborum dequibus
erudituis es uiritatem·

FUIT indiebus
herodis regis
iudeae
Sacerdos quidam
nomine zacharias
deuice abiae abia
& uxor illi defiliabus
aaron
& nomen eius elisabeth
erant autem iusti am
bo ante dm
incedentes inomnibus
mandatis
& iustificationibus dni
sine querela
& non erat illis filius
eo quod esset elisabeth
sterilis
& ambo processissent
indiebus suis·

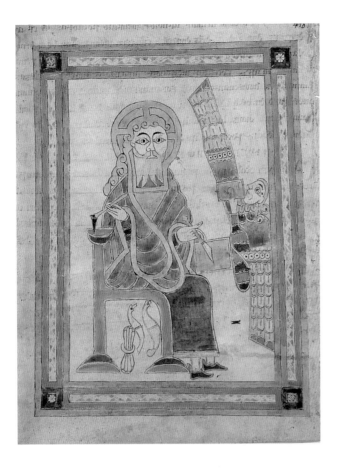

22 *Above*

**St Gall, Stiftsbibliothek,
Cod. 1395, p. 418**

This miniature of St Matthew is on
the only surviving leaf from a lost
Irish Gospel Book of the eighth or
ninth century. On the verso of the
leaf are magical charms written
partly in Old Irish. The leaf is
among the ancient fragments of
manuscripts from the Irish abbey of
St Gall.

23 *Opposite*

St Gall, Stiftsbibliothek, Cod. 51, p. 7

The abbey of St Gall in the hills
above Lake Constance in
Switzerland was established as a
monastery in the eighth century
on the site of the cell of the early
seventh-century Irish hermit Gall.
This Irish Gospel Book was written
in the second half of the eighth cen-
tury, presumably in Ireland itself,
and it probably reached the commu-
nity at St Gall during the course of
the ninth century. It has remained
there ever since.

books. Even today, twelve hundred years and many wars later,
Northumbro-Irish manuscripts are scattered right across northern
Europe. For instance, the magnificent Echternach Gospel Book
(Paris, B.N., ms. lat. 9389, PLS. 20–1) was written probably in
Northumberland, perhaps even at Lindisfarne, as the same scribe
seems to have written another great Gospel manuscript, Durham
Cathedral Library, MS. A.II.17. It is not at all unlikely that the
Paris volume came to Echternach in the mission of its founder, St
Willibrord. But it is only one of a huge cache of insular manu-
scripts from Echternach which, after the secularization of the
abbey in the French Revolution, passed in about 1802 to the
Bibliothèque Nationale (mss. lat. 9527, 9529, 9538, 10399,
10837, etc.). There are similar substantial runs of insular books
from the libraries of the Anglo-Saxon foundations of Fulda (many
now in the Basel Universitätsbibliothek and in the Kassel
Landesbibliothek), Würzburg Cathedral (now in the Würzburg
Universitätsbibliothek, PL. 24) and at St Gall (still in the old abbey
library, the Stiftsbibliothek, PLS. 22–3). Many books survive on
their own. Often there is no clue as to how they reached Europe
except that they have been there from time immemorial.
Examples, among many, are Leipzig, Universitätsbibliothek, MSS.
Rep. I.58a and Rep.II.35a (perhaps from Niederaltaich in Bavaria
but 'written presumably in Northumbria', according to E.A.
Lowe), parts of two manuscripts in the church of St Catherine,
Maeseyck, the lovely Barberini Gospels in the Vatican (Biblioteca
Apostolica Vaticana, MS. Barb. lat. 570, PL. 26), which has a
scribal invocation to pray for Uuigbald ('Ora pro uuigbaldo', con-
ceivably Hygebeald, bishop of Lindisfarne 781–802), St
Petersburg, Publichnaja Biblioteka, MS. F.v.I.8 (another splendid
manuscript with textual similarities with the Lindisfarne Gospels),
and St Gall, Stiftsbibliothek, Cod. 51 (written in Ireland but cer-
tainly at St Gall in the Middle Ages, PL. 23). All these are Gospel
Books, expensively made and exported by missionaries.

If we look back at the catalogue of missionary equipment sent
by Gregory the Great to St Augustine in 601 with 'all such things
as were generally necessary for the worship and ministry of the
church', we see that books are put on a par with sacred vessels,
vestments, and relics of the apostles and martyrs. When Benedict
Biscop was furnishing his new Northumbrian monasteries, he too
acquired liturgical objects and relics along with the books.
Manuscripts were part of the paraphernalia of Christianity. They
were regarded as essential accessories, like relics and vestments.
The fact that insular Gospel Books are preserved today in libraries,
not in vestry cupboards or high altars (or even museums), should
not prejudice our view of these artefacts as liturgical equipment.
The books survive (because later generations preserved libraries),
but it would be fascinating to know what else came with them in
the wagons which trundled across Europe in the wake of the
Anglo-Saxon missionaries. An evocative hint of this is given by a
tiny ribbon of vellum about 4½ inches long (114mm), still kept in

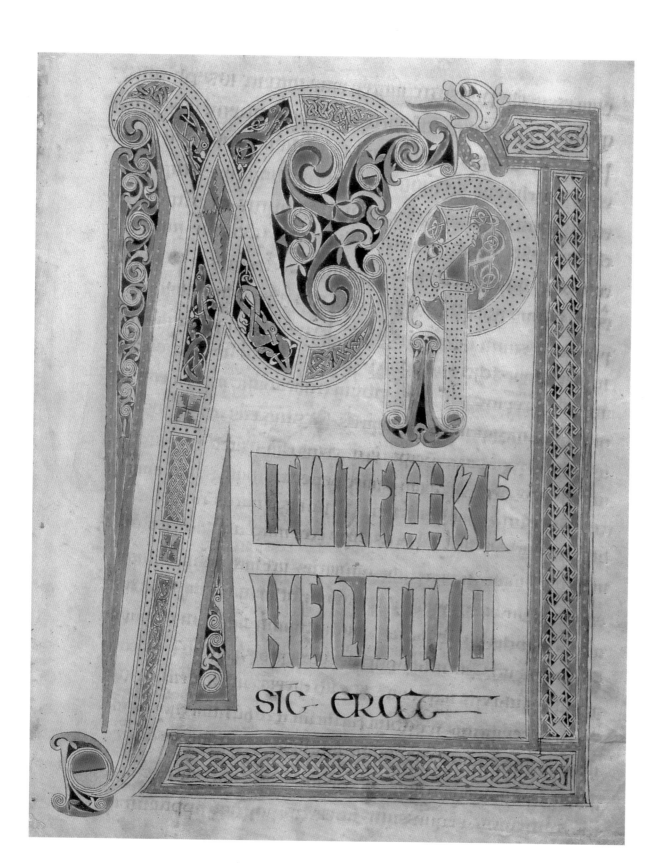

the abbey of St-Maurice in Switzerland. It was once wrapped around a relic and it is itself a label inscribed in an eighth-century insular minuscule 'de terra aeclisiae in qua sepultus est petrus primo'. It accompanied, therefore, as this caption tells us, a crumb of the earth from St Peter's first tomb in Rome. Benedict Biscop specifically fetched relics from Rome; it was the pre-eminence of St Peter himself which swayed the Synod of Whitby. This little relic, no doubt fraught with emotive value, must have come from Rome to the insular missionaries by whom it was labelled and lodged in a continental church.

In several manuscripts too there are traces of this line of supply from Italy to England to northern Europe. A Gospel Harmony in the Fulda Landesbibliothek (Cod. Bonifat. I) was written in south Italy for Victor, bishop of Capua, in the mid-sixth century, but it has insular annotations in a minuscule hand which some students

identify with that of St Boniface himself, founder of Fulda Abbey in 747. Two manuscripts from the Anglo-Saxon cathedral of Würzburg seem to have been brought from Italy to England before re-export to Germany: one had missing leaves replaced in Northumberland and the other has a signature of an abbess associated with Worcester in c.700.

There were probably three ways that an Anglo-Saxon community on the Continent could acquire books. It could receive them from the effects of its founder or from the luggage of a visiting Anglo-Saxon missionary. It could write its own manuscripts. It could send to Britain for manuscripts. The second method was easily done, if the monks had exemplars, and there are many 'insular' manuscripts copied out by Anglo-Saxons while on the Continent (PL. 24). It requires delicate tact to assign nationality to eighth-century books like Trier, Domschatz, Cod. 61, a Gospel Book

24 *Right*

Würzburg, Universitätsbibliothek MS. M.p.th.q.28b, fol. 43v

This manuscript of Isidore's *Synonyma* was written about the year 800. It comes from the ancient library of the cathedral of Würzburg, which had been established in the seventh century by St Kilian, a missionary from Ireland, and which continued to recruit insular clerics and to train local converts in the British style. Therefore, although in Anglo-Saxon script, the manuscript was very probably actually made in Würzburg.

signed by the Anglo-Saxon scribe Thomas, presumably while at Echternach Abbey (PL. 25), or Vienna, Österreichische National-bibliothek, Cod. 1224, a Gospel Book signed by Cutbercht, doubt-less an insular scribe, while he was in Salzburg. The third method is the most interesting, if only because it implies the existence of some kind of cottage industry for the export of manuscripts from Britain. There survive several fascinating letters to and from St Boniface and his successor as archbishop of Mainz, Lul, who both wrote from Germany between the 740s and 760s to the archbishop of York and to the abbot of Wearmouth/Jarrow trying to obtain copies of the works of Bede. The missionaries in Germany explained that they much regretted any trouble involved but none the less plainly itemized books which 'we request you will kindly have copied out and sent to us', as Boniface wrote. One such book prepared for export around 746 was no doubt the Bede in St

Petersburg (Publichnaja Biblioteka, MS. lat. Q.v.I.18, PL. 29). Perhaps we can evoke something of the spirit of these monks busily supplying manuscripts for missionaries if we try to imagine whoever wrapped up the relics from St Peter's tomb cited above: perhaps he or she divided up a pile of crumbs into many packages and labelled each one for wider distribution. So also St Boniface asked for manuscripts of Bede 'so that we also may benefit from that candle which the Lord bestowed on you'. The abbot of Wearmouth/Jarrow wrote almost in desperation to Lul in 763–4 saying they had dispatched all they could but that the terrible win-ter had hampered the scribes' progress and that they would still try to supply all the needed books, adding 'si vixerimus' ('if we live'). 'We can almost see him wringing his hands,' writes Dr M.B. Parkes.

The most enduring victory of Irish Christianity can now

25 *Right*

Trier, Domschatz, Cod. 61, fol. 1v

This is the frontispiece from a Gospel Book made in the second quarter of the eighth century, prob-ably at Echternach Abbey but at least in part by an Anglo-Saxon scribe called Thomas. It shows the traditional symbols of the four evan-gelists: a man for St Matthew, a lion for St Mark, an ox for St Luke, and an eagle for St John.

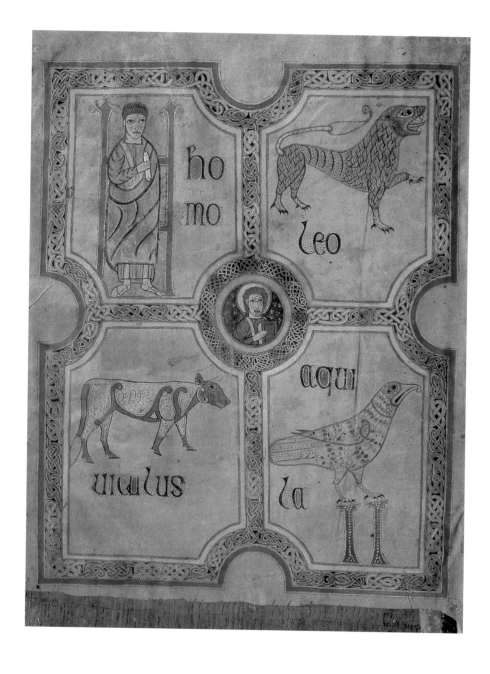

26 *Left*

**Rome, Biblioteca Apostolica
Vaticana, MS. Barb. lat. 570,
fol. 124v.**

The Barberini Gospels is English
work of the second half of the eighth
century. The miniature here shows
St John writing a manuscript on his
lap, with a pen in one hand and a
knife in the other, apparently seated
in the open air. The medieval prove-
nance is not known but the book is
quite likely to have been carried to
the continent relatively soon after
it was written.

27 *Opposite left*

**London, English Province of the
Society of Jesus; on loan to the
British Library, Loan MS. 74,
upper cover**

The St Cuthbert (or Stonyhurst)
Gospel of St John survives in its
remarkably elaborate original bind-
ing, by far the oldest extant
European decorated bookbinding.
The manuscript was made in
Northumbria in the late seventh
century. It seems to have been
buried with the body of St Cuthbert
in 698 and it was carried around
Northumbria inside the saint's coffin
for 400 years. In 1104, when the
relics of St Cuthbert were installed
in Durham Cathedral, the coffin was
opened and the tiny Gospel Book
was found miraculously preserved.
It has been kept as a relic ever since.

28 *Opposite right*

**London, English Province of the
Society of Jesus; on loan to the
British Library, Loan MS. 74, fol. 27r**

The script of the St Cuthbert Gospel
is a beautiful small uncial, but this
page is annotated in an insular
minuscule 'pro defunctis' ('for the
dead'), a heading which may allude
to use of the manuscript in the cere-
monies for the enshrinement of
St Cuthbert's relics in 698.

be seen. The early and slow uncial script was abandoned, even in Canterbury and Wearmouth/Jarrow, and the insular script became standard both for the grand Gospel Books and for the simple missionary texts. In Ireland today it more or less still survives, the longest lasting European handwriting, far more than a millennium after the last Roman uncial was used. The script was so intimately linked with its Celtic origins that the ninth-century library catalogue of St Gall listed together a whole group of missionary books as 'libri scottice scripti', and other monastic cataloguers used the term 'scottica' both for Irish and for Anglo-Saxon manuscripts, recognizable by their foreign script.

We are now in a position to look back over the writing of manuscripts for missionaries and to ask several questions which will recur in subsequent chapters but with different answers. Who made books? What use were books? Why were they decorated? On a superficial level, we know a surprising amount about the scribes of insular manuscripts, even many of their names. There are books signed by Sigbert, Eadfrith, Burginda, Edilbericht son of Berichtfrid, Wigbald, Cadmug, Cutbercht, Diarmait, Ferdomnach, MacRegol, Dubtach, and many others; we could probably not name so many scribes for surviving fifteenth-century French Books of Hours. The fact that so many scribal invocations appear, with and without names, is some evidence that the duplication of books was not a mere mechanical function, like building a

wall, but was a human and individual activity. No one in the later Middle Ages cared who had written out their manuscripts, but the insular monks did. Even the fact that Giraldus Cambrensis imagined that the Book of Kells was the work of an angel, not of a man, shows that he was considering the question.

Whether insular scribes worked in a scriptorium, or special place set aside for writing, is quite unknown. Several of the known scribes were themselves bishops, indicating (if nothing else) that they were not full-time copyists, though a seventh-century bishop was not exclusively an administrative official, as so often later, but a man chosen as a spiritual leader, a role which need not exclude practical labour. Billfrith, maker of the metal binding of the Lindisfarne Gospels, was an anchorite: he at least, presumably, did not work in a communal scriptorium. In fact, there is no proof that scribes even worked at desks, and some insular pictures of Evangelists show them as scribes writing open books on their laps: there are examples in the Lindisfarne, Maeseyck and Barberini Gospel Books. In the latter, the scribes seem to be sitting in a grassy meadow with flowers growing around them (PL. 26). The Wearmouth/Jarrow scribes were held up by cold weather in 763–4; they too may have worked in the open air. The Irish annotator of a St Gall Priscian of the ninth century claimed to be under the greenwood tree as the clear-voiced cuckoo sang from bush to bush.

When a medieval scribe ruled his vellum, he needed to multiply the page ruling throughout the book. He would measure the first page in a stack of unwritten leaves and then with a sharp instrument he would prick holes at the ends of the lines and push these right through the pile of vellum. When he turned to each page, therefore, he had only to join up the prickings to duplicate the ruling pattern from page to page. This is well known and applies throughout the Middle Ages. What is curious about insular manuscripts, however, unlike their continental counterparts, is that the prickings occur in both margins of a page instead of just in the outer margin. The explanation is easy. It means that insular scribes folded their leaves before they ruled them; continental scribes, by contrast, probably wrote on large oblong bifolia. We can go further than that. The little St Cuthbert Gospel of St John (the so-called 'Stonyhurst Gospel', PLS. 27–8) is the only insular book still in its original binding, and it has evidence of having been loosely stitched in gatherings before the proper binding was made. Similar little stitching holes can be detected in the Lindisfarne and Lichfield Gospels. Temporary sewing would hold the volume in shape while it was being written. A small book folded into secure gatherings can be written almost anywhere. Sometimes insular books must have remained in these *ad hoc* bundles of folded gatherings. Bede records that St Boisil (d.*c.*664) and St Cuthbert read through the Gospel of St John one gathering a day, strongly implying that the quires were quite distinct units. Books carried across Europe by missionaries would have been lighter without heavily fitted bindings. Nearly a third of the 'libri scottice scripti' at St Gall were described as 'quaterno' or 'in quaternionibus' – stitched

(perhaps) in quires, but unbound. Just because surviving medieval books are in library bindings does not mean they always looked like that.

Just as there is no surviving scriptorium from early Anglo-Saxon England, so there are certainly no library fittings, and almost nothing is known about how books were kept. The Ezra picture in the Codex Amiatinus includes a painted cupboard with hinged doors and shelves on which books are lying flat with their spines outwards. A seventh-century Jerome in Irish style but probably made at Bobbio has a contemporary inscription 'Liber de arca domno atalani' (Milan, Biblioteca Ambrosiana, MS. S.45.sup.) and the word 'arca' suggests a chest or box with possessions of Atalanus, abbot 615–22. A Gospel Book, however, may have been kept on an altar or with other liturgical apparatus rather than in a library (the association with vestments and relics has already been stressed). Especially in Ireland, a Gospel Book might have a *cumdach*, or portable shrine, made for it. Examples enclosed the Cathach of St Columba and the Books of Durrow and Mulling. It must be remembered that a Gospel Book was itself a holy object to be venerated and to be saved from the pagan. A Durham monk suffered terrible swellings when he impiously tampered with the Stonyhurst Gospel in 1104. There is a legend of the Irish scribe Ultan whose finger bones, having written out Gospels in Ultan's lifetime, performed a miracle after his death. It seems to have been especially in Ireland that Gospel Books had these near-magical talismanic qualities. Bede, in praising Ireland, says he had heard of victims of snake-bite being cured by drinking a solution of water and scrapings from the leaves of Irish manuscripts. As late as the

29 *Right*

St Petersburg, Publichnaja Biblioteka, MS. lat. Q.v.I.18, fol. 26v, detail

The historian Bede died in 735. This manuscript of his *Ecclesiastical History* was once believed to be in the author's own handwriting, and, although it can probably be dated to the decade after his death, it is almost certainly a product of the monks at Bede's own community at Wearmouth or Jarrow. The historiated initial is one of the earliest known, and it shows a saint – later but wrongly identified as St Augustine of Canterbury – holding a cross and a manuscript. The saint shown is actually St Gregory.

30 *Opposite*

Lichfield, Cathedral Library, MS. I, p. 220, detail

The Gospel of St Luke in the Book of St Chad, made probably in the second quarter of the eighth century, opens with an elaborate carpet page of entwined dragons and decoration.

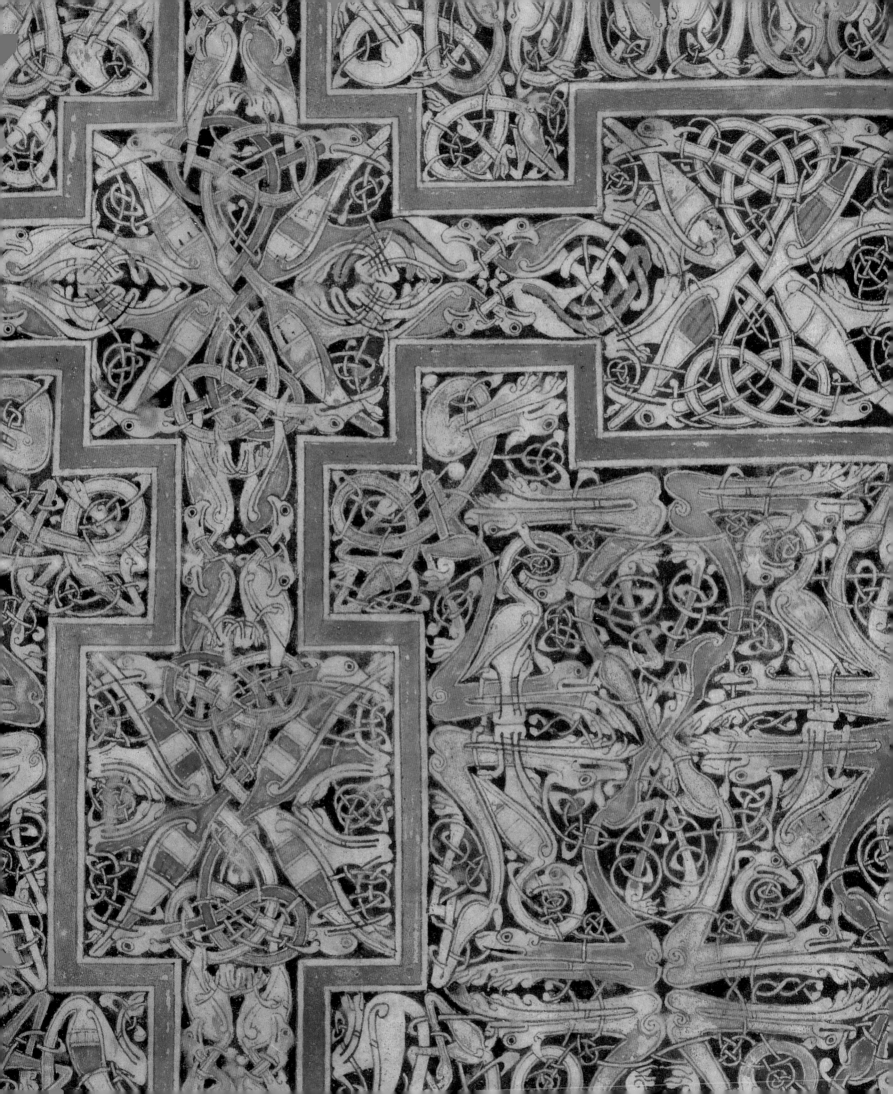

seventeenth century, the Book of Durrow was still being immersed in water to provide a cure for sick cattle.

Gospel Books were obviously the volumes most needed by missionaries. The next most popular authors were Isidore of Seville, Bede, and Gregory the Great, to judge from the numbers of surviving copies. All these had a practical evangelical function too. Isidore and Bede provide simple science and a careful explanation of the Church calendar. This must have had great value in presenting Christianity to the British pagans, whose sense of natural order and (especially) of chronology was so strong that even now we still use their pre-Christian names for the days of the week and for the major festivals such as 'Yule' and 'Eostre'. We can hardly imagine how embarrassing to the Christians the squabbles over calculating Easter must have been, and how comforting a textbook would be. Bede's *Ecclesiastical History* too had value as a manual for the conversion of pagans and it was very popular among the missionaries on the Continent. Gregory the Great was very highly regarded. It was he who had sent Augustine to England. His *Pastoral Rule* is the most fundamental missionary handbook. The St Petersburg Bede (fol. 26v) shows what is sometimes regarded as the earliest historiated initial in western art (PL. 29): the humble little drawing shows St Gregory half-length holding up a cross and clasping a book. No one would forget that St Gregory's initiative had brought both Christianity and book learning to Britain.

It is, however, in the Gospel Books that the most famous and most elaborate decoration occurs. With hindsight we look back on medieval manuscripts as if their illumination was a matter of course, but we must ask why these specific books (for the first time) were so elaborately ornamented. There is virtually no decoration in other texts. There must be several answers. The first and most practical function was as a means to find one's way about the Gospels. The text was used for reference. There were no chapter numbers or running titles in the eighth century. Even now, as one looks through the leaves of an insular manuscript, the bright carpet pages on the versos of leaves provide the quickest possible indicator of the beginning of each Gospel, and the initials of varying size have a convenience in separating the text into visually recognizable sections. Secondly, there is the theological reason. Gospel Books were decorated precisely because they contained the revealed word of God, which was being honoured by being ornamented and whose mystery and complexity were being praised by the amazingly elaborate illumination. The most splendid full-page ornament in insular Gospel Books occurred not only at the opening of each of the four Gospels themselves but also at Matthew 1:18, the beginning of the account of the incarnation of Christ, usually decorated

with a huge Greek 'XPI' monogram for the sacred name of Christ: in this way the Holy Name, too sacred to be easily legible, is worshipped by the art which forms it. Thirdly, there was probably a protective function in depicting crosses and the Evangelist symbols on the opening pages of a Gospel, as a talisman to ward off evil from the treasure in the book. Tales which have come down to us with the surviving insular Gospel Books are filled with accounts of semi-magical preservation of the books.

The final reason, however, takes us right back to the function of the books as missionary equipment. We can notice that there are really two kinds of decoration in an insular Gospel Book: the huge heavily outlined and brightly painted pictures, and the extremely delicate and endlessly varied plant-like interlace. Anyone can try a simple experiment. Prop up the facsimile of the Lindisfarne Gospels or the Book of Kells and walk backwards. At a few feet the initials lose their clarity, but at twenty paces the Evangelist portraits are magnificent. We remember now that on arrival in England, St Augustine held up in the open air religious paintings. Bede describes the effect of pictures in the church at Wearmouth 'to the intent that all ... even if ignorant of letters, might be able to contemplate ... the ever-gracious countenance of Christ and his saints'. These big books belonged to a missionary society. Their purpose was to show the word of God to ill-educated audiences. No doubt the big pictures did exactly that. A picture, wrote St Gregory, who sent the mission to England, is a kind of literature for the uneducated man. But to the convert and to the priest, allowed close access to the manuscript, the effect was altogether different. 'Look more keenly at it and you will penetrate to the very shrine of art. You will make out intricacies, so delicate and subtle, so exact and compact, so full of knots and links, with colours so fresh and vivid ... For my part, the more often I see the book, the more carefully I study it, the more I am lost in ever-fresh amazement, and I see more wonders in the book.' The writer is Giraldus Cambrensis about a visit to Ireland in 1185; his is the intellectual response of the literate priest and it is no less valid; it is very probably that of the art historian today.

Insular Gospel Books were made for missionaries. Once conversion was assured, the books become quite different. The last great Irish Gospel Book is the Macdurnan Gospels (Lambeth Palace Library, MS. 1370, PL. 31) made well into the ninth century. It was given to Christ Church, Canterbury, in the tenth century not by a missionary but by a king, Athelstan, king of Wessex and Mercia (c.924–39). We have moved beyond the world of Saints Augustine, Columba, Wilfrid, Ceolfrith, and Boniface, and are now in the age of kings and politics.

31 *Right*

**London, Lambeth Palace Library,
MS. 1370, fol. 172r**

The Macdurnan Gospels was made
in Ireland, perhaps in the late ninth
century. It is associated with
Maelbrigt Macdurnan, abbot of
Armagh (d.927). This page shows
the opening of St John's Gospel.
The manuscript was given to Christ
Church in Canterbury by Athelstan,
king of Wessex and Mercia (d. 939).

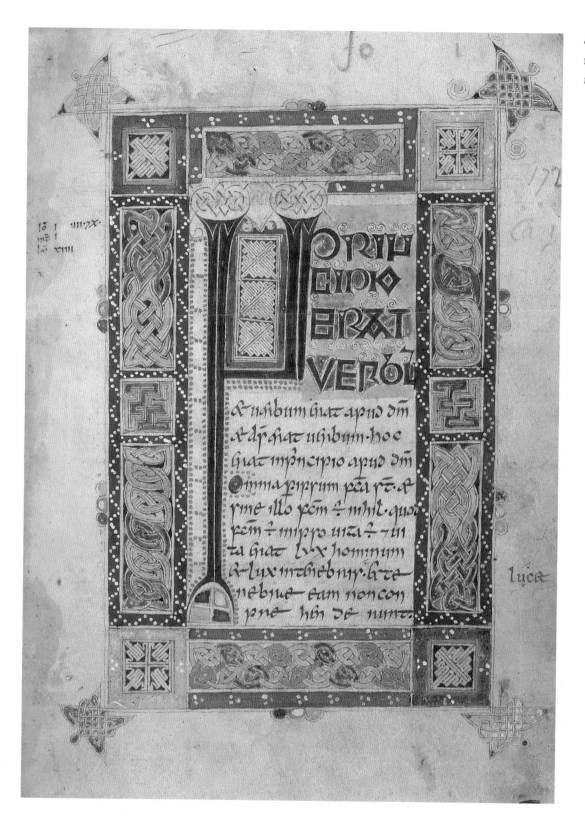

II

Books for Emperors

The legend recounts that in the year AD 1000 the Emperor Otto III, then an unbelievably rich young man of about twenty, ordered the opening of the tomb of Charlemagne at Aachen. His great predecessor had died in 814, nearly two hundred years earlier. It is said that they found the body of Charlemagne almost intact and fully clothed, seated on a chair, holding a sceptre and with a gold chain about his neck, and on his lap (the story claims) there was a splendid illuminated manuscript. Otto III removed these treasures, together with one of Charlemagne's teeth as a relic. The fact that a manuscript was among the symbols of state is important in the history of books. This was not a missionary text but part of the regalia of the Christian emperor.

The manuscript from Charlemagne's tomb was carefully preserved. It is traditionally identified with the so-called Vienna Coronation Gospels now in the Vienna Schatzkammer (PL. 33). It is a big square volume decorated with rather blotchy vibrant impressionistic paintings in heavy colours, totally unlike the intricately controlled mathematical designs of the Gospel Books we met in the western islands. The miniatures look more like wall-paintings and the vellum leaves are stained in purple. The style derives from Byzantine art and thus ultimately from classical antiquity. In fact, the Vienna Gospels includes the Greek name 'Demetrius presbyter' in gold capitals in the outer margin of the first page of the Gospel of St Luke, and it is not impossible that there were artists from Byzantium itself at the court of Charlemagne. At least three other manuscripts were painted in this Greek style in western Europe in the late eighth or early ninth century. They are the Xanten Gospels in Brussels (Bibliothèque Royale, ms. 18723), a Gospel Book in Brescia (Biblioteca Civica, Queriniana cod. E.II.9) and the Aachen Gospels which is still in the cathedral treasury in Charlemagne's capital (Domschatz-

kammer; PL. 35). The books were perhaps all decorated in Aachen, or at least at the imperial court which (in its primitive Frankish way) followed Charlemagne on his endless journeys around the royal residences over much of Europe. When the emperor travelled, he was followed by imperial wagons of gold, treasure, archives, and manuscripts.

Charlemagne's empire was vast and it eventually extended from the pleasant villas and orange groves of southern Europe, where classical learning and literacy had never completely disappeared, to the enormous wastelands of northern Germany, where wolves roamed the forests and where Roman culture was symbolized only by the ruins of abandoned garrisons. Without doubt, Charlemagne himself was a quite exceptionally brilliant man. He was literate and cultured; his favourite reading (we are told) was St Augustine's *City of God*; he understood some Greek; he was on intimate terms with popes and saints; he gathered around him the most cultured men of Europe, including Peter of Pisa, Paul the Deacon, Theodulf the Visigoth, and the great Alcuin; he himself was admitted to sainthood in 1165. At the same time Charlemagne was primarily a man of the north. His capital Aachen is in Germany today. He was a descendant of the Frankish tribesmen who ruled by extravagant displays of military arms and of personal wealth, by appalling double-dealing and thuggery, and who regarded a kingdom as the private property of a ruler who could use it entirely according

to whim. The ancient tribal leaders had held together their precarious kingdoms by military retinues whom they rewarded with gold and with the spoils of war. Charlemagne, for all his elegant classical dinner parties, was above all a Germanic military leader and his strategic success in warfare is literally legendary.

Charlemagne's own ancestors acquired the Merovingian kingdom by outmanoeuvring competitors. From the early seventh century they had been officials in the household of the Frankish kings. The family became mayors of the royal palace, and effective power was seized by Charles Martel in the 720s. In 751 his son Pepin the Short managed to get himself anointed king by St Boniface, and in 754, after skilful diplomatic appeals, Pope Stephen II crossed the Alps and at the abbey of St-Denis crowned Pepin and consecrated him and his two sons, Charles (the future Charlemagne, then aged about ten) and Carloman. Pepin died in 768 and Carloman in 771, leaving Charlemagne as sole king of the Franks.

One of the first really great manuscripts produced in Charlemagne's reign must have been the so-called Maurdramnus Bible, a huge book in six volumes now divided between the Bibliothèque Municipale in Amiens (mss. 6–7, 9, 11–12) and the Bibliothèque Nationale in Paris (ms. lat. 13174). It was made at Corbie Abbey near Amiens during the abbacy of Maurdramnus (772–81). It is a monumental volume intended for display at one of the greatest eighth-century monasteries, and it is sometimes suggested that a project of this size and expense would have needed the patronage of the royal treasury. The Maurdramnus Bible comprises the Old Testament only, and it is the Old Testament that contains the politically appropriate themes of the election of kings, maintenance of authority by warfare, the anointing of kings by patriarchs to confer legitimacy on their titles, and the vision of a tribal society invincible under the special protection of God. These were favourite subjects for the Carolingian propagandists of the eighth century.

King David's seizure of power over the Israelites must have been comforting to Charlemagne. There is no doubt that he identified himself with the Old Testament king and psalmist. Charlemagne's companions had a kind of private joke among themselves in which they pretended to be their heroes from classical antiquity: Alcuin was 'Flaccus' (that is, Horace), Angilbert, abbot of St-Riquier, was 'Homer', Charlemagne's son Pepin was 'Julius', but Charlemagne himself, to his friends, was 'King David'. Alcuin called him David in public and the nickname became known. One enchanting early Carolingian manuscript is a little Psalter written out at the order of Charlemagne himself for presentation to Pope Hadrian I (772–95). The book is now in Vienna (Österreichische Nationalbibliothek, Cod. 1861, PL. 34). It begins with an opening dedication (fol. 4r), written in gold and saying that the psalms are the golden words of King David and that Charlemagne is his golden successor. There is as much politics as politeness in Charlemagne choosing this volume for the papacy, or

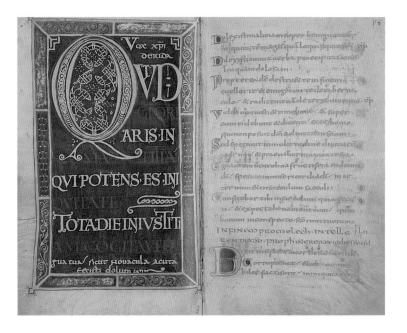

32 *Previous page*

Munich, Bayerische Staatsbibliothek, Clm. 4453, upper cover

The Gospels of Otto III (emperor 983–1002) is one of the most spectacular and luxurious of all imperial manuscripts. It survives in its original treasure binding set with jewels and classical intaglios around a tenth-century Byzantine ivory of the Dormition of the Virgin.

33 *Opposite above*

Vienna, Kunsthistorisches Museum, Weltliche Schatzkammer, Inv. XIII.18, fol. 76v

This great manuscript on purple-stained vellum is traditionally identified as the volume which the emperor Otto III discovered in the tomb of Charlemagne in Aachen. The volume is the so-called Vienna Coronation Gospels and was made in the late eighth century, probably in Aachen. The miniature of St Mark here is in the style of classical and Byzantine painting.

34 *Opposite below*

Vienna, Österreichische Nationalbibliothek, Cod. 1861, fols. 67v–68r

The Dagulf Psalter was written at the order of Charlemagne as a present for Hadrian I (pope 772–95). Many pages are written in gold or silver on deep purple grounds, an imperial device presumably chosen by Charlemagne, who hoped that the pope would crown him as emperor.

35 *Right*

Aachen, Domschatzkammer, s.n., fol. 13r

A full-page miniature in the Aachen Gospels shows all four evangelists seated with their symbolic attributes in a classical wilderness. Like the Vienna Coronation Gospels (PL. 33), the style of painting is inspired by classical art. It was made in Aachen in the late eighth century.

at least in having it known that he had ordered it (for there is no evidence that it actually left Germany), and Charlemagne ruthlessly manipulated papal support for himself, his kingdom, and (after his coronation in St Peter's on Christmas Day 800) for the new Holy Roman Empire. The Psalter for Pope Hadrian is signed by the scribe Dagulf (fol. 4v). The name appears in several contemporary documents; in a letter of Alcuin written between 789 and 796 he is called 'Dagulfus scrinarius', which means a kind of archivist. He was in the royal household. The book is beautifully decorated with majestic initials and headings in gold and silver, often on purple grounds (the imperial colour, deliberately chosen), and the script by Dagulf is an elegant minuscule.

This introduces a fundamental theme in Carolingian book production – the reform of handwriting and the adoption of minuscule script. Historians of manuscripts love to argue endlessly over exactly how and why this occurred. There had been many kinds of script used for writing books in Merovingian France, derived from various forms of Roman writing. Sometimes these were so bizarre that one can localize eighth-century manuscripts fairly closely from the use of a local script such as the 'Corbie a/b' script or the 'Luxeuil minuscule', which were employed in particular monasteries and their surrounding regions. In keeping with Charlemagne's carefully planned campaign to reform education, grammar, and liturgy, a new and very simple script was introduced with extreme efficiency and in all parts of the Carolingian dominions. It is known as Carolingian (or Caroline) minuscule. It is small and very round and has tall vertical ascenders and descenders, and was compact and no doubt quick to write and easy to read, and it was phenomenally successful. Virtually all Carolingian manuscripts were written in this famous minuscule.

At the risk of anticipating chapter 8, we can glance ahead and foresee that the majority of manuscripts of classical texts that were rediscovered by the humanists in the fifteenth century were Carolingian in date and therefore in this writing. The humanists wrongly convinced themselves that these represented original Roman manuscripts. They began to imitate Carolingian minuscule, abandoning the Gothic script of the period. At that time (and we are still looking ahead by seven hundred years) the art of printing was introduced into Italy, and the first Italian printers also adopted this neat round writing: it was called 'Roman' type. Printing had the remarkable effect of stabilizing letter forms and they have remained substantially unchanged ever since. We still use Charlemagne's script. It is probably the most long-lasting achievement of Carolingian civilization. Through a mistake in the dating of eighth- and ninth-century manuscripts, Carolingian minuscule is used (for example) for the printing of this book.

The manuscript usually regarded as the first to contain the new Carolingian minuscule writing is the Godescalc Evangelistary, as it is called, a Gospel Book which is now Paris, B.N., ms. nouv. acq. lat. 1203 (PL. 37). It was commissioned by Charlemagne and his

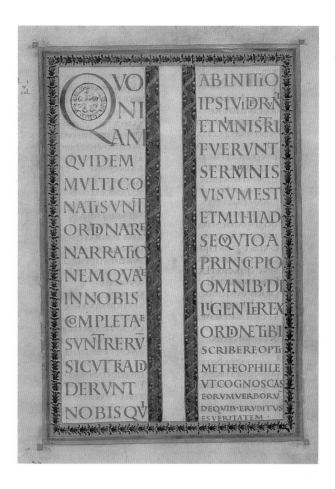

36 *Above*

Rome, Biblioteca Apostolica Vaticana, MS. Pal. lat. 50, fol. 8r

The magnificent Lorsch Gospels was illuminated in Charlemagne's court, probably in Aachen itself, in the early ninth century. It is written in gold script, and was presented to the great Carolingian abbey of Lorsch where about 830 it was described as a golden book. It passed eventually into the library of the Elector Palatine in Heidelberg, whose collections were acquired by the Vatican in 1623.

37 *Opposite*

Paris, Bibliothèque Nationale, ms. nouv. acq. lat. 1203, fol. 1r

The Godescalc Evangelistary was commissioned by Charlemagne and his queen in October 781 and was completed a year and a half later. The frontispiece here shows St Matthew writing his Gospel, apparently seated on a pile of cushions.

SCS �֍ MAT

queen Hildegard on 7 October 781 and completed on 30 April 783. It was written by the scribe Godescalc and (as the dedication verses explain) commemorates Charlemagne's fourteenth anniversary as king of the Franks and the baptism of his son Pepin by Pope Hadrian in Rome. One suspects Charlemagne was especially proud of this baptism: the manuscript includes a miniature of the Fountain of Life which may reflect the baptistery of the Lateran church in Rome, and thus this image entered Carolingian art. The Godescalc Evangelistary is illuminated in the same style as the Dagulf Psalter. They both belong to a whole group of closely related ceremonial manuscripts usually known as the 'Ada' group of books because one of them (now Trier, Stadtbibliothek, Cod. 22) includes a dedication to Ada, the servant of God, who is said to have been Charlemagne's sister. Some leaves of Ada's book seem to be in the hand of Godescalc also. Other manuscripts in this style include the St-Riquier Gospels (Abbeville, Bibliothèque Municipale, ms. 4) which was apparently given by Charlemagne to Angilbert, abbot of St-Riquier (790–814), the so-called Golden Gospels of Charlemagne from the abbey of St-Martin-des-Champs in Paris (Bibliothèque de l'Arsenal, Paris, ms. 599), the Harley Golden Gospels (B.L., Harley MS. 2788), the Lorsch Gospels (divided between the Vatican Library, MS. Pal. lat. 50 – PL. 36 – and the library in Alba Julia in Romania), and the St-Médard Gospels (Paris, B.N., ms. lat. 8850) which was given by Louis the Pious in 827 to Angilbert, abbot of St-Médard in Soissons.

These are all extremely grand manuscripts. Some of their interlaced initials reflect Celtic styles, but the whole appearance of these books is Mediterranean, with medallions like Roman coins and with classical pediments and marbled columns. Most of them are at least in part written in gold script on a purple-coloured ground, a device which (as Charlemagne's scribes certainly knew) went back to imperial antiquity. It is a very distinctive feature. Suetonius mentions a poem by Nero which had been written in gold; the emperor Maximinus (235–8) is said to have had a Homer written in gold on purple vellum; St Jerome in his prologue to the Book of Job criticizes those who like ancient books written out in gold or silver on purple leaves. It is a practice which probably survived into Charlemagne's time through its use in Constantinople. One can understand how important it was to Charlemagne, who was rebuilding his dominions on the model of classical antiquity, to propagate the image of the cultured emperor, and displays of books were (and are) among the accepted trappings of the cultured. Manuscripts written in gold on purple had a promotional value in symbolizing imperial culture. That is one reason why these spectacular manuscripts were made for distribution by Charlemagne's family to communities in his Christian empire, as it was called.

There may be a cruder, more barbarian, reason too. These books are heavy in gold. This was really quite a new development in Frankish manuscript production. Charlemagne's books look

38 *Above*

Brussels, Bibliothèque Royale, ms. II.2572, fol. 1r

This early ninth-century title-leaf of a manuscript of works by Peter the Archdeacon, records that the lord king Charles ordered the text to be transcribed. This copy was later in the library of Stavelot Abbey, near Liège.

expensive. The dedication verses in the Godescalc Evangelistary begin with the word 'gold' ('Aurea purpureis pinguntur ...'). Those in the Dagulf Psalter start 'Aurea daviticos ...': the text is not only golden but the volume is to be interpreted as comprising gold. It was the ancient Germanic custom for tribal leaders to reward their retinues in gold. Charlemagne regularly summoned his secular armies and in return for military service he gave lands and booty. The soldiers understood this. But the cohorts of religion – the monks of Corbie, Lorsch, and other imperial abbeys – were rewarded for spiritual service in the same way. In the most primitive sense, a Frankish prince distributed gold, and books were gold.

Charlemagne himself seems to have had a personal interest in manuscripts, if one can judge from remarks by his biographer Einhard, who mentions a great quantity of books that he had collected in his library, or from the observation that he liked to read St Augustine, histories, and tales of the ancients. One fragmentary library catalogue survives from about 790 and it was at one time supposed that it might record part of the holdings of Corbie Abbey (Berlin, Staatsbibliothek Preussischer Kulturbesitz, MS. Diez B.Sant.66, fol. 218r). However, the late Professor Bernhard Bischoff demonstrated that it is very probably a list of the texts belonging to the private library of the court of Charlemagne. It is an impressive roll-call of classical works, including books by Lucan, Statius, Terence, Juvenal, Tibullus, Horace, Claudian, Martial, Servius, Cicero, and Sallust. The Tibullus is especially tantalizing, as the earliest known surviving manuscript is no older than the late fourteenth century. The list itself occurs in a volume of little treatises on Latin grammar – works by Donatus, Pompeius, and others – and one can imagine Charlemagne reading up classical grammar with the anxiety of a modern self-made millionaire furtively gleaning books of etiquette.

Another grammatical manuscript probably from the court scriptorium of around the year 800 (Brussels, Bibliothèque Royale, ms. II.2572) has a spectacular opening page comprising eight lines of capitals recording that the lord King Charles commanded it to be transcribed from the original book by Peter the Archdeacon (PL. 38). We are told Charlemagne was so anxious to learn to write that he slept with writing materials under his pillow. It is rather touching to catch these glimpses of the great king trying to keep up with the cultural renewal that he had initiated, and perhaps he was trying to practise the new minuscule in the middle of the night. The decree of 789 commanding liturgical reform ordered that only skilful or mature scribes should be entrusted with the most solemn books and 'if the work is a Gospel Book, Psalter, or Missal, the scribes should be of the perfect age for writing diligently.'

Part of Charlemagne's promotion of education and book learning included the importation of the world's most distinguished scholars into his court. One of these was Alcuin (c.735–804), who had been born at York in England and who was related to St

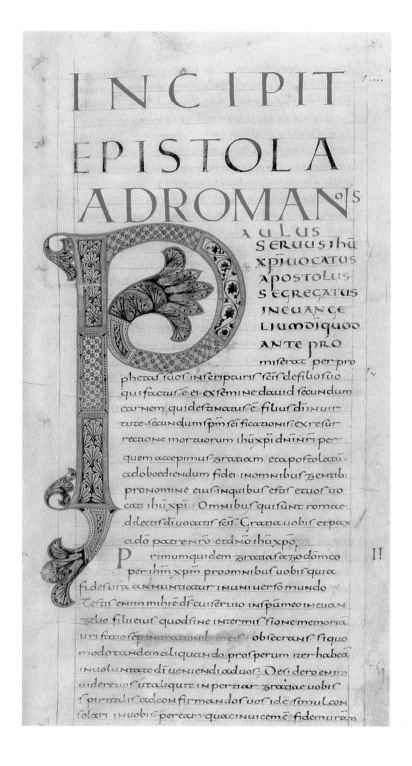

39 *Above*

Malibu, J. Paul Getty Museum, MS. Ludwig I.1, fol. 7r

In the ninth century, Tours became one of the great centres for the production and dissemination of vast manuscript Bibles which were acquired by monasteries in many parts of the Carolingian empire. Leaves and fragments of one such manuscript, written about 845, were recovered from later use in bookbindings at the abbey of St Maximin in Trier. This is the opening of the Epistle to the Romans.

Willibrord, the missionary bishop. He was already head of the cathedral schools in York when, during an embassy to Italy in 780, he met Charlemagne, who tempted him with two great abbacies and persuaded him to come to France. For upwards of ten years Alcuin then directed and inspired the revival of classical culture around the figure of Charlemagne. In 796 he retired to Tours, where he became abbot of St Martin's Abbey, and set in motion there a campaign of manuscript production which lasted far into the ninth century and made Tours the world centre for Bibles and for Carolingian minuscule script (PL. 39).

The making of manuscripts in the Frankish empire in the early ninth century slipped effectively from the court scriptorium into the great royal monasteries such as Chelles and St-Denis, near Paris, and Fleury, Rheims, Tours, Lorsch, St-Médard at Soissons, and elsewhere. The finest manuscripts were expensive and richly decorated. The best-known centre for book production in the early ninth century is Rheims, where manuscripts of really imperial quality were made in the time of Ebbo, who had been Charlemagne's librarian and who was appointed archbishop of Rheims in 816. The most extraordinary of the surviving Rheims

manuscripts is the famous Utrecht Psalter which is illustrated throughout with incredibly lively, vigorous, sketchy little drawings (PL. 40). The style seems to point straight back to the classical and Byzantine art which the court artists at Aachen introduced into Charlemagne's own books. One early ninth-century manuscript from the abbey of St-Denis can be partially dated from a curious feature in its decoration. Paris, B.N., ms. lat. 2195 is a copy of Cassiodorus's commentary on the Psalms made at St-Denis in the style associated with Abbot Fardulphus (793–806). One of its big initials includes several imaginary monsters and a surprisingly accurate sketch of the head of an Indian elephant (PLS. 41–2). Medieval artists knew about ivory but not many had seen elephants. This illuminator probably knew the elephant which was presented to Charlemagne by caliph Haroun-al-Rachid in the year 802. The elephant's name was Abulabaz and it lived until 810. Therefore the Cassiodorus manuscript cannot be earlier than 802. For all we know, Abulabaz's tusks survive in some of the magnificent Carolingian ivory book-covers which decorated the grandest Gospel Books (PL. 44).

Charlemagne died at Aachen on 28 January 814. Among various

40 *Left*

Utrecht, Bibliotheek der Rijksuniversiteit, Cat. Cod. MS. Bibl. Rhenotraiectinae, I, Nr.32, fol. 83r

The Utrecht Psalter was written and illustrated in Rheims between 816 and 835. It is one of the most classical-looking of all Carolingian manuscripts, written in rustic capitals and illustrated throughout with frenzied sketches, full of motion and life, like ancient Roman wall paintings. By about the year 1000 the book had been brought to Canterbury where it was much admired and imitated. After many adventures it was acquired by the ciy of Utrecht in 1716.

41 *Opposite left*

Paris, Bibliothèque Nationale, ms. lat. 2195, detail of fol. 9v

Charlemagne was given an Indian elephant in 802. Its name was Abulabuz and it excited much interest. One initial in a manuscript of Cassiodorus written at St-Denis in the first decade of the ninth century includes a remarkably accurate elephant's head; perhaps the artist had been to see Abulabuz.

42 *Opposite right*

Paris, Bibliothèque Nationale, ms. lat. I, detail of fol. 328v

Abulabuz died in 810, and knowledge of elephants slipped back into folk memory, like dragons and mermaids. This elephant, in the First Bible of Charles the Bald, Tours, c.846 (see also PL. 46), must be based on a description rather than on first-hand experience. The tusks figure clearly, for ivory was a precious commodity.

bequests he directed that three-quarters of the gold and silver in his treasury should be distributed among the twenty-one metropolitan churches of the empire and (probably the first time that anyone left this instruction) that his library should be sold and the proceeds given to the needy. This confirms again that it was part of the attributes of a Frankish ruler to distribute treasure, and it shows that books had a monetary value. Charlemagne's copy of Claudian came to Gembloux Abbey, only about 65 miles from Aachen. His Livy travelled further into the Frankish empire and was probably at Corbie and later at Tours. Charlemagne's unique Tibullus may have found its way to Fleury Abbey on the Loire and thence perhaps to Orléans. The dispersal of his library after 814 echoes Charlemagne's lack of any provision for keeping his empire intact after his death. He was enough of a barbarian and a politician to let the empire be subdivided among his heirs, and it was subdivided again and again on their deaths, until it was unrecognizable a century later.

The custom of commissioning treasure manuscripts continued among some of Charlemagne's descendants. His illegitimate son Drogo, bishop of Metz 826–55, owned at least two Gospel Books written entirely in gold (Paris, B.N., mss. lat. 9383 and 9388) and the amazing Drogo Sacramentary (ms. lat. 9428) which has 41 huge historiated initials of classical foliage filled with bustling little figures and scenes. The nearest, however, to a palace school of book production was that of Charles the Bald (PL. 43), grandson of Charlemagne and son of Louis the Pious, who, after fierce warfare with his half-brothers, held the kingdom of the western Franks from the treaty of Verdun in 843 and finally obtained the imperial crown in 875, dying less than two years later. His life reflects the same kind of desperate tribal struggle for leadership which marked the less civilized aspect of the Carolingian royal family. We find Charles the Bald preparing treasure manuscripts for his ecclesiastical vassals, like an old chieftain distributing gold bullion.

The grand manuscripts illuminated for the use of Charles the Bald include a prayer-book (now in the Munich Schatzkammer) and a Psalter (now Paris, B.N., ms. lat. 1152), both datable to before 869, and probably the famous Bible of San Paolo fuori le Mura (which belongs now to the abbey of that name in Rome, ms. f.1.m.337). This is a massive manuscript with 336 leaves about 17½ by 14¼ inches (443 by 362mm). It has 24 full-page paintings;

END

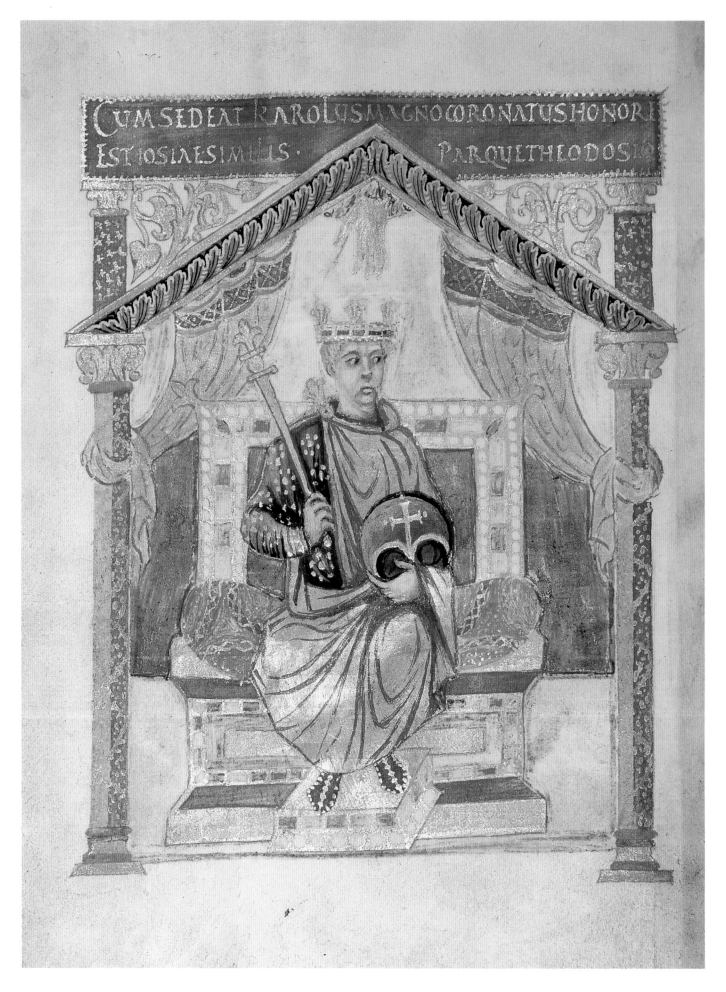

43 *Opposite*

**Paris, Bibliothèque Nationale,
ms. lat. 1152, fol. 3v**

Charles the Bald, who died in 877,
was the grandson of Charlemagne,
and was king of France from 840
and emperor from 875. Here he is
shown on his jewel-studded throne
in a miniature in a Psalter, perhaps
made for Charles at St-Denis,
*c.*850–69.

44 *Right*

**London, Victoria and Albert
Museum, Inv. no. 138–1866**

What happened to Abulabuz's tusks
after his death in 810? They may
have been salvaged for carving. This
is one of the ivory covers formerly
on the Lorsch Gospels of *c.*810
(cf. PL. 36).

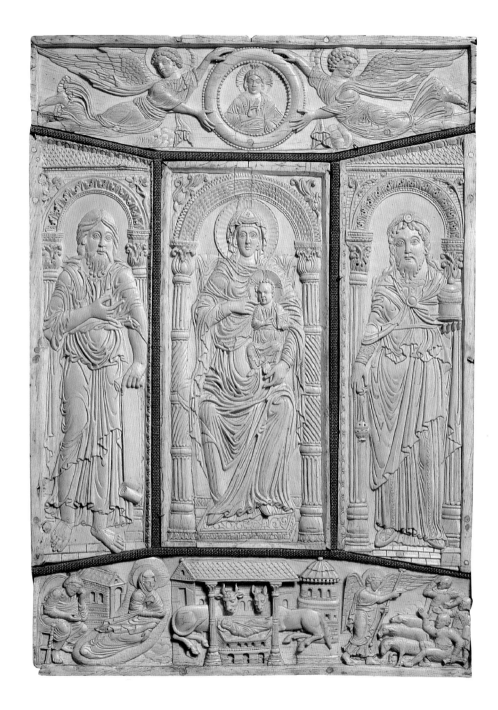

at least seven of them include scenes showing biblical kings. The figure of Solomon looks remarkably like Charles the Bald himself. The manuscript concludes with a portrait of Charles enthroned as king, holding in his left hand a golden disc inscribed with a monogram in red which has been interpreted as 'Charles king [and] caesar, save Charles and Richildis, this [is] king Solomon of the new Rome'. Probably it commemorates Charles's marriage to Richildis on 22 January 870.

But this spectacular manuscript is eclipsed by an even richer volume, made for the treasury of Charles the Bald. It is the Codex Aureus (or Book of Gold – the name is a valid one) of St Emmeram, now Munich, Bayerische Staatsbibliothek, Clm. 14000 (PL. 45). This is a volume of phenomenal luxury, still (by extreme good fortune) in its original golden binding profusely encrusted with jewels and pearls and gold repoussé pictures. If Charles the Bald identified himself with Solomon, he must have known the text of I Kings 6:21–2 describing Solomon's work on the temple at Jerusalem: 'So Solomon overlaid the house within with pure gold … And the whole house he overlaid with gold, until he had finished all the house.' On fol. 5v of the Codex Aureus is a portrait of Charles the Bald on a jewel-studded throne within a domed temple with angels and the hand of God above. On either side are armed soldiers and allegorical figures, representing Francia and Gotica, and on panels along the top and bottom of the page are gold inscriptions identifying this rich king as Charles, son of Louis, heir of Charlemagne, David (it calls him) and Solomon, by whose provision this book shines with gold. The manuscript has page after page of paintings, canon tables, and huge decorated initials, all brilliantly illuminated. Charles himself presumably provided the gold for the artists, who may have been working in the abbey of St-Denis, which the king retained as his own possession after the death of one of its abbots in 867. The Codex Aureus is signed by the scribes Beringar and Liuthard and is dated 870. There is a contemporary reference to Charles the Bald's manuscripts kept in his treasury. Certainly the Codex Aureus of St Emmeram was not for daily use, but was a dazzling display of the king's fiscal assets. After the death of Charles the Bald in 877, it came into the hands of his distant cousin King Arnulf of Bavaria who, soon after 893, passed it on to the abbey of St Emmeram in Regensburg. Thus its name comes from the monastery where it was finally received as a royal gift.

We gain some idea that rich manuscripts had a realizable financial value in the ninth century from references to thefts of such books. A Psalter written in gold script and with a treasure binding covered with pearls was given by Louis the Pious (d.840) to the abbey of St Hubert near Liège; the chronicle of the abbey records that the book was stolen and was sold by the thieves to a woman in Toul, over a hundred miles to the south. Lupus of Ferrières, writing to Hincmar, archbishop of Rheims, in 858, regretted that he had been unable to send a great manuscript of Bede and Augustine

for fear of losing it to robbers on the journey who would, he said, certainly be attracted by the beauty of the book.

The tremendous monetary value of imperial manuscripts worked both ways. A king both received manuscripts and presented them. A secular ruler might give a luxury manuscript to a monastery in return for prayers for his salvation. This would be seen as a very serious exchange, incalculably valuable for both parties. A monastery might make and offer a supreme manuscript to a king, and hope for patronage in return. This was certainly not just a one-sided payment either. The use of manuscripts in such diplomatic transactions underlines for us the value placed at that time on books, which we can understand today looking at the gold-studded volumes themselves, but it also reminds us that prayers offered by a monastery or military protection offered by an emperor were worth every penny of the investment in a valuable book. A good example of an alliance between emperor and monastery is the abbey at Tours. We mentioned earlier that Charlemagne's adviser Alcuin had retired to the monastery of St Martin at Tours. Here a great programme of manuscript production had been set in motion by Alcuin and his successors, Fridugisus (804–34), Adalhard (834–43), and Vivian (843–51). These abbots were royal appointments: Adalhard had been seneschal to Louis the Pious, and Vivian was a count and court official of Charles the Bald. Manuscripts produced under royal patronage at Tours were exported from there all over the Carolingian kingdoms. Probably two of them were presented to Lothair (d.855), half-brother of Charles the Bald and king of the Italian part of Charlemagne's empire. These are a Gospel Book (Paris, B.N., ms. lat. 266) and a Psalter (B.L., Add. MS. 37768). E.K. Rand, the historian of the scriptorium of Tours, described the former as 'Perfected. The *ne plus ultra* of excellence … The unsurpassed model of perfection in script and ornament among the books of Tours.' The monks were determined to impress King Lothair.

A better-known presentation from Tours is the famous First Bible of Charles the Bald, sometimes called the Vivian Bible: it now has the first shelfmark in the Bibliothèque Nationale in Paris (ms. lat. 1; PL. 46; detail, PL. 42). The manuscript was commissioned by the abbot to present to the king in c.846. It opens with an unusual miniature in three horizontal rows showing scenes from the life of St Jerome, translator of the Latin Bible. In the centre is Jerome dictating to a group of scribes and at the bottom Jerome distributes copies of his new translation. This probably has an allegorical allusion to Alcuin correcting the text of the Bible and having copies made and disseminated from his abbey in Tours. It is worth looking closely at the boxes from which St Jerome is shown handing out manuscripts: they are typical treasure chests, with wooden bands and massive metal locks. Books were equated with extreme wealth and the Word of God with treasure. The recipients are shown furtively hurrying away with the luxury gifts. The association between the manuscript and secular wealth is reflected

45 Left

Munich, Bayerische Staatsbibliothek, Clm. 14000, fol. 5v

The Codex Aureus of St Emmeram was made in France *c.*870 for Charles the Bald, who is shown here attended by soldiers and by personifications of Francia and Gotica. The manuscript was preserved in Regensburg by the eleventh century, where it was much admired and was copied for Henry II (see PL. 51).

again in its dedicatory verses which are illustrated with two imperial coins, one inscribed 'David rex imperator' and the other 'Carolus rex Francorum'. Thus the biblical King David is linked with Charles, king of the Franks. It is important that this is represented by gold coins. That is how many would have understood this copy of the Bible. In the Gospels, when Christ was shown an imperial coin, he asked whose portrait and inscription it bore, and when they replied 'Caesar's', he instructed his listeners to render unto Caesar the things that were Caesar's. The dedication miniature in the First Bible of Charles the Bald shows the king exactly like a tax gatherer receiving tribute. He is seated between administrative officials and armed soldiers fingering their weapons. From the left a delegation of nervous monks bring in the huge Bible partly wrapped in white cloth, and the king holds out his right hand to accept this addition to his treasury.

Charles the Bald died in 877, while marching across the Alps in one of the seemingly endless Carolingian dynastic feuds, this time against Carloman, king of Bavaria and Italy and great-grandson of Charlemagne. It was, in fact, Carloman's son and heir, Arnulf, who inherited the Codex Aureus of St Emmeram and perhaps other manuscripts from the library of Charles the Bald. Arnulf's own son, Louis the Child, king of the Franks 900–11, was the last direct descendant of Charlemagne to rule the German part of his great-great-great-grandfather's vast empire. When Louis the Child died without issue, Conrad, duke of Franconia, was elected king, and Conrad (who died in 918) nominated Henry the Fowler as his own successor. This sounds complicated, and indeed the thread of inheritance from Charlemagne is remarkably fragile and one generation succeeded another with great rapidity. Henry the Fowler's son was the Emperor Otto the Great. Now at last the line of succession becomes clear again. Historians grasp willingly at this rec-

ognizable figure and call this the 'Ottonian' age. The tenth century was certainly a great period in imperial history. It brought the nearest possible revival of the golden days of Charlemagne, with a fervour of political and religious reform, and it is often known as the Ottonian renaissance. It also produced a great many illuminated manuscripts.

Otto the Great was anointed king in 936 in Charlemagne's palace chapel at Aachen. After a turbulent military life and careful marriages, he brought great portions of Germany and Italy under his control. Even the pope eventually became his vassal, a shrewd political move which did much to stabilize imperial power. Otto was crowned emperor in Rome on 2 February 962. He lived until 973.

As Otto the Great consolidated his position and began to merge the state and Church into a powerful new administration, so the Ottonians looked back wistfully at the cultivated empire of the past. Bruno (925–65), Otto's brother, was appointed royal chancellor, arch-chaplain, and later archbishop of Cologne, and inspired a renewed interest in classical texts (he had learned Greek from the monks of Reichenau) and in grammar, rhetoric, geometry, music, astronomy, commerce, and the other refinements of civilization. Education again became a royal priority. There is an account in Ekkehard's chronicle of the abbey of St Gall in Switzerland of a visit to that monastery in the year 972 by Otto the Great with his son (the future Otto II, then aged about 17). They spent several days there. The boy discovered a locked chest in the monastic treasury and demanded that it be opened for him. It proved to be full of manuscripts. Young Otto helped himself to the best, as the monks stood by, unable to refuse. Later (following a diplomatic request from the monastery) some of the books were returned, but one which was never sent back was probably a Psalter (now in the Staatliche Bibliothek in Bamberg) with parallel

46 *Opposite*

Paris, Bibliothèque Nationale, ms. lat. 1, fol. 3v

This is a full-page miniature prefixing in the First Bible of Charles the Bald, sometimes known as the Vivian Bible. The manuscript was written in Tours, *c.*846, during the rule of Vivian (abbot 845–51). The miniature here shows scenes from the life of St Jerome, including the making and distributing of manuscripts of the Bible.

texts in two versions of Latin and in Hebrew and Greek, which had been made for Salomo III, abbot of St Gall, in 909. It says something about Ottonian court education that a Germanic prince would bother to seek out a manuscript in three ancient languages.

In the same year that they visited St Gall, Otto the Great arranged a marriage for his son. It was a political triumph. The bride was Theofanu, a princess of Byzantium. Throughout the whole Carolingian and Ottonian period, the Byzantine empire was regarded as the ultimate symbol of sophistication, and for a daughter of the eastern imperial house to marry the heir apparent of the German ruler conferred immense prestige on the west. (How the poor girl felt in northern Europe, twelve hundred miles from home, would not have been considered.) The original marriage charter of Theofanu and Otto still survives, and it is displayed in a special room in the state archives of Lower Saxony in Wolfenbüttel. This document of 14 April 972 is an ultimate imperial manuscript, a huge scroll written in gold in uncial and minuscule on purple vellum and decorated with great medallions of classical and mythological designs of animals infilled with ornamental scrollwork. It is a magnificent object. At last the tribal rulers of Europe glimpsed their own names in an inheritance which went back to the Emperor Augustus.

Otto II succeeded to the Holy Roman Empire in May 973, but he lived for only another ten years. He died in Rome and is buried in the crypt of St Peter's. The revival of manuscript illumination in his reign is partly due to Egbert, who was appointed to the archbishopric of Trier in 977 and was both a churchman and a member of the imperial chancery. A contemporary account of the translation of the relics of a saint in Trier in the time of Egbert describes the archbishop's procession, 'with crosses, candles, thuribles, Gospel Books set with gems, and every kind of ecclesiastical beauty'. The archbishop owned a Gospel Lectionary, now called the Codex Egberti (Trier, Stadtbibliothek, Cod. 24), which is signed by two monks Kerald and Heribert of Reichenau Abbey, the wealthy island monastery on Lake Constance. The book has 51 large illustrations, by far the most extensive cycle of pictures of the life of Christ in any known manuscript up to this date. The volume's lavish binding of gold and enamels survived until the eighteenth century. Egbert also almost certainly employed one of the very greatest medieval illuminators, the Master of the Registrum Gregorii, who was probably working at Trier from about 980 until at least 996. About half a dozen surviving manuscripts were painted or refurbished by this artist. One of them, a Gospel Book datable to before the death of Otto II, was given four hundred years later by the king of France to the Sainte-Chapelle in Paris (Paris, B.N., ms. lat. 8851). The same artist also painted two detached miniatures, one still in Trier (PL. 48) and the other now in the Musée Condé at Chantilly (PL. 47), from a volume of the Registrum Gregorii (hence the artist's name) which Egbert gave to Trier Cathedral. The surviving fragment includes a poem

47 *Above*

Chantilly, Musée Condé, ms. 14bis

This is a single leaf originally from the same manuscript as PL 48. It was a luxurious copy of the Epistles of St Gregory (or Registrum Gregorii). The manuscript was painted in Trier, *c*.983, and presented to Trier Cathedral by Egbert, counsellor to Otto II and archbishop of Trier 977–93. The miniature here shows an emperor receiving homage from the four provinces of his empire. It probably commemorates Otto II, who died in December 983 at the age of 28.

48 *Opposite*

Trier, Stadtbibliothek, MS. 171a, single leaf

Not only is this one of the most beautiful of tenth-century paintings, by the Master of the Registrum Gregorii (named after this manuscript), but it also shows a manuscript in use on a lectern and a monk listening to dictation and writing down notes with a stilus on a wax tablet.

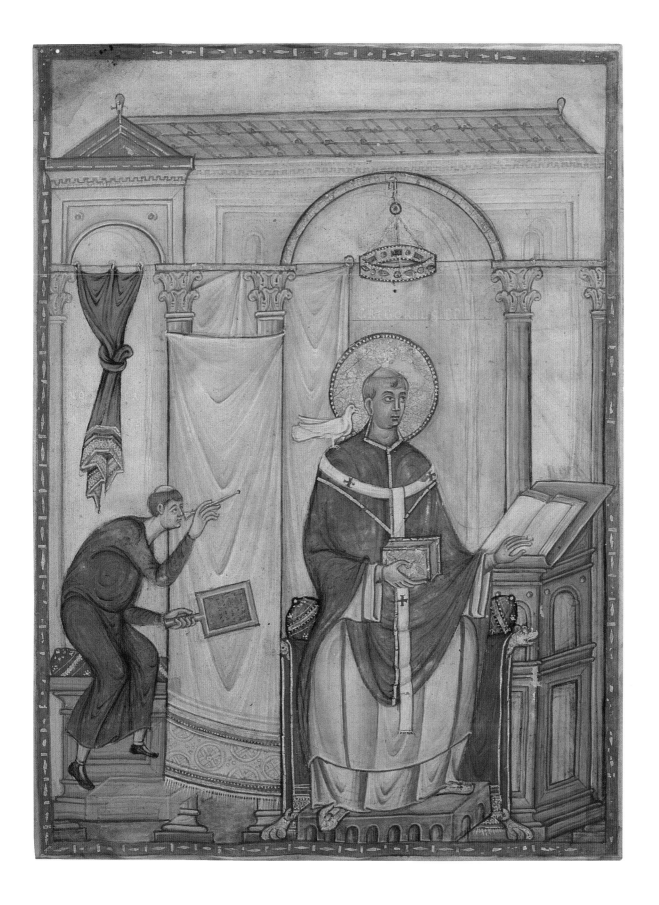

bewailing the death of Otto II in 983, and the Chantilly miniature of a crowned emperor with his staff and orb no doubt commemorates Egbert's late patron. It shows Otto enthroned under a tiled roof supported by classical columns, and from either side he receives gifts of homage from personifications of Germania, Francia, Italia, and Alamannia. It is a marvellous image.

It was under Otto III, emperor from 983 until his early death in 1002, that the Ottonian passion for books reached its high point. There survives in Bamberg a list of manuscripts which Otto III was given by Johannes Philagathos, his former tutor whom Theofanu had made bishop of Piacenza, probably before 997, including two copies of Orosius, two of Livy, a Persius, and other texts. This was a good nucleus of a classical library. We began this chapter with the account of Otto III opening the tomb of Charlemagne and finding a Gospel Book among the imperial regalia. Otto III considered himself doubly imperial, both through his Byzantine mother and his German father. He was extremely rich and powerful, and young enough to be almost blasphemously arrogant (he was less than five when his father died, and still only eleven on the death of his mother Theofanu in 991). Unlimited wealth is not good for young men. In 996 he promoted Bruno, his twenty-nine-year-old cousin, to the papacy; Bruno took the title of Gregory V, the first German pope, and then promptly crowned Otto III as emperor. The new pope himself ordered manuscripts to be sent to Rome from Reichenau for the confirmation of his own installation as

pope. He requested that the abbot of the monastery should deliver to him a Sacramentary, an Epistolary and a Gospel Book, and they were doubtless very splendid. When Gregory died three years later in 999, Otto installed as the next pope his former tutor, Gerbert of Aurillac, who assumed the name of Sylvester II. Even the popes were under the power of Otto III. In his manuscripts the emperor was represented almost on a level with God himself. Otto's Gospel Book now in Aachen, made at about the time of the imperial coronation in 996, shows the emperor seated within a mandorla in heaven with his arms outspread like Christ in glory and with the emblems of the four Evangelists hovering on either side of him. It is amazing that a monk could paint such an image. Another Gospel Book in the John Rylands University Library in Manchester includes Otto's portrait four times on the first page of St Matthew's Gospel (MS. lat. 98, fol. 16r), inscribed with the name of Otto, emperor of the Christian religion and of the Roman people. This illumination occurs on the page which recounts the descent of Christ from David and Abraham. It too is painted by the Master of the Registrum Gregorii, though not necessarily at Trier.

The grandest manuscript of all is the extraordinary Gospels of Otto III in Munich (Bayerische Staatsbibliothek, Clm. 4453). In modern monetary terms this must be a candidate for the most valuable book in the world (PLS. 49–50). It was made for Otto probably at Reichenau around 998–1001, a book for a millennium. It is in its original golden binding set with jewels and with a tenth-

49 *Right*

Munich, Bayerische Staatsbibliothek, Clm. 4453, fol. 24r

Otto III, emperor 983–1002, is shown here in his own Gospel Book, illuminated probably in Reichenau, *c.*998. He is attended by two clerics, perhaps Heribert, the chancellor of Italy, and Leo, the future bishop of Vercelli, and two armed soldiers. At the time this miniature was painted, Otto was approximately 18 years old and virtual master of Europe.

50 *Opposite*

Munich, Bayerische Staatsbibliothek, Clm. 4453, fol. 139r

This is another miniature from the Gospels of Otto III, probably illuminated in Reichenau, *c.*998. It shows St Luke, with a pile of manuscripts on his lap (note their bindings apparently studded with jewels) exalting all the Old Testament prophets who foretold the coming of Christ.

FONE PATRV DVCTAS BOS AGNIS ELICIT VNDAS

century Byzantine ivory panel (PL. 32). It was a magnificent and a sacred manuscript, whether open or closed. Inside it is of supreme imperial luxury with full-page illuminated initials, Evangelist portraits, 29 full-page miniatures from the life of Christ, and dominating all these, it has a pair of facing paintings showing the peoples of the world adoring Otto III. The worshippers resemble the Magi bringing offerings to the infant Christ. They are four women bearing gold and jewels and their names are written above in capitals: Sclavinia, the eastern European with dark red hair, Germania, a fair-skinned girl with long wispy blonde hair, Gallia, the black-haired French girl, and the curly-headed Roma, who is bowing lowest of all before the ruler of the empire. Otto himself is shown on the opposite page, seated disdainfully on his majestic throne, flanked by two priests with books (possibly to be

identified as Heribert, chancellor of Italy (d. 1021), and Leo, future bishop of Vercelli (d.c. 1026) and by two armed soldiers, one of them perhaps Gerard, count of the Sabine, the guard of the emperor (PL. 49). Otto III had built himself a palace on the Aventine Hill in Rome. His library included (amazingly) a fifth-century manuscript of Livy's history of Rome, probably one of the two copies from the gift of Johannes Philagathos; the transcript of it that he had made still survives in Bamberg. His seal had the legend 'Renovatio Imperii Romanorum', the restoration of the empire of the Romans. He thought himself at least as great as Caesar Augustus.

It is interesting to try to compare the Ottonian imperial manuscripts with those of Charlemagne and Charles the Bald. Sometimes it is quite clear that the later illuminators were actually

51 *Right*

Munich, Bayerische Staatsbibliothek, Clm. 4456, fol. 11v

Henry II, emperor 1002–24, was doubtless shown the precious Codex Aureus by the monks of St Emmeram in Regensburg and he commissioned a modern copy to be made of it. This miniature is based on that in PL. 45, painted 140 years earlier. His own portrait appears in place of that of his Carolingian predecessor. This copy, which is a newly-fashionable Sacramentary, rather than a Gospel Book, was made in Regensburg, *c.* 1010.

imitating known Carolingian manuscripts. One example is the Gospel Book made for Gero shortly before he became archbishop of Cologne in 969 (Darmstadt, Hessische Landes- und Hochschulbibliothek, MS. 1948): its Evangelist portraits and the miniature of Christ blessing are literally copied from the Lorsch Gospels, which was illuminated in the court school of Charlemagne in the early ninth century.

Even more remarkable is the use made of the Codex Aureus of St Emmeram. We have already described this famous ninth-century manuscript, which in the Ottonian period belonged to the abbey of St Emmeram in Regensburg (PL. 45). First of all, two monks at St Emmeram's, Aripo and Adalpertus, tried to update the manuscript by adding a frontispiece illustrating the Ottonian abbot Ramwold (975–1001). Then the emperor Henry II had the volume copied for

his own use. Henry was a fairly remote cousin of Otto III but, since Otto died without an heir, Henry was able to secure the throne in 1002; he was crowned emperor in 1014, and died in 1024. His imitation of the Codex Aureus of St Emmeram was painted not long before 1021 and it still survives in Munich (Bayerische Staatsbibliothek, Clm. 4456): many of its illuminations are almost exact reproductions, and the dedication miniature shows Henry on the throne of Charles the Bald (PL. 51). The text, however, has become a Sacramentary rather than a Gospel Book. This is a book for use at Mass, and perhaps represents a shift of royal taste from biblical narrative to involvement in the most solemn and impressive Christian display. The reform of the liturgy under the Ottonians resulted in a fashion for Sacramentaries and Gospel Lectionaries, and this happened to be consistent with the emperors' concepts of

52 Right

Munich, Bayerische Staatsbibliothek, Clm. 4452, fol. 17v

Henry II commissioned a whole series of luxury manuscripts for the cathedral at Bamberg. This is one, a Gospel Lectionary (or book of Pericopes) was probably illuminated at Reichenau in the early eleventh century. The miniature here shows the three Magi bearing their precious gifts, and perhaps Henry imagined himself as the king who brought to Christ a present of gold.

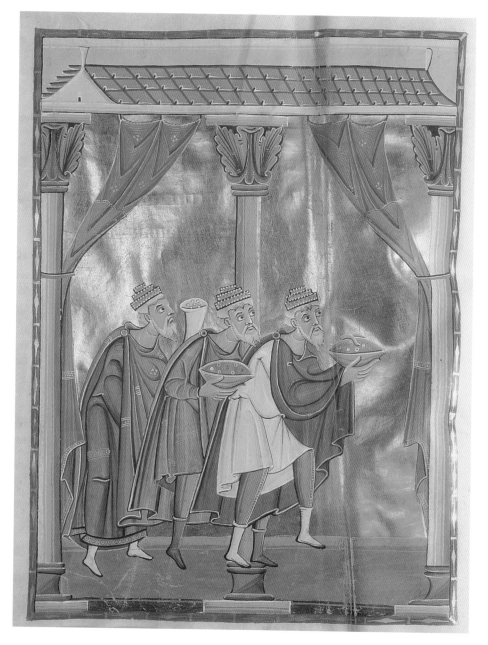

religious solemnity and of themselves as high priests and mighty kings. Henry II was proud to be depicted in a Missal; Charlemagne would probably have been rather frightened.

Another difference between manuscript production of the Carolingians and of the Ottonians is that there seems to have been no court school of illumination under the Ottonian emperors. Charlemagne employed scribes and artists in his household. Otto III and Henry II sent out to the monasteries. They chiefly used Trier, and then very probably Reichenau (PLS. 52, 55 and 56), and later Regensburg and Echternach. Otto III owned some older manuscripts which had come from Italy (such as his ninth-century life of St Sylvester illuminated at Nonatola), but the Ottonians seem to have commissioned no manuscripts there. Their use of monasteries does not necessarily mean that the artists were always monks, but

that they worked within a monastic context. A Gospel Lectionary now in Bremen actually illustrates this happening (Staats- und Universitätsbibliothek, MS. b.21, fols. 124v–125r; PL. 53. It shows the cloisters at Echternach Abbey, and busy working on the manuscripts are two men, one a layman and the other a monk, and on the facing page they are shown presenting their book to Henry III in about 1039–40.

Henry II (PL. 54) had a particular reason for wanting manuscripts. Unlike other emperors, who probably built up libraries mainly because books were treasure and partly because they conferred a suitable image of culture, Henry II planned to set up a religious foundation at Bamberg and to furnish it with manuscripts which he had collected. He declared in 1007 that as he himself had no children he had chosen Christ as his heir. He does not quite

53 *Right*

Bremen, Staats- und Universitätsbibliothek, MS. b.21, fol. 124v

The Ottonian emperors commissioned their manuscripts from many different places. This illustration from a Gospel Lectionary made for Henry III, *c.*1039–40, was illuminated at Echternach Abbey. The picture shows the work taking place in the cloisters of the abbey, but note that only one of the two craftsmen is a monk. Perhaps lay scribes and artists were more common that we might have guessed.

54 *Opposite*

Bamberg, Staatliche Bibliothek, Msc. bibl. 95, fol. 7v

'Henry the pious king' reads the Latin inscription around the arch here. The miniature shows Henry II carrying one of the Gospel Books which he commissioned, *c.*1020, for presentation to Bamberg, where it still remains.

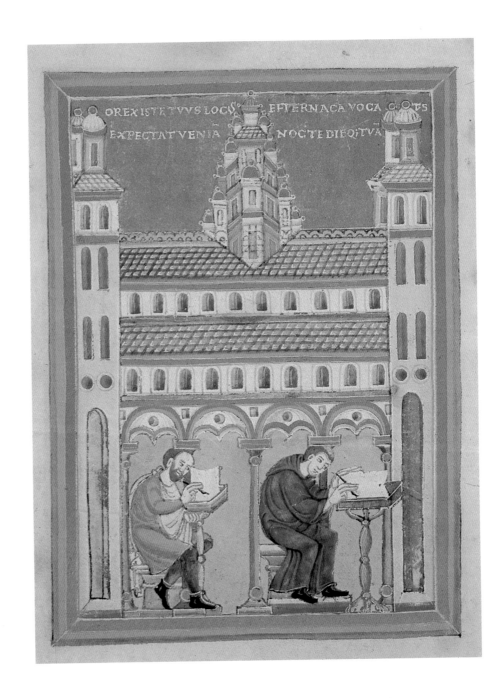

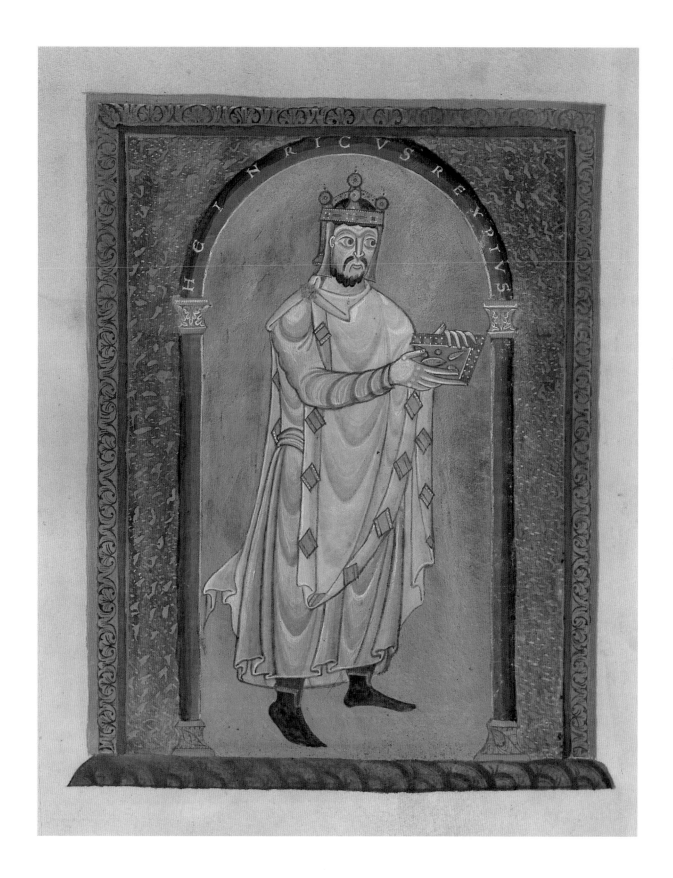

name Christ as his kinsman, but almost. His bequest included not only ancient books (such as the fifth-century Livy from the library of Otto III and Charles the Bald's copy of Boethius on Arithmetic, which had perhaps survived, like the Codex Aureus, in the monastery of St Emmeram) but also books from his father's library like the great Bamberg Apocalypse and an illustrated commentary on Isaiah (Bamberg, Staatliche Bibliothek, Msc. bibl. 140 and Msc. bibl. 76) and manuscripts made especially for himself, including a Gospel Lectionary related in style to the Gospels of Otto III and probably from Reichenau (Munich, Bayerische Staatsbibliothek, Clm. 4452). Once again, they are magnificently illuminated, with very many pages of miniatures painted on highly burnished gold backgrounds which really flash as the leaves are turned. The Apocalypse is a great illustrated guide to the end of the world, which some predicted in the year 1000 (PL. 56). The Lectionary opens with a miniature of Henry II and his queen Cunegund receiving crowns from Christ himself (PL. 55). Perhaps after all there was political propaganda here too. Henry was canonized in 1146 and Cunegund in 1200. The imperial couple are now the patron saints of Bamberg.

Nothing so clearly demonstrates the Ottonians' imperial wealth and grandeur as the manuscripts they commissioned. These are their most lasting monuments. The Carolingians were ultimately Frankish chieftains who needed books as fiscal assets and who melted down for bullion the gold planisphere owned by Charlemagne; the Ottonians, by contrast, were founders of an empire whose symbols of prestige are now already a thousand years old and still deeply impressive. Charlemagne's luxury manuscripts were made to influence his contemporaries; it may not be unfair to Henry II to suggest that his thoughts were for audiences of the future. The gold was the material of the kingdom of Heaven as well as of the imperial treasury on earth. In a theological sense, the illustrated

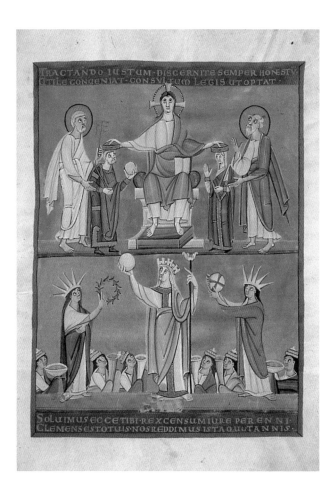

55 *Left*

Munich, Bayerische Staatsbibliothek, Clm. 4452, fol. 2r

In the Gospel Lectionary of Henry II the emperor himself and his wife Queen Cunegund are shown being presented to Christ, who places crowns on their heads as the world adores. It was painted in the early eleventh century, probably at Reichenau.

56 *Opposite*

Bamberg, Staatliche Bibliothek, Msc. bibl. 140, fol. 59v

The Bamberg Apocalypse was probably made at Reichenau, c.1001, for Otto III, who is shown here being crowned by St Peter and St Paul. The manuscript was inherited by Henry II, who presented it to Bamberg soon after its foundation in 1007.

57 *Overleaf*

Uppsala, Universitetsbibliotek, Cod. C.93, fols.3v–4r

Henry III, emperor 1039–56, continued the Ottonian custom of commissioning luxury Gospel Books. Here he is shown with his wife Agnes kneeling before Christ in heaven, and with saints Simon and Jude in his palace at Goslar. The manuscript was painted at Echternach, c.1050.

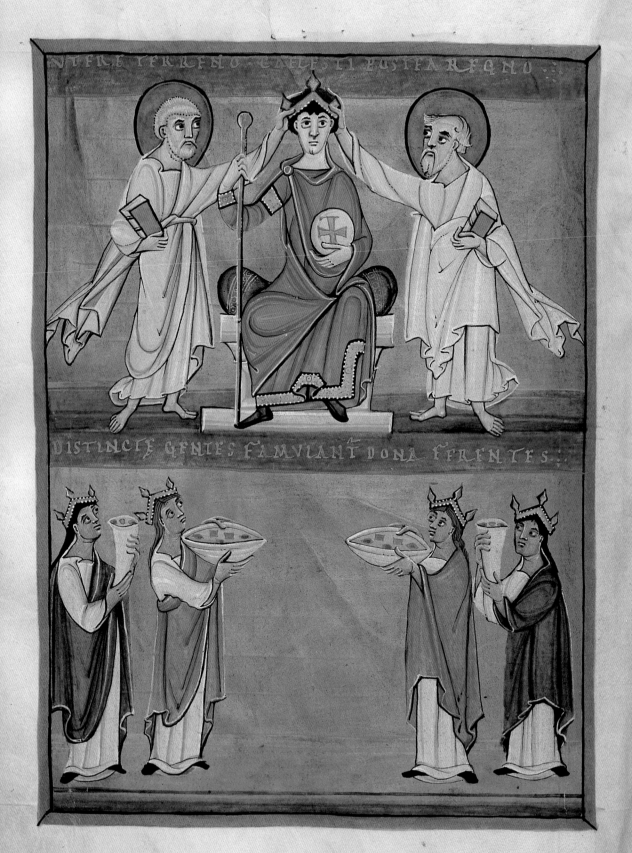

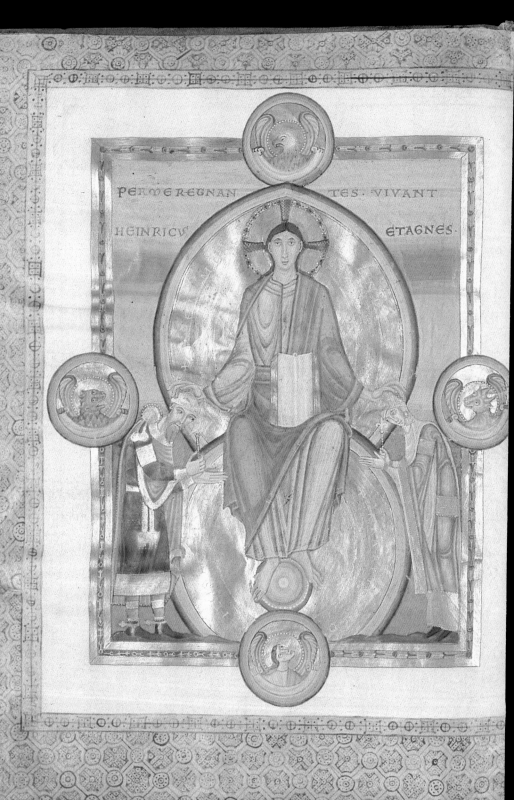

PER·ME·REGNAN TES·VIVANT

HEINRICVS ET·AGNES.

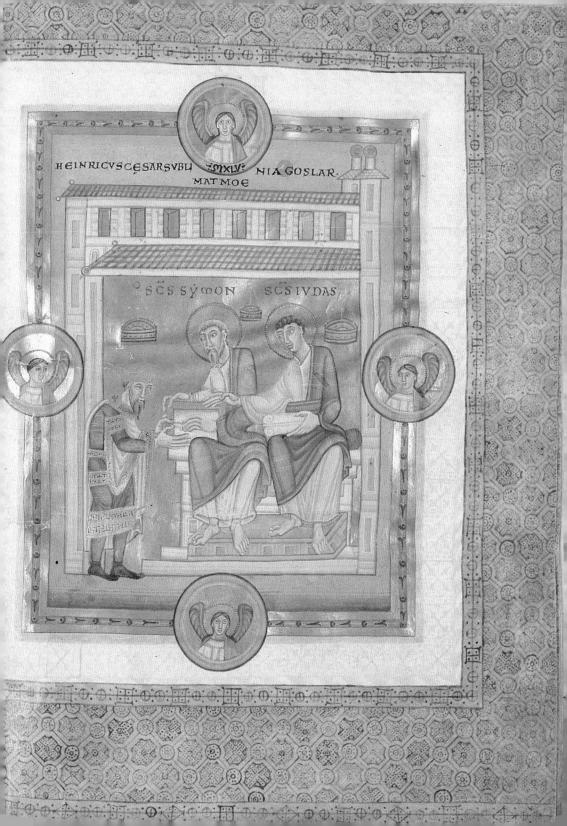

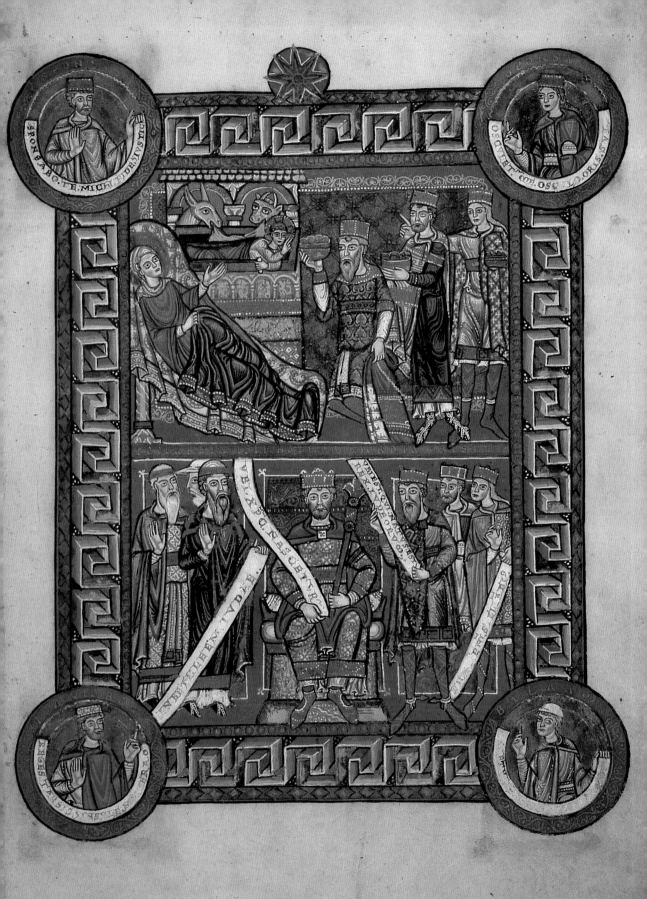

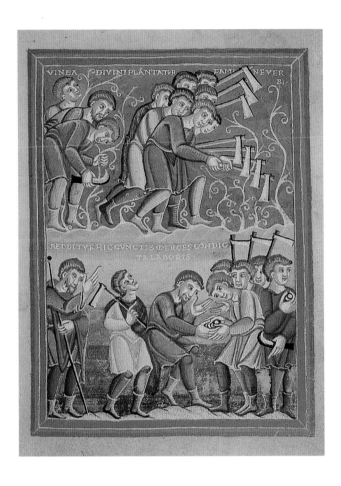

Apocalypse will only come into its true use on the day the world ends. One cannot plan further ahead than that.

No survey of the very expensive imperial manuscripts is complete without a reference to the eleventh-century Ottonian books made for Henry III, emperor from 1039 to 1056. The first were produced at Echternach Abbey and probably included the Gospel Lectionary of c.1039–40 now in Bremen (PLS. 53 and 59) a Gospel Book now in Uppsala (Universitetsbibliotek, Cod. C.93, PL. 57), c.1050, the celebrated Codex Aureus of Echternach (Nuremberg, Germanisches Nationalmuseum, MS. 20.156.142) of about 1053–6, and certainly the Golden Gospels of Henry III of about 1043–6 (El Escorial, Real Biblioteca de San Lorenzo, Codex Vitr. 17). This manuscript includes a fine miniature of Henry and his wife Agnes kneeling before the Virgin Mary (fol. 3r). Curiously, however, this is not an imperial image. Henry is not shown as master of the world, as Otto III would have required, but as a human being like the rest of us before the Mother of God.

The last manuscript of Ottonian grandeur comes from a century later again and it is certainly consciously archaic in function. It is the Gospel Book illuminated about 1185–8 by the monk Herimann at Helmarshausen Abbey for Henry the Lion (c.1129–95), duke of Saxony and Bavaria and founder of Munich (Wolfenbüttel, Herzog August Bibliothek, Cod. Guelf. 105 Noviss. 2°, and Munich, Bayerische Staatsbibliothek, Clm. 30055; PLS. 58 and 60). It is the final expression of a deliberately arrogant political claim. Henry the Lion, like his Ottonian ancestors, spent most of his life in desperate warfare to maintain his dominions, not least in his struggle with his cousin, the Emperor Frederick Barbarossa. He had married the daughter of the king of England, he had travelled to Byzantium and further, and had taken armies into Scandinavia, Russia, and Lombardy. Yet, despite all this, he was not yet emperor. The Gospel Book seems to be an incredibly expensive fanfare for the claims of Henry the Lion. It opens, like an early Carolingian manuscript, with a dedication leaf in burnished gold capitals beginning 'Aurea testatur' ('it is witnessed in gold' – as if gold alone adds credibility) referring to Henry as descendant of Charlemagne. It is illustrated with 17 canon pages and 24 elaborate full-page miniatures, including one (fol. 171v) showing Henry the Lion and his wife Matilda being crowned by God in the presence of their imperial and royal ancestors and the court of Heaven. This is pure Ottonian conceit. It is a book flashing with gold (the dedication refers to 'fulgens auro liber iste') and it was intended to symbolize extreme wealth and power. When the manuscript was sold at auction in London in 1983 it became by far the most expensive work of art ever sold, a record it held for some years until topped by Van Gogh's *Sunflowers*. The huge price is a reminder that even today imperial treasure manuscripts are still very, very expensive. That is the reason why they were made.

58 *Opposite*

Wolfenbüttel, Herzog August Bibliothek, Cod. Guelf. 105 Noviss. 2°, and Munich, Bayerische Staatsbibliothek, Clm. 30055, fol. 20r

The Gospels of Henry the Lion was illuminated at Helmarshausen Abbey, c.1185–8, for Henry the Lion, duke of Saxony 1142–95, cousin of Frederick Barbarossa, and is the last great manuscript in the Ottonian tradition. The miniature here shows the Magi adoring the Christ Child and consulting King Herod. In 1983, the manuscript became the most expensive book ever sold and it now belongs jointly to two German national libraries, one in Henry's dukedom and the other in Munich, a city founded by Henry.

59 *Above*

Bremen, Staats- und Universitätsbibliothek, MS. b.21, fol. 21r

This is from the same manuscript as PL. 53, the Gospel Lectionary made at Echternach Abbey for Henry III, c.1039–40. It shows the labourers working in the vineyard and receiving their wages.

60 *Left*

**Wolfenbüttel, Herzog August
Bibliothek, Cod. Guelf.
105 Noviss. 2°, and Munich,
Bayerische Staatsbibliothek,
Clm. 30055, fol. 112v, detail**

This detail from the Gospels of
Henry the Lion shows the Apostles
and the Virgin Mary gathered
together at Pentecost when the Holy
Spirit descended on all of them.

73

III

Books for
Monks

There is something altogether fascinating and rather impertinent about rummaging through other people's private belongings. We all know how revealing it can be to look along the bookshelves in an acquaintance's house and to realize what a lot we can tell about the owner's tastes and interests, his background, his travels, and his weaknesses and buying impulses. Only social manners may prevent us taking the books out and leafing through private letters and notes enclosed between the pages. No such inhibitions need worry the historian of medieval manuscripts. It is hardly possible to recommend too strongly the tremendous fascination of medieval inventories. Imagine how much we could learn about medieval monks if we could spend an hour or so in some cloister in the twelfth century browsing through all the monks' manuscripts, opening up one after another, discovering what titles they owned, where they got them from, and which books looked well used, and if we could ransack their cupboards and wardrobes, pulling out works of art for our own curiosity. We would discover in a few minutes far more than an archaeologist would find in years with a trowel and brush on the earthy site where the monastery had once been. Something of this treasure-hunt experience can be captured by reading medieval library catalogues. A considerable number of them survive, from enigmatic lists of cryptic titles (like the one mentioned in the previous chapter, written at the court of Charlemagne in the late eighth century) to detailed and indexed shelf catalogues like that of St Augustine's Abbey, Canterbury, compiled in the mid-1490s. If we combine our reading of these catalogues with trying to identify surviving manuscripts from known libraries, we shall learn a great deal about the cultural life of the Middle Ages. It is also fascinating simply to rummage about in someone else's library of eight hundred years ago.

English monasteries reached their peak in the twelfth century.

All of them certainly had books of some sort. By no means all monasteries compiled inventories of their libraries, and some catalogues which must have existed no longer survive. There are reasonably complete twelfth-century library catalogues for Peterborough Abbey, Durham Cathedral, Lincoln Cathedral, Whitby Abbey, Reading Abbey, Burton-on-Trent Abbey, and Rochester Cathedral. There are at least partial twelfth-century catalogues for Abingdon, Christ Church in Canterbury, Waltham, Worcester, and several other houses. Let us examine one catalogue. It is a typical example from the late twelfth century. The one chosen was compiled at Reading Abbey in Berkshire. The ruined site of the monastery itself is now in the middle of the town, and is encroached upon on three sides by the nineteenth-century prison (where Oscar Wilde wrote the *Ballad of Reading Gaol*), a municipal flower garden over the site of most of the abbey church, and a modern office development where the cloister once was. There are still massive battered ruins of flint rubble (which one can just glimpse from the train on the line through Reading between London and Oxford) but they convey little idea of the splendour of a complex of buildings where Henry I was buried and which, at about the time our catalogue was made, played host to Henry II, Thomas Becket, and Heraclius, patriarch of Jerusalem. The ruins have one bookish concession, for there is a monument on a remaining wall of the chapter house to commemorate the fact

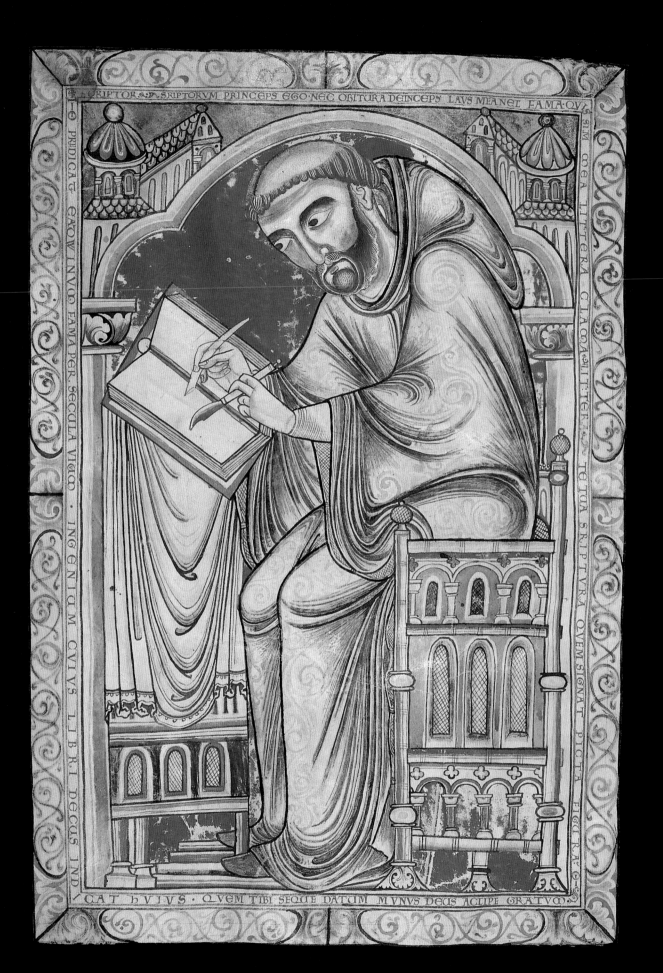

condemnat & inludit. Petr̄ tercio abnegat &
lacrimat̄. ihs pilato traditur. & iudas laqueo
se suspendit. de agri figuli iudiciu pilati . & de
baraba latrone . XXVIII
Passio ihu & sepultura & resurrectio ei. item q;
mandata & doctrina ei de baptismo.
EXPLICIVNT CAPLA·INCIP
LIBER SCDM MATHEVM·

BERGENERA

that the unique thirteenth-century manuscript of 'Sumer is icumen in', the best-known early English song, probably came from Reading Abbey.

The catalogue of the twelfth-century library of Reading Abbey survived in a curious way. It is one of the texts in the Reading cartulary, or book of charters, which was discovered about 1790 by a bricklayer who was taking down part of a wall in Shinefield House, near Reading. It was published in 1888 when the volume still belonged to the family of Lord Fingall, owner of Shinefield. The book is now in the British Library (Egerton MS. 3031).

The catalogue begins with a heading, in Latin (PL. 63), 'These are the books which are contained in the church of Reading'. It opens with four Bibles, in two or three volumes each. It goes without saying that the Latin Bible was the fundamental text of every medieval monastery. An important point (and one which will recur in the next chapter) is that old monastic Bibles were usually extremely large. We have discussed earlier huge books like the Codex Amiatinus of around 700 and the Bible of San Paolo fuori le Mura of around 870. Twelfth-century Bibles were gigantic too. The labour in making them was immense. The most famous surviving examples are the Bury Bible (only one volume still exists now) and the Dover (PL. 62), Lambeth, Winchester, and 'Auct' Bibles, all of which are (or were) in two volumes and at least 20 by 14 inches (505 by 350mm). The Durham copy was in four volumes. St Albans Abbey was unusual in owning a copy in a single volume (PL. 65). These are all monumental Bibles intended for use on a lectern rather than for private study. They are usually in handsome black script, and are sometimes marked up with accents so that they can easily be read aloud. The Reading Abbey catalogue is quite explicit. Three of their copies were in two volumes each and one was in three volumes. This three-volume Bible is mentioned again at Reading two hundred years later when it was described as being kept in the monks' dormitory as a spare to be used for reading out at mealtimes in the refectory. Perhaps it was getting too battered by then to serve as the daily copy. The twelfth-century catalogue records that the smallest of the two-volume Bibles had belonged to R., bishop of London. There are several candidates for this donor, the most likely being Richard de Belmais (1152–62) or Richard FitzNeal (1189–98). Episcopal donations are typical of the period too. There was a custom for bishops to give Bible manuscripts. Hugh de Puiset gave a lectern Bible to Durham where he was bishop from 1153 to 1195. It is very likely that the Reading copy was elegantly decorated at a bishop's expense. It was probably not for everyday use. A final Bible at Reading Abbey brings us down to the level of the common monk. 'A fourth, likewise in two volumes,' says the catalogue, 'which G. the cantor ordered to be kept in the cloister.' The cloister was where the monks walked and meditated. The cantor (or chanter – he was primarily in charge of education) had the fourth copy put out for the monks.

61 *Previous page*

Cambridge, Trinity College, MS. R.17.1, fol. 283v

The monk Eadwine, the prince of scribes (as the inscription calls him), is shown in this huge mid-twelfth-century portrait in a luxury glossed Psalter written at the cathedral priory of Christ Church, Canterbury. Eadwine is working with a pen and a knife together. Once assumed to be a self-portrait, this celebrated picture is perhaps commemorative of a famous Canterbury scribe of the past.

62 *Opposite*

Cambridge, Corpus Christi College, MS. 4, fol. 168v, detail.

The opening of St Matthew's Gospel in the Dover Bible shows the evan-

gelist holding his manuscript carefully in the fold of his robe and apparently undoing the clasp to open up the text. The manuscript was made in Canterbury in the mid-twelfth century and in the fourteenth century was recorded as MS. A.1 in the library catalogue of Dover Priory.

63 *Above*

London, British Library, Egerton MS. 3031, fol. 8v

The library catalogue of Reading Abbey was written out by the monks in the late twelfth century and records approximately 300 books then in their possession, beginning with Bibles and commentaries on the Scriptures, sometimes with the names of the people who gave the manuscripts.

The Reading Abbey library catalogue then continues with various glossed books of a Bible. This, in fact, is the way that the Bible was usually studied in the twelfth century: in separate books, each with a marginal gloss or commentary written down either side of the page in a smaller script (cf. PL. 86). It was a standard text, usually called the Gloss (with a capital 'G'). Here we find titles of the Pentateuch, Leviticus, Numbers, Deuteronomy, Joshua, Judges, Kings, Matthew, Mark, Luke, John, and so on, mostly bound in separate volumes. Several of the actual Reading copies described here still exist. The Leviticus is now in the Bodleian Library, Oxford, MS. Auct. D.3.12, the Books of Kings are Bodleian MS. Auct. D.3.15, the St Luke is Queen's College, Oxford, MS. 323, and the copy of Judges with other texts may be B.L., Add. MS. 54230, which is still in its original binding. If one checks against the books of the whole Bible one finds that the Reading monks had all but about seven volumes to complete a full set of the Gloss on all the Bible. Medieval cataloguers used to count up glossed books too to see how far short they were of a complete run. When St Augustine's Abbey in Canterbury received a set of twenty-one glossed books from an uncle of Abbot Roger (1176–1216), they described the benefaction as a complete Bible 'except Chronicles, Maccabees, and the Apocalypse'. These glossed books greatly appealed to twelfth-century monks. The Peterborough Abbey library catalogue records copies acquired in the time of Abbot Benedict (1177–94), and the St Albans chronicle says that when a set was obtained by the monks in the time of Abbot Simon (1167–83) they said they had never seen more noble books. We shall be meeting glossed books again in the next chapter as they were very popular among students in the early universities. The Reading catalogue actually describes several of them as 'glossed, as in the Schools'. The latest additions to the Gloss were edited by Gilbert de la Porrée (d.1154) and by Peter Lombard (d.1160). Reading Abbey had copies of both. This was a very up-to-date library. One, a Psalter with the Gloss of Gilbert de la Porrée, is described as having been given by Roger, who is perhaps the abbot from 1158 to 1164. The volume itself has been identified as Bodleian Library, MS. Auct. D.4.6, a Psalter with Gilbert's Gloss, medieval annotations referring to Reading, and a remarkable initial signed with the artist's name, 'Johannes me fecit Rogerio' ('John made me for Roger') (PL. 64).

A very large part of the twelfth-century Reading monastic library evidently comprised works of the Church Fathers. These open with Cassiodorus on the Psalms. The catalogue lists eighteen volumes of texts by St Augustine, ten by St Ambrose, seven by St Gregory the Great, eight by Bede (his biblical commentaries, not his history which we quoted in chapter I), and good runs of St Jerome and Origen. These authors formed the central core of any twelfth-century monastic library. It is worth stressing this (cf. PLS. 66, 67, 73, 75, 78, 83, 89 and 91). These were very old, fundamental texts which any self-respecting Romanesque library had an

66 *Above*

Cambridge, Trinity College, MS. O.4.7, fol. 75r, detail

Here a man is trying to teach a bear the alphabet. 'ABC', he says, and the bear grunts 'A'. This initial, drawn in outline, occurs in a manuscript of commentaries by St Jerome written for the cathedral priory of Rochester, Kent, c.1120.

67 *Opposite*

Chicago, Newberry Library, MS.12.1, fol. 1r

This is a mid-twelfth-century manuscript of St Augustine from the library of Reading Abbey, with the fifteenth-century ownership inscription at the top threatening malediction against anyone who removes it from the monastery.

obligation to own: Augustine on the Psalms in three volumes, Gregory's *Moralia* on Job in two volumes, Ambrose's *De Officiis* bound up with his *Enchiridion*. They were all at Reading and in most other libraries at the time. Yet this passion for owning the old theological classics was comparatively new in England. A monastery before the Conquest of 1066 might own a few volumes by chance or need, but a Norman abbey systematically set about building up its holdings. They often wrote them together, and they stored them as great sets. As it happened, seven of the twelfth-century manuscripts of St Augustine's works recorded in the Reading Abbey catalogue passed after the Reformation to one J. Reynoldes (1577) and remained together in the collections of James Bowen (1748) and Sir Thomas Phillipps (1822) and were still a group when purchased *en bloc* in 1937 by the Newberry Library in Chicago (MSS. 12.1–7). Three of them have the medieval ownership inscription of Reading Abbey and a curse against anyone who takes them away: 'Liber sancte Marie Radying[ensis] quem qui alienaverit anathema sit' (PL. 67).

The Church Fathers make up many bulky volumes, not easy to read. The ones in Chicago amount to 762 leaves of closely written Latin. Were they used much by the monks? If not, the cynic will ask, why own them? There is something in the concept of a monastery as a repository for religious knowledge, especially long-respected religious knowledge in an age troubled (almost for the first time in England) by a fear of heresy. Furthermore, in the twelfth century, and probably never since, it was still possible to think of human knowledge as finite. The biblical scholar Gilbert (who taught in Auxerre and became bishop of London from 1128 to 1134) was known as 'The Universal', because it was thought he knew everything. There was no sarcasm in the nickname. Judged in relation to the number of books then in existence, the monk William of Malmesbury (d.c.1143) was perhaps the most well-read Englishman of all time. Not until the nineteenth century was library comprehensiveness again so much admired. Reading Abbey owned a copy of St Jerome's *De Viris Illustribus*, which amounts to an encyclopedia of famous authors and their works. A medieval librarian could use it as a check-list of all the books that existed up to that time. It would be a most useful bibliographical handbook for outfitting a collection. The smattering of classical texts at Reading perhaps reflects this vague ideal of comprehensiveness: Seneca, Virgil, Horace, and Juvenal. Whether all these books were used often may be revealed by the chance use of an adjective here and there in the catalogue: four times in the list of nearly three hundred volumes the cataloguer throws in the comment 'utilis' or 'magne utilitatis', a 'useful' work. He applies the term to a collection of excerpts from biblical history, a volume of quotations from the Fathers, an excerpt from Peter Lombard's *Sentences*, and a book of saints' lives. These are all secondary works. There is something rather touching about the fact that it was the summaries and quotations which the monks at Reading mention in their cata-

Aurelii Augustini de uera religione liber incipit.

Cum omnis uitę bonę ac beatę uia in
uera religione sit constituta in qua un̄
d̄s colitur. & purgatissima pietate cogno
scit̄. principium naturarū omniū. a quo uni
uersitas omnis & inchoat̄ & pficit̄ & tenet̄.
hinc euident̄ error dephendit̄ eorū po
pulorū qui multos deos colere quā unū uerū d̄m & d̄ūm omni
ū maluerunt. qd̄ eorū sapientes qui philosophos uocant̄
scolas habebant dissentientes & templa cōmunia. Non
enī ut populos uel sacerdotes latebat de ipsorū d̄eorū na
tura quā diuisa sentirent. cū suā qsq; opinionē publice
confiteri n̄ formidaret. atq; omnib; si posset psuadere
moliret̄. Omis tam̄ cū sectatorib; suis diuersa & aduersa
sentientib; ad sacra cōmunia nullo phibente ueniebant.
Nunc n̄ agit̄ qs eorū senserit uerius. sed certe illud sa
tis q̄ntū m̄ uidet̄ apparet. aliud eos in religione susce
pisse cū populo. & aliud eodē ipso populo audiente defendis
se putant̄. Socrates tam̄ audatior ceteris fuisse phibet̄. iuran
do p canē quēlibet. & lapidē quēlibet. & qcqd naturatū
eēt in pmptu. & q̄si ad manū occurrisset. Credo intelli
gebat qualiacunq; opa naturę quę administrante diui
na pudentia gignerent̄. multo quā hominū & qtrūlibet
opificū ee meliora. & ideo diuinis honorib; digniora. quā
ea quę in templis colebant. Non q̄ uere lapis & canis eēt
colenda sapientib; sed ut hoc m̄ intelligerēt q̄ possent
tanta supstitione demersos ee homines. ut emergenti
b; hic eēt a turpis demonstrand̄ gradꝰ? Ad quę ueni
re si puderet. uiderent q̄nto magis pudendū eēt in
turpiore consistere. Simul & illos qui mundū istū

logue as useful while they accept without comment the multi-volumed patristics with which the library was handsomely stocked.

The Reading Abbey catalogue is comparatively unusual among library lists in that it includes liturgical manuscripts. These were kept in the abbey vestries and chapels rather than with other library books. Looking through the Reading catalogue, however, one gains the impression that the compiler had systematically searched for books in all corners of the abbey. Obviously he began in the main library. We do not know where this was. It would not have been a special room in the twelfth century, and could well have been in the cloister (PL. 68). There are indentations in the ruined east wall of the cloister at Reading which might possibly have enclosed book cupboards, but perhaps books were stored in free-standing chests either in the cloister itself or in the very wide slype (passage-way) which at Reading ran off the south-east corner of the cloister between the chapter house and the church. With a little imagination, and a plan of the ruins of Reading Abbey, one can see the cataloguer moving from room to room. He lists the principal books first. Then he describes a two-volume Breviary in a chapel off the cloister (he has not moved far), then walking clockwise round the cloister he went up the passage (its ruins are still there) to the guest house, infirmary, and the abbot's lodging (four more Breviaries recorded), back into the cloister and through the refectory on the south side (three books for reading at meals, including a two-volume Lectionary) and on again right round to the door into the abbey church. He found three great Missals (two in precious bindings and one for the early morning service) and seventeen smaller Missals for everyday use by the monks in church and in the chapels. He counted fifteen Graduals – that is, music for the Mass – including two in the abbot's private chapel. There were six full Processionals and seven smaller copies for specific occasions (they would be easier to carry as the line of monks walked chanting round the cloister), and there were seven Antiphoners, big volumes of church music for the daily round of services. There were three Psalters for the novices (they probably learned to read from them) and four more copies chained in the church and the infirmary, a very early reference to the practice of chaining up manuscripts. With Lectionaries, Tropers, Collectars, and other specialized liturgical texts listed, we gain an impression of a great many books in daily use at Reading Abbey. The information is all the more valuable because minor liturgical books have seldom survived from the twelfth century: constant use, obsolescence, and religious reformation have caused the loss of all but a few precious scraps of English Romanesque liturgy (cf. PL. 69). In considering the history of medieval book production, it is too easy to overlook whole categories of manuscripts, just because they no longer exist. No complete liturgical books survive from Reading Abbey. There may be a fragment from a Reading servicebook now at Douai Abbey in Berkshire, which acquired it in 1943 (MS. 11). It comprises four leaves written and decorated in the first half of the

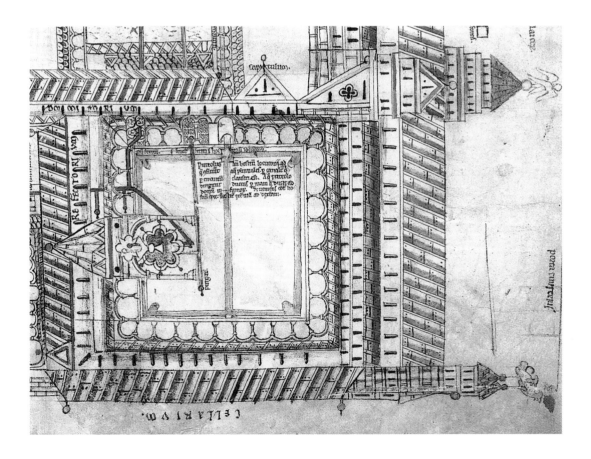

68 *Opposite*

**Cambridge, Trinity College,
MS. R.17.1, fol. 285r, detail**

The cloister of a monastery was
probably where twelfth-century
monks generally kept their books
and did their reading, and many
manuscripts may have been made
in the cloisters too. This detail of
a stylized plan of about 1165 shows
the large cloister of Christ Church
Cathedral Priory, Canterbury, at
a time when there were certainly
chests of books in this cloister.

69 *Right*

**London, British Library,
Royal MS. 2.A.X, fol. 2r**

Every twelfth-century English
monastery must have had many
service-books, but these rarely sur-
vive because they were used to
pieces throughout the Middle Ages
and what remained were then sys-
tematically destroyed at the
Reformation. This Breviary of
c.1150 was made at St Albans
Abbey. At the top of the page is a
note that it was kept in the cup-
board in the choir, and at the foot is
a curse against anyone who should
remove it from St Albans.

ueris mois: 7 spe incorporeos posse
pena corpalis ignis affligi: 18 ignit
corpal' cruciabit demones: 7 hoies.
S' et hely odoro: in epta ad ephes:
infernum sub tra. ee: nemo ambigat.

mensit die. ad uespa: e statuta sol
lempnitat. Veru eungelu scpta in
different. 7 die azimoy p pascha:
7 p dieb; azimoy post pascha solet.
un lucas. dies fest azimoy. q di
pascha. ite ioht. Cu pmo azimoru
die. l. xv. luna res agered: ait. Et
ipi n intient in ptoriu. u n contami
naretur: s; manducarent pascha. qp
7 pasce dies azimist. e. celebrari pcep
e. unam qppe diem agno imolato ad
uespa. vij. ex ordine dies secunda azi
moy. qp ihc semel p nob passut. p oe
tempp qp. vij. dieb; agit: in azimit
sinceritatis 7 uitatis pcipit. ee. ui
uendum. M. cclxxv.

Vnc qggati sunt R. cl vii.
pncipes sacerdotu. 7 seniores ip. in
atium. pn. sac. q. dice. cayphas. 7 osci
lium secert. ut ihm dolo. re. 7. oc. di
cebant aut. ñ in die. fe. ne forte tu
mult fieret in po. Qvi debuant
uicino pasca uictimas parare: pa
rietes templi leuigare: pauimenta
uertere: uata mundare: meunte g
scilicet: qm occidant dum. io aut no
lebant in die festo gsentire neci ei
qp tu fecert. ne ppls q diligebat eu
insurget ill. 7 defender innocente.

cu gsumasset ihc. M. cc. lxxiiij.
sermones hos omis. R. c. l. vi.
dix discipls suis. L. cc. lx.
Scitis: qa p biduu. A. x c vi.
pascha fiet. 7 fili' h ois tradet. ut
crucifigat: Consumatis uerbo
7 ope sermonib; cunctis ab initio
euangelii. ut his copleit. de scdo
aduentu dui. u se uenturum in
claritate p dixit: passurum se
ostendit. ut sacramentu crucis
admixtu ee. gle etnitatis ammo
neat. erubescant q putant salua
torem. passionis pauore dixisse: pa
ter si fieri pot: tu. a. me. ca. i. Nam
p sciuit se tradendu: nec ui'u fug.
p biduum. i. p duos dies celebra
turi erant iudei suum pascha. ui
delicet. xiiii. luna p eqnoctium.
h sane int uer pascha 7 azima di
cat. qd pascha solus dies appella
t. in quo agnus occidebatur ad
uespam. hoc. e. xiiii. luna primu
mensis. xv. aut luna. qn egressut. e
pp ille de egypto: succedebat fes
tiuitas azimoy. cui. vij. dieb;
i. usq; ad uigesimam pma eiusdem

Vnc abiit un de. xij. M. cclxxiij.
q dr iudas scarioth: R. clx.
7 locut'. e. ad pncipes L. cc. lxii.
sacerdotu. 7 magistratib; 7 ait illis.
qd uultis m dare: 7. e. uo. eu. e: qui
audientes gauisi st. 7 gstituert ei. xxx.
argen. 7 exinde q rebant oport: u eu
tra. sine turb. Iudas un de. xij. nu
mero: ñ micto corpe: ñ aio. a pncipi
b; ñ inuitat. nulla necessitate gstrin
git. s; ipa sponte sceleratae menti
init consiliu. Nec in uenditione
magistri certa ptulat summa: u de
cara re. s; qm utile tradent mancipi
um: in potestate posuit ementiu.
Multi hodie iude sceluf exhorrent.
nec tu cauent. Nam cu p muitib; saltu
testimoniu dixit: p secto uitatem ne
gando: dum uenditum. Cu sp cietate
ititutatis discordie peste comaculat:

twelfth century, and the text includes responses for the Sundays after Trinity, one of which is distinctively Cluniac, the reformed Benedictine order to which Reading then belonged. Its script resembles that of known Reading manuscripts, and it is certainly the kind of manuscript the monks there would have made and used.

Both the keeping of books and the making of them in the twelfth century were essentially monastic. Monks need books. They needed service-books in large quantities, if we can judge from the Reading Abbey lists. But more than that, monasteries were the focal points of intellectual and artistic life in the twelfth century. Very few manuscripts were produced entirely independently of a monastic or religious context. It is difficult for us, so long afterwards, to comprehend the paramount importance of the monastic life in the twelfth century; the flourishing of the monasteries is one of the remarkable features of Romanesque Europe. At the time of the Norman Conquest there were about thirty-five monasteries in England. They included the uniquely English institution of cathedral priories (places like Winchester, Durham, and Christ Church in Canterbury), which were cathedrals staffed with Benedictine monks instead of priests and canons, and which figure prominently in the history of book illumination in the twelfth century. Probably the cathedrals preceded the monasteries in their desire for comprehensive libraries. Soon all institutions were swept into a vast programme of monastic reform and recommitment and the establishment of new religious orders and the building of new monasteries and abbeys on an extraordinary scale. Many old monasteries were rebuilt, like Winchester, Durham and Canterbury, or even transferred to new sites, like Tewkesbury. The Cluniacs arrived in England about 1077; their houses included Reading Abbey itself, founded by Henry I in 1121. The

Augustinians came to Britain in 1105, the Cistercians in 1128, the Gilbertines (an entirely English order) in 1131, and the Carthusians in 1180. They took their recruits from the local population and many people joined. However we explain it away now, there was quite clearly a whole movement of spiritual dedication. By 1200 there were over five hundred monasteries and priories in England, almost all constructed within the previous century. The old Anglo-Saxon way of life gave way to internationalism. 'With their arrival', William of Malmesbury recollected in the twelfth century, 'the Normans breathed new life into religious standards, which everywhere in England had been declining, so that now you may see in every village, town and city, churches and monasteries rising in a new style of architecture.'

A monastery needed books as part of its essential furniture. It is not necessary to ask whether the monks used all the books often (though some monks sometimes certainly did) any more than we need explain liturgy, prayer, or architecture in exclusively utilitarian terms. A monastery was not properly equipped without a library. A famous (though later) quotation from a Swiss Carthusian observes that 'a monastery without books is like a state without resources, a camp without troops, a kitchen without crockery, a table without food, a garden without grass, a field without flowers, a tree without leaves.' Where did monasteries get books from? Reading Abbey, founded in 1121, had nearly three hundred books by the time the catalogue was drawn up in the late twelfth century. With another five hundred or so monasteries in England, all needing books at that time, the efforts put into book production were considerable. They were so successful that English twelfth-century books are the oldest which still survive in comparatively large numbers.

The simple answer to the question of where the books came

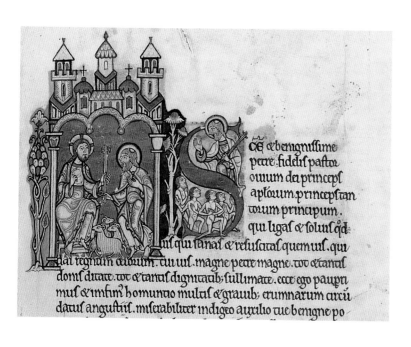

from, is to say that the monks made them. They sat in the cloisters and wrote them out. Basically, this is true, especially in the twelfth century. But a scribe could not simply write a book. Before anything else, he needed an exemplar, that is, another copy of the same text, carefully corrected and made intelligible, which then acted as the model for the new manuscript. Any manuscript text, unless it is autograph or the scribe knows it by heart, needs a second copy at the time of writing. This is so fundamental that it tends to be overlooked. The mechanics of how this worked in practice, however, are difficult to discover. Suppose, for example, that the monks of a relatively new monastery in the far south-west of England had heard that the legal *Decretum* of Gratian was now all the fashion in Italy, that a Premonstratensian canon called Zacharias in Besançon in the 1140s had compiled a most ingenious harmony of the Gospels (PL. 70), or even that the late archbishop, Anselm of Canterbury, had assembled a volume of spiritual meditations that would greatly help the monks (PL. 71). They would need access to someone else's copy. It is tantalizing to know so little about how and where scribes obtained a text, especially if they were monks whose rule did not encourage them to travel freely.

No doubt one monastery often lent books to another. One can easily imagine this happening among the Cistercian houses, for instance, as the order was efficiently centralized. The geographical proximity and the close relationship between Rochester Cathedral and Christ Church, Canterbury, furthermore, probably explains some remarkable parallels between collections of books there. Scribes at Bury St Edmunds apparently also made use of texts from Christ Church, Canterbury. A ninth-century Cassiodorus from Hereford was the exemplar for a late eleventh-century copy made at Salisbury. The late Dr N.R. Ker followed up a ninth-century volume of St Augustine (which was at Burton-on-Trent by the twelfth century) which was the ultimate ancestor of copies made at Salisbury, Hereford, Rochester, and elsewhere.

Sometimes an abbey wanting a book must have found it easier to send a scribe to copy a new text on location than to send a messenger to borrow the precious exemplar and carry it back to the first house for transcription and then to send the messenger all the way back again to return it. There survives part of an interchange of letters, datable to between 1167 and 1173, from the prior and abbot of St Albans who wrote to Richard, prior of the abbey of St-Victor in Paris, to try to obtain a list of Richard's own writings and to ask whether a copyist might be sent to St-Victor to copy out on location any texts of Hugh of St-Victor still missing from the St Albans library. Once St Albans had them, then perhaps other English houses could send scribes there, and so the process could be repeated. There were four of Hugh of St-Victor's works in the Reading library catalogue (one still survives – Bodleian Library, MS. Digby 148), and the scribe perhaps borrowed or used the exemplars from somewhere such as St Albans.

Having obtained an exemplar, the next stage in making a manu-

script was to prepare the blank leaves of vellum. Animal skins for making vellum were no doubt often a by-product left over by the abbey butcher. Since a massive book like the Winchester Bible would probably have needed skins from some two hundred and fifty sheep, it is difficult to imagine so many animals being killed for the sole purpose of supplying vellum. A brief insight into this supply occurs in the contemporary life of St Hugh of Lincoln. From 1180 to 1186 Hugh was prior of the Carthusian house of Witham in Somerset. He was personally acquainted with King Henry II, and one day in conversation with Henry he mentioned how few books they had at Witham and explained that the problem was the lack of vellum. According to the chronicle, the king then generously gave him ten marks of silver to buy some. Two important points emerge here. One is that vellum was available commercially but it was expensive: ten marks was a large sum (though we do not, of course, know how much vellum it bought; PL. 72). The second is that the monks at Witham had none. It is significant, therefore, that they were Carthusians. According to the austere Carthusian customs of 1130, they never ate meat. Therefore they had no butcher and (we now learn) no vellum. The Benedictines, by contrast, were probably seldom short of vellum.

There is a twelfth-century monastic account of how to make vellum in the *De Diversis Artibus* of Theophilus, probably written at Helmarshausen Abbey in north Germany. Skins are soaked in running water for several days. They are then immersed in a solution of lime and water for up to a fortnight. Then all the hair is scraped off (in practice, it falls away quite easily) and the skins are put back into the lime solution for as long again. Next they are rinsed, stretched over a frame and dried in the sun, and cleaned over and over again with pumice and water. The crucial point is that the skin is dried and scraped under tension. Plenty of fresh running water was essential for vellum making. One notices that the manuscripts written at Salisbury in the late eleventh century are on some of the worst possible vellum, thick, yellow and rough, and it is curious that the Norman site of Salisbury, the bleak hill now called Old Sarum, was eventually abandoned for the principal reason that it had no access to running water. Perhaps that is why Salisbury vellum was so bad. Again, things must have been easier for the Cistercians, whose houses were almost always built by rivers.

There is a curious reference to vellum in the abbey chronicle of Bury St Edmunds. In describing the huge Bible made for the monastery about 1135 and painted by the artist Master Hugo, the chronicle says that as the illuminator could not find suitable material locally, he obtained vellum in Ireland ('in Scotiae partibus'). This is rather puzzling. In fact, one of the two volumes of this Bible still survives (Cambridge, Corpus Christi College, MS. 2) and, sure enough, all its miniatures and some of the illuminated initials are painted on separate pieces of vellum pasted into the Bible. There are, it happens, other examples of this practice throughout the Middle Ages – manuscripts with illustrations on

72 Right

**Copenhagen, Kongelige Bibliotek,
MS. 4, 2°, fol. 183v, detail**

Vellum (or parchment) was a valu-
able commodity. This thirteenth-
century German initial shows a
monk examining a sheet offered for
sale by a professional parchment-
maker who has other sheets rolled
up under his arm. Behind is the
wooden frame on which the wet
skin is stretched and scraped with
a curved knife, called a *lunellum*,
shown propped up in front.

uos nisi xpm ihm & hunc crucifixum. Si ipse
dns descendit & ascendit: manifestu e qa &
pdicatores ipsi descendunt imitatione. ascen
dunt illuminatione: ascendunt & pdicatioe.
Et si aliqnto uos diutius tenuimus. consilium
fuit: ut importune hore transirent. Arbi
tamur iam illos pegisse uanitate suam. Hos ait
qm pasti sum epulis salutarib; que restant
agamus: ut die dominicu sollempnit imple
amus in gaudiis spualib; & comparem gau
dia ueritatis. cum gaudio uanitatis. Et si hoc
remus doleamus: & si dolemus oremus: si oram
exaudiamur: si exaudim. & illos lucremur.
Explicit omelia .vii. Incipit octaua de nuptiis
in chana galilee. & aqua in uinu conuersa

Miraculum dni nri ihu xpi qd
de aqua uinum fecit: n e
miru his qui nouerit qa
ds fecit. Ipse enim uno il
lo die fecit in nuptiis in
sex illis idriis qs impleri q̃
pcepit: qui omni anno facit hoc in uitib; Sic
enim qd miserunt ministri in idrias in uinu con
uersum e ope dni: sic & quod nubes fundunt
in uinu conuertit eidem ope dni. Illud autem
n miramur: quia omni anno fit. Assiduitas
amisit ammirationem. Nam considerationem
maiorem inuenit: qm id qd factum e in
idriis aque. Qs e enim q considerat opa di
quib; regit mundus: & n obstupescat obru
turq; miraclis? Si consideret uim uni gra
cuilibet seminis: magna queda res e: hor
ror e considerantia. S; qa homines in aliud
intenti. pdiderunt considerationem opum
dei: in qua darent cotidie laude creatori
tanqm seruauit s ds inusitata queda q
faceret: ut tanqm dormientes homines ad
se colendum mirabilib; excitaret. Mortu
us resurrexit: mirati sunt homines: tot
cotidie nascunt & nemo miratur. Si consi
derem prudenti: maioris miraculi e ee qui

n erat: qm reuiuiscere qui erat. Idem tamen
ds pater dni nri ihu xpi p uerbum suu facit
hec omnia: & regit que creauit. Priora mi
racula fecit p uerbum suu dm apud se: pte
riora miracula fecit p ipsum uerbum suu in
carnatum: & ppter nos homine factum. Si
cut miram que facta sunt p homine ihm:
miremur que facta sunt p dnm ihm. Per do
minu ihm facta sunt celu tra mare: & ois
ornatus celi. opulentia terre. fecunditas ma
ris. Omnia hec que oculis subiacent p ihm
dnm facta sunt: & uidem hec. & si e in nob
spc illius. sic nobis placent ut artifex laudet
nil ad opa conuersi. ab artifice auertamur:
& faciem qdam ponentes ad ea que fecit.
dorsum ponamus ad eu qui fecit. Et hec qdem
uidemus: & adiacent oclis. Quid illa que n
uidemus sicut sunt angli. uirtutes. dnati
ones. potestates. omnisq; habitator fabrice
huius sup celestis. n adiacens oclis nris: qm
qm sepe & angeli qndo oportuit demonst
rauerunt se hominib; nonne ds & p uer
bum suu id: unicu filiu suu dnm nrm ihm
xpm fecit hec omnia? Qd ipsa anima hu
mana que n uidet: & p opa que exhibet in
carne. magna pbet ammirationem. bene con
siderantib; A quo facta e n a do: Et p qm
facta e n p filiu dei? Nondu dico de anima
hominis. Cuius uis pecoris anima quom regit
molem sua: sensus corporis exerit. oculos ad
uidendu. aures ad audiendum. nares ad pa
piendum odore. os iudicium ad sapores dis
cernendos: menbra denuq; ipsa ad pagenda
officia sua? Num qd hec corpus. & n anima
id: habitatrix corporis agit? Hec tamen ui
detur oculis: & ex his que agit ammiratione
mouet. Accedat consideratio tua etiam ad
anima humana: cui ds tribuit intellectum
cognoscendi creatore suu: dinoscendi & dis
tinguendi inter bonu & malu: hoc e inter
iustum & iniustum. Quita agit p corpus. Atten

separate inserted onlays of vellum. Perhaps for some reason from time to time illuminators found the surface of the locally made leaves unsatisfactory.

The way that a sheet of newly made vellum was folded depended on the dimensions of the book that the scribe was planning to make. A really big manuscript, such as a lectern Bible, would be made up of bifolia (pairs of leaves) almost as large as a single skin of vellum, with one fold across the middle. Four of the bifolia would then be placed one inside the other to form a gathering of 8 leaves (or sixteen pages). For a big folio manuscript of a patristic text such as Augustine or Cassiodorus or Josephus, the skin might be folded in half and then in half again, and when the edges were trimmed off there would be a package of four leaves (or eight pages) up to about 14 inches (260 mm) in height. If the sheet was folded yet again before it was cut, it would make eight leaves (sixteen pages), something like 10 by 7 inches (255 by 180 mm). This

is a fairly standard size for many twelfth-century texts. If the sheet could be folded in half yet another time, it would end up small and narrow, like many little grammatical and other short treatises of the time. It is worth mentioning too that medieval manuscripts, like modern printed books, are usually taller than they are wide. This is inevitable if one begins by folding an animal skin which is naturally oblong. When paper was first introduced for making pages of books, the makers tended to follow the same custom, though it was no longer essential. Books are still taller than wide: this is because, more than six hundred years ago, their ancestors were made by folding natural vellum.

If you rub your fingers on a sheet of vellum, you can feel the difference between the rough and usually yellower side (where the hair has been rubbed off) and the smooth whiter side which was the flesh side of the skin. If the scribes made their gatherings by folding the vellum in half several times, as explained above, it will always work out exactly that the hair-side faces the hair-side and the flesh-side faces the flesh-side throughout a gathering. This makes for neatness. The first page of a gathering would be the hair-side, and the neatness then applied right throughout the manuscript. Medieval scribes always arranged their leaves like this if it was at all possible. Most twelfth-century manuscripts are made up of gatherings of eight leaves. These gatherings were eventually assembled in order and stitched to form a book.

It always used to be supposed that scribes worked with just a bifolium or pair of leaves open on the writing desk, and perhaps they often did. One would imagine that this would have been simplest. It is odd, however, that almost all medieval pictures of scribes (and there are many of them in Evangelist portraits) show them writing into what seems to be a whole book lying open. This may be just an artistic convention, but it is a disconcertingly consistent one (e.g., PLS. 10, 19, 26, 53, 61, 101). There is tentative evidence that twelfth-century scribes wrote into the pages of loosely stitched gatherings rather than just on detached pairs of leaves. These seem often to have been held together by a single tacketing stitch around the upper inner corner of the loose gathering. It has even been argued by some students of manuscripts that

74 *Left*

Durham, Cathedral Library, MS. A.I.10, fol. 227r

This manuscript of the commentary on the Apocalypse by Berengaudus was written at Durham cathedral priory in the early twelfth century. The marginal prickings for ruling the guidelines and the guidewords for the rubricator are just visible on the extreme right-hand edge. By the fifteenth century the manuscript was in use in the refectory at Durham.

(especially in the fifteenth century) small books could have been written on completely uncut vellum with all sixteen pages of one quire still on one huge sheet, some side-by-side and others upside down, so that when the big piece of vellum was finally folded over and over and trimmed, it would form a continuous text.

Before a scribe began to write, he had to measure out the page carefully and rule a grid of faint lines to keep the text straight and within a regular pattern. He would have to decide whether the text would be in one column or two: at the beginning of the twelfth century many books were still in a single column format, but by about 1170 manuscripts were generally larger and often in two columns. Compare, for example, the early twelfth-century St Augustine in PL. 83 with that of 1167 in PL. 73. By 1200 some small books were in double column. Actually ruling each leaf was tiresomely slow. The scribe would therefore measure up only the first page of a stack of unwritten leaves and with a sharp instrument he would prick the measurements in the extreme margins of a pile of leaves. When he came to each page, then, he simply had to join up the prickings in order to multiply the ruling pattern exactly throughout a quire. It is worth looking out for these pricked holes in a twelfth-century book: if nothing else, they may indicate whether the three outer margins have been cropped much by the binder (PL. 74). In the earlier twelfth century the holes are in outer margins only and so had been ruled with the bifolium spread open. By about 1150 one notices the prickings in the extreme inner margins as well, and therefore the scribes must have folded their blank leaves before ruling them. There is a difference too in the instrument used for ruling. Before the twelfth century the lines are almost always scored with an awl or possibly the back of a knife. By the mid-twelfth century, most English scribes ruled their guide-lines with an instrument which draws a line like a modern pencil. Perhaps the graphite mines at Borrowdale in Cumberland supplied this new substance, but sharpened silver and especially lead also produce very similar marks on a rough surface like vellum. It is worth noting details like ruling and pricking when one examines a Romanesque book as, taken together, these can provide interesting clues for dating a manuscript.

One of the ways that we can assign a date to a manuscript is to examine its script. Sometimes this is the only way of guessing a book's age. Of course there is no degree of precision here and it would be foolhardy to date a twelfth-century manuscript within a lesser span than about thirty years on the basis of its script alone. But fashions evolve, and they still do, of course. Probably all of us can look at an old postcard (for example) and, without really knowing why, could date it within a decade or so with some accuracy. The decision is probably based on a coming together of a whole range of clues. Handwriting, page layout, size, colouring, style of decoration, choice of illustration, and so forth, may all contribute to an impression of date. This kind of subjective judgement, based on experience, can be applied to manuscripts. Anyone

can sometimes be spectacularly wrong, and we have all known the follies of over-confidence. Certain developments in twelfth-century English script can be isolated. A backwards sloping script is not likely to be earlier than the mid-twelfth century. A wavy contraction line (written over a word to indicate that 'n' or 'm' has been omitted) is an early feature: a straight line usually belongs to the second half of the twelfth century or later. The mark like a cedilla under 'e' to represent the 'ae' of classical Latin (e.g., 'uitę bonę ac beatę' for 'uitae bonae ac beatae' in the first line of text in PL. 67) suggests a date before about 1175, or after about 1450. If the two lower-case letters 'pp' occur together and are actually fused to form a single double form, then the manuscript is not earlier than about 1140, and if they are clearly separate it is not later than about 1180. This is really quite a useful test. If there are combinations of other round letters like 'de', 'be', and 'ho', the manuscript falls within the last third of the twelfth century or later. If the manuscript uses an ampersand (&) for 'et' rather than a mark like a 'z', it is likely to be twelfth-century rather than thirteenth.

Localizing a twelfth-century English manuscript on the basis of its script is disappointingly difficult: indeed even whether it was written in England or in France is sometimes very uncertain. Romanesque art was remarkably cosmopolitan and so was monastic discipline, and in any case after 1066 many English monasteries were staffed by Norman personnel. What always used to be thought of as one of the earliest signed English manuscripts, a late eleventh-century copy of Jerome on Isaiah (Oxford, Bodleian Library, MS. Bodley 717), has a coloured drawing of the illuminator 'Hugo Pictor', Hugh the Painter (PL. 75). The book comes from Exeter Cathedral but there is a good case for suggesting that Hugh himself was a monk of Jumièges Abbey not far from Rouen in Normandy, and other manuscripts with decoration attributable to Hugh include a St Augustine from Fécamp Abbey, also in Normandy (Rouen, Bibliothèque Municipale, ms. 464), and a St Jerome which belonged to the cathedral library at Durham (Durham Cathedral Library, MS. B.II.9). Both Exeter and Durham had energetic bishops who came from Normandy, Osbern FitzOsbern (1072–1103) and William of St Calais (1081–96) respectively. Both clearly commissioned books in their native land for the libraries of their new English cathedrals. Thus a single scribe who wrote out a splendid Bible for Durham (MS. A.II.4 there, with an inscription recording it as the bishop's gift) also worked on a Lanfranc manuscript from Exeter (Bodleian Library, MS. Bodley 810) and in at least two manuscripts certainly made for Bayeux Cathedral in Normandy. It is simplest to suppose that he worked in Normandy. Books commissioned there were then brought over and in turn served as exemplars. To some extent this happened at Canterbury too. Lanfranc, who was archbishop from 1070 to 1089, imported at least one manuscript from his old abbey of Bec in Normandy. It is a volume of *Decretals*, now Trinity College, Cambridge, MS. B.16.44. It has a contemporary inscription

recording that Lanfranc actually purchased it ('dato precio emptum') from Bec, and that he brought it to England and gave it to Christ Church, Canterbury, from which (the note says) no one should remove it on pain of damnation. The Canterbury monks evidently admired its novel, rather spiky, prickly Norman script, and for a generation or so the handwriting was imitated and developed by them, a rare local script probably exclusive to Kent (PL. 79).

Who actually were the scribes in a twelfth-century English monastery? Most were probably the monks themselves. Hugh the Painter, whom we have just mentioned, sketches himself holding a pen and an inkpot, and there is every reason to suppose he was a scribe as well as an artist: he is tonsured and wears a Benedictine habit (incidently, he shows himself as left-handed). Diversity of labour was encouraged in monasteries. Making books for the abbey was one of many tasks with which a monk might find himself involved, like gardening, or mending furniture, or teaching in the school. St Osmund, the Norman bishop of Salisbury (1078–99), is recorded as having encouraged the transcription of books for his cathedral and, it is said, even wrote and bound some himself. Probably monks worked quite slowly, as they had other duties to attend to. One late twelfth-century English glossed Exodus

(Lambeth Palace Library, MS.110) has notes by the scribe which seem to indicate how much work he did each day. He began on 'lundi' and by 'samadi' had written only twelve leaves. When an exemplar was not easily available within a monastery and (as suggested above) the scribe had to travel elsewhere, or when the amount of work to be done exceeded the labour available, the monks could call in professional help. One of the earliest references to professional scribes in England occurs in the chronicle of Abingdon Abbey. It records that Faricius (abbot 1100–17) employed six professional scribes to copy out patristic texts, but he left to the monks (the 'claustrales') the task of writing Missals, Graduals, Antiphoners, and other liturgical books. We have seen from the Reading Abbey catalogue that there were a great many of these liturgical manuscripts in a monastery. The point is that they were not books which required difficult journeys in search of accurate exemplars and, furthermore, they needed copying in quantity. Monks in the cloister could duplicate them fairly simply. Abbot Simon of St Albans (1167–83), who corresponded with the abbey of St-Victor in Paris about copying books from there, is also specifically recorded as employing two or three choice scribes at his own expense (PL. 89), and he left an endowment to pay for a scribe for the personal use of abbots in the future. The names of

75 Right

Oxford, Bodleian Library, MS. Bodley 717, fol. 287v, detail

At the very end of this late eleventh-century manuscript of St Jerome's commentary on Isaiah is a tiny portrait of 'Hugo pictor', Hugh the Painter, with the caption that this is a picture of the painter and illuminator of the book. Curiously, he seems to be left-handed. The book belonged to Exeter Cathedral, but Hugh himself may have worked in a monastery in Normandy.

76 Opposite

Paris, Bibliothèque Nationale, ms. lat. 11575, fol. 1r, detail

This commentary by Florus on the Epistles of St Paul belonged to Corbie Abbey. It is dated 1164 and is signed by the scribe Johannes Monoculus. The long descender of the first illuminated initial includes in the foliage little roundels of a monk, with his name Richard, who presumably supervised the commission, and of the artist, a layman, seated at a sloping table, with his name above him, Felix.

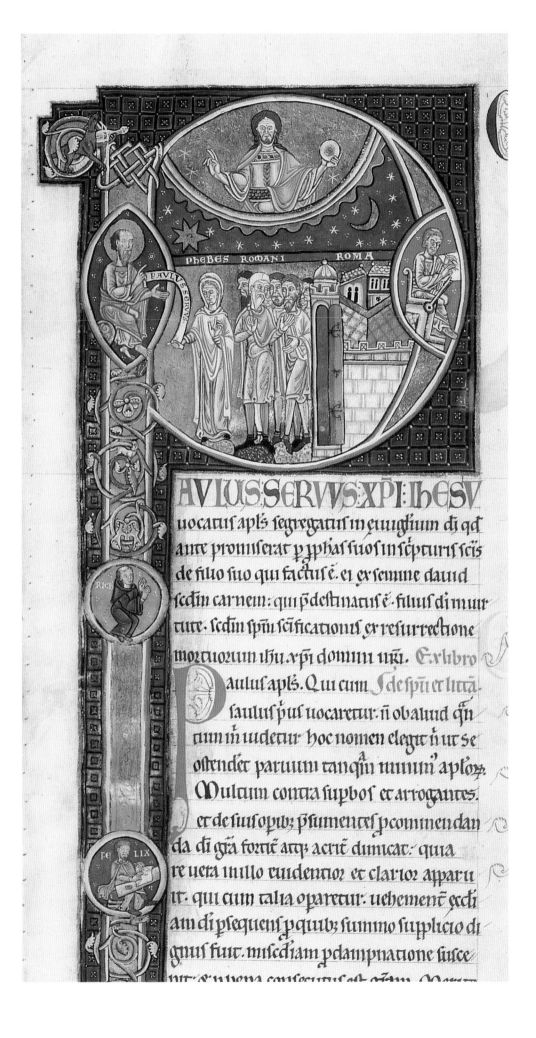

PHEBES ROMANI ROMA

PAVLVS SERVVS

AVLVS.SERVVS·XPI·IhESV

uocatuſ apłs ſegregatuſ in euuugłium di qd
aute promiſerat p iphaſ ſuoſ in ſcpturiſ ſcis
de filio ſuo qui factuſ e̅. et ex ſemine dauid
ſecdin carnem: qui p̅deſtinatuſ e̅ filiuſ di in uir̅
tute. ſecdin ſpm̅ ſcificatioiuſ ex reſurrectione
mortuorum ihu xp̅i domini uxi. Ex libro

Pauluſ apłs. Qui cum de ſpu̅ et litt̅a.
ſauluſ p̅uſ uocaretur: ñ ob aliud q̅n
tum iñ uidetur hoc nomen elegit ñ ut ſe
oſtendet paruum tanq̅m minimñ aplo̅z.
Multum contra ſupboſ et arrogantes.
et de ſuis opib; p̅ſumenteſ p̅commendan
da di g̅r̅a fortiñ atq; acriñ dimicat: quia
re uera in illo euidentior et clarior appar̅u
it. qui cum talia oparetur. uehemeñt eccłi
am di p̅ſequenſ p quib; ſummo ſupplicio di
gnuſ fuit. miſediam p̅ dampnatione ſuſce
ṗir · & uue ña conſecutuſ e̅. etiam. Nam

93

several scribes are preserved in manuscripts from Cirencester Abbey, an Augustinian house in Gloucestershire. Two energetic abbots of Cirencester, Serlo (1131–47) and Andrew (1157–76), supervised the writing out of patristic manuscripts for the house, and about twenty of the books still survive, mostly now in Hereford Cathedral and Jesus College, Oxford (PL. 77), and, remarkably, many still have contemporary notes of the scribes' names. Most were inmates of the abbey. They included Adam (who later became prior), Deodatus, Jocelin, Simon of Cornwall, Odo de Wica (PL. 78), Serlo himself, Walter, Alexander the Cantor, and especially Fulco (who also later became prior) with six and a half manuscripts to his credit (PL. 77). But among the names is Ralph de Pulleham, described in Jesus College, MS. 52, as a 'scriptor', a professional scribe, who wrote Jesus College, MSS. 62, 63 and fols. 42–131 of MS. 52 in collaboration with Alexander, cantor of Cirencester. Perhaps many monasteries used men like Ralph de Pulleham. The monks did most of the work, but a professional scribe may have been called in to help and advise on the stocking up of a monastic library. It would have been an interesting job to have had in the twelfth century.

Good-quality script and elegant layout are features of twelfth-century monastic books, but appearance alone, however agreeable, is no use to a monk if the text is not reliable. Of course all copyists sometimes made mistakes in transcribing. Today even the most professional typist needs facilities for correcting errors. Pictures of twelfth-century scribes (like Prior Laurence in Durham University Library, Cosin MS. V.III.I, or Eadwine in Trinity College, Cambridge, MS. R.17.I, PL. 61) show them scratching away at the page with a little scimitar-shaped knife which they hold in their left hands. This knife was partly to sharpen the pen (a penknife, that is) but also to scrape out mistakes. Vellum is a tough enough material to withstand quite a few erasures. If you peer closely at almost any page of a twelfth-century manuscript you can see little rough patches in the text where the scribe has scraped off a wrong letter or two and rewritten them. This must have happened as the scribe was working: constant vigilance was necessary. The easiest mistake to make is when the scribe has just copied the last word of a phrase and he looks back at his exemplar and his eye alights accidentally on another word which ends like the one he has just written. He then starts to copy out the second half of the wrong sentence in error. The technical term for this is homoeoteleuton. It is especially likely to happen if one is copying Latin because many words end similarly. Another fault a scribe can easily commit is to expand a contraction wrongly. The old schoolboy horrors of 'hic, haec, hoc' and 'qui, quae, quod', which might occur as an abbreviated h' or q' in an exemplar, could easily confuse a scribe to whom Latin was (at best) only a second language. Sometimes mistakes were a result of well-informed uncertainty. In Plate 74, for example, five lines from the bottom of the first column, the exemplar may have read 'in hoc l'o' and the scribe was uncertain whether to expand this as

77 *Above*

Oxford, Jesus College, MS. 53, fol. 159v, detail

The ownership inscription in a twelfth-century manuscript of Bede from Cirencester Abbey reads, in translation, 'The book of St Mary of Cirencester, from the time of Andrew the second abbot [1147–76], written out by the hand of canon Fulco, afterwards prior, while Alexander de Weleu was cantor.'

78 *Opposite*

Oxford, Jesus College, MS. 67, fol. 3r

An unusually large number of twelfth-century books from Cirencester Abbey are signed by their scribes. This copy of Bede's commentary on St Mark was written out by Odo de Wica, canon of the Abbey. At the foot of the first column are the tiny guidewords by the scribe for the decorator to copy when he came to inserting the large red heading above.

de diuersis ultimi temporis tempta
tionib; futuris pluribus disputans,
seductiones animonet precauenda.

ij. Orem aduentu solu patrem scire
dicens: nescientes eam seruos ui
gilare precipit ceorare.

iij. De alabastro unguenti. ul peti
tione inde traditouis. ac preparata
tione pasche refert. necn ce ce
ne ei mistice panditur sacramentu.

iiij. Traditionis ac passionis eius
gesta narrant.

v. Resurrectionis eius inde
breuiter ueritate monstrata
quorundam incredulitas cle
menter arguitur. ce ascensio at
q; a dextris di confessio. uel
discipulorum predicatio. signi se
quentib; indicatur. Exp. Cap.

INICIŪ EVANGE
LII IHU XPI.

SICVT SCP
TVM EST
IN YSAIA PPHA

Inciu euangelii ihu xpi filii spepritz in ysaia ppha.

Offert
REN
Dy ch
ESI
hoc
Evan
gelii
mar
ci prin
cipium, principio mathei
quo ait. liber generationis
ihu xpi filii dauid. filii a
braham. atq; ex utroq;
unus dns nr ihc xpc. dei
ce hominis est filius intel
ligendus. Et apte primus
euangelista filiu hominis
eum. sed's filiu di nomi
nat. ut a minorib; paula
tim ad maiora sensus nr
exurgeret. ac p fidem ce
sacramenta humanitatis
assumpte. ad agnitionem
diuine eternitatis ascen
deret. Apte qui huma
nam erat generationem
descepturus, a filio homini
cepit. dauid scilicet; siue a
brahe. de quorum stirpe
substantiam carnis assup
sit. Apte is qui libru suum
ab initio euanglice predica
tionis inchoabat. filiu ma
gis di appellare uoluit

'*in hoc libro*' or '*in hoc loco*', for both make sense, and he therefore wrote both as alternative readings. The next time this manuscript was copied, a scribe might well choose the wrong alternative and so a variant would enter the textual tradition of Berengaudus.

It would seem as though there was often a second scribe who checked through a text after it had been written, comparing it as carefully as possible with the original. If there was the odd word which had slipped in by mistake, he could simply cross it out or (in a way which was less upsetting to the appearance of the page) underline it with a row of dots. A reader would know that he had to omit this word. Longer phrases or whole paragraphs which had to be cancelled could be marked 'va' at the beginning and 'cat' at the end: 'vacat' meaning that the words in between these syllables should not be there. Additions which had to be made were often scribbled in by the corrector in the extreme outer margins and were subsequently transferred into the body of the text, generally by erasing several lines and rewriting them in a more compressed way to include the missing phrase. The words jotted in the margins ought then to have been erased, though they sometimes still remain. One imagines that the corrector was the head or supervisor of the scribes. In manuscripts from Salisbury and Winchcombe corrections in the same hand occur in volumes by a variety of scribes. There, at least, one man proof-read books as they were written. When that had been done, the exemplar could be returned to its owner.

The illustration of twelfth-century manuscripts is very much admired today. The paintings of the Winchester Bible, for instance, must rank among the greatest works of art ever produced in England (PLS. 80, 81 and 88). The finest have a quality unmatched anywhere in Europe in the twelfth century. There is great elegance too in twelfth-century English coloured initials in the text. These were almost certainly painted by the scribes while they were writing out the book. The main colours of these are red, pale blue, and (particularly in England) green. Sometimes they used brown, purple (especially at Canterbury), yellow, and other colours. Often the initials would be shaped like little flowers and petals. They add great gaiety to a twelfth-century manuscript.

The decision as to whether a manuscript was to be decorated would of course have to be taken before it was written. Spaces would have to be marked out, and the scribe would leave these blank for the miniatures or initials. It raises a fundamental question of why twelfth-century monks decorated their books at all. It is a very difficult question to answer. It obviously worried the medieval Cistercians too: their fundamental principles were for stark simplicity in life-style and architecture, and St Bernard specifically condemned unnecessary ornamentation formed of distracting animals and monsters. Yet their manuscripts often have painted initials and even miniatures and sometimes gold. In the Cistercian statute of 1131, saying that initials ought to be made of one colour only and not illustrated, one can see that they could not

79 Left

London, British Library, MS. Cotton Claudius E.V, fol. 41v, detail

This manuscript of church law was made at the cathedral priory of Christ Church, Canterbury, about 1125. Many of its decorated initials are formed from animals and mythological creatures. The initial 'A' here is made up of a man and a dragon fighting for possession of a fish.

80 Opposite

Winchester Cathedral, MS. 17, fol. 169r

The page of the Winchester Bible with the end of the books of Jeremiah and the beginning of Baruch has two large illuminated initials. On the left is the Prayer of Jeremiah, following Lamentations. It shows Jeremiah with a scroll, praying to God. Across on the right, at the start of Baruch, is an even larger initial showing the prophet reading from a manuscript before King Jechonias and all the people in the city of Babylon.

noster completi sunt dies nri qa uenit finis nr
Uelociores fuerunt psecutores nri COPH
aquilis celi sup montes psecuti sunt nos in
deserto insidiati sunt nobis 5 ibus REX
Spus oris nri xpc dns capt est in peccatis
nris cui diximus in umbra tua uiuemus ingen
Gaude & letare filia edom quiha SEN
bitas interra bus adte quoq; puemet calix
inebriaberis atq; nudaberis TAV
Completa est iniquitas tua filia syon non
addet ultra ut transmigret te Visitauit ini
quitate tua filia edom discoopuit peccata tua
FINIT LAMENTATIO IEREMIE PPHE

INCIPIT ORATIO EIUSDEM

RECORDARE dne quid acciderit nob
intuere & respice op
probrium nostrum
Hereditas nra uersa
est ad alienos domus
nre ad extraneos
Pupilli facti sumus
absq; patre matres
nre quasi uidue

Aquam nostram pecunia bibimus & lig
na nostra precio comparauimus
Ceruicibus minabamur lassis
non dabatur requies
Egypto dedimus manum & assyrus
ut saturaremur pane
Patres nostri peccauerunt & non sunt
& nos iniquitates eorum portauimus
Serui dominati sunt nri & non fuit
qui nos redimeret de manu eorum
In animabus nris afferebamus panem
nob a facie gladii in deserto
Pellis nra quasi clibanus exusta est
a facie tempestatum famis
Mulieres in syon humiliauerunt
uirgines in ciuitatibus iuda
Principes manu suspensi sunt facies
senum non erubuerunt
Adolescentibus impudice abusi sunt
& pueri in ligno corruerunt
Senes de portis defecerunt iuuenes
de choro psallentium
Defecit gaudium cordis nri uersus est in luc
tum chorus nr cecidit corona capitis nri
ue nobis quia peccauimus
Propterea mestum factum est cor nrm ideo
contenebrati sunt oculi nostri
Propter montem syon quia disperiit

uulpes ambulauerunt in eo
Tu autem dne in eternum pmanebis soliu tuu
in generatione & generationem
Quare imperpetuum obliuisceris nri & dere
linques nos in longitudinem dierum
Conuerte nos dne adte & conuertemur in
noua dies nros sicut a principio
Sed piciens reppulisti nos iratus es contra
nos uehementer FINIT ORATIO IEREMIE

INCIPIT PROLOGUS IN LIBRU BARUCH NOTARII IEREMIE PPHE

Liber iste qui baruch nomine pnotatur in hebreo
canone non habetur sed tantum in uulgata editione Si
militer & epla ieremie pphete Propter notitiam autem
legentium hic scripta sunt quia multa de xpo nouissimisq;
temporibus indicat

FINIT PROLOGUS

De oratione & sacrificio pro uita Nabuchodonosor

INCIPIT LIB BARUCH NOTARII IEREMIE PROPHE ET VERBA LIBRI QUE SCRIPSIT

baruch filius neeri filii amasie filii sedechie
filii sedei filii helchie in babylonia in anno
quinto in septima die mensis in tempore quo
cepunt chaldei ierlm & succenderunt eam igni
Et legit baruch uerba libri huius ad aures ie
chonie filii ioachim regis iuda & ad aures uni
uersi populi uenientis ad librum & ad aures
potentium filiorum regum & ad aures presbi
terorum & ad aures populi a minimo usq;
ad maximum eorum omnium habitantium in
babylonia ad flumen sudi Qui audientes
plorabant & ieiunabant & orabant in con
spectu dmi Et collegerunt pecuniam sedm
quod potuit unius cuiusq; manus & miserunt
in ierlm ad ioachim filium helchie filii salon
sacerdotem & ad reliquos sacerdotes & ad
omnem populum qui inuentus est cum eo in ierlm

imagine books without any painted initials at all (PL. 73). Decoration as such was not simply a luxury. Contemporary descriptions of manuscripts generally do not mention illumination. The St Albans Abbey chronicle, praising Abbot Simon (1167–83), exalts the great artistic quality of the chalices, crosses, and other gifts commissioned by Simon, but in complimenting his illuminated manuscripts says just that they were wonderfully accurate ('authentica') and hurries on to describe the painted cupboard where they were kept. The life of St Hugh, discussing what must be either the 'Auct' or the Winchester Bible (in any case, a very richly illuminated book), praises not its initials but the corrected text which gave it such a special attraction. The chronicler William FitzStephen, recounting how Thomas Becket obtained manuscripts for his cathedral between 1164 and 1170, mentions only the accuracy of the texts, with no reference to the remarkable illumination. The Reading Abbey library catalogue makes no hint of beauty or decoration as a distinguishing feature of any book, though it lists titles like a Bestiary (PL. 82) and an Apocalypse, almost certainly full of pictures. One almost wonders whether they noticed book illumination at all.

This brings us to the true function of decoration in a twelfth-century book. It was clearly not just because it was pretty. The twelfth century was an age which delighted in the classification and ordering of knowledge. Its most admired writers, men like Peter Lombard and Gratian, arranged and shuffled information into an

order that was accessible and easy to use. Twelfth-century readers loved encyclopedias. They wanted books that could actually be consulted. We have seen that the Reading Abbey catalogue singled out as useful not the necessary many-volumed Church Fathers, but the practical summaries and extracts. The fact that monks began making library catalogues at all reflects this fascination with order and accessibility of universal knowledge. Let us then consider book illumination in these terms. It suddenly becomes easy to understand. Initials mark the beginnings of books or chapters (PL. 85). They make a manuscript easy to use. A bigger initial is a visual lead into a more important part of the text. It helps classify the priorities of the text. Like the use of bright red ink for headings (something one notices in twelfth-century books after working on earlier manuscripts), coloured initials make a massive text accessible to the reader. A newspaper does this today with headlines of different sizes. In fact, a modern popular newspaper is a good example of a thoroughly accessible text and uses very many of the devices of a twelfth-century illuminated manuscript: narrow columns (less eye strain), big and small letters, running-titles along the top of the page, catchwords (leading a text from page 1 through to page 2, for instance), and, above all, pictures. These help explain a written text visually, they provide a reminder of a familiar image, they help the user to choose which sections to read next, they make for a satisfying page layout, and they can be amusing. Yet any reader of a modern newspaper will fiercely defend his choice of paper by

81 *Left*

Winchester Cathedral, MS. 17, fol. 198r, detail

The great Winchester Bible was written and illuminated by a team of artists at Winchester Cathedral between about 1160 and about 1175. The opening of the book of Hosea shows the prophet preaching to the Israelites and confounding the Devil.

82 *Opposite*

New York, Pierpont Morgan Library, M.81, fol. 19v, detail

Mother monkeys, according to the Bestiary, love one baby but neglect the other. When she is being hunted, the mother will carry the favourite one in her arms, leaving the other to cling on behind, but when she gets tired she will drop the one from her arms and only the unloved baby will survive. This manuscript Bestiary, perhaps made in Lincoln, was given to Worksop Priory in 1187.

sic dicit iacob. Quid sine causa clamabit o
nager agrestis in pabulum desiderans: Simili
ter ce aptls petr. de diabolo dicit. Aduersari
nr circuit qrens sic leo quem deuoret. Onager
interpretatur asinus fer. onon qppe gu asinum
uocant. agrian fertu. Hos affrica bt mag
nos ce indomitos. ce in deserto uagantes.
Singli au feminarum gregib psut. Nascentib;
mascclis zelant. ce testiclos morsib; detincat
Qd cauente mats. eos in secretis occultant.

Sermo eiusd̃ de uerbis aplĩ · nescitis quia corpora ũra membra xp̃i s̃ · & que
pacuntur · ſ de constituendis ep̃is ·
Sermo eiusdem de uerbis apl̃i · non sic pugno quasi aerem cedens · & cet̃a
Sermo eiusdem de uerbis apl̃i · & de psalmo · xco · cui uult miseret̃ · & quẽ
non uult indurat · & cet̃a · ſ b̃tus legem xp̃i · ſ hẽc sapiences ·
Sermo eiusdem de uerb̃ apl̃i · inuicem onera ũra portate · & sic adimple –
Sermo eiusdem de uerb̃ apl̃i · inuicem onera ũra portate · & cet̃a ſ egia ·
Sermo eiusdem de uerb̃ apl̃i · spe salui facti sum · spes aut que uidet n̄ é spes ·
Sermo eiusdem de uerb̃ apl̃i · uidete quomo caute ambuletis · n̄ ut insipientes ·
Sermo eiusdem de uerb̃ apl̃i · in actib; aplorum · ſ in templum ·
Sermo eiusdem de uerbis apl̃i de actib; aplox̃ · petrus & iohs ascendebant
Sermo eiusdem de uerbis apl̃i beati petri · audiuim̃ uoce dilata de celo · hic
é filius m̃s dilect̃ · & habemus certiorem sermonem ppheticum ·

INCIPIT SERMO SC̃I AUGUSTINI DE UERBIS EUANGELII
SECUNDUM MATHEUM.

Agite penitentiam apppinquauit enim regnum celorum ·

UANGELIUM AUDIUIMUS ·
& in eo dominum eos arguentẽ qui faciem celi
norunt pbare · & tempus fidi regni celox̃
appinquantis nesciunt inuenire · Iudeis au
hoc dicebat · ſ etiam ad nos sermo puenit ·
Dom̃n aut ipse ihc xp̃c · euangl̃ii sui pdicatio
ñe ita cepit · Agite penitentiã · appinquauit eñi regnũ celox̃ ·
Et iohs apl̃s eius simil̃r · Et iohs baptista & pcursor ipsĩ ita cepit ·
Agite penitentiã · appinquauit enim regnum celox̃ · Et modo
corripit dñs qui nolunt agere penitentiã · appinquante regno
celox̃ · Regnum celox̃ ñ ueniet cum obseruatione · sic ipse ait · Et
iterum ipse ait · Regnum celox̃ int̃ uos é · Prudens g̃ accipiat
unusquisq; monita pceptoris · ñ pdat temp̃ misedie saluatoris ·
que in impenditur · quã diu humano generi parcit · Ad hoc eñi

83 *Left*

**Lincoln Cathedral,
MS. A.3.17, fol. 8v**

This early twelfth-century copy of
St Augustine's sermons was certain-
ly at Lincoln Cathedral by about
1150, and is very likely to have been
made there. It has coloured and his-
toriated initials throughout. The
large initial here shows Christ
preaching repentance.

84 *Opposite*

**Oxford, Bodleian Library,
MS. Ashmole 1431, fol. 20r**

A Herbal is a book about all kinds
of plants and their medicinal uses.
The science derives ultimately from
ancient Greek sources rather than
from practical observation. This
copy, with about 150 coloured
drawings, was made for St
Augustine's Abbey in Canterbury
at the end of the eleventh century.

praising the text, not the layout or illustrations. It is not surprising that the twelfth-century chroniclers from St Albans, Lincoln, and Canterbury complimented the accuracy of manuscripts when what they meant was that they liked using them.

Now we can look at the great illuminated manuscripts of twelfth-century England. Some have miniatures which are really part of the text: diagrams which make texts more comprehensible, like the classified schemes of the universe and charts of the bodily humours in a late eleventh-century handbook of science from Thorney Abbey (St John's College, Oxford, MS. 17) or the great emblematic illustrations in a copy of Richard of St-Victor's commentary on Ezechiel from Exeter Cathedral (Bodleian Library, MS. Bodley 494). Others come near to this. A Bestiary, or book of animals, is really only usable with pictures: Pierpont Morgan Library M.81, of about 1185, has 105 of them (PL. 82). The information in herbals too is difficult to extract without illustrations: Bodleian Library, MS. Ashmole 1431, from St Augustine's, Canterbury (PL. 84), and MS. Bodley 130, from Bury St Edmunds, both have about 150 miniatures each. But even manuscripts of the Church Fathers must be able to be used. The nine historiated initials and 71 decorated initials in Lincoln Cathedral MS. A.3.17 must have made St Augustine's sermons a pleasure to open instead of a burden (PL. 83). The reader would not lose his place either: initials are a visual aid to remembering. The great illustration cycles of the lives of saints must have helped readers understand rather thinly written texts, like the 55 miniatures in a copy of the life of St Cuthbert made at Durham (University College, Oxford, MS. 165) or the 32 full-page miniatures and 13 historiated initials in the Bury St Edmunds copy of the life of St Edmund (New York, Pierpont Morgan Library, M.736). A journalist with not much story today fills out his article with photographs. The famous Bibles of the twelfth century had wonderful historiated initials at the beginning of each book, and for the prologues. A giant Bible is difficult to use without a guide to lead one through the vast text: pictures provide exactly that. They identify and grade the importance of texts. The more ingenious the miniature, the greater its practical function. Decoration is a device to help a reader use a manuscript.

Unfinished manuscripts give an idea of the sequence of illuminating an initial. First of all, the artist lightly sketched in with plummet (or charcoal) the design of the letter. Circles and curves were sometimes done by using a pair of compasses and one can see a tiny hole pricked in the middle. The design would then be picked out carefully in pen and ink (PL. 87). This is apparently because it is difficult to paint smoothly over the top of a drawing of lead which leaves tiny granules on the page. Gold is rare in monastic manuscripts before the mid-twelfth century, possibly because until that time most artists worked outside in the cloister and gold leaf is so fragile and thin that it is almost impossible to manipulate in a breeze. Beside one initial in a late twelfth-century Bible in the

SERVUS XPI

thu. uocat apls.

egregat ineuuan-

gelui di. q̃ ante p̃miserat p̃ pphe-

tas suos. inscripturis scis. de filio suo.

qui fact + ei exsemine dauid. sedm

carne. quipdestinat est filiuf dei

inurtute sedm spm sanctificatiois.

exresurrectioe mortuoy ihu xpi dni

nri. pque accepim gram 7 apltatu.

adobediendu fidei. inoib; gentib;

p noie eius. inquib; estis q̃ uos uo-

cati ihu xpi. oibz; qui st rome di

lectis di. uocatis scis. Gratia uob. 7

pax. ado patre nro. 7 dno ihu xpo;

primum quide gras ago do meo

p ihesum xpm. p omnib; uob. quia fi

des ura annuntiatur inuniuerso

87 *Left*

**London, British Library,
Royal MS. I.B.XI, fol. 72r**

This page shows the opening of St
Luke in an unfinished mid-twelfth-
century Gospel Book from St
Augustine's Abbey in Canterbury.
The design has been drawn in pencil
and then inked over in preparation
for painting. The rubricator has
filled in the opening words of the
text in alternately red and dark blue
letters, following guidewords still
faintly visible at the top right. A
note for the scribe is in the upper
margin, 'scribatur lucas': 'Luke is to
be written'.

88 *Opposite left*

**Winchester Cathedral,
MS. 17, fol. 268r, detail**

The Winchester Bible was left
unfinished. This initial for
Ecclesiastes has been partly sketched
in ink and the burnished gold has
been added before the work was
abandoned. The subject was to have
been the vanity of human desires. It
shows a king resisting all the wordly
treasures and temptations which his
courtiers hold up for his delight.

89 *Opposite right*

**English Province of the Society
of Jesus, Stonyhurst College,
MS. 7, fol. 3v, detail**

St Gregory, the author of this com-
mentary on Ezechiel, is painted as if
he is holding the text by stretching it
into the historiated initial. The book
was made for St Albans Abbey at the
commission of Simon, abbot
1168–83, and the artist, who was
probably an itinerant professional
brought in from outside, is known
now as the 'Simon Master'.

Cathedral Library at Durham is a specific instruction written for the illuminator in plummet, 'de auro', to be done in gold, as it was (MS. A.II.1, fol. 133r). If there was gold in a manuscript, it would be applied first of all before the colour (PL. 88). That is because it was laid on over glue and then rubbed or burnished until it shone, and the action of burnishing might damage other painted areas. Then the colours were applied with a brush or quill, the basic pigments first and then gradually worked up, no doubt with a finer brush, to a high degree of finish.

The colourist was not necessarily the same man as the designer of an initial, particularly if a whole team of artists was working together. The Winchester Bible, for example, was a project which certainly kept a fair number of illuminators employed over a period of some years. The late Walter Oakeshott, who spent much of his long life studying this celebrated manuscript, frequently found evidence of an initial having been sketched by one artist and subsequently painted and subtly altered by another. Sometimes one artist left instructions for another to complete a miniature. An example is Bodleian Library, MS. Auct. D.1.13, perhaps from Winchester though later at Exeter. The book is a mid-twelfth-century Epistles of St Paul glossed and has a fine full-length initial on fol. 1r showing incidents in the life of St Paul (PL. 86). If you look closely at the initial, you can make out tiny letters of the alphabet in the middle of each area of colour, and those that are intelligible include 'r' on the red areas, 'v' on the green, and 'a' on the blue. This was, quite simply, what is now called 'painting by numbers'. A good artist drew the initial and indicated the colours for a lesser craftsman to colour in. One thing that emerges is that

they were speaking Latin or (more likely) French: 'rouge', 'vert', and 'azur'.

Possibly the artist of this initial was a professional, called in to help the monks decorate their book. What seems to be the work of the same artist occurs in Avranches, Bibliothèque Municipale, ms. 159, a chronicle written at Mont-St-Michel in Normandy and completed in 1158. If it was actually the same man, he must have travelled to or from France. The phenomenon of wandering illuminators is the simplest way of explaining what seems to be the work of the same artist cropping up in several quite different places. Examples include the miniatures by the mid-twelfth-century illuminator of the huge Lambeth Bible, perhaps from Canterbury, which are uncannily similar to the paintings on fragments of a Gospel Book documented as having been made at Liessies Abbey in Hainault in 1146. Another case is the so-called Simon Master who worked at St Albans around the 1170s (PL. 89): the same artist (so it seems) occurs in manuscripts from Worcester Cathedral, Bonport Abbey in Normandy, and perhaps Troyes in eastern France. But the most weird link of all is the amazing relationship between the style of at least two of the artists of the Winchester Bible and the murals in the chapter house of a monastery at Sigena in northern Spain, more than six hundred miles from Winchester. If any of these are really the same actual artists (as is generally believed), then they must have been travelling professionals. Too little is known about these people. A commentary on the Pauline Epistles made for Corbie Abbey in France, c.1164, shows tiny portraits of a monk called Richard (he has his name written behind him), who may be the member of the abbey

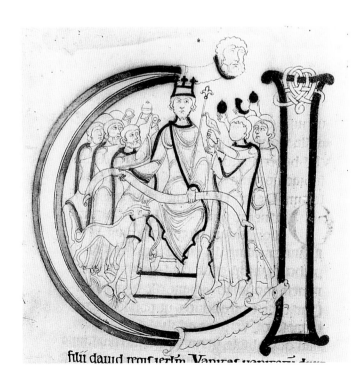

who supervised the production, and of the artist, Felix, a layman who was doubtless co-opted to do the illumination (Paris, B.N., ms. lat. 11575, fol. 1r; PL. 76). One wonders if illuminators like Felix called on monasteries asking for work, or whether the monks sought them out for special projects. What is clear, however, is that monks were anxious to possess decorated books, and monasteries could no longer always do the illumination themselves.

When the script was finished and the decoration complete, the final stage of book production was to bind the volume. Almost all twelfth-century bindings are of wooden boards covered with leather. The quires (or gatherings) of a manuscript would be arranged in order (numerical signatures and, later, catchwords helped this) and then sewn onto several horizontal thongs of leather. The thongs were then threaded into tunnel grooves in wooden boards, pulled tight, and pegged into place. Twelfth-century boards had square-cut edges and were made flush with the edges of the pages, not like the covers of a modern hardbound book which overlap slightly. The boards were then covered with leather (PL. 90). Almost always this was white skin, though surviving examples have often mellowed to an agreeable yellow-brown. The spines were flat. Occasionally the leather was coloured red and (in England very rarely) tanned and stamped with little impressed pictures. Far more often than mutilated surviving twelfth-century bindings are able to show, the books seem to have had what are called 'chemise' covers of soft tawed leather which fitted right around the outside of the volumes, considerably overhanging the edges, so that the whole book could be wrapped into a self-contained white leather parcel (PL. 91). We can assume that all the books in the Reading Abbey catalogue, for instance, were bound in white except for eight whose bindings were specified: two Missals in silver, two books in red leather, and four books in stamped leather. A good example of a plain white twelfth-century Reading Abbey binding is B.L., Egerton MS. 2204.

A distinctive feature of a bookbinding in the twelfth century is that it had little tabs shaped like half-moons sewn at the top and bottom of the spine, projecting through any chemise cover. Such tabs can be seen in many twelfth-century pictures of bookbindings (PLS. 61, 62, 80, 86 and 94, for example). The titles of the books are sometimes written along the spines too. The Reading Abbey example just mentioned has 'Beda super lucam' written from the bottom to the top of the spine, exactly as listed in the catalogue. These features may tell us how the books were stored. Manuscripts were probably kept in chests with the fore-edge downwards. The edges of the boards were flush with the pages so that it was a neat fit. The title was visible on the spine. The tabs were for lifting the book out of the chest. That is how we would find the manuscripts if we could be miraculously transported back to the twelfth century to rummage through the cloisters in a monastic library.

90 *Above*

Oxford, Jesus College, MSS. 70, 68, 53 and 63

All these twelfth-century books from Cirencester Abbey survive in their original bindings of wooden boards cut flush with the edges of the pages and covered with white skin. At the top and bottom of each end of the spines are round tabs, perhaps for lifting the volumes out of the chests where they were kept.

91 *Opposite*

London, private collection, s.n., fols. 17v–18r

This manuscript of St Ambrose, *c*.1150, belonged to the priory of Stoke-by-Clare in Suffolk. Its original binding is more or less intact with a loose chemise cover of soft leather which extends beyond the edges so that when the book is closed it virtually forms a self-contained parcel.

IV

Books for Students

Among the most obvious owners of books are students, whether schoolboys learning basic Latin, or postgraduates refining and expanding their researches. The universities of Europe blossomed into international prominence from the late twelfth century onwards, and their need for textbooks brought about a revolution in the medieval book trade. A Bolognese lawyer Odofredo (d.1265) tells an anecdote about a father who offered his son an allowance of a hundred pounds a year to study at the universities of Paris or Bologna: to the father's distress, the boy went to Paris and squandered his money on manuscripts frivolously decorated with gold initials. The Latin says that he had his books 'babuinare de literis aureis' which literally means the initials were filled with baboons, monkeyed-up, as the father might have said when the student came home penitently at the end of term, not at all as when the father himself had been young. It would have been almost impossible a century earlier for a private individual to commission textbooks and have them expensively illuminated, and even now the father did not understand the need for them. This chapter will try to take the son's point of view.

Tracing the date of foundation of a medieval university is notoriously difficult. This is partly because the patriotic pride of an antiquarian for his own *alma mater* may beguile his imagination into ascribing the founding of the University of Paris to Charlemagne or of Oxford to King Alfred, and partly because universities did not start issuing their own corporate statutes until some time into the thirteenth century, and there is almost no way of documenting when students began gathering around a master to listen to his teaching. In northern Europe the story must begin in Paris in the first half of the twelfth century. Masters like William of Champeaux (c.1070–1121), Hugh of St-Victor (d.1142, PL. 94) and the still almost legendary Peter Abelard (1079–1142) attracted crowds of students to their lectures in the precincts of the cathedral of Notre-Dame in Paris and across the Seine at the church of Ste-Geneviève and at the abbey of St-Victor. These schools certainly existed in the twelfth century. There is nothing especially unusual in the fact of lectures taking place in these surroundings. Really any cathedral chapter had a chancellor whose responsibilities included the education of the cathedral personnel and of various clerical scholars, and he was able to give permission to masters to teach grammar, rhetoric, theology, and other subjects. This was already happening at Laon, Auxerre, Rheims, probably Chartres, Poitiers, and elsewhere in France. These cathedral schools rose and disappeared according to the reputation of the masters, men like Anselm of Laon, Gilbert the Universal, and Gilbert de la Porrée. We have seen in the last chapter that in the mid-twelfth century the abbey of St-Victor in Paris enjoyed a reputation for scholarship which brought monks from St Albans in England asking for copies of new books written by the masters who taught there. Undoubtedly some students who attended lectures in Paris returned home with books they had somehow acquired or made during their studies. Master Guido of Castello (who died as Pope Celestine II in 1144) had attended Abelard's lectures and he bequeathed to his old monastery of Città-di-Castello in Umbria a set of books which included Abelard's *Theologia* and his *Sic et Non*. It is a very early instance of a student bringing home textbooks. A

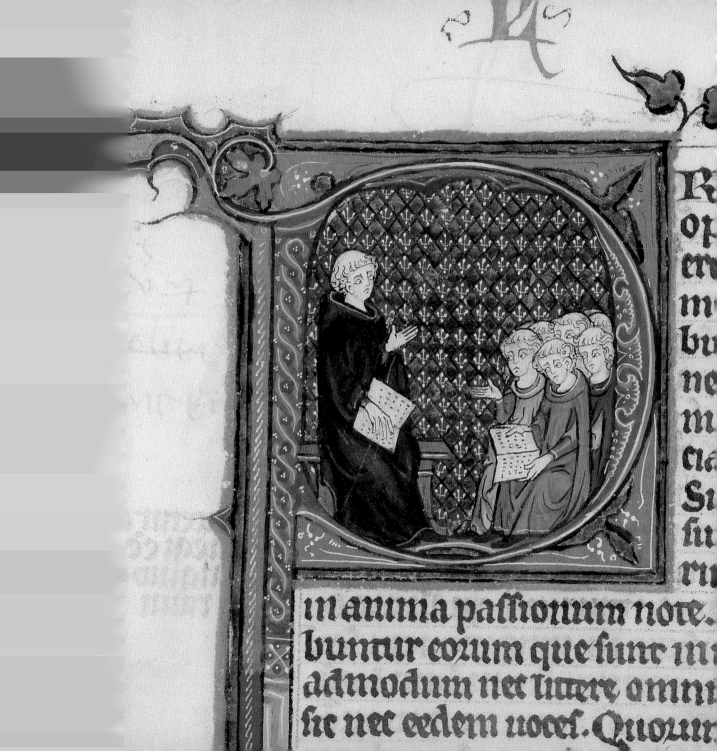

op
er
m
bu
ne
m
cla
Si
fu
m

in anima paffionum note.
buntur coum que funt in
admodum nec littere omni
fic nec eedem uocef. Quoni

Sciō q̄dam iudam uertū de sup celestibz michtam z ysaiam pferre psonam dm̄ q̄ captiuitatē illorum iutra nīa pmittit z raditū ao montē sc̄m innouissimis diebz q̄ nos contraria hoi iu dicantus uniusa despuimꝰ z secūdū res hystorie uitatem. q̄cq̄d de iertin celestibz somptiatur ao ꝯt referūt ecctam zao eos qui ut ip̄i pecm̄ ex ea egꝛdiuntur. ut p penimā re ūituntur. de q̄ singe illuminar iertin quia uenit lumē tuum.

ꝟaias interp̄ saluator dm̄. iu das ꝯfessio. iertin uisio patis. o zias formido dm̄. ioathan pfe fectio dm̄. achaz tenens z robust̄. ezechias imputū dm̄. qui enim p̄sidente dn̄o saluat z ē filius amos. i. fortis atque ro bust cernit sp̄uatr uisionē ꝯ fessiōis dm̄ anīe pecca plaguz z patis dum pꝛ penimā misit ab lucem z etīa pace quiescit z cūcta illuꝰ tempora sub for mudine dm̄ mectir. xp̄ fectio ne z robore. z cum omnia fecit dicat. Seruus inutilis sum q̄ debui facere fecit.

audite. c. zc. Sup q̄s ꝓpha cū filius. q̄ cū iudam z ieru salē. z q̄ tp̄ore uidit initio demonstratū ē. Nūc celū z ꝑtā ao audiendū puocat. Innocantur x dn̄s pmoysen celum z ꝑram cum p̄to ist darer legem suam sic. Atten de celum. z loquar. audiat z u. o. m. post ꝓuaricationē p̄ti eosdem uocat intesti monium. ut oīa clestiā

sedente zc. ꝗ n statim natiaūt q̄ ouea sunt sic h. duo tre cōli zc. hoc dicit dn̄s ady dumeā. ip̄e ꝑ uirtutē uide tes dm̄ quoꝗ̈ octi semp ao dn̄m sc̄i illō. ao te leuatū o. m. q̄. h.i. ce. z alibi. leuate odōs uros z uidere. r. q. i. s. c. z zc. De octis dr̄. lucerna corpris tui ē o. z. z pꝛ q̄ uidetur uoces. nō q̄ ignorabant sedm̄ montanum qui si uide bit.

amos pat̄ isaie non xrī ꝓphā. z uus ē diuisis enim apd hebreos scribuntur uus. Iste eni pmā z extremam hr aleph. z sade. Ile autē am. i samech. iste ut auiunt interpꝛ formudino. z robustus. Ile ꝓ grauuisz durus. sz iste ꝓpha fuit sic hebreis ꝯtenunt qui patres auos. atauosque ꝓpharum quor nosia z pnūpio ꝓphetie ponuntur ꝓphas suisse ꝯtendit.

uod intitulo sub ozia. ioathan achaz z ezechia ꝓphasse dicuntur non sic malis ꝓphis q̄ spialit sub uno quoꝗ̈ dictum sit nescimus z ao fine usꝗ̈ uo luminis plene distuguntur. Sciendū q̄ ezechiā mertin. xii. anno romuli qui nosis suū mutalia edidit ciuitatem rognare cepisse ut intre hystorie ap pareant anno res qin gentilis.

In diebz ozie ozias ip̄e est q̄ z azarias. Uno autem eodemꝗ̈ tempore ysaia osee ioel z amos ꝓphasse z regibz qui intitulo pꝛ nuntur ꝓmptū est cognos cere sed principi um uerbi domi ni suit in osee.

VISIO YSAIE

sp̄uat Hoc e

ꝯuerecunde/de se quasi de alio. ❡sp̄ua z fortis robust̄. z ꝓ saluatois dm̄. filii amos quam ui dit. ❡alii cont. ꝯfessione. z quasi pon dus tribulationis. ❡uisione pac. ❡beniamini

dit sup iudam et ie rusalem in diebz ozie ioathan a chaz ezechie regum iuda. Audi

❡domini pfectōis. ❡dn̄i formudo. ❡tenu aisc robust̄. ❡tp̄ū domini

audite celi zc. Que excelsa sūt audite zc. zc ozc

few decades later there is reasonable evidence of monks studying in the Parisian monastery schools and acquiring their own manuscripts. One of these is Master Robert of Adington, who is documented in Durham in the 1190s and who left to the cathedral there a set of books, of which one (now Durham Cathedral Library, MS. A.III.16) includes a list of glossed books of the Bible, with recent works by Peter Lombard, Peter Comestor, Peter of Poitiers, Helduinus, and other Parisian masters, and these books (the list tells us) had been kept by their owner at the abbey of St-Victor in Paris (PL. 93). A very similar list of late twelfth-century textbooks survives in Dijon, Bibliothèque Municipale, ms. 34. These belonged to a certain Theobald and were kept by him at the Parisian abbey of Ste-Geneviève. Almost certainly Robert of Adington attended lectures at St-Victor and Theobald at Ste-Geneviève.

However, it is really to the masters around the school of Notre-Dame that we should be looking for the origins of the University of Paris. One of the outstanding teachers there was Peter Lombard, author of the *Sentences* (the greatest twelfth-century theological encyclopedia, PL. 96) and of the Great Gloss on the Psalms and Pauline Epistles (PLS. 97–8). Peter Lombard taught in the cathedral schools of Notre-Dame and in 1158 became bishop of Paris (PL. 95). He died in 1160, bequeathing to Notre-Dame his own library, including the autograph manuscript of the *Sentences*. Peter Lombard established a tradition of scholarship in Paris which is still unbroken. Peter Comestor, who was probably the Lombard's pupil and died about 1169, wrote the *Historia Scholastica*, a kind of summary of biblical history which was to become a textbook for generations to come. With authors like Peter the Chanter, Peter of Poitiers, and Stephen Langton, all working in and around the cathedral schools within the twelfth century, we are faced with a formidable senior common room.

It is difficult to know whether there was already anything we would now call a university before about 1200. From the third quarter of the century, the masters who taught in the schools at Notre-Dame were still of course licensed formally by the chancellor of the cathedral, but they seem to have had an independent admission procedure for newly qualified graduates. In fact, the production of manuscripts is one of the best forms of evidence that the Paris schools were taking on a life of their own in the late twelfth century. The most fundamental textbook was the Bible, and the form in which the Bible was studied in the cathedral schools was in the twenty or so separate volumes which made up the Gloss on the Bible. We met references to these volumes in the Reading Abbey catalogue (above, p. 78) and they were sometimes described there as 'like the copies read in the Schools'. The two biblical Glosses by Peter Lombard were (according to his pupil Herbert of Bosham) left scarcely finished on their author's death, and they were edited for publication in the 1160s and issued as part of those huge sets of the Gloss on the Bible. These were published from Paris. A fair

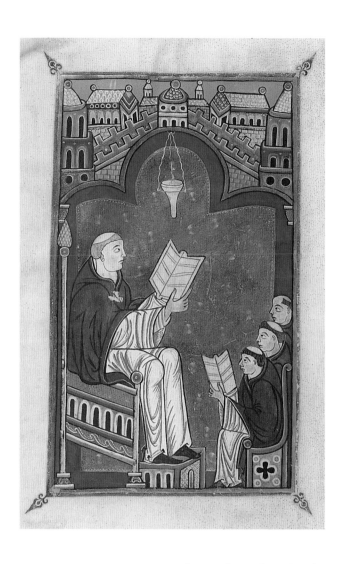

92 *Previous page*

London, British Library, Burney MS. 275, fol. 176v, detail

This initial shows a master in a disputation with his students. It marks the opening of Aristotle's *De Interpretatione* in an anthology of grammatical and scholastic texts illuminated in the early fourteenth century. The manuscript has a grand provenance, for it belonged to Gregory XI, pope 1370–8, and to the anti-pope Clement VII who gave it to the Duc de Berry in 1397.

93 *Opposite*

Durham Cathedral Library, MS. A.III.14, fol. 4v

This glossed manuscript of the book of Isaiah belonged to an English scholar in Paris, Robert of

Adington, who stored a number of manuscripts (including this one) at the monastery of St-Victor in Paris, c.1180–93. He later returned to England and presented his old textbooks to Durham Cathedral.

94 *Above*

Oxford, Bodleian Library, MS. Laud Misc. 409, fol. 3v

Hugh of St-Victor, an Augustinian who died in 1142, was one of the first masters to teach theology to students in Paris. At this date there was no recognizable university and Hugh's classes took place in his own monastery of St-Victor. This late twelfth-century illustration is from a manuscript of the works of Hugh of St-Victor given to St Albans Abbey in England by William of Trumpington, abbot 1214–35.

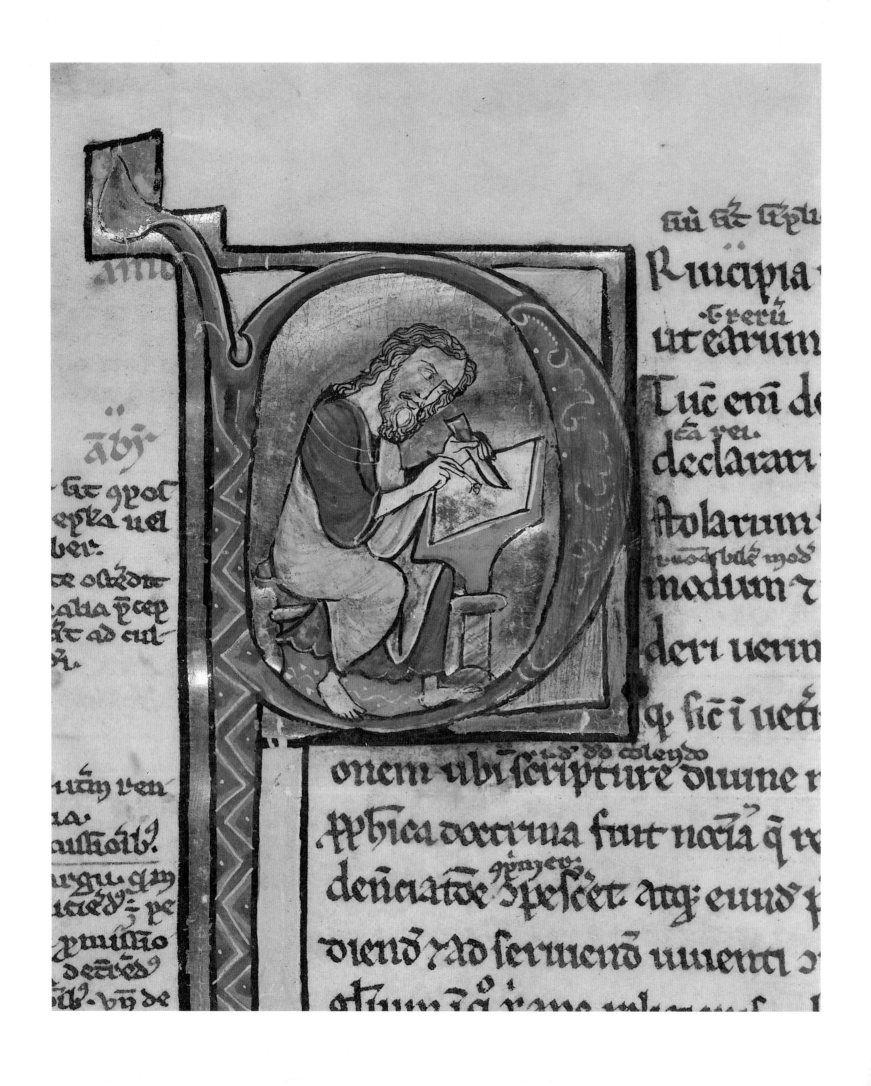

number of them survive: large, well-written books with splendid decoration including illuminated initials formed of spirals of vine stems full of tiny yellow or white lions which clamber through the decoration. A particularly fine example of this kind of book is Paris, B.N., ms. lat. 11565 (PL. 97), a copy of Peter Lombard on the Psalms, which belonged to a cleric who died at St-Victor during the abbacy of Guérin (1172–93). There are examples of this style of decoration in manuscripts of the biblical Gloss (PL. 93), the *Sentences*, the *Historia Scholastica*, the *Decretum* of Gratian, and a few other Parisian textbooks, and we find that the first owners of the manuscripts were often former students of the schools. In a way, the argument is circular: the flourishing of the schools allows us to attribute surviving manuscripts to Paris, and the number of attributable manuscripts enhances our impression of the Paris schools within the twelfth century.

What is almost certainly the earliest medieval reference to a bookshop comes from Paris no later than the last quarter of the century. It occurs in the letters of Peter of Blois, archdeacon of Bath, who says that when he was in Paris on business for the king of England he saw some law books laid out for sale by B. the public bookseller. He thought that his nephew would find them useful, he

97 *Left*

Paris, Bibliothèque Nationale, ms. lat. 11565, fol. 31v

This richly illuminated manuscript of Peter Lombard's *Great Gloss* on the Psalms must have been made in Paris about 1180. It belonged to a canon of St-Victor in Paris, named Nicholas, who bequeathed it to Guérin, abbot of St-Victor 1172–93, who, in turn, gave it to the abbey of St-Germain-des-Prés, also in Paris.

98 *Opposite*

London and Oslo, The Schøyen Collection, MS. 258, fol. 128r

This too is Peter Lombard's *Great Gloss* on the Psalms, probably illuminated in Paris, *c.*1200. The Bible text is written in red ink with the commentary in black. In the margins are the abbreviated names of the sources, similar to modern footnotes, from which Peter Lombard took his quotations, mainly from Augustine and Cassiodorus.

annuntiabūt coli. adorabūt angli. z syon. i. ecclia
uidet audiuit hȳ dcēȝ. ṣ qd angli eum adorant. qd
annuntiauert coli. i. z qd uiderunt oēs. ṗ. glo. e.
z qd ꝯfundantur adoratores ydolox. z ĩ letatie
iudet enim pū ꝯdebat se solam uenire ad rṗm. ṣ ia
de socio gentibȝ lecatum. ut de cornelio. frs ᵹ. nĩ s
quem petrus bapzauit. Et sīue iude. a. rṗi qui
dez ṗpter iudiciatus do
audierunt. H. apli. ĩhs
mine. quie tant ĩ iudea. quia gentes recepūt
uibum dei. z ĩ letatis. z magnifiabūt deum.
hoc. ṗs. uid. tudo. q̃ sunt eȝ no ē ṗsonax accep
tio dī. s. oms accipī. qui ad eum ueniunt. ut
iudītia dicit. qd ꝯecitis ocigit ĩ isrl. ut. ple. ᵹi
int. z qi quis quereret. q̃ sunt illa iudītia. sub
Oĩitu dominu satisfī
dicit. Qm tu. d. es. al
nul ir omnem terram
potentia. z hec. ir oēm
ms exaltatus es. se om
ē. quia nō uidor ui
nos deos. ds. ē. s. z genutum. secȝ. z o rṗe. nĩmi
eral. es. qi eȝ ṗi. ir sedin opa. Thec. sup oẽ deos. q.
nō modo. fr malos. doȝ. sī. z ir bonos. s. boies ȝan
gł ex. l. ṗ tiram. z deox peccatox. z iustox accipe. l. ṗo
ram z deos sut eum imparentes. z cēel ostibȝ. zē
Qui diligitis dominu
tral. sīt. ᵹ. Qui dilui
dūe malum: erodediēȝ
eis. d. o. malum. i. chā
aūs sedīm suox ipndem
toluīt. cū quo nō dili
anu peccata l ubabit reos.
gitur dī. s. emo. H. po
o duobȝ. do. set. Si ūcū cepit odisse maugnū. sub
secut pseautiones. ne timeas. qī dūs custodiat
animas sēorȝ suox. de quibȝ tollendiȝ. ē ulmū
gnī pseautiois. Grauiox. H. pseautio. quaaias
tollere conatur. s. eas dūs credit. z sicut ipam
ꝯmittut. aias aū nō possunt occedere. uū segṛ
de manu. pec. i. de diaboli potestate. libabit ue
os. Quod si frater quererit te ṗuidere lucem istam
nec tures. quia ueta lux ē. tibi. Lux. H. frdi or
Lux orta est iustox: z ree. cor. te. ᵹ
iustic corde letitia.
bȝ. s. ṗ o ia dī. placeret
ta ē. letitia ṗ spem. nō. ue ĩ miseriaȝ sēā spe
Letamini iusti in domi
am salu. ᵹ. leca
nor. z ꝯfitemini ĩ ĩo
minu tū. ir do. nō ĩ
moio sanatis eius.
mundo i quo sunt ṗs
minu. sure. z lecati. ā frem inī me. sci. e. i. lau
date eum. qi memor fuit scifiare nos. quia
nisi uelleȝ. nō gauderetis ĩ illo. ṗs dand̄

antate dño canticu nouū: Cāticū
Tdtulus iste patet. ṗs iste. ir. ē coͧ
qui de utroqȝ aduentu agunt. unȝ
bȝ. oibi ē cā spei z timoris. spei ṗ ṗia
pūm aduentū. timor ṗ iudiciū.
sedi aduentus. z si ṗer terrentur: ĩ semp uū
a descrīptie sunt. qi noua untȝ. monet ad laude
z eruitatione. Qod. biꝑtitus ṗs. ṗ agit de os
tensioe saluatis de ire. Sed ditut oibȝ. oib ĩo
dis laudandū. eē. z annuntiandū ibi. iubi

late dō inuitat ᵹ. ad laudeart. O uos qui nom
estis ĩ rṗo. olim ueteres in adam.
Cantate domino canticum nou
um quia mirabi
lia fecit. Cantate
domino canticū nū
ei. z lingua. ec. nouū
de incarnatione rṗi.
hois redemptioe. nouū
quia nichtale nūdo
audierunt. uū qȝ mi
rabilia fecit. Que mirabilia: nō solum gēcomu
nias: sī z hec singulare. s. quod dextera ei. i. Equi
dī dextera pūs. ṗ muta opatioe. z brachiū sem
ṗe idem rṗer quidī brachium ṗ fortitudine.
Sainabit sibi dextera
Saluauit nō dicēt ᵹd
ee brachium sanctum
s. intelligens. oxheruēts
eius. qd sunt magni miraculi. M. ai. H. ē qd to
tum orbem cēre. z morte erena exepit. qm qd mor
tuos suscitauit. saluauit duo sibi obtw adds. qᵉ
multi saluauit corpoalit. z sibi ipris nō ei. qui
accepta corpoali sanitate dasceruūt. Qui. u. eqᵉ
ti casti erant. sanati aduiti fiunt. z qui cū eqᵉ
tarent. nemine ledebant receptis miribȝ. oxpm
munto innocentes. isti ᵹ sanati sunt: b. nō ei. s.
qui quiṗ fide intus sanantur. Sanantur. sane
in ᵹ. ei. l. sedm alia let. Sainabit se deū. ei. zq̄
qui quereret. ubi ea dextera. ē. subd. Notū
Notum fecit dūs salu
fecit do. salu. su. i. rṗm
tare suum in ospectu ge
ea. H. dextera. i. r̄ brac
tium reuelauit iustil
hium que ṗ salutare
am suam. rṗe. quibȝ fecit notum. ĩ osṗcl. ū
le. si ĩ ꝯxer. gen. te. nō sub uelae. osc. iustam
suā. i. salutare. rṗo dr salutare eo qs siluauit
nia. eo qd ĩfucat secȝ. Recorȝ. c. mu. su. ṣ
Recordatus est mise sue
ut bz frs libaret. z ĩ
z ueritati sue domui
tatis sue quia ĩ unco
isrl. erbibelūt. qi fidie ad fauem eū uidebt.
si quibȝ ē recordatus. dominu isrl. i. uidentiū
deum. r̄. ita. recoṛ. c. mu. l. i. mia ēquod ṗmis
hano secȝ uita s. quia reddidit ĩ subḋ. z ue
rtatis sue. mia ē ṗmise ṗmissioē. ṗmissio
roddtūr uitatē. b. cut doxtum isrl. qui moddo ṗ
fidem uidet uitatem. rṗ. l. ṗ spem uidebit. z ne
ad litteram putes isrl. unam gentē. subd. Vi
Viderunt omnes ter
derut mente oms t
mini fines salutare dei
mini tre. i. a fĩno ui
q: ad cĩnum. Quid: salutare. d. i. i. ibm. ĩodi
et oĩis. quia nō quibȝdam tm. datus ē rṗe. e
Iubilate deo omnis terra:
bilate. ir. pars ū dicet
Cantate reuultate z psal
omnibȝ modis laud
ite. dum eȝ z annuntiando. quia ueū uider
q. d. quia hec fec. ᵹ. iubilate dō uoce. sū iubi
iubiluṣ. H. gaudeniū ē qd nec poter totaceri

says, so he agreed a price and left. Subsequently, Peter continues, the provost of Sexeburgh came and offered the vendor more money for the same books and carried them off by force. Peter of Blois says he was extremely annoyed. It is difficult to know how much to read into this anecdote. There is no supporting evidence for an actual book trade, as we would know it, at this early date. The seller is here described as 'B. publico mangone librorum', which is not a flattering term – a public monger of books. Very possibly he owned no more than a market stall. There is little doubt that the law books were second-hand. Manuscripts were always very expensive, and no stallkeeper would tie up capital in new books on the chance of a sale. None the less, here were secular books commercially available from a dealer well enough known to be recognizable by his initial B and who was able to haggle over the price and was not averse to breaking his word for a greater profit. The atmosphere had certainly changed from that of the cloistered monk working only for the glory of God. One very early thirteenth-century Parisian manuscript of Sts Luke and John glossed has a contemporary note recording that it was bought for 100 Parisian shillings from 'Blavius bedellus' (Paris, Bibliothèque Mazarine, ms. 142, fol. 191v): Blavius the beadle could possibly have been B. the bookseller who cheated Peter of Blois. It may be that we have chanced on the name of the earliest bookseller in Europe.

The manuscript which includes the note of the purchase from Blavius is one of fourteen surviving glossed books of the Bible (now mss. 131–44 in the Bibliothèque Mazarine in Paris) which were eventually bequeathed to the abbey of St-Victor by brother Peter of Châteauroux, who is recorded as a canon there in 1246. If each volume cost anything like the 100 shillings which Blavius charged, the set came to about £70. Three volumes from the same set (mss. 131–2 and 136) are decorated by an artist whose hand has been recognized in other manuscripts. By grouping these together we can gain some impression of luxurious textbooks made for wealthy scholars in Paris around 1210. The books by the same illuminator include a copy of Gratian's *Decretum* (Liège, Bibliothèque de l'Université, ms. 499), the *Isagoge* of Joannitius (Bethesda, Maryland, National Library of Medicine), a Latin didactic poem by Gilles de Paris (B.L., Add. MS. 22399), and a splendid manuscript

of Ptolemy's *Almagest* (Paris, B.N., ms. lat. 16200), which ends with a colophon by the scribe saying that he wrote and perfected the book from an exemplar at the abbey of St-Victor in December 1213 (PL. 99). These four books are respectively legal, medical, literary, and astronomical. With the glossed biblical books, therefore, the artist produced volumes from each of the four faculties (as they later became) of canon law, medicine, the arts, and theology. The exemplar being kept at St-Victor reminds us to be cautious about ascribing the production to a professional bookshop as early as 1213. These manuscripts belong to that half-way world between the monastic book production of the abbeys and the entirely secular workshops of the stationers who kept their own exemplars. The market, however, was certainly the emerging university.

It is very easy to look back with hindsight on Paris at the beginning of the thirteenth century and to imagine emerging booksellers commissioning manuscripts and selling them to students. But the picture is not so simple, or so modern. The circulation of books preceded the evolution of the book trade. Manuscripts were always costly to make and therefore they had a resale value, but buying a second-hand book from a fellow student or from his dispersed effects is not at all the same as purchasing a ready-made new manuscript from a professional bookseller. We cannot know, for example, if Blavius had himself had any part in making or commissioning the glossed books he sold: very possibly he did not.

One early Parisian manuscript has what seems to be the name of its actual maker. A Bible in the Bibliothèque Nationale (ms. lat. 11930–1) is signed in gold letters 'Magister Alexander me fecit' (Master Alexander made me). His title may hint at an association with the schools but this does not necessarily mean that he was literally a *magister*. Perhaps he was just a master-craftsman. In any case, he was not a monk. The emblazoned inscription announces that Alexander made the book, but it is possible that he was not simply or necessarily only the artist but that he arranged for the making of the book. He may have been someone like Alexander the Parchmenter (d.1231) who lived with his wife Avelina in the rue Neuve-Notre-Dame, opposite the cathedral, the street where stationers began to settle during the course of the thirteenth century. Curiously – unlike books by the illuminator of the Ptolemy

99 *Opposite*

Paris, Bibliothèque Nationale, ms. lat. 16200, fol. 4r

The earliest dated scholastic manuscript explicitly made in Paris is this copy of Ptolemy's *Almagest*, a treatise on astronomy, in the Latin translation of Gerard of Cremona. Its colophon records that it was copied from an exemplar at St-Victor Abbey and that it was finished in December 1213.

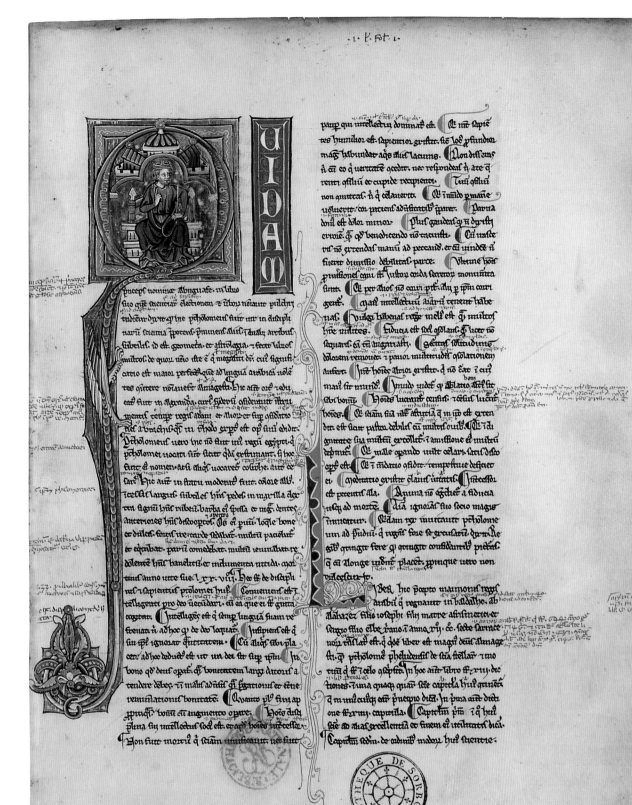

of 1213 – other surviving manuscripts painted by the same artist as Master Alexander's Bible are almost all biblical. One of them, a copy of Peter Lombard on the Pauline Epistles, now Troyes, Bibliothèque Municipale, ms. 175, belonged to Roland, abbot of Montiéramey from 1207 to 1225, which gives some kind of date for the group. Alexander's workshop, if that is what it was, illuminated at least nine surviving one-volume Bibles.

The arrangement and publishing of the Bible was the most enduring monument of the scribes and illuminators of Paris in the early thirteenth century. This deserves some attention. It has a major place in the history of manuscripts. The way that the Latin Bible was redesigned and promoted from the Paris schools was one of the most phenomenal successes in the history of book production. The Bible is not an easy book to publish: a very diverse collection of ancient historical and literary texts sanctioned by divine authority and forming a vast and complex record of the Word of God. Of course, the Bible has been central to Christianity from the beginning. We have mentioned manuscripts written at Wearmouth or Jarrow for Ceolfrith around AD 700 and those from the Carolingian court. But (with a very few distinguished exceptions) Bible manuscripts had been made up of several separate volumes, usually enormous in size, which were intended as vast monuments to be displayed on a lectern or altar in a church or in the refectory of a monastery. The monks of Reading Abbey had kept a two-volume Bible in the cloister, and a three-volume copy for use at meals. These volumes were not portable in the usual sense, and they were not designed for private study. Twelfth-century students of the Bible text (and naturally there were many) would make use of those twenty or so distinct volumes which made up a glossed Bible. Fundamentally, however, they regarded the Scriptures as a collection of separate texts, which could be read in any order. One studied the Psalms, or the Gospels (PLS. 100 and 101), or the Minor Prophets, for example. Biblical scholars were known as 'Masters of the Sacred Page', a term which echoes this concept of the biblical corpus as the sum of a great many pages of Holy Writ rather than as a single book within two covers.

Some time in Paris in the late twelfth or early thirteenth century all this began to change. This is really very significant. The Bible was now put into a single volume. The order and names of the biblical books were standardized, the prologues ascribed to St Jerome were inserted systematically, and the text was checked for accuracy as far as possible. For the first time the text was meticulously divided up into numbered chapters which are still in use today. The so-called *Interpretation of Hebrew Names*, an alphabetical dictionary of the Latin meanings of Hebrew proper names, was added at the end. More important in the history of publishing are the changes to the physical appearance of the book. Scribes used the thinnest silky vellum. The pages became extremely small. They employed headings at the top of each page, little red and blue initials throughout the text to mark the beginning of each chapter,

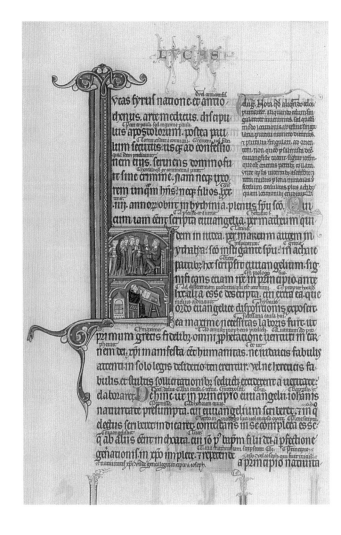

100 *Above*

Rome, Biblioteca Vaticana Apostolica, MS. Vat. lat. 120, fol. 165r

This glossed manuscript of St Luke is very fine Parisian work of c.1220. The initial shows a clerical scholar seated at his desk, with two books before him and others in a cupboard behind, pointing up at Luke, who is said to have been a medical doctor by profession and who is here pronouncing on a specimen in a flask.

101 *Opposite*

Rouen, Bibliothèque Municipale, ms. 96, fol. 91r, detail

The opening initial in this glossed manuscript of St John shows the evangelist writing his Gospel at a sloping desk, with holes on the right for pots of different coloured inks. The manuscript was illuminated in Paris at the beginning of the thirteenth century.

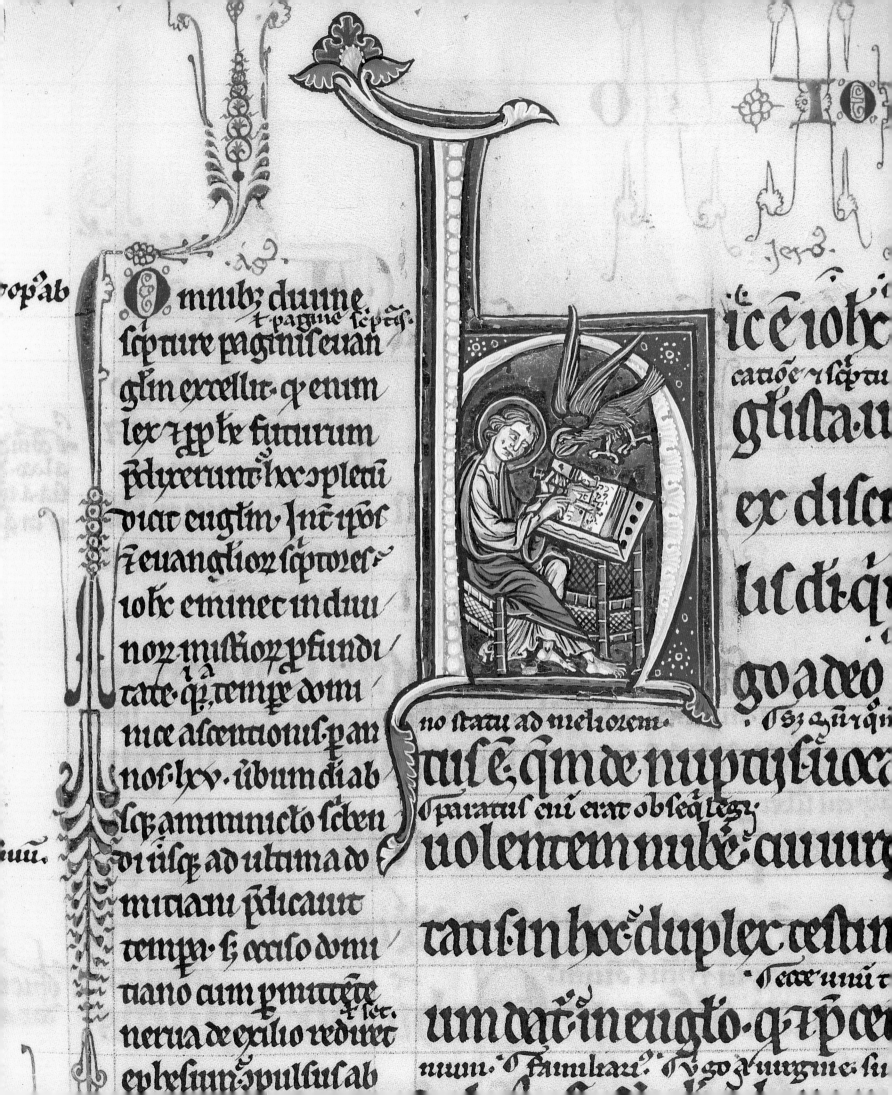

Omnibz diuine
✝ pagine scptis.
scpture paginis euan
gliis excellit. q; eium
lex ⁊ ppbe futurum
pdixerunt h[e]c ǝpleti
dicat euglin. Int xpo
⁊ euangelior scptores
iohs eminet in diui
nor multior pfundi
tate. q; tempe domi
nice ascentionis par
nos lxv. librum dia b
scpam iniuncto scben
di usq; ad ultima do
mitiani pdicauit
tempr. s; occiso domi
tiano cum pmittete
nerua de exilio rediit
ephesium pulsus ab

ic e ioh
catoe ⁊ scptu
glista. u
ex disc
lis di q
go a deo
sz �text
no statu ad meliorem.
tus e. q̄ in de nuptiis sua cca
pparatus cui erat obsecꝫ tegꝫ
uolentem nube: cui ur
tatis in hoc duplex testi
ᵗcex unit
um dat in euglio. q̄ xpc
nium. ꝷ familiari. q̄ go ⁊ uirgine

and the text was now written in black ink in a microscopic script in two columns. The effect was dramatic. The new type of Bible was an absolute bestseller. These tiny manuscripts were evidently sold in vast numbers in the thirteenth century (PLS. 102–6). Bibles were produced in such huge quantities between about 1240 and about 1280 that copies served the needs of all the rest of the Middle Ages: fourteenth- and fifteenth-century Bibles are remarkably rare because the ubiquitous thirteenth-century copies must still have been easily available. Even now, these are by far the most common surviving books from the thirteenth century. More than that, the Bible design master-minded in the early thirteenth century has so fundamentally entered the subconsciousness of all of us that, even now, seven hundred years later, Bibles still look the same. Choose a traditional printed Bible from a good bookshop today. Look at its physical layout. It is on tissue-thin paper, very like the 'uterine' vellum of the thirteenth century. It is probably octavo in size, like almost every thirteenth-century copy. It has the same order of biblical books, headings, the same division into chapters (with verses, not introduced until the sixteenth century)

and – many centuries after this layout has been dropped from most other texts – it is in minute writing in two narrow columns. Look at the binding and the coloured edges. The chances are that the cover will look like leather and be black or red or blue: these are the three colours of thirteenth-century Parisian painting. It is hardly possible to find another object which was so new in 1200 and which is still made with so little modification today.

It is difficult to know exactly when this new form of Bible was devised. Thomas Becket owned a Bible in one volume which was shelved at Canterbury among glossed books and copies of Peter Lombard which Becket almost certainly brought from Paris in 1169–70. It may have been an extremely early example. Generally one-volume Bibles are very rare before about 1200, and unusual before about 1220. Probably the Paris masters contributed to the new format, and the name of Stephen Langton comes to mind. He was lecturing on the whole Bible in Paris from the early 1180s until 1206. The division of the Bible into chapters is usually ascribed to him. The earliest dated use of chapter numbers is in a manuscript of Stephen's commentary on the Minor Prophets made

102 *Opposite left*

Private collection, s.n., fol. 275v

Many mid-thirteenth-century uni-
versity Bibles are illustrated with
tiny historiated initials at the start of
each book of the Bible. Here is the
opening of Esther, with Esther her-
self and King Ahasuerus above. This
manuscript seems to have belonged
to a Franciscan in Germany.

103 *Opposite right*

**North America, private collection,
s.n., fol. 216r**

This Bible, made in Paris for
Dominican use, shows the same
page as in PL. 102, the opening of
the book of Esther, illustrated simi-
larly with Esther before Ahasuerus
(Esther 2:8-9), but by a different
illuminator and perhaps ten or
twenty years later in date, c.1270.

104 *Left*

**Oxford, Wadham College,
MS. 1, fol. 397v**

It is rare that university Bible manu-
scripts are signed with exact dates.
The scribe records that this Bible
was finished in 1244 and that
William, known as the knight of
Paris, completed it and deserves all
good things for his labour. The ini-
tial here shows an angel encouraging
St Paul to write to the Ephesians.

105 *Above*

**Private collection,
s.n., fols. 178v–179r**

The success of thirteenth-century
Bibles is often associated with the
Franciscan and Dominican friars
who used such manuscripts as they
travelled preaching across Europe.
This copy of c.1250 probably
belonged to the Dominicans in
Auxerre.

sio seruo eius. S. tens au ei ab urbe roma
de carcere p sup scptum onesimum Incipit

Aulus epla ad phy
apls lomenam
iunctus xpi z tij
motheus frat phi
lomeni dilecto et
adiutori nro rapi
e sorori kisse sue z
archippo z multo
ri nro z eccte que in domo tua est. gra no
bis z par a deo pne nro in dno ihu xpo. Gra
ago deo meo semp memoria tui faciens
in oronibz meis. audiens caritatem tua.
et fidem quam habes in dno ihu z in omi
scos. ut coioato fidei tue euidens fiat. z ag
nitide ois boni in xpo ihu xpo. Gaudium
enim hui magnum z ¢solationem in cari
tate tua. ex uiscera scox requieuit pte
ster quod multam fiduciam hns in xpo
ihu impandi z q ad rem ptinet ip carita
tem magis obsecro cum sis talis. ut pau
lus senex nc au z uunctus ihu xpi. Obse
cro te p meo filio que genui in uinculis
onesio. qui in aliqn inutilis fuit. nc au
z z z mi utilis que remisi z. Tu au illum
et mea uiscera suscipe. Quem uoluera
ego mecu detinere. ut p te m ministra
ret in uinclis eungliz. S·me z silio aute
tuo nichil uolui face. ut ne uelut ex ne
cessitate bonu tui eet. sz uoluntarium
forsitan enim ido discessit ad horam ad te
ut in etnu illum recipi iam no seruu set
p seruo carissimu frem z maxie m. Qua
to au magis z i in carne z in dno. Si g ha
bes me socium suscipe illu sic me. Si au
aliqd nocuit z aut debet hoc in imputa
Ego paulus scpsi mea manu ego redda
ut ni dicam q z te ipm m debs. Ita frat
ego te fruar in dno. refice uiscera mea in
xpo. Confidens de obediencia tua scpsi z

sciens qm z supid q dico facies. Simul
au para m hospicium. Nam spero p ono
nes uras donari me uobis. Salutat te
epaphras ¢captiuus ms in xpo ihu.
¢marcus aristarcus. demas z lucas adiu
tores mei. Gra dni nri ihu xpi cu spu
ito ame. Plogus ad hebreos
In pmis dicendo ¢ cur aplm paulus i uac
epla scbendo ñ seruauit morem suu.
ut ut uocabulum nois su ut ordinis
describeret dignitatem. Hec ca e qd ad
eos scribens. qui ex circumcisione cre
diderant ñ gentium apls z ñ iudeorū
S·tens quoz eoz supbiam sua ex humi
litatem ipe demonstrans. meritum offi
cii sui noluit ante ferre. Nam suli m z to
hannes apls ip huilitate in epla sua
noim suu eadem rone ñ ptulit. hanc g
eplam fertur aplm ad hebreos ¢scptam
hebraica lingua misisse. cuius sensum
et ordine retinens lucas euugtista post
excessum bi apli pauli greco sermone
¢posuit. Incipit epla ad hebreos.

ultiphariē multis
ex modis olim d¢
loqns pub z i phe
tis. nouissimis
diebz istis locut
est nobis in filio
que ¢stituit he
dem uniuox p
quem fecit z scta. Q¢ cum sit splendor
glie z fi¢ sube eius. portansqz oia ubo
uirtutis sue purgatone pecca sedet ad
dexteram maiestatis i excelsis. Tanto me
lior angelis effectus. quanto dei differenti
p illis nom hereditauit. Cui ñ dixit ali
cando angloz. filius ms es tu. ego ho
die genui te. Et rursum. Ego ero illi i
patre z ipe erit m in filium. Et cum itez
intro unuge m orbe terre dicit. Et adorent

in 1203 (Troyes, Bibliothèque Municipale, ms. 1046). Probably he was one of those who helped transform the concept of the sacred page into that of the Bible as an entity, and Stephen Langton deserves even greater fame than is already accorded to him for drafting Magna Carta.

Some time in the second quarter of the thirteenth century the text of the Latin Bible was thoroughly revised in Paris and attempts were made to standardize the manuscripts. Roger Bacon, writing in about 1267, says this was done by the masters and stationers of Paris some forty years before. This takes us back to about 1227. Perhaps there were already some stationers in Paris by then, but Roger Bacon was probably just trying to belittle the accuracy of the so-called modern text by implying commercial rather than exclusively academic motives. The suggested date, however, is very close to 1229, when the Dominicans opened their general theological school at St-Jacques in Paris. By 1236 they had their own list of corrections to the Bible text. The Dominicans are to be taken very seriously indeed when we are considering biblical scholarship and publishing in the thirteenth century. St Dominic (1170–1221) had founded the Order of Preachers with the primary aim of teaching and confirming fundamental truths in order to resist heresy and to educate intellectuals in orthodox religion. The new universities had an important place in their campaign. The Dominicans set up their French headquarters in Paris in 1217, and in Italy at Bologna and in England at Oxford. Soon every major university town had a Dominican convent. The Dominicans had two reasons to welcome the publication of the new one-volume Bibles. First of all, Bible scholarship was at the heart of their teaching at St-Jacques in Paris, and men like Hugh of St Cher and Thomas Aquinas himself, who both lectured there, were among the greatest biblical scholars of any age. All Dominican convents had a *lector*, whose duties included teaching the Bible. Secondly, the friars were preachers. They literally went out across Europe with the Word of God. The Bible was as useful as a Breviary (and the size of thirteenth-century Bibles may have been inspired by Breviaries). It was the ideal book for the preacher's satchel. Many-volumed folio Bibles were no use during a sermon: a preacher needed a copy he could carry. Many of the greatest publishing successes in history have been with very small books: Aldines, Elzevirs, and Penguins; the friars used the Paris Bibles because they fitted into a medieval pocket.

Not long after the Dominicans established themselves in Paris, the Franciscan friars came into prominence too and set up their own schools there in 1231. They too travelled widely, preaching as they went. The rivalry between the two orders can be exaggerated, and no doubt both groups used similar kinds of manuscript. As a generalization, however, the Dominicans zealously promoted traditional scholarship while the Franciscans tended to be concerned with more humble social problems and popular piety. St Bonaventura, the great Franciscan theologian teaching in Paris between 1248 and 1257, remarked that the Dominicans put learning before holiness, but that the Franciscans put holiness before learning. Both orders of friars were important in the history of the university. The Dominicans certainly wrote out some manuscripts themselves, and their constitutions of 1220–1, 1240, and 1243 stated that the prior might assign manuscript copying to any Dominican friar whose script was good enough. Often these must have been just sample sermons or other books for their own use. Perhaps they sometimes wrote out manuscripts for outside customers. The Franciscan General Council of 1260, however, specifically prohibited their friars from making books for sale. Franciscans were bound by a vow of poverty, and book production was dangerously profitable. A prohibition usually implies that the opposite is sometimes taking place. Some Dominicans and a few Franciscans were probably among those involved in making books in Paris in the thirteenth century.

By the mid-century the secular book trade was evidently taking over much of the business of producing manuscripts. We know a fair amount about a bookseller called Nicolaus Lombardus, for example. He is recorded in the tax lists and elsewhere between 1248 and his death in 1277. We know his exact address in the rue Neuve-Notre-Dame, and the names of his two wives, Beatrice, who had died by 1267, and Adalesia, whom he married soon after and who bore him a daughter Odelote. His surname Lombardus suggests that he was of Italian descent. He occurs in a university document of August 1254 in which he stands as surety for

106 *Opposite*

Private collection, s.n., fol.434v.

Another Bible, painted in Paris about 1285, shows initials here in the Epistles of St Paul. The first, for the letter to Philemon, simply depicts St Paul seated with his book and sword, but the second, for the letter to the Hebrews, shows St Paul speaking to a Hebrew, identifiable by his medieval Jewish hat.

123

Odelina, widow of Nicholas the Parchmenter (another colleague from the trade), who was selling her house between the law schools and the Mathurin Convent; the house was bought for £32 on behalf of the chancellor of Paris. We find his name too in a note in a manuscript (Paris, B.N., ms. lat. 9085) which records that Gui de la Tour, bishop of Clermont (1250–86), had bought from Nicolaus Lombardus, 'venditor librorum', a whole set of glossed books of the Bible written out by one scribe ('de una manu'), and that the bookseller undertook to supply one of the three remaining volumes by the feast of St Remigius (1 October) and the other two by Easter or Pentecost, and that on the delivery date Gui would then return two other volumes which he had apparently received as a pledge from Nicolaus to offset a cash advance, and would pay over 40 Parisian pounds in money still owing. The inscription can be dated between 1250 and 1260, and it supplies a great deal of information. It shows unambiguously that the bookseller was the agent for commissioning new manuscripts. In fact, five volumes of this set, originally of eleven volumes, still survive. They show the hands of three different scribes, so the contractual requirement for one hand must mean that text and gloss were to match from page to page. Thus we learn that Nicolaus is responsible for this too but that he did not do the work himself. One of the volumes has a tiny note by its scribe at the end of a gathering, 'This is the second quire that I have completed – 5 Parisian *sous*', the sum which he charged for writing it. But the client, Gui de la Tour, paid the bookseller and not the scribe. At five *sous* for two gatherings, the cost of writing alone for a set of eleven volumes could come to several tens of pounds. With scribes, pen flourishers and illuminators, at least thirteen different people were involved in this expensive enterprise. The figure of £40 still outstanding is only about half the £70 which we calculated earlier as the theoretical price for the partial set of glossed books sold by Blavius in the first years of the century, but the price may be only for the three volumes. It is, however, more than the price of the house where the late Nicholas the Parchmenter had lived.

In this case the scribes' names are unknown, though they were subcontracted by the bookseller. A few thirteenth-century Parisian Bibles preserve the names of their scribes. One is dated 1244 and signed by William, 'known as the knight of Paris' ('dictus miles Parisiensis'; Wadham College, Oxford, MS. 1, PL. 104). Another is dated on the feast of St Leonard (6 November) 1267 and signed by frater Johannes Grusch (Sarnen, Bibliothek des Kollegiums, MS. 16). Was he a friar perhaps? A third is signed by Adam (Paris, B.N., mss. lat. 16748–9), who could be the Adam of St-Michel who is recorded in a scribbled note in Paris, B.N., ms. lat. 12950, fol. 125v, as having written out a volume of Peter Lombard's *Sentences* in 1284. St-Michel is on the left bank opposite Notre-Dame, in the heart of the university. Sometimes specific illuminators can also be identified by name. Two mid-thirteenth-century Parisian miniatures from a canon law manuscript, probably the *Decretum* of Gratian, are signed on a scroll with the name of Gautier Lebaube (New York, Pierpont Morgan Library, G.37, PL. 107). The late Robert Branner ingeniously proposed that this artist was the 'Gualterus illuminator' who appears on the tax roll for the parish of Ste-Geneviève in 1243. Features of the artistic style include twisting vine stems, and one can note in passing that Gualterus paid 9 pence tax for owning a vineyard.

We began this chapter with the tale of the student squandering his allowance on illuminated manuscripts. By the mid-thirteenth century one can see how this happened. There were many professional illuminators in Paris. The surviving manuscripts are often beautifully ornamented and the gold really sparkles in the light. Whereas gold in monastic manuscripts had generally been applied flat onto the page, these thirteenth-century illuminators built up their initials underneath with gesso ('plaster of Paris', in fact). In Paris this gesso was left white, whereas elsewhere in Europe it was generally mixed with pink or brown to give a warmer colour. When thirteenth-century gold leaf was laid on top and rubbed to a highly burnished finish, it can sparkle like great droplets of golden mercury. The effect must have been very seductive to bibliophiles.

107 *Opposite*

New York, Pierpont Morgan Library, G.37, fol. 1r

Medieval Church law defined the degrees of family relationship within which a person might or might not be allowed to marry. In a society with much less social or geographical flexibility than today, this was an important matter for debate. This Tree of Consanguinity, from a Paris manuscript of the mid-thirteenth century, is actually signed by the artist in a scroll held by two men at the foot, 'Gautier Lebaube fit larbe' ('Gautier Lebaube made the tree').

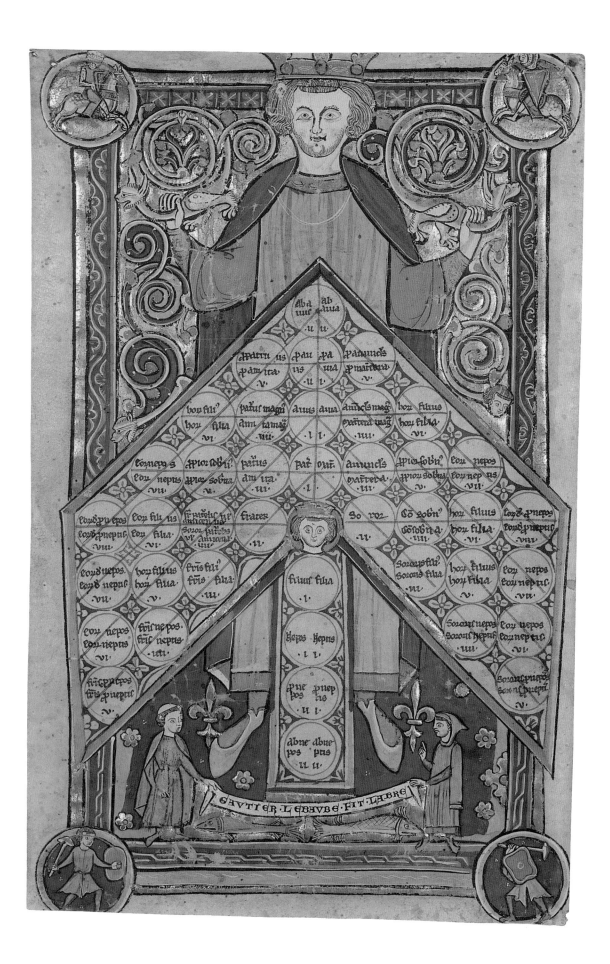

Miniatures were in bright colours, predominantly red and blue, with clear black outlines. They look very like tiny stained-glass windows, both in colour and design.

Robert Branner's *Manuscript Painting in Paris during the Reign of St Louis* (University of California, 1977) was the first serious attempt to classify the illuminators of thirteenth-century Paris according to their styles of painting. The author shuffled a great many illuminated manuscripts into clusters which he cautiously termed 'workshops'. However this worked in practice (artists working from home, one imagines, perhaps with an apprentice or two in the attic), there was considerable business in manuscript decorating for the student market. One 'workshop' illuminated Bibles and liturgical books as well as three glossed books of the Bible, a Peter Lombard, two textbooks of civil law, and the *Decretals* of Gregory IX. Another workshop illuminated seven glossed books of the Bible, two copies of Peter Lombard, a Bible dated 1260, and a

copy of Hugh of St Cher. These were all the sort of books a student would need. Students with a hundred pounds to spend could acquire marvellous copies.

It is quite clear that by the mid-thirteenth century the University of Paris was drawing scholars and masters from all over Europe. Books go hand in hand with scholarship, in terms of both buying and writing. There were four principal areas of teaching. They all needed manuscripts. The first of these was the faculty of arts. This incorporated such subjects as grammar, logic, arithmetic, geometry (PL. 110), music, and astronomy (PL. 109), and was formally recognized as a faculty in the area of Ste-Geneviève on the left bank in 1227. The district is still known as the Quartier Latin after the principal study. A statute of 1255 listed the books on which a master in the faculty of arts was required to lecture: they included Priscian for Latin grammar and a substantial run of the Latin translations of Aristotle, including all the logical works,

108 *Opposite*

Vienna, Österreichische National-bibliothek, Cod. 2315, fol. 100v

This is an unusually handsome medical textbook, made for a wealthy client in Paris about 1280. It comprises works by Hippocrates and Galen in the Latin translation of Constantinus Africanus. The manuscript is signed by its scribe, Ugo Cappellarii. The miniature shows a doctor and his student discussing a patient.

109 *Left*

North America, private collection, s.n., fol. 11r

These are the works of John of Sacrobosco, who taught mathematics and astronomy in Paris from about 1220. This manuscript was illuminated in Paris in the late thirteenth century, and shows here the end of the *Algorismus*, on arithmetic, and the opening of the *De Sphera*, on the sphere of the terrestrial globe and on the movements of the stars and the planets. It is based on the works of Ptolemy.

the *Physics*, *Metaphysics*, *On the Soul*, *On Animals*, and *On the Heaven and Earth*. The second faculty was law. This may have been one of the oldest disciplines in the Paris schools, to judge from surviving twelfth-century manuscripts of Gratian and from the story of Peter of Blois finding law books for sale. However, Paris never achieved in legal studies the reputation of Bologna or even Orléans, Angers, or Toulouse. The fact that many Paris students owned glossed law manuscripts which seem certainly to have been written in Italy (presumably Bologna) suggests that these books were imported into France ready made and that they did not form the stock-in-trade of the Paris scribes. Even the richly illuminated Sorbonne copy of Gratian (now Sorbonne, ms. 30) is Italian work. The third faculty was medicine. Here we have a specific list of reading for students in the statutes of *c.*1270–4. Medical students needed the compendious *Ars Medicinae* collected by Constantinus Africanus (*c.*1015–87) together with the *Viaticum* and the works of Isaac usually associated with it (PL. 115). They required the *Antidotarium* (a twelfth-century pharmaceutical textbook ascribed to Nicholas of Salerno) and they needed two unspecified volumes of *Theoretica*

and *Practica*. A particularly finely illuminated Parisian manuscript of Constantinus Africanus's translation of Hippocrates (now Vienna, Österreichische Nationalbibliothek, Cod. 2315) is signed by the scribe Hugo Cappellarii, which literally means Hugh son of the Hatter (PL. 108). Perhaps he kept two trades to tempt wealthy medical students. Finally there was in Paris the faculty of theology. This was the most prestigious course of study. The student spent six years as an undergraduate, four of them attending lectures on the Bible and two studying the *Sentences* of Peter Lombard. He then became a bachelor of theology and proceeded to further biblical studies. It is hardly surprising that manuscripts of the Bible and of Peter Lombard are the most common surviving books from thirteenth-century Paris. They were actually used in the lecture room.

It is worth stressing too the influence of Aristotle's works in the literary life of the University of Paris. The enormous awakening of interest in Aristotelianism swept through the universities late in the first half of the thirteenth century (PLS. 92 and 111–12). In fact, much of Aristotle was not unknown in the Romanesque period (the *Elenchi* and *Topica* were listed in the twelfth-century

110 *Left*

Oxford, Corpus Christi College, MS. 283, fol. 165r

In his mid-20s William of Clare was a student in Paris where he bought a number of textbooks, including this manuscript of Euclid's mathematics bound up with a copy of the statutes of the University of Paris datable to soon after 1266. By 1277 William was back in England and gave his manuscripts to St Augustine's Abbey in Canterbury.

Reading Abbey catalogue, for instance), but in the Latin translations of Boethius, Gerard of Cremona, James of Venice, Michael Scot, and others, Aristotle's immense corpus of writings on logic, natural science, and philosophy became the starting point for new research not only in the arts but also in Christian theology. In essence what Aristotle provided was a method of academic argument. It was a way of systematically speculating on both sides of a proposition in order to reach a solution. A master would cite a whole series of authorities and linked arguments in favour of a hypothesis. He would then bring together another series of similar arguments in support of the opposite view. The conclusion then ingeniously redefines the original question and presents a logical solution. This may seem to us rather trite, but in the thirteenth century it was remarkably new (and, in the opinion of many, dangerously so) to argue out the case against Christianity, for instance, in order to reaffirm (and perhaps even to define more exactly) a fundamental truth. This became the scholastic method of argument. It can be applied to almost any proposition. The famous satirical example of the schoolmen debating how many angels could stand on the head of a pin may seem ridiculous (that was why it was invented), but it conceals an academic discipline which was enormously influential in a medieval university.

One fact that very clearly emerges from even a brief look at the book business in thirteenth-century Paris is the immense number of texts being published by members of the university. It seems as though everybody wanted to write a book. The wealth of scholastic commentaries on the *Sentences* of Peter Lombard, for example, is really daunting. The greatest author among them all was St Thomas Aquinas (*c*.1225–74), who taught at the Dominican convent of St-Jacques from 1252 to 1259 and from 1269 to 1272, and it was at Paris that much of his finest writing was done and from Paris that it was disseminated. His best-known work is the monumental *Summa Theologiae*, a vast corpus of theological knowledge, but his scholastic output included a commentary on the *Sentences* (composed at St-Jacques, 1252–7), commentaries on Aristotle (PL. 113), and the *Catena Aurea*, a Gospel commentary composed of a 'chain' of quotations from the Church Fathers. The fact that over 1,900 manuscripts of works by Aquinas were listed by the

I I I *Left*

**Oxford, Merton College,
MS. 271, fol. 17v**

The works of Aristotle in Latin translation became central to many areas of study in the universities from the mid-thirteenth century. This manuscript of the *De Animalibus* was made in Paris in the third quarter of the thirteenth century but may well have been used in Oxford. The initial here introduces the chapter on fish.

Leonine Commission in 1973 attests to the author's immense popularity. It is only just exceeded by the 2,200 manuscripts of Latin texts of Aristotle recorded in the census published between 1939 and 1961. The ultimate point of dissemination was the book trade in the schools of Paris.

But Thomas Aquinas was not alone in writing books for students. The Dominicans at St-Jacques included Hugh of St Cher (c.1190–1263), the great biblical commentator and philosopher Albertus Magnus (c.1206–80), who was regent master in Paris from 1242 to 1248, Peter of Tarentaise, who taught from 1259 to 1264 and probably 1267 to 1269 and who died as Pope Innocent V in 1276, William of Moerbeke (c.1215–86), the great Aristotle translator who was probably trained in Paris, Eckhart (c.1260–1327), regent master 1311–13, and Durand of St Pourçain (d.1334). The Franciscans in Paris included the celebrated Alexander of Hales (d.1245), Alexander's even greater pupil St Bonaventura himself (1217–74), Richard of Mediavilla (d.c.1300, PL. 114), and later Duns Scotus and Nicholas of Lyra. Among the secular masters in the schools of Paris were prolific writers such as Peter of Poitiers, regent master 1167–1205, Simon of Tournai (d.c.1203), Robert of Courçon (d.c.1218), Stephen Langton, Philip the Chancellor (d.1236), Odo of Châteauroux (d.1273), William of Auvergne (d.1249), William of St Amour (d.1272), Gerard of Abbeville (d.1272), Henry of Ghent (d.1293), and Arnold of Villeneuve (d.c.1311). These are just a few selected from the faculty of theology only. Paris masters produced a tide of new texts, often long ones, and the problems of publishing them must have been stupendous for the newly founded book trade. 'Here ends the second part of the *Summa* of the Dominican brother Thomas Aquinas', wrote one scribe after 750 pages of closely written script, 'the longest, most verbose and most tedious to write; thank God, thank God and again thank God' (New College, Oxford, MS. 121, fol. 376v).

How did they do it? How could so many massive texts be multiplied at comparative speed and without enormous expense? The answer is really very important, and it will take some detail to explain. They used what is known as the *pecia* system. It was very ingenious, and it was completely new. Briefly it worked as follows. From the second half of the thirteenth century, certain booksellers in Paris had a special title. They were known as university stationers. A stationer owned a great many specially made exemplars of university textbooks and these were kept unbound in loose gatherings. Each of the gatherings was numbered and known as a piece, or *pecia*. The stationer would hire out the *peciae* to scribes or students who wanted to copy the text. Because the pieces were separate, he could rent out a text to many customers at once and each could transcribe a different part of one exemplar. The scribe then had to bring back the *pecia* he had just copied and collect the next number in the sequence. In the meantime the one he had just returned could be hired out to another client. Thus a text of 312 leaves (for example) instead of being lent to one scribe for six months while he copied it out at the rate of twelve leaves a week (for instance), could be used to reproduce up to 26 identical copies during the same time and each one would be only one remove from the original exemplar.

This direct link with the exemplar is crucial too. Normally a manuscript book was copied one from another in a long chain of relationships which delight and dismay textual critics, who record how a text gets more and more corrupt as scribes made little mistakes and unknowingly passed them on. Under the *pecia* system, however, there was (at least in theory) only one occasion for error as every scribe had the master-copy before him.

A further essential aspect of the *pecia* method of publishing is that it was closely controlled by the university. Each year during the vacation a commission of masters would examine the stationers' exemplars for accuracy. If the majority (or at least six) of the *peciae* were found to contain errors, they had to be corrected at the stationer's expense. The commission would then issue an official list of texts available, with the titles of the approved *peciae*, the number of pieces in each, and the price for hiring them. Thus in the 1275 list, the earliest known, there is a copy of Aquinas's commentary on St Matthew comprising 57 pieces at a fixed rental of

112 *Opposite*

Paris, Bibliothèque Nationale, ms. lat. 12953, fol. 276r

This volume of many Aristotelian texts was illuminated in Paris about 1260. The opening of the *De Differentia Spiritus et Animae*, attributed (wrongly) to Aristotle himself, is illustrated with a miniature of the Tree of Jesse. The manuscript was made with wide margins for glossing in the classroom.

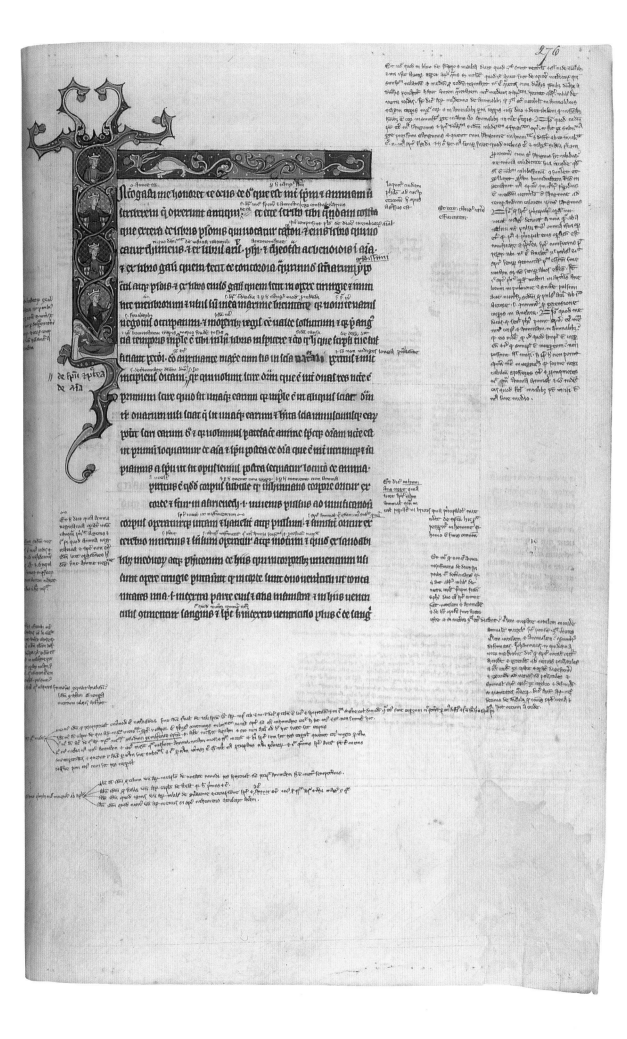

3 *sous d'or* for the set. The same set was still available in the second surviving list dated 1304 but the price for hiring them had gone up to 4 *sous* for the set. This official list would be displayed publicly in the stationer's shop. The 1275 list offers 138 different texts and that of 1304 has 156 texts, many of them in the same *peciae* as the list of almost thirty years before. There was thus a considerable choice for the student visiting a bookshop.

The fundamental university regulations controlling the hire of *peciae* were published in the nineteenth century. The understanding of how the method worked in practice will forever be associated with the name of the indefatigable Jean Destrez (d.1950), who spent his life systematically peering at university textbooks of the thirteenth and fourteenth centuries. What he found was very remarkable. He noticed that at regular intervals in the margins of scholastic books were consecutive series of numbers sometimes with the letter 'p' or even 'pecia' in full (PL. 113), and that the totals of these often corresponded with the number of pieces in the university lists. What must have happened is that the scribe noted down the number of the *pecia* he was beginning to copy (or at Bologna, which we shall consider in a moment, which he had just finished copying). This would not only remind him which piece to ask for next when he returned to the stationer but might also serve as a way of assessing his payment, if he was a professional scribe. The marks are very valuable for us in localizing surviving manuscripts in the schools and particularly crucial for a modern editor anxious to get as close as he can to a correct version of an authentic text. By 1935 Destrez had inspected more than seven thousand university manuscripts and said that he found about a thousand with *pecia* markings of some sort; by the time of his death he had seen very many more. It is still a hope that one day Destrez's lists of these manuscripts will be published.

Very occasionally the sets of actual *peciae* still survive. These are the original numbered gatherings which the stationer hired out. At some time the stationer would have decided that a set was obsolete

113 *Left*

Paris, Bibliothèque Nationale, ms. lat. 14706, fol. 122v

This is a characteristic university manuscript made in Paris in the late thirteenth century. It is the commentary by Thomas Aquinas on the *Metaphysics* of Aristotle. In the left-hand margin is a *pecia* note, 'xxxv. pe[cia]'. It shows the point at which the scribe was beginning to copy out the 35th *pecia* which he had hired from the university stationer.

114 *Opposite*

Paris, Bibliothèque Nationale, ms. lat. 14563, fol. 1r

The Franciscan theologian Richard of Mediavilla (c.1249–c.1300) was regent master in Paris 1284–7. This manuscript of his commentary on the *Sentences* of Peter Lombard shows, in the upper left-hand corner, the author himself lecturing to Franciscan students and, in the lower right, Christ tending a sick man in a miniature to illustrate a discussion of the Good Samaritan. The manuscript was made in Paris in the early fourteenth century and belonged to the Abbey of St-Victor in Paris.

and so would bind it up like a book and sell it off cheaply. They are usually rather unattractive volumes on thick over-thumbed vellum. One example is Paris, B.N., ms. lat. 3107, the actual set of 57 *peciae* for Thomas Aquinas's *Summa contra Gentiles* dating from about 1300. Apparently some pieces in the set had got lost when it was in circulation and have been replaced by a different scribe. Perhaps this happened during one of the annual inspections as the volume is full of corrections too, some signed 'R' or 'Rad', presumably Radulphus. Another surviving manuscript, Paris, B.N., ms. lat. 15816, is one of the contemporary copies taken by a client from this set of 57 *peciae* when they were in circulation. It includes the *pecia* numbers which correspond with those on the separate sections of the original exemplar.

There are still many controversies about exactly how the *pecia* system operated. Mention of the subject is the quickest possible way of starting an argument among a party of palaeographers. One area of contention is the relationship between the author's final draft of a text and the pieces which the stationer lent out. This matters a great deal to a modern editor of a medieval text. Did an author take his newly written textbook round to a stationer (or did the stationer ask for it first, or did it have to be on some textbook list, or did a stationer just buy a copy in the trade?), and then what

happened? Presumably the stationer would not want to hire out his only set, and so one imagines that he prepared and retained an office copy. Was it this version or only the loose lending copies which were checked by the university? Despairing scholars have found that *pecia* manuscripts are often less accurate than one might have hoped. Something of the mechanics of thirteenth-century publishing emerges from Father P.-M. J. Gils's work on Thomas Aquinas's commentary on the third book of the *Sentences*. This text was in circulation in Paris by 1272 but it was later revised by Aquinas himself. By remarkable good fortune the original set of *peciae* still survives in Spain, now bound up as a book (Pamplona Cathedral Library, MS. 51). It has actually been updated from the original text into the revised edition, presumably by the Dominicans at St-Jacques where Aquinas was living. It seems as though the stationer called in his old set of pieces for this text and literally sent them back to the author's convent for revision. The Pamplona Cathedral volume has the name of the stationer at the top of each of the numbered pieces, and he was called William of Sens.

Professors Richard and Mary Rouse, historians from Los Angeles, have traced a whole family of Parisian booksellers 'of Sens': Margaret, Andrew, Thomas, and William, who successively lived in the rue St-Jacques in the university quarter of Paris from

115 *Left*

Private collection, s.n., fol. 65r, detail

This is a detail from a medical anthology illuminated in Paris in the mid-thirteenth century. It illustrates the *De Dietis* of Isaac Judaeus, and shows special food being recommended for a sick patient.

116 *Opposite*

Tours, Bibliothèque Municipale, ms. 558, fol. 1r

The illuminator, Master Honoré, from Amiens, was the most highly regarded Parisian manuscript artist of the years around 1300. By 1296 he was in the employ of the king. This manuscript of the *Decretum* of Gratian contains a purchase note that 'In the year 1288 I bought the present Decretals from Honoré the illuminator dwelling at Paris in the Rue Erembourc-de-Brie for the sum of 40 Parisian pounds ...'

Column 1

[Prologue text in heavily abbreviated Gothic Latin, partially legible]



Concordia discordantium canonum ac primum de iure naturae et constitutionis

Humanum genus duobus regitur, naturali videlicet iure et moribus. Ius naturale est quod in lege et in euangelio continetur. Quo quisque iubetur alii facere quod sibi uult fieri et prohibetur alii inferre quod sibi nolit fieri. Unde xpristus in euangelio: Omnia quecumque uultis ut faciant uobis homines et uos eadem facite illis. Hec est enim lex et prophete.

Diuine leges natura, humane moribus constant.

Column 2

...pant qui aliqualis gentibus placent. Fas diuina lex est. Ius lex humana. Transire agri alieni fas est. Ius non est. Ex uerbis huius auctoritatis euidenter datur intelligi in quo differant inter se lex diuina et humana, cum omne quod fas est nomine diuine uel naturalis legis accipiatur, nomine uero legis humane mores in scriptis redacti tradantur.

Ius generale nomen est, lex autem iuris est species.

...Ius generale nomen est, lex autem iuris est species. Quid sit lex? Lex est constitutio scripta...

[Remaining columns in heavily abbreviated medieval Latin, largely illegible]

before 1275 until at least 1342. Their business was on the same side of the same street as the convent of St-Jacques itself. This must have been an ideal location for a shop which seems to have had an exceptionally good stock of Dominican texts and which was perhaps somehow involved in the publication of Thomas Aquinas. The friars only had to walk a few paces from their convent to the bookshop. It is not surprising, therefore, to find William of Sens updating his *peciae* of Thomas Aquinas as soon as the new version was available.

The question of when the *pecia* system began is complicated by Italian documents which hint at some kind of hiring out of exemplars in the universities there as far back as 1228. In fact, however, the earliest datable surviving manuscript with *pecia* numbers seems to be the copy of Hugh of St Cher on the Pauline Epistles, which was bequeathed to Durham Cathedral by Bertram of Middleton,

who died in 1258 (Durham Cathedral Library, MS. A.I.16). Therefore the *pecia* method was in operation by that year at the very latest. The author was another Paris Dominican and the book is certainly a Parisian copy. It is extraordinarily difficult to follow the *pecia* method back any earlier than the circle of the masters from St-Jacques in the mid-thirteenth century.

By 1300 the Parisian book trade was thoroughly organized, efficient, and under full control of the university. Even the sale of vellum was under the strict supervision of four official university assessors. There were regulations in 1316 requiring booksellers to take an oath of allegiance to the university and laying down guidelines on the hiring out of *peciae* and restricting the profit on the sale of second-hand books. There were blacklists of those who refused to subscribe. Booksellers benefited from coming under university control not only because of the business advantage in official recog-

nition but also, quite simply, because after 1307 membership of the university provided exemption from taxation. This was no doubt a huge bonus to members of the book trade. It is a disadvantage for us in trying to identify who made books, because their names and addresses disappear from the surviving tax rolls.

As it happens, one way and another we know a fair amount about the personnel of the book trade in Paris around 1300. There were at this time about thirty booksellers, of whom about half were on the left bank, around the rue St-Jacques and the university quarter, and about half had shops in the rue Neuve-Notre-Dame opposite the cathedral on the Île de la Cité. The names of very few scribes have come down to us. Probably they were very often students making books for their own use or supplementing their allowances with extra pocket money. Pierre Giraut is one on the tax lists of 1297–1300. The names of illuminators are not at all

rare in the tax rolls. About forty-five are known by name in the decade or so around 1300, including Master Honoré, who is documented as living in the rue Erembourc-de-Brie and who later became royal illuminator to Philippe le Bel (PL. 116). Some illuminators were women. Some had other trades too, such as Estienne le Roy and Enart de St-Martin, who were illuminators and book-binders (c.1297–1300), Gilbert l'Englais, who was an illuminator and a lawyer (1292–1300), and Thomase, a woman illuminator and innkeeper in 1313. Jehan d'Orli, who had been an illuminator and innkeeper in 1297, devoted himself entirely to his second profession in 1298–1300. Probably it was more profitable. The image of a man selling pints of beer while decorating manuscripts is very appealing, and perhaps not ridiculous. An inn was a good place for students to congregate too.

So far in this chapter we have been looking exclusively at the

117 *Opposite*

Berlin, Staatliche Museen Preussischer Kulturbesitz, Kupferstichkabinett, Min.1233

University lecture theatres have changed little in 600 years. This miniature, from a manuscript of the commentary on Aristotle's *Ethics* by Henricus de Allemania, is signed by the Bolognese illuminator Laurentius de Voltolina, in the second half of the fourteenth century. It shows the author lecturing from his copy of Aristotle and his students either following in their own manuscripts or chatting or sleeping.

118 *Right*

Oxford, New College, MS. 288, fol. 3v

This view of New College in Oxford was drawn c.1461–5. The College was founded in 1379 and the old quadrangle shown here survives almost unchanged today. The steps on the right lead up into the dining hall. The passage in the centre left, through which a man is walking, leads through to the chapel and cloisters. The college library was on the upper floor of the building on the extreme right. In the foreground is Thomas Chaundler (d.1490), warden of New College 1455–75, with the fellows and scholars of the college.

University of Paris. This is deliberate. Not only was Paris the most international of the medieval universities but probably too it was the innovator in the great advances of the book trade: the devising and marketing of pocket Bibles, the establishment of organized bookshops, and the publishing of textbooks by the *pecia* method. But Paris was certainly not the only place where students needed books. Bologna must undoubtedly have been the second most important city in Europe for the production of books in the thirteenth century. It too made one-volume Bibles, and textbooks with *pecia* marks. The university there was probably older than Paris, and it was second to none in the Middle Ages for the study of law. There were law schools in Bologna from at least 1100, traditionally associated with Irnerius who was perhaps teaching as early as 1088. By the late twelfth century Bologna had an international reputation for legal studies. As Paris published theology, so Bologna published law.

There were two fundamental categories of legal studies in the Middle Ages. Both were taught at Bologna. Both provided manuscripts. The first was civil (or secular) law, and the second was canon (or ecclesiastical) law. Written civil law went back to the great code assembled for the Emperor Justinian in the sixth century. It is made up of extracts from ancient Roman law and legal textbooks and was supplemented in Justinian's lifetime by additions known as the *Novellae*, the *Digest*, and the *Institutes*. All these together formed the corpus of civil law. Manuscripts are enormous in size, often include commentaries by Bolognese masters, and mostly date from the thirteenth and fourteenth centuries.

By contrast, canon law was entirely medieval in origin. Its basic encyclopedia was the *Decretum*, or *Concordantia Discordantium Canonum*, of Gratian, an otherwise almost unknown Camaldolese monk working about 1140 in Bologna. It is a textbook which became a bestseller (cf. PL. 116). It was like Peter Lombard's *Sentences* in that it organized information under subject headings, and for centuries it was the most popular student guide to canon law. It is not a book of laws as such. This was the role of the

Decretals. These were official collections of papal and episcopal letters which actually laid down Church law on specific subjects. *Decretals* could be enforced in the Church courts. They are all associated with names of popes. The first are known as the *Decretals* of Gregory IX, and were compiled in 1234, probably by the Dominican Raymond of Peñafort (1185–1275, PL. 119). They were supplemented by two further sets of *Decretals*, those of Boniface VIII in 1298 and of Clement V in 1317. The three comprised the corpus of canon law. *Decretals* were dispatched by the papacy to the universities of Bologna and Paris with the command that the text should be taught in the schools. There could be no greater compliment to manuscript production in Bologna and Paris than this papal confidence in the publishing skills of those two universities.

In fact, Bologna largely cornered the market in legal manuscripts and there were 119 civil and canon law texts on the Bolognese *pecia* list of the first half of the fourteenth century. Manuscripts were published with marginal commentaries by masters of the law faculty there such as Bernard of Parma (d. 1263) and Giovanni d'Andrea (d. 1348). With the commentaries, these were huge manuscripts. It is said that students would walk into the lecture hall followed by servants carrying the heavy volumes (cf. PL. 117). Perhaps the Bolognese scribes liked large books (unlike those of Paris), since the only other substantial category of manuscripts ascribed to that city before about 1300 are choirbooks, also huge. In the thirteenth century at least, the business of illuminating textbooks was not as well organized in Bologna as in Paris. The student who in the story wasted his money on books was given by his father a choice of going to Paris or to Bologna; he chose Paris. Dante mentions one Bolognese illuminator, Oderisi da Gubbio (recorded 1268–71, in fact), who excelled (wrote Dante, *Purgatorio* XI.80–1) in that art which in Paris is called illumination. Paris had the reputation, quite clearly. It seems to have been not uncommon to make and export Bolognese legal manuscripts with the illumination left blank. When the volumes were remarketed

119 *Opposite*

**Oxford, Bodleian Library,
MS. lat. th.b.4, fol. 168r**

The *Decretals* of Gregory IX, published in 1234, became the central textbook of Church law, studied in Bologna, Paris and Oxford. This early manuscript, surrounded by the commentary by Bernard of Parma (d. 1266), is dated by the scribe, Leonardo de Gropis of Modena, who records that he completed it on Wednesday 12 July 1241. The commentary itself has been heavily glossed by a contemporary reader, possibly during lectures.

through the book trade of the northern universities the miniatures would be added. It would be fascinating to know exactly how this happened. One Bible written and illuminated in Bologna in the third quarter of the thirteenth century is filled with information supplied by the scribe (Paris, B.N., ms. nouv. acq. lat. 3189). He was an Englishman, he says, called Raulinus, from Fremington in Devon, and had spent two years studying at the schools in Paris but had wasted his money on women and loose living and so he had come on to Bologna to earn his living as a scribe, but there too, he confesses with the hope that the Virgin will forgive him, he continued to frequent taverns and fell in love with a girl called Meldina. This gives a good image of the internationalism of the Bolognese book trade. Royal MS. 10.E.IV in the British Library is a copy of the *Decretals* of Gregory IX with the prologue addressed to the University of Paris, but the script is Italian and the miniatures are English: one could imagine that it might have been written in Bologna, sold in Paris, and illuminated in Oxford.

In England before the fifteenth century, Oxford was the only university of importance (PL. 118). Of course Cambridge had existed from the thirteenth century but it is incredibly difficult to point to any manuscripts certainly made there. B.L., Harley MS. 531 is a volume of scientific texts by Sacrobosco dated 1272: it was certainly in Cambridge by the fifteenth century but whether it had been written there is a different question. Oxford, however, had many of the attributes of a university book trade: one-volume Bibles, textbooks, stationers of some sort, and possibly (not certainly) the *pecia* system. One of the first pieces of evidence

for the existence of a university in Oxford, in fact, is a late twelfth-century charter witnessed by a bookbinder, a scribe, two vellum-makers, and three illuminators. One Oxford manuscript is dated 1212, which is remarkably early (Paris, B.N., ms. fr. 24766). It may be that MS. W.15 in the Walters Art Gallery in Baltimore is as old: it is a glossed Gospel Book with added legal formularies which have been plausibly ascribed to Oxford in 1202–9. By the middle third of the century we have a good clutch of surviving manuscripts illuminated (and two of them signed) by W. de Brailes, presumably the William de Brailes who is documented among personnel of the book trade in Catte Street in Oxford between about 1230 and 1260, including a Bible possibly as old as 1234 (Bodleian Library, MS. Lat. bibl. e.7). There are other illuminators recorded in Oxford at this time too, including Robert, Job, Walter of Eynsham, Robert de Derbi, and Reginald. A set of glossed books of the Bible may be the work of Reginald, who (Mr Graham Pollard discovered) lived at no. 94 High Street with his wife Agnes between about 1246 and 1270. The manuscripts are B.L., Royal MSS. 3.E.I–V (PL. 120), and the last volume includes a note (fol. 102v) that a defective gathering was given to Reginald at Oxford to continue. Furthermore, someone (presumably the illuminator) has added up exactly how much decoration has been supplied for the book, and has entered the totals into each of the five volumes. He counts a combined total of 12,406 little initials and paragraph-marks and 1,453 large initials. Clearly he expected payment by the initial. Here is really a student manuscript frivolously decorated.

120 *Opposite*

**London, British Library,
Royal MS. 3.E.V, fols. 90v–91r**

This is the fifth and last volume in a set of glossed biblical manuscripts written and decorated in Oxford in the mid-thirteenth century, partly by the illuminator Reginald. Coloured initials and rubrication continue as far as the left-hand page here, after which they were left unfinished. On the lower left is a note recording for payment purposes that the total number of large initials supplied so far in this volume is 229 and of small letters and paragraph-marks 1,782.

V

Books for Aristocrats

'Emperors and kings, dukes and marquises, counts, knights, townsfolk ... take this book and have it read to you.' With these words Marco Polo addresses his audience and begins his account of a journey across the world in the second half of the thirteenth century, a tale which introduces Genghis Khan, Prester John, the One-Eyed Cobbler, and the Wrestling Princess, as well as his historically reliable description of the almost unknown world he had seen between Venice and China. The emperors and kings, to whom the book was supposed to be read, must have felt that the whole story sounded like a romance. Mahaut, countess of Artois, commissioned a copy to be written and illustrated in 1312, within five years of the completion of that particular version of the text, and the book appears in the countess's payment record as *roman du grand Kan*, true-life geography already called fiction. One of the finest Marco Polo manuscripts, made about 1400, was bound up with Bodleian Library, MS. Bodley 264, an Alexander romance dated 1338. It has a famous miniature of Marco Polo about to sail from Venice, which is shown like the backdrop of a pageant on a sunny day with bridges, flags, boats, swans, islands, and little groups of richly dressed citizens hurrying along cobbled streets or standing, talking, or waving (PL. 122). The reminiscences of the shrewd Venetian merchant were transformed by scribes and illuminators into a text to be enjoyed by the rich with stories of Alexander the Great, Charlemagne, and King Arthur. Many listeners must have enjoyed Marco Polo as fiction. King Charles V of France owned five copies, one of them bound in a cloth of gold.

Marco Polo's book describes his adventures on an incredible voyage. A journey or a pilgrimage is the setting of much medieval fictional narrative. Travelling was slow in the Middle Ages and often adventurous. It also provided occasion for travellers to pass the time by singing and telling stories, and this in itself contributed something to the rise of literature. This chapter, which concerns fiction and romance, will take us along the pilgrim road through France to the shrine of St James of Compostella, to the Crusades and back, up the waterways of the Rhine and into northern Europe and unsteadily out into the north Atlantic in wooden boats, and safely in April from London along the pilgrims' way to Canterbury.

Elements of vernacular literature go back to campfires and taverns, centuries before anything was written down. The *jongleurs* of France were certainly singing and dancing from time immemorial. Their name has the same derivation as 'juggler' in English, and entertainers and acrobats belong to a profession far older than that of manuscript illumination. The *troubadours* of Provence were chanting their songs of love and heroism long before these were first recorded in the twelfth century. As wayfarers passed through southern France, they must have picked up wandering minstrels or listened to their songs on the journey. Pilgrims from northern Europe travelling to Compostella in Spain came past the tomb of the Carolingian hero, Roland, who was buried at the foot of the Pyrenees, and they crossed the pass at Roncevaux where Roland and his troops were said to have been killed by the Saracens in the eighth century. Of course travellers were shown these sites and they heard the *chansons de geste*, the songs of deeds, recited by professional entertainers. When someone wrote it down, then the *Chanson de Roland* became literature. There are fewer than ten

The manuscript page shows an illuminated miniature with a detailed cityscape, ships on water, and figures, surrounded by a decorative border. Below the miniature are two columns of medieval text in a Gothic script, with large decorated initials.

121 *Previous page*

The Hague, Rijksmuseum Meermanno-Westreenianum, MS. 10.B.23, fol. 2r

Charles V, king of France 1364–80, was the supreme aristocratic book collector, who owned nearly 1,000 illuminated manuscripts, including this copy of the *Bible Historiale* which was presented to him by Jean Vaudevar in 1371, as shown in its frontispiece.

122 *Left*

Oxford, Bodleian Library, MS. Bodley 264, fol. 218r

Marco Polo sets sail for the Far East. This famous English miniature of about 1400, illustrating a manuscript of Marco Polo's *Li Livres du Graunt Caam*, shows the adventurer boarding a little boat to take him out to his ship anchored in the Venetian lagoon. Though interpreted by an English illuminator, the city of Venice itself is recognizable: the church of San Marco with its four bronze horses and the Palace of the Doges beside it, and the column on the waterfront surmounted by the lion of St Mark.

123 *Opposite*

Cambridge, Trinity College, MS. O.9.34, fols. 4v–5r

The *Roman de Toute Chevalerie* of Thomas of Kent is a romance on the chivalric adventures of Alexander the Great. This manuscript was written in southern England *c*.1240–50. The miniature on the left shows the Duke of Tyre attacking Alexander's tower on an island and throwing his men into the sea. On the right Alexander attacks Tyre and shoots a crossbow down at the city from a scaffold brought in on a boat.

surviving manuscripts and fragments of the *Chanson de Roland* (despite its enormous fame now as the greatest *chanson de geste*), and they are all unillustrated, except for one copy in Venice with a small initial showing Charlemagne. The oldest manuscript (Oxford, Bodleian Library, MS. Digby 23) was made in England in the twelfth century – perhaps within the first half of the century though this is highly controversial – and it is an unassuming little manuscript, suitable for a minstrel's wallet. It is unambiguously a manuscript of poetry, with the first letter of each line slightly separated from the text block itself and with dots marking the end of each line. It has a clearly recognizable verse format. Even the fact that the book is English shows how far the story had travelled.

Some Charlemagne romances probably crossed Europe with the crusaders, who no doubt enjoyed singing of legendary heroes conquering the infidel. The *Chanson d'Aspremont* was apparently composed in Sicily or the far south of Italy, and it was known to the knights of Philip Augustus and Richard the Lion Heart spending the long winter of 1190–1 camping in Sicily before setting sail on the final leg of the ill-fated Third Crusade against Saladin. The *Chanson* concerns Charlemagne and his allies in Italy crossing the mountainous 'Aspremont' in the Apennines to march against the Saracen king Agolant. Crusaders must have found it easy to identify themselves with the heroes of the story. One of the earliest manuscripts of the *Chanson d'Aspremont* is also English in origin (B.L., Lansdowne MS. 782) and dates from about 1240–50. It has 45 coloured drawings of rather home-made quality. The same workshop probably illustrated another romance on the life and travels of Alexander the Great, Thomas of Kent's *Roman de Toute Chevalerie* (Cambridge, Trinity College, MS. 0.9.34), which has 152 coloured drawings of knights and battles (PL. 123). It is easy to imagine returned soldiers ordering illustrations for these old songs in order to demonstrate to admiring relatives at home the valour of holy warfare.

The movement of legends went the other way too. Modena

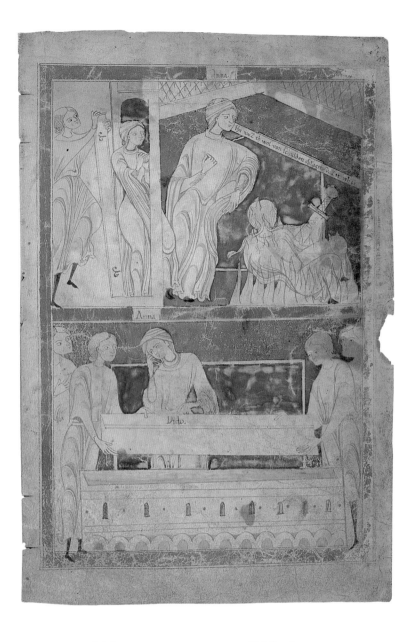

Cathedral in northern Italy has carvings of the very early twelfth century showing King Arthur of Britain and his knights rescuing Winlogee (a variant of Guinevere) from the wicked knight Mardoc. The twelfth-century mosaics in Otranto Cathedral in the extreme south-eastern tip of Italy depict 'rex Arturus' among the famous men of the past, such as Noah and Alexander the Great. Some British traveller had brought songs and tales to Italy. In France the twelfth-century poet Chrétien de Troyes began to collect the Arthurian stories told (as he says) at the royal court, and to write some of the earliest French poems on the Holy Grail and on Lancelot. Something over thirty manuscripts (at least half of them in the Bibliothèque Nationale) contain poems ascribed to Chrétien de Troyes. One, made about 1230, is signed by its scribe Guioz who writes that he has a shop before the church of Notre-Dame-du-Val in Provins (Paris, B.N., ms. fr. 794). It is an extremely early reference to some kind of scribe/bookseller presumably advertising his services, doubtless equipped to write out other similar texts for clients. The Chrétien de Troyes tales themselves became the source for other Arthurian legends.

These heroic tales also passed over into Germany. The warrior duke Henry the Lion (whose Gospel Book, described in chapter 2, proclaims his descent from Charlemagne) commissioned from Pfaffe Konrad (Konrad the priest) a German version of the song of Roland, the *Rolandslied*, written about 1170. It may have come about through an importation of Anglo-Norman culture into the ducal household after Henry the Lion's marriage in 1168 to Matilda, daughter of Henry II of England. At about this time, Heinrich von Veldeke adapted Virgil's epic *Aeneid* into a German romance (PL. 124), and it was perhaps partly recited at the wedding of the Countess of Cleves to Landgrave Ludwig II of Thuringia, for the epilogue tells that the author's unique and unfinished manuscript was stolen by one of the guests and not returned for nine years. There are twelfth-century German poems on Alexander the Great and King Arthur too. Most of the great writers of epic poetry in Germany all belong to the decade or so on either side of 1200. They include Hartmann von Aue (fl. 1170–1215), who translated Chrétien de Troyes; Wolfram von Eschenbach (d. after 1217), author of *Willehalm*, the story of a knight who falls in love with a Saracen girl, and *Parzival*, the tale of a young knight errant who is eventually admitted to the Round Table of King Arthur and to the company of the guardians of the Holy Grail at Munsalväsche; and Gottfried von Strassburg (c. 1210), who wrote *Tristan*, the romance of a nephew of King Mark (of 'Tintajoel' Castle in Cornwall) who accidentally drinks a love potion with Isolde, the king's betrothed. Only slightly later is Rudolf von Ems (fl. 1220–54), whose huge poems include a massive *Weltchronik*, a history of the world as far as King Solomon which in some manuscripts has hundreds of illustrations. The greatest German medieval poem of them all is the *Nibelungenlied*, written c. 1180–1210. The most important thirteenth-century copy

of the text is now the last remaining manuscript of over a thousand once in the library of the Princes of Fürstenberg (Donaueschingen MS. 63). The epic is long and immensely complicated. Briefly, it concerns Siegfried, who helps King Gunther marry the terrible Brunhild because Siegfried wants to marry Kriemhild, Gunther's sister, but Brunhild (misunderstanding Siegfried's rank) has him killed; so Kriemhild, who has in the meantime married Etzel, king of the Huns, cunningly invites the enemies of Siegfried to a feast with the intention of avenging his death and obtaining the Nibelung treasure (which has been thrown in the Rhine), but in the massacre which ensues everybody dies.

Not all German secular writing was quite so bloodthirsty. The *Minnesingers* are still romantic figures in history. The word *Minne* is often translated as 'love' (for these were knightly minstrels who sang of fair damsels), but these were not mere songs of passion but of a courtly aristocratic wistful secret love for an often unattainable or inaccessible woman (PL. 125). There is an almost fairytale atmosphere about the wandering *Minnesingers* like Reinmar von Hagenau (fl. 1160–1210) and Heinrich von Morungen (*c.* 1200).

The minstrels brought vernacular entertainment into the courts of southern Europe also. Troubadours like Rambertino Buvarelli (d. 1221) sang in Bologna in the Provençal language. Dante ascribes the origin of Italian poetry to the court of the Emperor Frederick II (1194–1250), king of Sicily and Jerusalem, who gathered around him a group of writers known (not strictly correctly) as the 'Sicilian poets', and there exist poems by Frederick himself and by his chancellor Pier della Vigna. It must be stressed that the rise of secular poetry throughout Europe from about 1200 onwards does not mean that poetical manuscripts are common. They are, in fact, exceedingly rare. Many troubadours were probably hardly literate and the audiences listened to literature rather than reading it. The significance of secular verse, however, is that (within a couple of generations at most) the fashion for vernacular literature spread through the courts of Europe, and the minstrel lad of the Dark Ages gave way to the writer of medieval romances. An early jongleur composed his songs as he went along, but a thirteenth-century poet prepared a specific text and when that happened, he needed manuscripts.

Among the most remarkable literary manuscripts of the thirteenth century are the songbooks of Alfonso X, 'el Sabio' (the Wise), king of Spain from 1252 to 1284. Like Frederick II, Alfonso encouraged the arts of astronomy, law, and history. From his youth he had begun to collect and write in Galician a series of songs or *Cántigas* in honour of the Virgin Mary, and he commissioned spectacular Castilian manuscripts of these and had them richly decorated. Four of the volumes survive, one in Madrid (from the Cathedral of Toledo and probably the oldest copy), one in Florence (unfinished), and two marvellous volumes which Philip II obtained at great expense from Seville Cathedral for the royal monastery he was building at the Escorial. They are still in the

sixteenth-century library there. The second of these manuscripts has the astonishing total of 1,255 miniatures, usually arranged six to a page with captions in Spanish and ornamental borders (El Escorial, Real Biblioteca de San Lorenzo, Cod. T.j.1). The miniatures illustrate miracles described in the songs (PL. 127). The first page opens with a miniature of King Alfonso himself holding up one of his songs on a long scroll which he points out to his admiring courtiers. The second miniature shows three musicians playing as the king listens to them and dictates words to two clerics who write first on scrolls and then transfer the text and music into a big volume, from which four cantors are singing. The following thousand or so miniatures form an amazing documentary on medieval secular life: singing, fighting, feasting, church building, riding, being shipwrecked, going to church, attending a hanging, stealing money, sleeping, travelling, dying, praying, wrestling, hunting, besieging a city, sailing, painting frescoes (the scaffold collapses but the artist is saved because he was painting the Virgin Mary), giving birth, playing dice, serving in a shop, keeping bees, hawking, bull-fighting, shearing sheep, writing books, frying eggs, ploughing, fishing, and so forth. The manuscript must have delighted the court of Alfonso the Wise.

In France the tradition of illustrating literary manuscripts probably began with versions of the tales of King Arthur. The *Lancelot* romance exists in many forms, including that ascribed to Walter Map, and it brings together the legends of Camelot, the Lady of the Lake, the Holy Grail, and the death of Arthur, which all still form part of our folk culture. About fifty *Lancelot* manuscripts have survived, in various versions (PLS. 2, 126 and 128). One of the earliest illustrated copies of the prose version is Rennes, Bibliothèque Municipale, ms. 255, which can be ascribed to the circle of the royal court in Paris perhaps as early as the 1220s. It comes from that moment in Parisian book production which was discussed in the last chapter, when professional artists moved in to supply the needs of the court on the one hand and the students on the other. In a rhymed preface to a chronicle of Philip Augustus written in the second half of the 1220s (B.L., Add. MS. 21212) the author says he will use French prose 'si com li livres Lancelot', which suggests that such books were well known to his readers. One Parisian bookseller of the mid-thirteenth century signed himself 'Herneis *le romanceeur*', the seller of romances, and added to a manuscript an invitation to his shop in front of Notre Dame in Paris (Giessen, Universitätsbibliothek, cod. 945, fol. 269v).

Other early French romances were copied in Hainault (such as Chantilly, Musée Condé, ms. 472, *Lancelot* and other romances signed by their late thirteenth-century scribe Colin le Frutier, the greengrocer), and in Picardy, especially, it seems, in workshops in Amiens. Two Amiens scribes of romances are known by name. One was Jeanne d'Amiens le Petit, who probably wrote Arras, Bibliothèque Municipale, ms. 139 (verse lives of saints and other texts) in 1278, and another was Arnulfus de Kayo, who signed

Bonn, Universitätsbibliothek, cod. S.526, in Amiens in 1286 (PL. 126). This is a splendid copy of *Lancelot* with over 345 miniatures. It must have been an expensive book to make and it supposes a wealthy patron. A similarly high-class *Lancelot* manuscript whose first owner can be identified from its heraldry is in the Beinecke Library at Yale University (MS. 229), a very fine copy in three volumes illuminated for Guillaume de Termonde (1248–1312), second son of the count of Flanders. The inventory of the possessions of Jean d'Avesnes, count of Hainault (d.1304), includes a Lancelot manuscript described as bound in red, and the will of the count's brother, Guillaume d'Avesnes, who was bishop of Cambrai (d.1296), mentions a 'livre de gestes' which was to be given to the abbey of St-Sépulchre in Cambrai because (the will says) one of the monks had made it. These minor nobles therefore are the kind of people who must have commissioned and enjoyed the romances of King Arthur's knights.

The best-known French romance of the thirteenth century is the *Roman de la Rose*, a huge poem of over 20,000 lines, which was written by two authors who never met each other. The story begins with a lover going to bed one night and dreaming that he has found himself by a stream on a lovely May morning with the sun shining and the birds singing. He is admitted into a garden where he sees and falls in love with the Rose in bud (PL. 129). He is rebuffed in all his advances and only after elaborate adventures and debates with allegorical gods is he finally able to achieve his heart's desire by winning the Rose. It sounds rather trite in this brief summary but in fact is entertaining to read and is crammed with fascinating incident and observation. The first 4,058 lines of the poem were composed about 1230–5 by Guillaume de Lorris, who probably came from Lorris near Orléans and who abandoned his text unfinished. It was then continued and completed after 1268 and perhaps before 1274 by Jean de Meun, who writes a reference to himself into the text. The God of Love is made to appear in the story and to bemoan the death of all the love poets of the past, including his faithful servant Guillaume de Lorris. Then (the God of Love predicts) Jean Chopinel from Meung-sur-Loire will come more than forty years later and will be so fond of the poem that he will try to finish it in order that the knowlege of love may be carried 'through crossroads and through schools, in the language of France, before audiences throughout the kingdom'. Thus another 17,000 lines were added and the poem completed. Jean de Meun (d.1305) was well known as a poet and translator and lived in Paris in the rue St-Jacques, the same street as the Dominican convent and the Sens family of stationers whom we

128 *Left*

London, British Library, Royal MS. 20.D.IV, fol. 260r

This manuscript of *Lancelot du Lac* was illuminated in France around 1300 and belonged to the Bohun family in England by the late fourteenth century. The miniature here shows Lancelot (in the centre, with a white helmet and on a brown horse) fighting a knight who has beheaded a young man and has presented the head and torso to Queen Guinevere. In the border, an ape makes a man perform tricks.

129 *Opposite*

Geneva, Bibliothèque Publique et Universitaire, MS. fr. 178, fol. 1r

The *Roman de la Rose* was by far the most widely read French literary text of the Middle Ages. This copy is signed by its scribe Girart de Biaulieu, cleric of St-Sauveur in Paris, and is dated 1353. The opening page shows the author asleep in bed in front of a tapestry of roses, then waking up and putting on his shoes, walking in the garden, and entering the walled orchard.

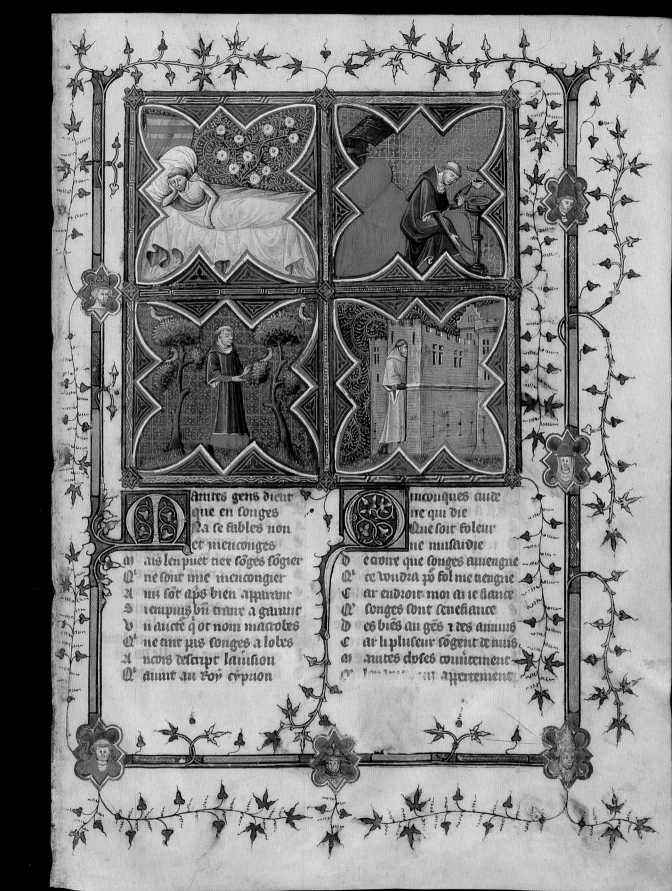

antes gens dient
que en songes
Na se fables non
et menconges

ﾃ ais len puet tier songes songier
Q ne sont mie menconcgier
A nuz sor aps bien apparance
S reaupuis bu tramr a garunt
V n aucte q̃ ot nom matroles
Q ne tint pas songes a lobes
A ncois descript lauision
Q aunit au roy cyprion

unconques auide
ne qui die
Que soit toleur
ne nuisaudie

D e aonre que songes aueugue
Q ue woudra pͦ sol me uengue
C ar endroit moi au ne stance
Q songes sont senesiance
D es biés au gés ⁊ des annuis
C ar li pluseur songent de nuis
ﾃ antes closes couuitement
Q l'ﾢﾢﾢﾢﾢﾢﾢﾢﾢ aut apprtement

met in chapter 4. He was an experienced author fully aware of the value of books 'in the language of France'.

The *Roman de la Rose* was a great success throughout the rest of the Middle Ages. Over two hundred manuscripts are known. Its circulation was perhaps helped by the poem's reputation of having erotic overtones. There is a thirteenth-century glossed Acts, Canonical Epistles, and Apocalypse in the Bibliothèque de Ste-Geneviève in Paris (ms. 75) with a medieval note that its owner, a priest in Senlis, exchanged it for a *Roman de la Rose*. No doubt he hurried away delightedly from the deal. Many copies are beautifully illuminated and at least five have over a hundred miniatures each. Two surviving copies belonged to the Duc de Berry (Paris, B.N., mss. fr. 380 and 12595). One manuscript (Paris, B.N., ms. fr. 2195) is dated at the end 31 May 1361 and includes an acrostic which spells out the name of its scribe as 'Johan Mulot'; this copy was still being enjoyed a century later as it has an ownership inscription of Massiot Austin of Rouen, who says he bought it in June 1470 from a book dealer in Rouen called Gautier Neron, and that if he loses it the finder who returns it to him shall be rewarded with a good pot of wine (fol. 146v). Another *Roman de la Rose* was written at Sully-sur-Loire in 1390 (Paris, Bibliothèque de l'Arsenal, ms. 3337), and the scribe records that he began it on 26 August and worked without a break until 8 November. This is 75 days, which works out at about 290 lines a day.

A fourteenth-century *Roman de la Rose* in the Bibliothèque Nationale includes a charming marginal illustration of a man and a woman sitting at separate desks writing out and illuminating the manuscript with little racks behind them on which the newly-made pages are hanging up to dry (ms. fr. 25526, fol. 77v, PL. 130). These are probably self-portraits of the '*librarius et illuminator*', Richard de Montbaston, bookseller in the rue Neuve-Notre-Dame, recorded in 1342, dead by 1353, and of his wife Jeanne, '*libraria et illuminatrix*', who inherited the business after his death. Their book-trade colleagues in the same street included Geoffroy de St-

Léger, recorded in 1316 and until at least 1337, who was apparently also both a bookseller and an illuminator (his name appears beside miniatures in Paris, Bibliothèque de Ste-Geneviève, ms. 22) and whose identified output was principally literary texts, including three manuscripts of the *Roman de la Rose* attributable to his hand. Among his clients were two queens of France, Clémence of Hungary, second wife of Louis X, and Jeanne of Burgundy, wife of Philip IV. In the same street also lived Thomas de Maubeuge, bookseller recorded between 1316 and 1349, who certainly specialized in French literary texts; among others, he supplied a manuscript for Charles IV in 1327 for the huge sum of £120.

Obviously not all medieval courtly literature was in French, but there is certainly an implication that romances were appropriate in the French language; the word *romance* originally meant simply the vernacular speech of France. Marco Polo's memoirs were almost certainly first written down in French, though the author was a Venetian. Sir John Mandeville's fictional *Travels* were composed in French in order to reach a wider public than in English or in Latin 'pour ce que pluseurs entendent mieulx rommant qe latin' (says the writer, PL. 131). Brunetto Latini, the first great literary figure of thirteenth-century Italy, wrote one of his books, the *Trésor*, in French because he thought this was 'plus delitable et plus commune a tous langages'. The fact that nearly thirty illuminated copies of the text survive shows that he was at least partly right. Obviously many English aristocrats spoke French as their mother tongue, as their Norman ancestors had done. At least one fourteenth-century *Roman de la Rose* seems to have been made in Spain, but in the French language of course (formerly Astor MS. A.12). In Italy too literature in French was quite intelligible. A surprising number of Arthurian romances in French seem to have been written out by Italian scribes in Italy. A really beautiful illuminated example is in Paris, B.N., ms. nouv. acq. fr. 5243, the *Romance of Guiron le Courtois*, one of Arthur's knights, painted in Lombardy or perhaps even Venice in the late fourteenth century. In the mid-

130 *Left*

Paris, Bibliothèque Nationale, ms. fr. 25526, fol. 77v, detail

The lower margin of a mid-fourteenth century *Roman de la Rose* shows a man and a woman sitting at separate desks writing out and illuminating the manuscript with little racks behind them on which the newly made pages are hanging up to dry. These may well be self-portraits of the husband and wife team of booksellers in Paris, Richard and Jeanne de Montbaston.

131 *Opposite*

London, British Library, Add. MS. 24189, fol. 8r

The fictional *Travels* of Sir John Mandeville purport to be an account of a journey to the Far East. This coloured drawing in an eastern European manuscript of the early fifteenth century shows Mandeville's party sailing into Syria and paying a landing tax to the local customs officer.

muto cie non ira morto. oa ii come
ao colin piacque ilqualle essento egli ifi
nito viere per leggie in comutabile ao
tutte le cosse mondane auere fine. Il mio
amore oltre aognialtro feruentemente et i
ilquale mina forza oiproponimento o
oi configho o oiuergogma euitente o
pericolo che seguire nepotesse auea potuto
nerompere nepiegare perse metesimo in

fibile cie sempre ireano allegri. Ene per
quello mossa oa focoso oisio alcuna malinco
nia sopramene nelle loro menti inquelle
conuiene che com gmue noia si oimori se oa
nuoui ragionamenti non e rimossa sanca
chelle sono molto meno forti che gliuomini i
no fostenere ilche vegli mamorati huomini
non aouiene si come noi possiamo apertame
te uevere essi se alcuna malinconia o graueca

132 *Above*

**Oxford, Bodleian Library,
MS. Holkham misc. 49, fol. 5r, detail**

The *Decameron* of Giovanni
Boccaccio recounts the tales told to
each other by a group of young men
and women sheltering together from
the plague in the church of Santa
Maria Novella in Florence. In this
manuscript, made for Teofilo
Calcagni in the Este court of Ferrara
in the third quarter of the fifteenth
century, the young people are
shown gathering for the story-
telling.

133 *Right*

**London, British Library, Yates
Thompson MS. 36, fol. 65r, detail**

The sails are hoisted in the little ship
carrying Virgil and Dante on their
journey to Purgatory in a manu-
script of the *Divine Comedy* made in
Siena in the 1440s for Alfonso V,
king of Naples 1416–58. The initial
here is attributed to the Sienese fres-
co painter Vecchietta and other
miniatures in the volume are
ascribed to Giovanni di Paolo.

134 *Opposite*

**Paris, Bibliothèque Nationale,
ms. it. 74, fol. 1v**

All the levels of Hell are depicted in
this full-page frontispiece in a manu-
script of Dante's *Inferno* illuminated
in Florence *c.*1420–30. This minia-
ture, which is attributable to the
artist Bartolomeo di Fruosino, is
based on a fourteenth-century fresco
in the Strozzi Chapel in the church
of Santa Maria Novella in Florence.

Take vp on me more than ynough
As demen of my self yat I were oon
I wol bileuen yat I am noon
An housbonde shal not ben inquisityf
Of goddes pryuete ne of his wyf
So he may fynden goddes foysou there
Of ye remenaunt nedeth not to enquere
What shulde I more say but the millere
he nolde his wordes for no man forbere
But tolde his cherles tale in his manere
Me forthynketh yt I shal reherse it here
And therfore euy gentil wight I preye
Demeth not for goddes loue yt I seye
Of euel entente but for I mot reherse
her tales alle be they bet or werse
Or ellis falsen som of my mattere
And therfore who so list not to here
Turne ouer the leef and chese another tale
ffor ze shull fynde ynowe grete or smale
Of storyal thyng yt toucheth gentillesse
And eke moralite and holynesse
Blame not me zif yat ze chese amis
The millere is a cherl ze knowe wel this
So was the reue eke and other mo
And harlotrie they tolde bothe two
Avyse zow and put me out of blame
And eke men shal not make ernest of game

Here endeth ye prologe and bigynneth ye tale.

Whilom ther was dwellynge in oxenford
A riche gnof yt gestes heeld to borde
And of his craft he was a carpenter
With hym ther was dwellynge a poure scoler
That hadde lerned art but al his fantasie
Was turned for to lerne astrologie
And coude a certeyne of conclusions
To demen by interrogations
Zif yat men asked hym in certeyn houres
Whan yt men shulde haue drought or shoures

fifteenth century Borso d'Este, duke of Ferrara, wrote asking a friend to dispatch 'as many French books as possible, especially of the story of the Round Table, for I shall receive from them more pleasure and contentment than from the capture of a city.'

Certainly, however, not all Borso d'Este's literature was in French, for by his date there were many great vernacular books in Italian. In 1464 he commissioned a *Lancelot* in Italian, for example, and his friend and courtier Teofilo Calcagni ordered a splendid copy of Boccaccio's *Decameron*, the boisterous tales supposedly told to each other on ten successive days by young men and women taking refuge together from an outbreak of the plague in 1348 (PL. 132). The supremacy of Italian literature goes back, of course, to the great *Divina Commedia*, or *Divine Comedy*, of Dante Alighieri (1265–1321). It is one of the supreme works of mankind. The tremendous power and artifice of Dante's writing is quite unique in all the Middle Ages. As literature, the *Divine Comedy* far eclipses the *Roman de la Rose*, though the texts are more or less contemporary and Dante and Jean de Meun knew each other. It may not be necessary to remind ourselves that the *Divine Comedy* is an account of an astonishing voyage through the underworlds and into heaven itself. The scene opens on Easter Thursday in the year 1300 when the poet has lost his way in a dark wood. He is rescued by the poet Virgil who has been sent by three women, the Virgin Mary, St Lucy, and Beatrice, the girl Dante loved. Virgil escorts Dante right down into the centre of hell, and up through purgatory, and Beatrice herself leads him on into paradise. It is a poem of enormous intelligence and majesty, and it was extremely widely read. Over six hundred fourteenth-century manuscripts survive and probably even more from the fifteenth century (PL. 134). It attracted no fewer than fifteen medieval commentaries, including those by Dante's son Jacopo (written before 1333) and by Jacopo della Lana, Guido da Pisa (PL. 136) and others. From the distribu-

tion of manuscripts one can guess that the text was especially popular in Florence in the mid-fourteenth century and again around 1400. Some manuscripts are very grand productions (like those owned by the Visconti family in Milan and the Aragonese royal library in Naples, PL. 133, or the amazing late fifteenth-century unfinished copy with full-page drawings by Botticelli), but others are quite humble in execution and are quite often written on paper. The first dated illustrated copy was written out in 1337 by Ser Francesco di Ser Nardo da Barberini (Milan, Biblioteca Trivulziana, MS. 1080) and was illuminated in Florence by the artist known as the Master of the Dominican Effigies. The legend is that Ser Francesco provided dowries for his daughters by writing out a hundred manuscripts of the *Divine Comedy*, and it is curious that there are at least three other copies so closely related to the signed manuscript in their script and decoration that they must all have been produced together: Florence, Biblioteca Medicea-Laurenziana, MS. Strozzi 152; Florence, Biblioteca Nazionale, MS. Palat. 313; and New York, Pierpont Morgan Library, M.289. The proceeds of even a few such books would make any daughter worth chasing.

Judged simply as luxury manuscripts for aristocratic self-indulgence, copies of Geoffrey Chaucer's *Canterbury Tales* come a poor third after the *Roman de la Rose* and the *Divine Comedy*. This text too describes a journey and the stories told by pilgrims as they travel the fifty miles or so from Southwark in London to the shrine of St Thomas Becket in Canterbury Cathedral. There exist about eighty-five manuscripts of all or part of the *Canterbury Tales*, but they are not lavishly illustrated like the French or Italian romances. Only one, the famous Ellesmere Chaucer (San Marino, Huntington Library, MS. EL.26.C.9), has marginal illustrations of the twenty-three pilgrims who recounted stories in the text, and two others (Cambridge University Library, MS. Gg.4.27, and the fragments

135 *Opposite*

Lichfield, Cathedral Library, MS. 29 (2), fol. 41v

Manuscripts of Chaucer's *Canterbury Tales* were frequently illuminated but seldom illustrated. This copy was probably made in London in the second quarter of the fifteenth century, and shows here the opening of the Miller's Tale.

136 *Right*

Chantilly, Musée Condé, ms. 1424, fols. 113v–114r, detail

The naked souls of the damned appear here in the margins of a manuscript of Guido da Pisa's commentary on Dante's *Inferno*, probably made in Pisa, c.1345.

157

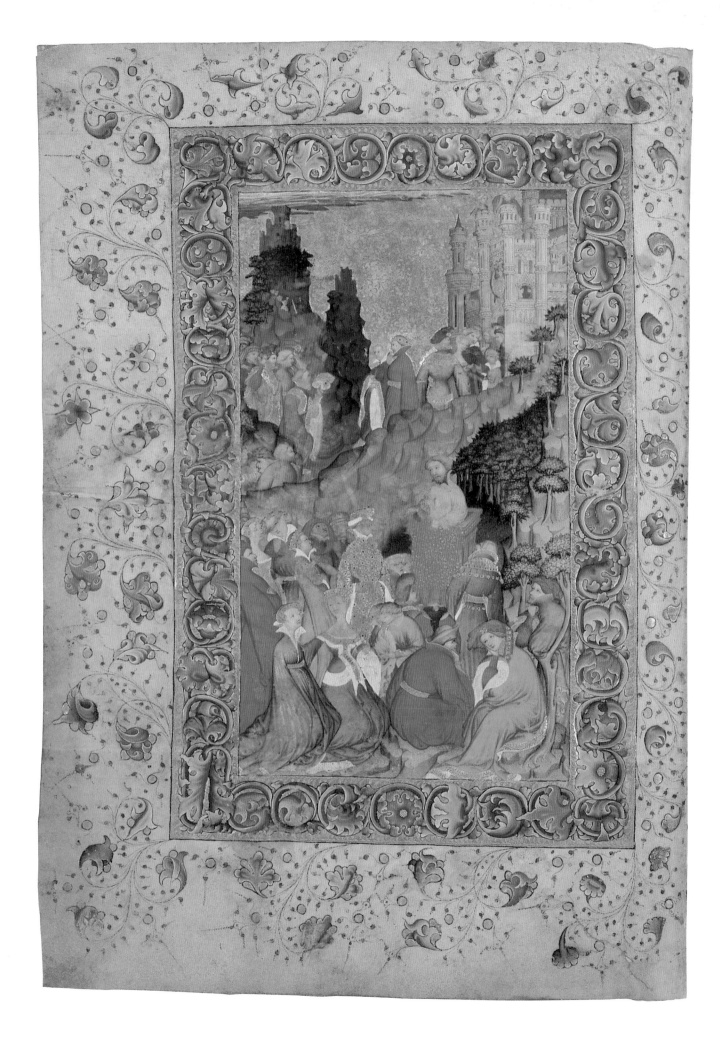

now in Manchester and Philadelphia) perhaps once had similar pictures which have now mostly disappeared. B.L., Harley MS. 1758 has blank spaces for miniatures which were never added. All the other manuscripts are without illustrations (PL. 135), and a third of them are written on paper.

It is difficult to know how to interpret the fact that there was no developed tradition of illumination for secular texts in England as there was in France and Italy. Perhaps the tales were meant for reading out loud and pictures would have been superfluous if the poems were ever recited in public as shown in the famous frontispiece to Chaucer's *Troilus and Criseyde* in Cambridge, Corpus Christi College, MS. 61, where the author declaims from a lectern in the midst of an aristocratic picnic (PL. 137). This miniature, however, is French in style and must represent a courtly ideal rather than a common practice. It seems likely that literary patronage was simply different in England. There were almost no great English aristocratic art collectors in the lifetime of Chaucer (*c*.1340–1400), except perhaps Richard II himself, whose little library in 1384–5 mainly comprised Arthurian romances in French and a *Roman de la Rose* (valued at one pound), all inherited from his grandfather. Chaucer himself probably translated the *Roman de la Rose* but the text never became popular and no complete copy is

known (PL. 138). This may be partly because English aristocrats could as easily enjoy it in French as in English, and partly because the English book trade developed more slowly than its continental counterparts. Though gradually more facts are emerging about the London book trade in the late Middle Ages, especially after the formation in 1403 of the Mistery of Stationers, a combined guild of scribes and illuminators, there were certainly no great shops for the commercial illustration of secular books. Some of the most important manuscripts of Chaucer were demonstrably written out by part-time scribes whose principal occupations were in the royal chancery and elsewhere. The two earliest references to copies of the *Canterbury Tales* in English wills date from 1417 and 1420. The first belonged to Richard Sotheworth, a priest and chancery clerk, and the second to John Brinchele, a London tailor. It is interesting that Sotheworth came from Canterbury and was Master of Eastbridge Hospital there, and Brinchele is recorded as living in Southwark: thus these two middle-class owners of manuscripts lived at either end of Chaucer's fictional journey. They may have had very local reasons for buying the text.

The old unanswered question which has haunted linguists for generations is to decide at what time national languages came into common use and when (and why) they were first written down,

1 3 7 *Opposite*

Cambridge, Corpus Christi College, MS. 61, frontispiece

This miniature forms the frontispiece to a manuscript of Chaucer's *Troilus and Criseyde* of the very beginning of the fifteenth century. It shows Chaucer himself in a pulpit in the centre reciting his verse in the open air to a party of aristocrats sitting and standing in a glade beside a fantastic Gothic castle.

1 3 8 *Right*

Glasgow, University Library, MS. Hunter 409, fol. 57v

Chaucer's *Romaunt de la Rose* is a translation into Middle English verse of the *Roman de la Rose* of Guillaume de Lorris and Jeun de Meun. As a work of popular literature, the text was evidently not a success, and this imperfect manuscript of about 1450 is the only copy to have survived.

since all education came from the Church and all churchmen knew Latin. It is frequently said that women had an important role in promoting vernacular writing because girls were not customarily taught Latin as thoroughly as boys. It is quite true that vernacular prayer-books can often be traced to nuns rather than to monks, for example. One cannot tell who gathered round the poet who recited epics by the fire after dinner in the medieval hall, but women may well have been there. In 1252 the queen's chamber at Nottingham Castle was painted with scenes of Alexander the Great. The audience listening to Chaucer in the *Troilus and Criseyde* manuscript mentioned above includes nine women, and it is doubtful whether they would have been so attentive if the lecture had been in Latin. In fact, the earliest dated Lancelot manuscript must have been written by a female scribe (Paris, B.N., ms. fr. 342). It was made in 1274 and ends with the request that the reader will pray for the scribe, 'pries pour ce li ki lescrist'; 'ce li' is a feminine pronoun.

The aristocratic patronage of manuscript illuminators in the court of France in the first half of the fourteenth century was often associated with women. A major patron, for example, was Mahaut, countess of Artois (d.1329), great-niece of St Louis and mother of Queen Jeanne of Burgundy. From at least 1305 until 1327 she commissioned many secular romances and in many cases her account books supply us with the cost or the values of the manuscripts. These include not only the Marco Polo with which we began this chapter (written in Mahaut's own castle of Hesdin in 1312), but also a *Histoire de Troie* and a *Roman de Perceval* which she bought in Arras for £7.1s. in 1308, a *Voeux de Paon* and a *Vie des Saints* bought from the Paris bookseller Thomas de Maubeuge for £8 in 1313, and a *Bible en francois* bought from the same bookseller for no less than £100 in 1327. Noblewomen were the patrons of other well-known manuscripts. They included Jeanne d'Evreux, Blanche de France (daughter of Philip V), Jeanne de Belleville, Jeanne de Navarre, Bonne of Luxembourg, and Yolande of Flanders. By no means all their manuscripts were secular romances (many were prayer-books) but their support strengthened the tradition of expensive manuscript illumination which merged with a passion for vernacular literature during the reigns of John II (1350–64) and Charles V (1364–80).

By the mid-fourteenth century a great many massive folio texts were being translated into French and richly illuminated for aristocratic libraries. They included weighty texts such as Boethius, Vegetius, Livy (PL. 140), Aristotle, and St Augustine, all translated into French. A rather surprising success was an adaptation of Peter Comestor's *Historia Scholastica*, a twelfth-century university textbook which enjoyed a remarkable revival among the newly literate nobility of the fourteenth century. It consists of a summary of the historical sections of the Bible which, like the legends of Troy or Alexander, include some first-rate stories. The *Historia Scholastica*, or *Bible Historiale* in French, was translated by Guyart des Moulins,

139 *Above*

London, British Library, Royal MS. 15.D.III, fol. 398v, detail

Here Jonah is cast up out of the mouth of the whale. This is one of over a hundred miniatures of the Old and New Testaments in a luxurious copy of the *Bible Historiale* made in Paris *c.*1415 and certainly in England by the mid-fifteenth century. The miniature here is attributable to the workshop of the Egerton Master.

140 *Opposite*

Paris, Bibliothèque de Sainte-Geneviève, ms. 777, fol. 316r

This royal copy of Livy's history of Rome translated into French by Pierre Bersuire was illuminated in Paris about 1370. It belonged to Charles V, king of France 1364–80, and later, after the defeat of France by the English, to Henry V's two brothers, John, Duke of Bedford, and Humfrey, Duke of Gloucester. The miniatures here show the Romans sending a declaration of war to Philip V of Macedon, landing in Macedon, enlisting the support of neighbouring kings, and going into battle.

canon and later dean of St-Pierre d'Aire (about thirty miles south-east of Calais), in the four years leading up to February 1295, and it was revised by him before about 1312. Over seventy manuscripts of the text are known, mostly richly decorated (PL. 139). The earliest is a single volume in the British Library (Royal MS. I.A.XX) which is dated in Paris in 1312 by a scribe Robert de Marchia who says in the colophon that he is in prison. It is not a beautiful manuscript (perhaps his cell was uncomfortable) but it nevertheless has forty-eight miniatures. Five years later, Bibliothèque de l'Arsenal, Paris, ms. 5059 was written and signed by the scribe Jean de Papeleu in the rue des Ecrivains in Paris. This is no rough production: it has 176 fine miniatures and is of excellent quality. Another copy with ninety-three miniatures belonged to John II of France and has an extraordinarily dramatic provenance (PL. 141). According to an early fifteenth-century inscription on the verso of its flyleaf (B.L., Royal MS. 19.D.II), it was captured from King John at the Battle of Poitiers on 19 September 1356 and was bought for 100 marks (just over £66) by the constable of the English army, William de Montacute, earl of Salisbury, as a present for his wife Elizabeth, and when she died in 1415 her executors resold it for £40. It is a massive book, 16½ by 11¼ inches (420 by 285mm), with 527 leaves which were probably originally bound in three volumes, and it is interesting to visualize the king of France struggling onto the battlefield with such a manuscript under his arm.

The loss of this *Bible Historiale* was soon made up in the French royal court, however. In 1371 Charles V was given another glorious copy, which is now in the Rijksmuseum Meermanno-Westreenianum in The Hague (MS. 10.B.23). Its full-page frontispiece by Jean Bondol shows Charles V himself sitting in an armchair and gazing admiringly at an illuminated manuscript which a kneeling courtier holds open for him to read the beginning of Genesis in French (PL. 121). At the end of the text is a long French poem explaining to the king that the manuscript was presented to him by his servant Jean Vaudetar, who is shown in the miniature, and that (says the poet) never in his life has he seen a *Bible Historiale* decked out like this with portraits and events by one hand, for which (the verse continues) he went backwards and forwards, night and morning, through the streets and often with rain falling on his head, before it was finished. Perhaps he should not have bothered to go to all this effort. The copy of the *Bible Historiale* which the royal family really liked must have been Paris, B.N., ms. fr. 5707, dated 1363, which has autograph ownership inscriptions on one regal page (fol. 367v) signed by Charles V, the Duc de Berry, Henri III (1574–89), Louis XIII (1610–43), and Louis XIV (1643–1715).

The great fascination of the *Bible Historiale* was not only that it was scriptural but also that it was historical. It might be fairer to call it a chronicle of biblical history. Medieval aristocrats loved history, and history (like Bible stories, saints' lives, and oriental travel) mingled with romance, especially when rendered 'de latin

141 *Left*

London, British Library, Royal MS. 19.D.II, fol. 5v, detail

This manuscript of the *Bible Historiale* belonged to John II, king of France 1350–64, and was captured from him when he was defeated by the Black Prince at the Battle of Poitiers in 1356. William de Montacute, earl of Salisbury (1328–97), who fought in the Battle, purchased it for 100 marks. The miniature here shows God creating the animals and Adam.

142 *Opposite*

Paris, Bibliothèque Nationale, ms. fr. 301, fol. 147r

The *Histoire Ancienne jusqu'à César* is an account of the history of the ancient world, written like a Gothic romance. In this full-page miniature the Greeks, dressed as medieval knights, bring the wooden horse into Troy and subsequently sack the city and put the Trojans to the sword. This vast manuscript belonged to the Duc de Berry, who purchased in it Paris in April 1402.

en romans', as Pierre Bersuire put it in the heading of Livy's history which he translated for John II in the 1350s. Romantic history took several forms. The first was ancient history. Here fact became entangled with legends of the fall of Troy and of Alexander the Great. The *Histoire Ancienne jusqu'à César*, a romantic account of ancient heroes and battles, was composed between 1206 and 1230 and survives in nearly forty manuscripts (PL. 142). Three of these were actually made in Acre in the Holy Land during its occupation by the crusading forces: Brussels, Bibliothèque Royale, ms. 10175, Dijon, Bibliothèque Municipale, ms. 562, and B.L., Add. MS. 15268. It is pleasant to think of crusaders reading up their ancient legends while they were out in the Middle East. Even Troy cannot have seemed far away as they gazed out on the eastern Mediterranean over the ramparts of Acre. Trojan history had an extraordinary fascination for the medieval aristocracy (cf. PL. 144), and Guido delle Colonne's *Historia Destructionis Troiae* (completed in 1287) was adapted and translated into almost every vernacular language, including Icelandic. The English claimed that their country had been founded by refugees from the sack of Troy, and they derived the name 'Britain' from Brutus, a Trojan prince whose story begins the *Brut Chronicle*, the best-known Middle English history book. The first book ever printed in the English language was a Trojan history, *The Recuyell of the Histories of Troy*, published in Bruges by William Caxton probably in 1473–4 and issued under the patronage of Margaret, duchess of Burgundy. The Burgundian ducal family were passionate admirers of Troy, and Philip the Good owned at least seventeen manuscripts tracing his own descent from the Trojans.

The great patriotic chronicle in the French court was the *Grandes Chroniques de France*. It too opens with the siege of Troy but quickly moves to the history of the Franks and the chivalric descent of the French kings (PL. 143). The text was compiled in the royal abbey of St-Denis in the mid-thirteenth century and was translated into French in 1274. It is extravagantly partisan, and obviously caught the imagination of the kings of France, who made sure it was updated from time to time to include themselves. They presented luxurious copies to visiting kings and dignitaries. It was the favourite reading of Charles V. The Duc de Berry owned several copies, including one he had originally borrowed from St-Denis to show to the Emperor Sigismund. More than a hundred manuscripts have survived and it became the first dated French book to be printed (Paris, 1476).

Only slightly more serious history was represented by the *Speculum Historiale*, or 'Historical Mirror', by Vincent of Beauvais (*c.*1190–*c.*1264). Vincent was an immensely hardworking Dominican encyclopedist and protégé of King Louis IX. His huge compilation on the history of the world comprises thirty-one books divided into 3,793 chapters and begins with the creation of the world and ends with the Crusade of Louis IX in 1250. The early manuscripts are in Latin and not illustrated. Curiously, the first translation was not into French, the usual channel by which academic texts passed into romance, but into Middle Dutch, the *Spieghel Historiael*, a verse adaptation prepared in the 1280s by Jacob van Maerlant at the request of Florent, count of Holland. The only surviving manuscript was made about 1330 (The Hague, Koninklijke Bibliotheek, MS. KA.XX) and has 43 miniatures

143 *Opposite*

London, British Library, Cotton MS. Nero E.II, vol. I, fol. 131v, detail

The French royal family commissioned manuscripts of the *Grandes Chroniques de France* as diplomatic presents and for their own delight. This copy, illustrated by the Boucicaut Master *c.*1415, contains the French royal arms but is not identifiable in the king's inventory and may therefore have been intended as a gift. The miniature here shows Charlemagne returning to France after the death of Roland.

144 *Right*

Paris, Bibliothèque Nationale, ms. fr. 782, fol. 2v, detail

In the prologue to his *Roman de Troie*, Benoît de Sainte-Maure tells that Cornelius, the nephew of Sallust, discovered a whole cupboard full of ancient Trojan romances while he was looking for a grammar. This manuscript of the *Roman de Troie*, written in Italy in the early fourteenth century, illustrates the tantalizing book cupboard itself.

· Cornelus ·

145 *Left*

The Hague, Koninklijke Bibliotheek, MS. KA.XX, fol. 213v

The earliest translation of Vincent of Beauvais's *Speculum Historiale* was into Middle Dutch. It was prepared by Jacob van Maerlant at the request of the Count of Holland. The only surviving manuscript of this *Spieghel Historiael*, written about 1330, illustrates here the battle of Charlemagne and Roland.

146 *Opposite*

Paris, Bibliothèque de l'Arsenal, ms. 5080, fol. 341v, detail

The *Speculum Historiale* was translated into French in 1332 by Jean de Vignay at the request of Jeanne de Bourgogne, queen of France. This copy of the *Miroir Historiale*, as the translation was called, was made very soon afterwards, *c.* 1335, for her son, John the Good, then aged about 16, afterwards king of France. It later passed to the libraries of Charles V and Charles VI.

(PL. 145). A French edition was translated by Jean de Vignay at the request of Jeanne de Bourgogne, queen of France, and was completed in November 1332. Almost at once it became one of the great illustrated books. A copy in four volumes was made about 1335 for Prince John (later John II, king of France 1350–64), who must have been about sixteen when the manuscript was given to him. One surviving volume alone from this copy, now in the Bibliothèque de l'Arsenal (ms. 5080, Plate 146), has no fewer than 450 miniatures. It remained in the French royal library and is one of five sets of the *Miroir Historial*, as they called it, in the inventory of the library of Charles V, mostly described as 'très bien hystoriez', which means well illustrated. A version by William Caxton, *The Mirror of the World* (Westminster, 1481), is in fact the first English book printed with illustrations.

It is difficult to know exactly why vernacular manuscripts came to be illustrated so grandly. It is in marked contrast to the humble little troubadour texts of the twelfth century. Aristocratic owners loved Gothic miniatures, and a French *Bible Moralisée* made for John II of France in the mid-fourteenth century has the scarcely credible total of 5,122 miniatures. There is certainly enormous charm in the delicate little figures with swaying hips, like Gothic carvings, and the abstract tessellated backgrounds. French secular texts usually have almost square miniatures set into one column of a double-column

text. They are sometimes within cusped architectural frames in red, white, and blue, the colours of the French royal family. Often formal ivyleaf borders run up and down the margins, sometimes terminating with tiny butterflies or imaginary animals. The first page of a French romance often has a half-page composition formed of four smaller miniatures placed together, and sparkling ivyleaf borders surround the page. In Germany, Italy, and England miniatures are no less frequent, but tend to be more informally placed on the pages. They are often without frames and spill over across the columns or even along the lower margins.

These were books for aristocrats. The manuscripts were probably originally intended to be carried in by the librarian, bound in beautifully coloured silks, and placed on a lectern so that the owner might listen to readings from his favourite authors. The miniatures are probably not much more than decoration to be admired as the reading was going on. A statute of the Sienese painters' guild of 1356 describes the purpose of painting as being for 'those who do not know how to read'. It is too harsh to say that aristocratic owners were illiterate, but there are gradations of literacy, and for any inexperienced reader illustrations convey scenes and atmosphere which someone reading fluently and fast can gain from the text. Pictures of battles and ships and kings and lovers convey pleasure to those who see them, and perhaps after all the main purpose of a romance is to provide enjoyment.

VI

Books for Everybody

No one has ever counted up how many Books of Hours still exist. It would be possible to do (and very useful) but would require patience, as Books of Hours are now more widely scattered around the world than any other object made in the Middle Ages. Though fair numbers of them have ended up in major national libraries (something over 300 each in the British Library and in the Walters Art Gallery in Baltimore and more in the Bibliothèque Nationale in Paris), these manuscripts have always been rather despised by serious librarians and have been enormously admired by private collectors. That is exactly why Books of Hours were made. They were not for monks or for university libraries but for ordinary people. They are small and usually prettily decorated books. They were intended to be held in the hand and admired for their delicate illumination rather than put on a library shelf and used for their text. They still appeal enormously to bibliophiles. A Book of Hours is almost the only medieval work of art which a moderately wealthy collector today can still hope to own. At least at the moment, a single leaf from a manuscript Book of Hours need be no more expensive than the book you are now reading. It is an extraordinary tribute to the energy and industry of those who produced Books of Hours that even now, five hundred years later, their manuscripts have still not quite disappeared from circulation in the bookshops. The enchanting miniatures in Books of Hours are often reproduced now for Christmas cards and postcards: we all take delight in the scenes of shepherds singing under a festive sky (PL. 150), the Flight into Egypt by starlight past fairytale castles and fantastic landscapes, and in borders of flowers and animals sparkling with gold and colour. It is a very direct appeal, and a very old one. The poet Eustache Deschamps (1346–1406) describes the bourgeois wife who feels she is not properly fitted out unless she owns a Book of Hours, beautifully made, illuminated in gold and blue (says the poem), neatly arranged and well painted and bound in a pretty binding with gold clasps. It was the first time that any kind of book became really popular, even among people who had never owned books before. The very great appeal of Books of Hours was understood by the medieval booksellers, who manufactured and sold these volumes in immense numbers.

Books of Hours today are probably most famous for their association with the names of great medieval aristocrats, like the Duc de Berry (1340–1416) and Mary of Burgundy (1457–82, PL. 170), and it is certainly true that the patronage of the immensely rich nobility must have given a great boost to the fashion for owning illuminated manuscripts. It must have made a few artists very rich too. But the Duc de Berry, for example, would not have seen himself primarily as a collector of Books of Hours: he owned about 300 manuscripts, of which only 15 were Books of Hours, 16 were Psalters, and 18 were Breviaries. He also possessed at least ten castles, 50 swans, 1,500 dogs, a monkey, an ostrich, and a camel. It is fair to suggest that it was hardly a typical household. He probably commissioned books like other art treasures through an agent such as Jacques Rapondi, a member of a great family of international brokers and merchants originally from Lucca in Tuscany. The Duc de Berry probably never entered a bookshop, and manuscripts painted for him are untypical for many reasons. His greatest manuscript, the *Très Riches Heures* (now in the Musée Condé at Chantilly,

147 *Previous page*

Baltimore, Walters Art Gallery, MS. W. 294, fols. 67v–68r

A Book of Hours is a lay person's prayer-book, which would be read at home or carried about on special occasions. This example, made in northern France about 1500, survives in its attached chemise cover of red velvet with its edges sewn in silver thread. The velvet would wrap around the manuscript when the book was closed up.

148 *Above*

Vienna, Österreichische National-bibliothek, Cod. 1897, fol. 243v

Margaret Tudor (1489–1541), daughter of Henry VII, is shown here kneeling at her devotions in the Book of Hours made for her and her husband, James IV, king of Scotland 1488–1513. The manuscript was made in Ghent or Bruges probably soon after their marriage in 1503. The artist, named the Master of James IV from this manuscript, is perhaps to be identified as Gerard

Horenbout, who probably later came to England in the service of Henry VIII.

149 *Opposite*

New York, Pierpont Morgan Library, M.945, fol. 107r

This is from the Hours of Catherine of Cleves, Duchess of Guelders (1417–76), illuminated probably in Utrecht, c. 1440. This is the opening page for the office of Compline for use on Mondays. The miniature shows an angel leading naked souls from the jaws of Hell, and in the lower border a man is trying to catch birds in a noose, using two caged birds as decoys.

PL. 151) is famous precisely because it is such a freak. It is far bigger and far richer than any normal Book of Hours, and it was left unfinished when the duke died.

For the present chapter it will be more useful to leave aside the very opulent royal Books of Hours and to consider the more typical manuscripts which any well-to-do medieval family might have purchased. A Book of Hours is a compendium of different devotional texts which the owner could read in private. One learns to recognize each of the separate sections of a Book of Hours. This is quite easy to do. The core of the manuscript (usually about a third of the way through the volume) comprises the Hours of the Virgin: a standard series of prayers and psalms intended to be used in honour of the Virgin Mary at each of the canonical hours of the day. These are Matins, Lauds, Prime, Terce, Sext, None, Vespers, and Compline. It is because of these that the text is called a 'Book of Hours'. Each one begins at least with a big illuminated initial and generally with a painted illustration too. They are almost always in Latin. Matins starts 'Domine labia mea aperies' ('Lord, open thou my lips') and goes on 'Et os meum annunciabit laudem tuam' (PLS. 152 and 162–3) 'And my mouth shall show forth thy praise' – to use the translation which is still used in Matins in the English prayer-book). All the other hours, except Compline, begin 'Deus in adiutorium meum intende' (PLS. 150, 156 and 160, 'God make speed to save me'). Sometimes the words are abbreviated but they should always be recognizable. They occur below the miniatures on all those Christmas cards reproduced from manuscripts. Compline, which is the last hour of the day, begins 'Converte nos deus salutaris noster' (PLS. 149, 161 and 181–2, 'Direct us, God of our salvation'). Each of the hours, then, consists of a very short hymn, psalms (usually three of them – such as Psalms 119 to 121 at Terce, or 122 to 124 at Sext), a brief reading or *capitulum* (chapter) and a prayer. All these are interspersed with sentences headed with '*Ant.*', '*V.*', and '*R.*'. These are the antiphons, versicles, and responses and they can differ greatly from one manuscript to another.

The owner of a Book of Hours was meant to stop eight times a day and read the appropriate text, probably speaking it quietly under the breath. There are certainly some contemporary descriptions of people doing exactly this. Some Books of Hours include miniatures showing their owners using the manuscripts themselves (PL. 148). Monks and nuns, of course, were obliged to read their Breviary the same number of times a day, and the central text of a Book of Hours is basically only a shorter and lay version of the same round of monastic prayers. Cynics will ask whether Books of Hours were really used much. We do not know the answer. The fifteenth-century theologian Jean Quentin advised lay people to recite at least Matins and Prime upon waking in the morning before leaving the bedchamber. Some existing manuscripts are in such fresh condition that it is difficult to imagine that they were read often, but perhaps the examples that survive are just the

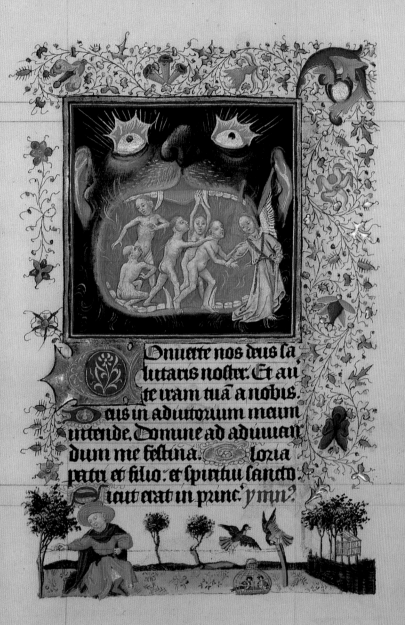

Onuerte nos deus sa
lutaris noster. Et au
te iram tuã a nobis.
eus in adiutorium meum
intende. Domine ad adiuuan
dum me festina. loria
patri et filio: et spiritui sancto.
iait erat in princ' ymn?

150 *Right*

Private collection, s.n., fol. 71r

The Annunciation to the Shepherds
marks the opening of the Hour of
Terce in a Book of Hours illuminat-
ed in Paris about 1410. The shep-
herds gaze up at an angel breaking
through the scarlet sky with a scroll.

151 *Opposite*

**Chantilly, Musée Condé,
ms. 65, fol. 195r**

The *Très Riches Heures* of the Duc de
Berry is one of the best-known man-
uscripts in the world, and yet it was
completely unknown until the mid-
nineteenth century. It was conceived
on a scale infinitely grander than
that of any other known Book of
Hours. It was illuminated by the
Limbourg brothers for the Duc de
Berry between about 1411 and 1416
when it was abandoned unfinished.
This miniature, for the Mass of
St Michael, shows the archangel bat-
tling with the devil above a beautiful
and still recognizable view of Mont-
Saint-Michel in Normandy.

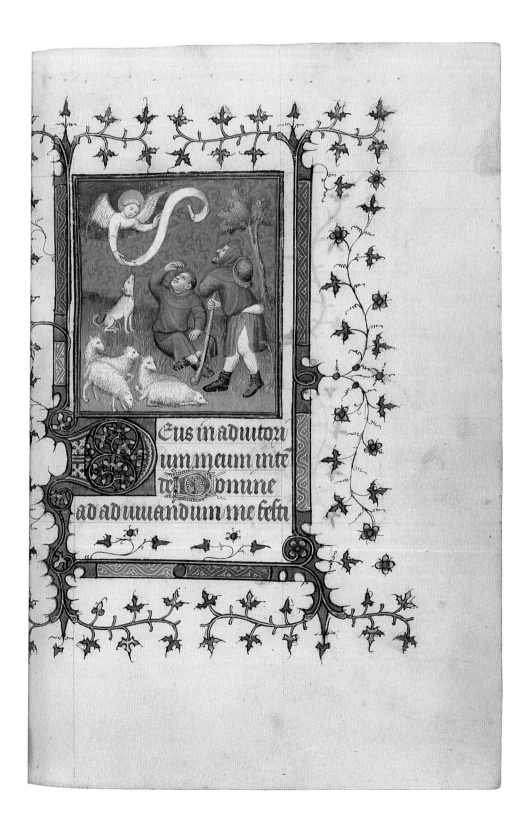

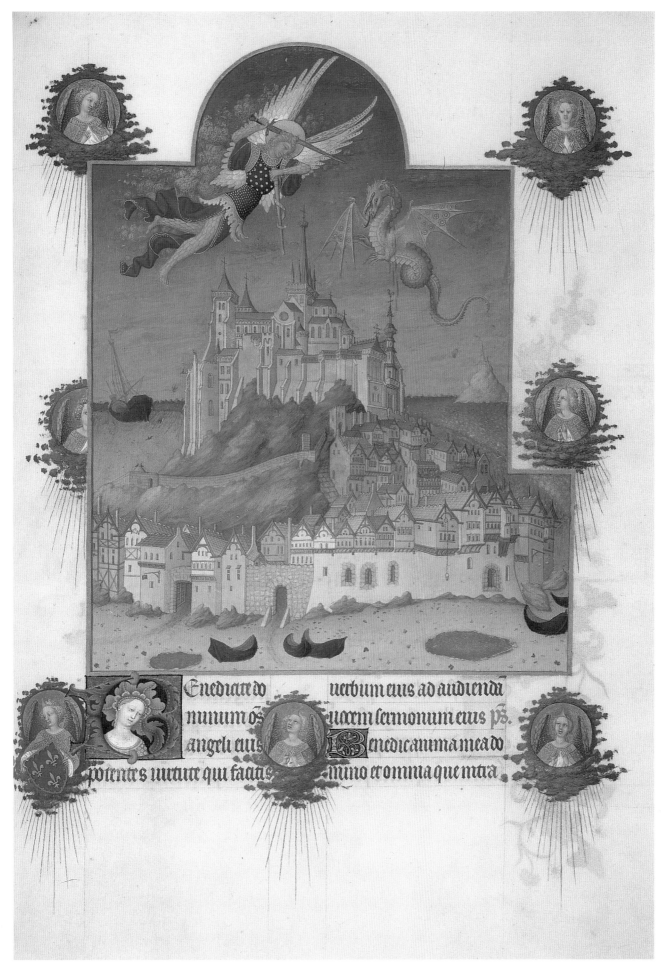

exceptions; possibly the ordinary copies were simply read to pieces. It sounds a great nuisance to have to go through a whole service so often in the day, but in fact you can experiment with reading a Book of Hours aloud and it takes only about three and a half minutes to mumble through one of the shorter offices.

Other fundamental texts in a Book of Hours are as follows. Manuscripts almost always open with a calendar of the Church year, listing saints' days for each month and headed with an illuminated 'KL' at the top of the page (PL. 159). Ordinary saints' days are usually written in black ink and special feasts are in red ink (this is the origin of the term 'red-letter day'). A pretty variation (characteristic of Paris and later of Rouen also) is for the saints' names to be written alternately in red and blue throughout with the important festivals written in burnished gold. Then there are

sometimes short texts between the end of the calendar and the Hours of the Virgin. Often these comprise four short readings from the Gospels and two prayers to the Virgin which are known from their opening words as the 'Obsecro te' and 'O intemerata'. Following the Office of the Virgin in a Book of Hours we can expect more texts. Again these vary, according to date and region and (very probably) just how much a customer was prepared to pay. The most easily recognizable are the Penitential Psalms with a Litany, and the Office of the Dead. The Penitential Psalms are seven in number (Psalms 6, 31, 37, 50, 101, 129, and 142, PLS. 175–6) and are all on the theme of the sinner seeking forgiveness. The Litany is an exceedingly ancient incantation. It lists a whole series of saints' names followed by 'OR', which is 'ora pro nobis', pray for us:

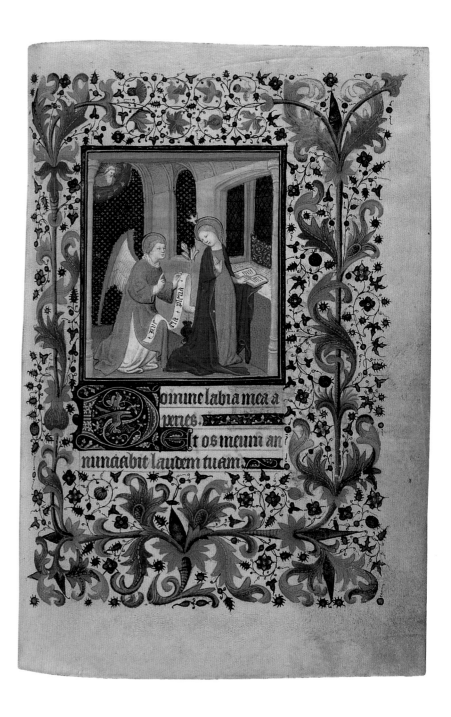

152 *Right*

Japan, private collection, s.n., fol. 27r

Matins in a Book of Hours almost always opens with a miniature of the Annunciation, usually with the Virgin Mary looking up from reading her own book of devotions to see the archangel Gabriel greeting her and bringing news that she is to become the mother of the Saviour. This Book of Hours was painted in Paris in the workshop of the Boucicaut Master, *c.*1412.

Holy Mother of God – pray for us,
Holy Virgin of Virgins – pray for us,
St Michael – pray for us,
St Gabriel – pray for us,

on so on, including angels and archangels, apostles and evangelists, martyrs, confessors and virgins, and then pleas such as

from hardness of heart – Good Lord deliver us,
from lightning and tempest – Good Lord deliver us,
from sudden and unexpected death – Good Lord deliver us.

It is a very emotive text, going right back to the earliest Christian liturgy and associated with the Penitential Psalms from at least the

tenth century. The fear of sudden death was a real one in the Middle Ages, plague and warfare being always imminent. One can see during the fifteenth century the development of the obsessive fascination with death, the skeletal spectre attacking indiscriminately (PL. 153), and with the symbols of death which remind us all of our mortality. This brings us to the Office of the Dead in a Book of Hours. It is a long section usually towards the end. It is a comparatively late element in medieval piety in that, though its origins go back to the ninth century, it hardly came into general use until the thirteenth century. The Office of the Dead comprises further psalms and readings primarily intended to be said around the bier of a dead person (PL. 155), but also recited daily as a reminder of one's mortality and (as some thought) as a protection against dying suddenly and unprepared.

153 *Right*

Private collection, s.n., fol. 72r

The legend of the Three Living and the Three Dead tells of three young men who were out riding one day. Suddenly three skeletons appeared. 'Who are you?', the young men asked and the skeletons replied, 'We are you when you are dead.' Their meeting is shown here at the opening of the Office of the Dead in an eastern French Book of Hours of *c.* 1490.

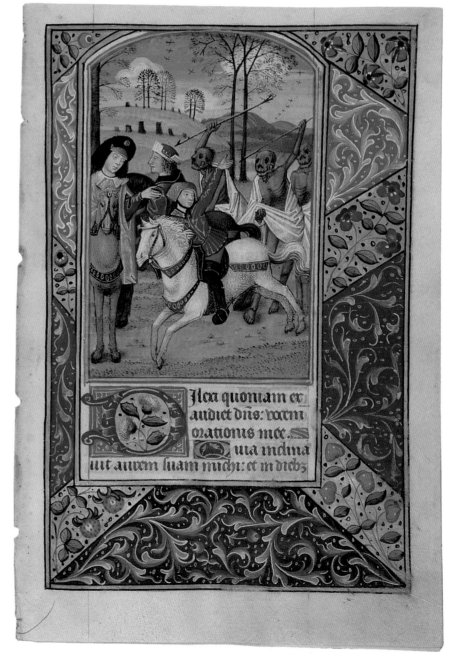

These are some of the essential elements in a Book of Hours. The selection varies enormously, however. Some manuscripts are huge devotional compilations, which must have rested almost permanently on a lectern, while others are very small and portable and were certainly carried about during the day. Many manuscripts include short rounds of Hours of the Cross and Hours of the Holy Ghost (PL. 154). Frequently they include prayers to particular saints, known as the Memorials (or Suffrages) of the Saints. These generally come right at the end. Other prayers may include two in French, the *Quinze Joyes* (PL. 173) and the *Sept Requêtes*. One also finds eccentric little texts like the verses of St Bernard, sometimes preceded by an anecdote explaining their origin. One day (the rubrics in the Book of Hours tell us) the Devil appeared to St Bernard and boasted that he knew of seven special verses in the Psalms so efficacious that whoever recited them daily could not die in sin. St Bernard cried, 'What are they? Tell me at once!' 'I shan't', said the Devil, 'You shall not know them.' St Bernard then replied that he would have to recite the entire Psalter every day in order to be sure of including the seven magic verses, and the Devil, fearing that this excessive devotion would do too much good, quickly revealed the verses.

Because a Book of Hours was not an official Church service-book of any kind but a compendium largely made by secular booksellers for use at home by the laity, variations (and mistakes) abound. The makers of Books of Hours added what was required by the customer rather than by some Church authority. To the modern social historian there can be great interest in these peculiar prayers grafted on to the end of the essential Book of Hours text. St Margaret was invoked during childbirth, St Apollonia was called upon by sufferers from toothache (a historically minded dentist could do a fascinating survey plotting in which parts of Europe these prayers occur most), and credulous incantations and extravagant offers of thousands of years' indulgence for the use of some little prayer all have their place in coming to an understanding of lay piety in the fifteenth century. The fact is that Books of Hours were extremely popular. Families who had never owned another manuscript went out to purchase a Book of Hours. Manuscripts are sometimes crammed with added dates of domestic births and deaths and christenings, like the Victorian family Bibles. We can gauge something of the vast market for Books of Hours from the fact that when printing was invented there were at least 760 separate printed editions of Books of Hours published between 1485 and 1530. When we think that surviving manuscript copies are even more numerous than printed versions, we realize that even more must have been produced by hand than were ever printed. It was the basic book for medieval households. Some of its texts (almost forgotten today) must have been known by heart by half Europe. We should remember too that it was from the Book of Hours that children were taught to read. Isabelle of Bavaria is

known to have ordered a Book of Hours for her daughter Jeanne in

1 54 *Above*

**Private collection,
s.n. fols. 45v–46r**

This minute Book of Hours is shown here actual size. The book itself is only 37 mm high. It was made in France, perhaps in Tours, in the early sixteenth century. This is the opening of the Hours of the Holy Ghost, with a tiny miniature of Pentecost.

1 55 *Opposite*

**The Netherlands, private collection,
s.n., fol. 142r**

This is a Book of Hours translated into Dutch, illuminated in Utrecht, c.1465. The miniature, from the opening of the Office of the Dead, shows a Funeral Mass, with a priest reading from a manuscript and shaking holy water over the bier. The hooded figures in the foreground are not monks but professional mourners, dressed in black.

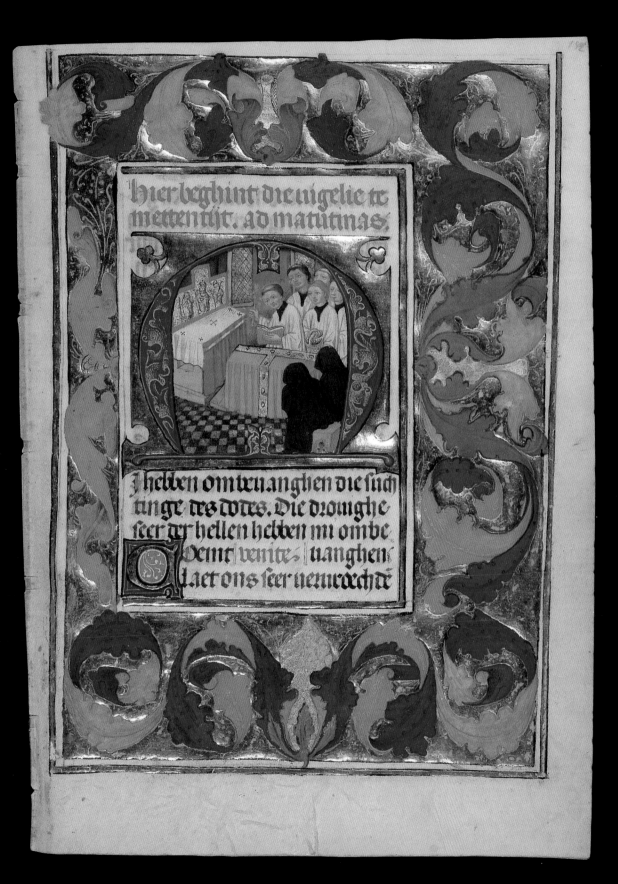

Hier beghint die vigelie te metten tijt. ad matutinas.

J hebben omteuanghen die such tinge des dotes. Die droughe seer ter hellen hebben mi ombe Ḋeint venite uanghen Laet ons seer nemrdechtē

1398 and an 'A, b, c, d, des Psaumes' for her younger daughter Michelle in 1403: both girls were then about six or seven. The word 'primer', meaning a first reading book, is said to derive from the office of Prime (PL. 156). To the great majority of the medieval population of Europe, the first book they knew, and often the only one, must have been the Book of Hours.

It sometimes seems surprising, therefore, that there is still no critical edition of the text for use by students of the Middle Ages. Its cultural impact (if that is not too pompous a term for an illuminated prayer-book) was wider and deeper than that of many rare literary texts worked over and over again by modern editors. It reached people too with no other knowledge of literacy. Anyone who could be encouraged to edit the first proper printed edition of the Book of Hours since the sixteenth century would win the gratitude of all historians of manuscripts. The task, however, will be made immensely complicated by the number of surviving manuscripts and their endless subtle differences.

These variations should be a delight, however, to historians of books. They can help us localize and sometimes date manuscript Books of Hours. This makes the Book of Hours a particularly valuable text for the study of fifteenth-century art. Whereas a panel painting or a pottery jug or a piece of furniture, for example, could often have been made almost anywhere in Europe, a Book of Hours can sometimes be localized to the very town where it was to be used. The first thing to check is the 'Use' of the Hours of the Virgin. This is a test principally of value for manuscripts made in France. We have mentioned that the psalms and readings within the Hours of the Virgin are interspersed with verses and responses. These often varied greatly according to the local custom ('Use') of a particular diocese. Exactly why they varied is difficult to understand: some really quite small towns like Thérouanne, Bayeux, and Le Mans patriotically had their own Use. There are other more general Uses such as that of Utrecht (which was normal for all the Netherlands), Sarum or Salisbury (which was used throughout England and in continental manuscripts intended for English customers), and the ubiquitous Use of Rome which occurs in all Italian Books of Hours, in most Flemish Books of Hours (this is particularly frustrating), and increasingly often in France by the end of the fifteenth century. None the less it must be the first priority of the student of a Book of Hours to identify its Use.

1 56 *Opposite*

**England, private collection,
s.n., fols. 30v–31r**

English Books of Hours were often
known as 'Primers', from the office
of Prime. This little Book of Hours
was probably made in London,
c. 1400, and the opening here shows
the beginning of Prime.

1 57 *Right above*

**London, British Library,
Add. MS. 35216, fols. 62v–63r**

A Book of Hours can sometimes be
localized by variants in the text.
Here, towards the end of None,
about half-way down the left-hand
page, are the antiphon *Sicut lilium*
followed by the capitulum *Per te dei*,
both characteristic of the Use of
Paris. The manuscript was certainly
made in Paris, about 1475.

1 58 *Right below*

**England, private collection,
s.n., fols. 107v-108r**

This Book of Hours shows approxi-
mately the same part of the text,
towards the end of None, as in Plate
1 57, and it was made at about the
same date. However, the antiphon
here is *Fons ortorum* and the capitu-
lum is *Et radicavi*. These are charac-
teristic of the Use of Besançon, and
the book was doubtless made in
Besançon in eastern France.

The simplest method is to look for the offices of Prime and None in the Hours of the Virgin. If the book has miniatures, these are the ones illustrated with the Nativity and the Presentation in the Temple. Then turn to the end of the office and locate the *capitulum*, which is a short reading of several lines and ought to be marked 'c' or 'cap'. Just before this, perhaps in smaller script, will be an antiphon indicated with 'a' or 'ant'. Note down the antiphon and *capitulum* both for Prime and for None (PLS. 157–8). The most common variations are shown in the table.

Be fairly careful. There can be deceptive exceptions. B.L., Add. MS. 35218 is of the Use of Besançon but the manuscript is signed and dated in Barcelona in Spain. Paris, B.N., ms. lat. 1425 is of the Use of Limoges but the scribe explicitly claims that he made it in Paris in 1449. Sometimes scribes must have copied their exemplars

PRIME		NONE		
antiphon	*capitulum*	*antiphon*	*capitulum*	**Use of**
Assumpta est …	Quae est …	Pulchra es …	In plateis …	**Rome**
Benedicta tu …	Felix namque …	Sicut lilium …	Per te dei …	**Paris**
Maria virgo …	Per te dei …	Pulchra es …	Et radicavi …	**Rouen**
O admirabile …	In omnibus …	Germinavit …	Et radicavi …	**Sarum**
Ecce tu pulchra …	Ego quasi …	Fons hortorum …	Et radicavi …	**Besançon**
O admirabile …	Virgo verbo …	Ecce Maria …	Et radicavi …	**Poitiers**
Doe du ontsprekeliken …	Van aen beghin …	Siet Maria …	Ic bin verhoget …	**Utrecht**

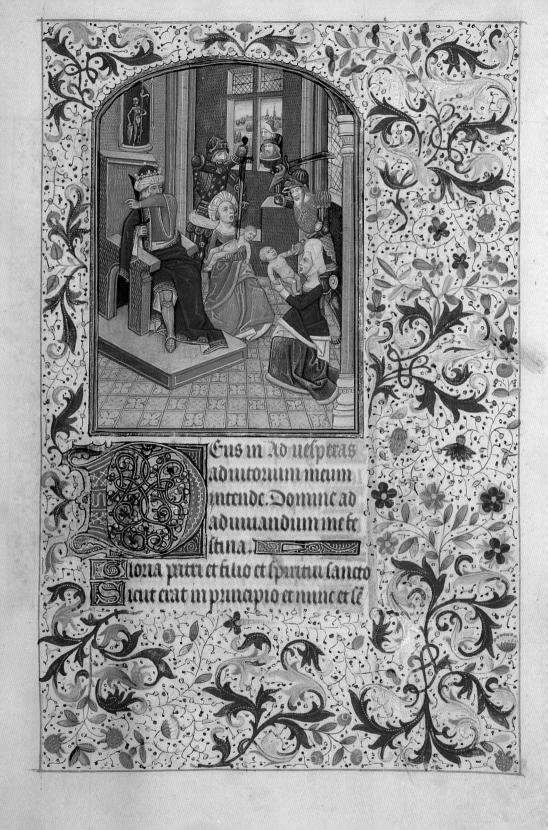

Eus in Ad uesperas
adiutorium meum
ntende. Domine ad
adiuuandum me fe
stina.

Gloria patri et filio et spiritui sancto
Sicut erat in principio et nunc et se

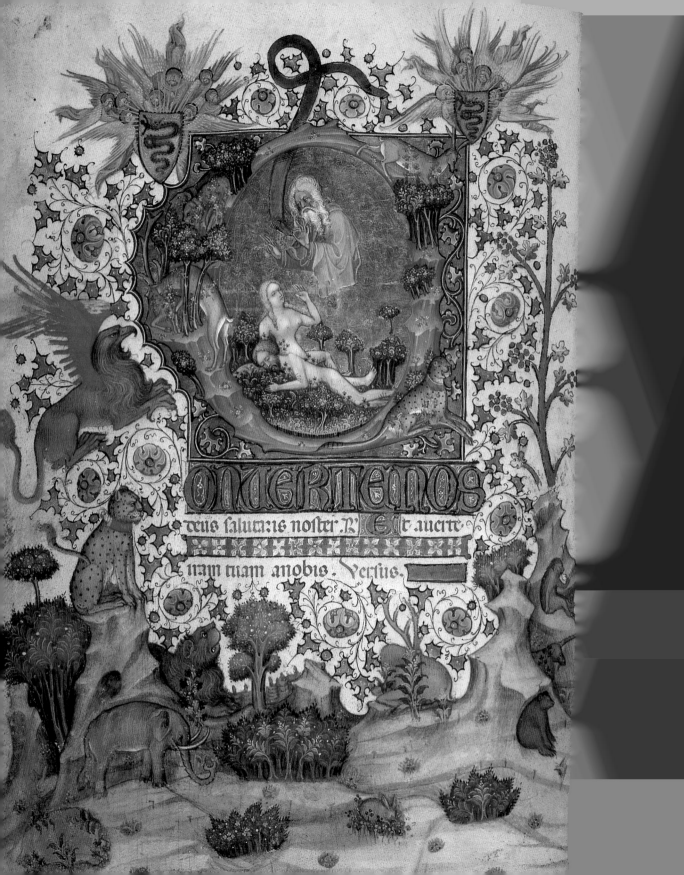

161 *Opposite*

Florence, Biblioteca Nazionale, MS. L.F. 22, fol. 46v

One of the first major Italian Books of Hours was begun *c.*1388–95 for Giangaleazzo Visconti, duke of Milan 1378–1402, and completed for his second son, Filippo Maria Visconti, duke 1412–47. This miniature is from the second campaign, painted in Milan by Belbello da Pavia in or soon after 1428. It shows the creation of Eve in the Garden of Eden.

162 *Right above*

New York, The Metropolitan Museum of Art, The Cloisters Collection, Acc. 54.1.2, fols.15v–16r

The tiny Hours of Jeanne d'Evreux, queen of France, was made in Paris about 1325, relatively early in the history of Books of Hours. This shows the opening of Matins. The manuscript seems to be the book described in the royal inventories as having been illuminated by Jean Pucelle and given to the queen by her husband, Charles IV, and it is listed later as belonging subsequently to Charles V and to the Duc de Berry.

163 *Right below*

Private collection, s.n., fols.15v–16r

This is a very early Book of Hours, made probably in Liège about 1310. Like the thirteenth-century Psalters which Books of Hours came to replace, it begins with a cycle of full-page miniatures. The final miniature, showing the Magi, leads here into the opening of Matins on the facing page.

without really noticing the antiphons. One can imagine too a merchant from Besançon (for example) visiting a bookshop in Paris to order a Book of Hours to take back to his home town. The big workshops in Rouen were evidently able to supply manuscripts of the Use of Coutances, Lisieux, Evreux, and elsewhere in Normandy as well as of the Use of Rouen itself. Flemish workshops had a long-standing tradition of making books to sell to the English merchants in Bruges: they made Books of Hours of the Use of Sarum and often marked them 'secundum usum Anglie' (according to English use, PL. 160). None the less, it is useful (and quite fun) to delve into antiphons and to come up, like a conjurer, with a really obscure local Use.

Now turn to the calendar at the beginning. This indicates the saints commemorated on particular days of the year and was useful both for Church observance and for writing the date on documents (which are likely to be dated on the Eve of Michaelmas, for instance, or the Feast of St Martin, rather than 28 September or 11 November). Look for local saints singled out in red. If your Book of Hours is of the Use of Paris and the patron saint of Paris, St Geneviève, is in red or gold on 3 January, then almost certainly the manuscript is Parisian. If you think it may be from Rouen, check for St Romanus singled out in red on 23 October; the calendar may also include other Rouen feasts such as the Translation of St Romanus on 17 June, and SS. Ouen, Austrebert, and Wandrille. For Ghent and Bruges, try SS. Bavo (1 October, PL. 159) and Donatian (14 October); for Tours, try St Gatian (18 December) as well as St Martin (11 November); for Florence, try St Zenobius (25 May); and for Venice, try the Dedication of St Mark (8 October). The Litany and Memorials are also worth looking at. There may be invocations of local saints there too. Both the calendar and the Litany may provide clues for dating a manuscript, especially if they include saints who were not canonized until the fifteenth century. St Nicholas of Tolentino (10 September) became a saint in 1446, St Vincent Ferrer (5 April) in 1455, St Osmund (4 December) in 1457, and St Bonaventura (14 July) in 1482. An especially useful name is St Bernardinus of Siena, who died in 1444 and was canonized in 1450. His cult spread very quickly, and when a determined owner assures you that his Book of Hours is fourteenth century, look at 20 May in the calendar: if Bernardinus is there, the book cannot be older than the mid-fifteenth century.

Using these tests for dating and localizing Books of Hours and aided by the more usual techniques of script and decoration, the history of Books of Hours can be plotted from surviving manuscripts. There are a few thirteenth-century copies from England, France, and Flanders. They are generally very small manuscripts, rather like the little Psalters of the period which were intended to be slipped in the pocket or carried at the waist (PL. 163). Fourteenth-century Books of Hours exist in reasonable numbers for France and England, and some are expensively illuminated manuscripts like the charming Hours of Jeanne d'Evreux, queen of

France, painted in Paris about 1325 and now in the Cloisters Museum in New York (PL. 162). We have already seen how Paris had an organized book trade around its university from the thirteenth century and we must certainly ascribe to Paris many of the best-known Books of Hours of the period of Jean, Duc de Berry. The *Très Belles Heures* of the Duc de Berry was begun about 1382, and his *Petites Heures* dates from about 1388. Both are Parisian manuscripts. By about 1400 a great many Books of Hours were being written and illuminated in Paris. Probably for the first time books were being produced in quantity for sale. The generation of about 1400 to 1420 was the greatest for the manufacture of Books of Hours of the Use of Paris. They are often of lovely quality. In the meantime we start to find some of the earliest Italian Books of Hours. Perhaps the most famous of these is the Book of Hours of Giangaleazzo Visconti, Duke of Milan, begun c. 1390, and completed for his son, Filippo Maria Visconti, about or soon after 1428 (PL. 161). The first Books of Hours that can be firmly attributed to London date also from the late fourteenth century. Flanders too began to make Books of Hours commercially followed in the early fifteenth century by the Netherlands. With a few noble exceptions, these are usually rather uninspired and provincial-looking manuscripts: the greatest Netherlandish illuminators still moved to Paris to practise their trade. Artists like the Limbourg brothers and the Boucicaut Master came to Paris from the north to the centre of the book trade. Paris drew illuminators from all over Europe. The principal business for most of them must have been Books of Hours.

Unfortunately (from the point of view of art, anyway), politics intervened. The English invaded and defeated the French at the battle of Agincourt in 1415. Their prisoners included Jean de Boucicaut, marshal of France, and owner of one of the finest of all Books of Hours. Paris was already torn by the civil war between the Armagnacs and the Burgundians, which lasted until the assassination of John the Fearless, duke of Burgundy, in 1419. A year later the English armies of Henry V entered Paris. This seems to have marked the end of the first great period of the production of Parisian Books of Hours. It is extraordinary how difficult it becomes to localize manuscripts in Paris between about 1420 and the mid-century. The social disturbance caused by civil war and foreign occupation must have been terrible. Hungry people do not buy books. Only one outstanding illuminator stayed on in Paris, the so-called Bedford Master, who takes his name from a Breviary and a Book of Hours associated with the English regent of France, the Duke of Bedford, brother of Henry V. It really seems as though all the scribes and illuminators fled to the provinces. Certainly the fashion for owning Books of Hours spread right over France in the middle third of the fifteenth century. We can ascribe Books of Hours to Amiens, Rouen, Rennes, Nantes, Angers, Tours, Bourges, Dijon, Besançon, Troyes, Rheims, and elsewhere in a huge circle around Paris. An enormous number of manuscripts were made – not necessarily expensive ones, but capitalizing on a

vast market for books. In certain provincial cities, such as Rouen and Tours, the trade in Books of Hours was so successful that it continued to flourish even after the middle of the fifteenth century when other illuminators drifted back to the capital.

An independent tradition of manuscript production in Flanders was in the meantime moving rapidly into the making of Books of Hours. They were not just for local customers, but (with typical Belgian business acumen) for export as well. After the Treaty of Arras in 1435, the dukes of Burgundy were able to move the seat of their vast dominions to Flanders, and some great illuminators worked for the Burgundian court in Lille, Tournai, Valenciennes, and elsewhere. Ducal patronage attracted the personnel of the book trade, as it had in Paris in the late fourteenth century. The market towns of Ghent and Bruges were ready when the last duke of Burgundy died in 1477. These essentially bourgeois towns, unburdened by warring local princes, became world centres for Books of Hours. Many were made for sale to England, like the manuscript in Plate 160; in fact, probably the majority of surviving fifteenth-century Books of Hours of the Use of Sarum give away their true origin by featuring saints such as St Donatian of Bruges in the calendar. Books of Hours were being made in Bruges for the Italian market as early as 1466, if one can judge from a privately owned example of the Use of Rome dated in that year and written in a rounded Italian script. Another, in the Newberry Library in Chicago (MS. 39) is probably not much later; it is in a Spanish script and several rubrics are in Catalan. The style of illumination is so typical of Bruges that it seems certain to have been made there, perhaps by a Catalan scribe, for sale to Spanish visitors. By 1500 the art of manuscript illustration in Ghent and Bruges was second to none in Europe. The Flemish Books of Hours were especially famous for their realistic borders looking as though flowers had actually fallen onto the pages, and for their delicate miniatures with marvellous landscapes. Simon Bening (PL. 164), the best-known Bruges painter of Books of Hours, was praised in his own time as the greatest Flemish artist for painting trees and far distances. The customers evidently adored these jewel-like manuscripts.

Books of Hours were made elsewhere in Europe too. German examples are curiously rare (Austrians like Nicolas von Firmian and Franz Thurn und Taxis, postmaster in the Tyrol, ordered theirs from Flanders), but Spanish and Portuguese Books of Hours exist. Italian examples are numerous, usually small books without elaborate decoration. English Books of Hours might have been even more common if they had not been discarded at the Reformation. Dutch Books of Hours are very numerous, especially from the later fifteenth century. They can be particularly fascinating because the text was usually translated into the Dutch language (PL. 155), and the miniatures have biblical scenes set in a homely atmosphere with tiled floors and crowded domestic interiors filled with the paraphernalia of the sitting rooms of the bourgeois families who first owned the manuscripts (PL. 166).

164 *Above*

New York, The Metropolitan Museum of Art, Robert Lehman Collection, Acc. 1975.1.2487

Simon Bening (1483–1561), of Bruges, is the most celebrated Flemish manuscript illuminator. His work was sought by patrons in all parts of Europe. In old age he painted a self-portrait of himself seated at a steeply sloping desk beside a window, working on a miniature of the Virgin and Child. He holds his glasses in his left hand.

Very few Books of Hours are signed by their makers. Most of these are either very early or very late. A Book of Hours in St Petersburg was written by Gilles Mauleon, monk of St-Denis, for Jeanne of Burgundy in 1317 (Hermitage Museum). Another in Châlons-sur-Marne was made for a local musician there by J. Bruni in 1537 (Châlons-sur-Marne, Bibliothèque Municipale, ms. 12). One Book of Hours of the Use of Besançon made about 1410 is signed by the scribe Alan with the information that his wife illuminated the book (Paris, B.N., ms. lat. 1169). The miniatures, frankly, are of very low quality and it is possible that this was not a commercial partnership but simply that Alan and his wife could not afford to buy a manuscript and so made one themselves. Paris, Bibliothèque de l'Arsenal, ms. 286 is a beautifully illuminated Book of Hours made in 1444 by a monk Jean Mouret for his own use. Jehan de Luc, sire de Fontenay and secretary to the king,

made a Book of Hours for his own wife, Françoise Brinnon, in 1524 (The Hague, Rijksmuseum Meermanno-Westreenianum, MS. 10.F.33). All these are rather peculiar manuscripts, mostly made by amateurs. Generally people wanting a Book of Hours probably ordered one from a bookshop.

In previous chapters we were introduced to the bookshops in the rue Neuve-Notre-Dame in Paris opposite the Cathedral of Notre-Dame. It was doubtless from booksellers that many people would have ordered a Book of Hours around 1400. The client probably explained what he wanted, and might have been shown a selection of second-hand Books of Hours. It is possible (but not probable) that the keeper of the shop had some ready-made unbound gatherings of new manuscripts in stock. The customer would discuss which texts he wanted added to the basic core of the Book of Hours. He would perhaps choose a script from a sheet of

165 *Right*

Private collection, s.n.

The scribe of this Book of Hours records that he completed it in 1408, in the year that the bridges of Paris fell down. This refers to the floods which washed away the Petit Pont, the Grand Pont and the Pont Neuf on 29–31 January 1408. The manuscript, with miniatures in the style of the Boucicaut Master (this miniature shows St Peter) belonged to the late Sir Alfred Chester Beatty and its separate leaves are now dispersed in many collections. This was folio 152r.

166 *Opposite*

Switzerland, private collection, s.n., fol. 7v

This is the Annunciation from a Book of Hours in Dutch made probably in the southern Netherlands, *c.*1440. The manuscript is painted in the style of the Master of Guillebert de Mets, and belonged to the Augustinian nunnery of Bethany, near Mechlin. Like many Netherlandish miniatures, it shows a corner of a bourgeois interior with tiled floor, simple wooden furniture, and books and boxes piled high on a shelf.

ghen ghec[
ewelyc co[
der alre sal[
Olyc[
On[
iubileren [
te vore be[
dats nut l[
ben. Inde[
gwoet con[
heere en v[
sy alle ey[
hi. Iaer [
ghemaec[
comt lac[

sample handwritings like that dated 1447, now in The Hague
(Koninklijke Bibliotheek, MS. 76.D.45). Sometimes but not always
the bookshop owner may also have been a scribe (as stationers like
Raoulet d'Orléans and Jean l'Avenant certainly were). One shop
in Paris was owned by Pierre Portier, recorded as one of the uni-
versity stationers in 1376 and still in business in 1409. In
November 1397 he received 64 shillings from Isabelle of Bavaria
for writing eight vellum quires for a Book of Hours (this works
out, in fact, at a shilling a leaf) and a further 54 shillings 'pour avoir
nettoyé, blanchy, corrigé, reffourni, doré, relié et mis à point les-
dictes heures'. Thus there were two separate accounts, of which
Pierre Portier may have worked on one himself but may have sub-
contracted the other. One was for writing out the book, and the
other for cleaning and whitening the vellum before writing and for
correcting and tidying up the text afterwards, gilding the edges and
binding the finished product. In a surviving contract for a Book of
Hours commissioned in Dijon in 1398, the client, Guillaume de
Chamois, bourgeois of Dijon, was required to supply both the
exemplar to be copied and the vellum for the work itself. The
bookseller, Maître Jehan Demolin, '*clerc et escripvain*', promised to
deliver the completed Book of Hours in three months. A total of
eighteen miniatures were agreed upon, of which twelve were to be
standard subjects for the usual divisions of the text and six addi-
tional subjects were to be painted 'as it will please Guillaume to
specify'. The all-inclusive price was ten gold francs, of which
Guillaume de Chamois paid nearly three-quarters in advance.

It is very rare for surviving Books of Hours to contain exact
information about when they were written, and it is only by his-
torical deduction that we can date major manuscripts like the
Hours of Charles the Noble to around 1405 or the *Belles Heures* of
the Duc de Berry to around 1409. Two Parisian Books of Hours,
however, contain very interesting dated colophons. The first was
formerly in the Chester Beatty collection (W.MS. 103), and its
miniatures are now dispersed among private collections (PL. 165)
and several libraries including Princeton University, the University
of North Carolina, and the Barber Institute in Birmingham. It had
an inscription on fol. 158v that it was made in the year 1408 when
the bridges of Paris fell. The second manuscript is Bodleian
Library, MS. Douce 144, which has a similar inscription on fol.
271r that it was made and completed in the year 1407 when the
bridges of Paris fell (PL. 167). It is written by the same scribe as
the Chester Beatty manuscript. The three bridges of Paris were
swept away by floods between 29 and 31 January 1408 (they called
this 1407 in the Bodleian volume as the year was still reckoned as
beginning on 25 March). Obviously the event was of great impor-
tance to the makers of these two Books of Hours. One wonders if
the bookseller's stall was on the bridge, perhaps the Petit Pont
which joined the Île de la Cité to the left bank and the student
quarter. We know that the bridges included the covered shops of
merchants, money changers, drapers, smiths, and other craftsmen,

CHAPTER VI
BOOKS FOR
EVERYBODY

and one can see the Petit Pont built up with houses in miniatures of Paris such as that on a Book of Hours in the John Rylands University Library in Manchester (MS. Lat. 164, fol. 254r, PL. 168) or on the leaf from the Hours of Étienne Chevalier in the Metropolitan Museum in New York.

Both the Books of Hours in 1408 have miniatures by more than one illuminator. The two distinct styles in the Bodleian volume have led art historians to ascribe it to the Boucicaut Master or a close follower and to an artist whose style is very like the early work of the Bedford Master. These are the two very big names in Parisian manuscript painting in the early fifteenth century. There is circumstantial evidence for identifying these two artists with Jacques Coene (who is documented in Paris from 1398 to 1404) and perhaps Jean Haincelin (who seems to be documented in Paris from 1403 to 1448). Their styles of illumination are quite distinct:

the Boucicaut Master paints tall, haughty, aristocratic figures in beautiful clear colours: the Bedford Master depicts shorter, more human figures often with snub noses. The collaboration of the two major painters in a single Book of Hours does not necessarily mean that the painters worked together. There were many manuscript artists in Paris at this time. We recognize their styles and art historians assign them sobriquets such as the Egerton Master (cf. PL. 139), the Troyes Master, the Master of the Brussels Initials, the Master of the Harvard Hannibal (PL. 173), and many others. From archival sources we also know the real names of many illuminators in Paris at this time living on the left bank in the rue des Enlumineurs (now rue Boutebrie) and elsewhere. The problem is matching the names with surviving miniatures. What probably happened is that the bookseller arranged with the client the extent and subjects of the illumination required, as Jehan Demolin did,

and then sub-contracted out the loose leaves. Some quires were sometimes sent out to one illuminator and some to another (PL. 169). With a little imagination one can visualize the bookseller's apprentice hurrying across the street with several gatherings for the Boucicaut Master to paint, and dropping off a few further up the road at the house of the Bedford Master, and leaving the less important leaves with the assistant who worked for the Master of the Coronation of the Virgin. Some weeks later, when these were done, the bookshop collected up the separate sections, paid the artists, tidied up and bound the leaves (we have seen Pierre Portier doing this in 1397), and then presented the book to the customer, with an invoice. The image is fanciful, but there is no other way to explain the changes of illuminator from one gathering to the next and the bizarre collaboration of different painters in an otherwise unified Book of Hours.

Understanding what was going on in the artist's house is even more difficult. The Boucicaut Master, whose style is in the main miniatures of both the Books of Hours dated 1407–8, takes his name from a vast and lovely Book of Hours with 44 miniatures made about 1405–8 for the Maréchal de Boucicaut (Paris, Musée Jacquemart-André, ms. 2). The artist himself was no doubt called upon to paint such a grand manuscript with his own hand. Altogether, however, more than 30 other Books of Hours have been ascribed to the same workshop, all between about 1405 and 1420. If one adds together the number of miniatures in each, the total is not far off seven hundred (PLS. 152 and 171–2). To add in too the richly illustrated secular texts in the style of the Boucicaut Master (texts like the copies of the *Grandes Chroniques de France* with hundreds of miniatures each, cf. PL. 143), the grand total of surviving miniatures ascribed to the circle of the Boucicaut Master

169 *Opposite*

New York, Pierpont Morgan Library, M.358, fols.169v–170r

This French Book of Hours of *c.*1440–50 was abandoned unfinished. The designs of the borders were drawn first in pencil, the burnished gold was applied, and then the colours were gradually blocked in. It can be seen quite clearly that the illuminators were working in separate quires, for the left-hand page here is the final page of one quire (note the catchword) and the right-hand page is the first of the next quire. The illumination on the left is much more advanced.

170 *Right*

Vienna, Österreichische National-bibliothek, Cod. 1857, fol. 152r

The Hours of Mary of Burgundy (1457–82), heiress of Charles the Bold, is one of the most refined and elegant of princely Books of Hours. It was illuminated in the southern Netherlands, probably *c.*1477, by the eponymous Master of Mary of Burgundy. This is a characteristic text page from the manuscript, flamboyantly written and decorated.

in a space of only about fifteen years is just over eighteen hundred. That is more than a hundred paintings a year, two a week, judged merely from those that happen to survive.

The only way they can have achieved this kind of output must have been with pattern sheets which were designed by the master and which could be copied out at great speed perhaps by apprentices. One sees remarkably similar miniatures from one manuscript to the next. Sometimes pictures are the same but exactly in reverse, suggesting that designs were copied on tracing paper (which was called *carta lustra* or *carta lucida*) and applied back to front. There must have been model sheets for all the standard scenes required in a Book of Hours: the Annunciation at Matins, the Visitation at Lauds, the Nativity of Christ at Prime, the Annunciation to the Shepherds at Terce, the Adoration of the Magi

at Sext, the Presentation in the Temple at None, the Flight into Egypt at Vespers, and (usually) the Coronation of the Virgin at Compline. (These are events in the life of the Virgin which were supposed to have taken place at the same time of day as the appropriate recitation of the respective offices in a Book of Hours.) Sometimes figures from one composition were used for another: the calendar miniature of courting couples in April could provide a pretty girl with a garland to accompany the shepherds in their vigil at Terce, and the sower in October could be transferred to the background of the Flight into Egypt at Vespers.

The ultimate source of some of these compositions can occasionally be traced back to known paintings. The Limbourg brothers adapted a Florentine fresco by Taddeo Gaddi for one of their miniatures in the *Très Riches Heures*, for example. Another instance

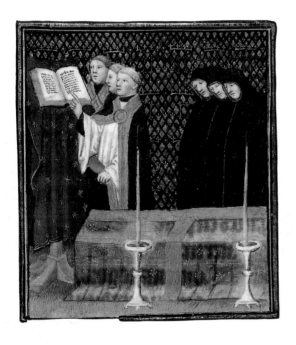

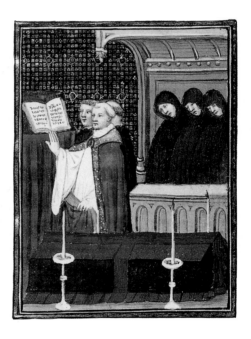

171–172 *Left*

Private collection, s.n.; Brussels, Bibliothèque Royale, ms. 11051, fol. 138r, details

The workshop of the Boucicaut Master in Paris in the first decades of the fifteenth century must have achieved a virtual production line in high-quality Books of Hours. Compositions recur almost identically from one manuscript to another, and presumably derive from pattern sheets held by the Master. These two miniatures, both datable to *c.*1410–15, illustrate a funeral Mass for the Office of the Dead.

173 *Opposite*

Private collection, s.n., fol. 227r

The Master of the Harvard Hannibal is named after a single miniature of the coronation of Hannibal in a manuscript of Livy at Harvard University. He was perhaps a pupil of the Boucicaut Master, and seems to have headed a workshop in Paris from about 1415 until the city fell to the English in 1420 when he may have emigrated north. In this Book of Hours, painted about 1420, he shows the owner kneeling before the Virgin and Child.

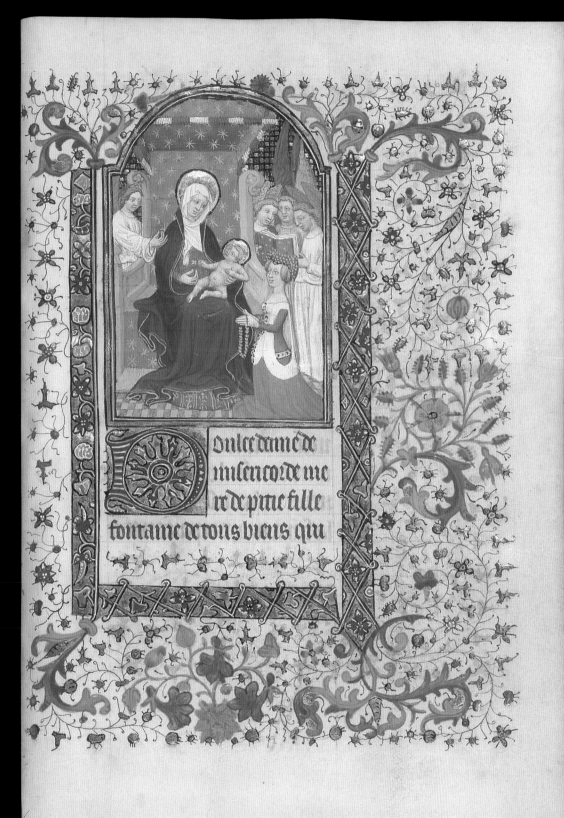

ouɫce dame de
miſentozde me
re de ꝓꞇre fille
fontame de tons biens qui

occurs in Books of Hours produced according to patterns of the Bedford Master. One of the most splendid portraits by Jan van Eyck, now in the Louvre, shows the French chancellor Nicolas Rolin (1376–1462) kneeling before the Virgin and Child. In the background, seen over the rampart and battlements of a castle, is a marvellous distant view of a winding river and a bridge with people hurrying across and (if one peers closely) a castle on an island and little rowing boats and a landing-stage (PL. 174). It was painted about 1435–7. The view is now famous as one of the earliest examples of landscape painting. The Bedford Master must have admired it too, perhaps in Rolin's house where the original was probably kept until it was bequeathed to the church at Autun. The same landscape was copied almost exactly, even to the little boats and the bends in the river, into the backgrounds of several miniatures from the circle of the Bedford Master such as the former Marquess of Bute MS. 93, fol. 105r (PL. 175), and the mid-fifteenth-century Hours of Jean Dunois in the British Library (Yates Thompson MS. 3, fol. 162r). It was adapted slightly for Bedford miniatures such as Malibu, J. Paul Getty Museum, MS.

Ludwig IX.6, fol. 100r, where the fortified bridge has contracted into part of a castle (PL. 176). Nicolas Rolin has been transmogrified into David in penance. In this case, one can assume that Jan van Eyck had invented the design, unless, of course, he was consciously copying a Bedford Master Book of Hours and was depicting Rolin as the penitent. The scene gets gradually transformed in other manuscripts into the usual view from the palace of King David in the miniature to illustrate the Penitential Psalms in northern France and then in Flanders. The battlements stay on but the river becomes a lake and then a courtyard (still with little people hurrying to and fro) in the Ghent/Bruges Books of Hours of the sixteenth century. The Bedford Master's sketch of a detail in a portrait that had interested him was transformed remarkably over a hundred years as one illuminator after another duplicated and adapted the original pattern.

Too little information survives on exactly how illuminators kept and copied these patterns. It is important to break away from the modern notion that an artist should strive for originality and that a creator has a kind of monopoly on his own designs. A medieval

174 *Left*

Jan van Eyck, The Madonna and Chancellor Rolin, detail
Paris, Musée du Louvre

Jan van Eyck's portrait of Nicolas Rolin (1376–1462), kneeling before the Virgin and Child, was painted *c.*1435–7. Certain details of the background, including the view of a bridge seen over a crenellated wall, were copied into the pattern sheets of manuscript illuminators. Rolin himself, incidentally, is shown using a Book of Hours with an attached chemise cover of wrap-around red textile weighted in each corner.

175 *Opposite left*

Switzerland, private collection (formerly Marquess of Bute MS. 93), s.n., fol. 105r

This Book of Hours in the style of the Bedford Master was illuminated in Paris about 1440. The miniature shows David at the opening of the Penitential Psalms, but the details of the background are carefully copied from Jan van Eyck's portrait of Nicolas Rolin (PL. 174).

176 *Opposite right*

Malibu, J. Paul Getty Museum, MS. Ludwig XI.6, fol. 100r

This Book of Hours is by a late collaborator and follower of the Bedford Master, working in Paris about 1440–50. It too shows David in penance. The background echoes that of the Rolin portrait (PL. 174) with the same island and boat but now the bridge has contracted into a castle and other details are modified.

artist was expected to work according to a specific formula, and this must often have meant using designs and compositions with a familiar precedent. In fact, the genius of a medieval illuminator is reflected in the skill with which he could execute an established subject. Careful adherence to an artistic tradition was required of an artist, as a violinist today is praised for following his score with consummate skill, or as a medieval author often begins a great work of literature by explaining or claiming that he is retelling an old story. A customer would expect a particular subject, especially in a book as naturally conservative as a prayer-book. Illuminators must have borrowed patterns from each other. The Bedford and Harvard Hannibal Masters seem to have shared models. There was probably a lot of knocking on doors in the rue des Enlumineurs. This practice of reusing old designs extended far beyond Paris. Artists took their experience with them, like the Fastolf Master, who left the capital about 1420 and apparently moved to Rouen and by about 1440 seems to have been in London. If he did not travel himself, his models certainly did. Thus general Bedford designs occur in Books of Hours made far from their place of ori-

gin. Three compositions from the Boucicaut Hours are repeated in New York, Pierpont Morgan Library, M.161, a Book of Hours probably made in Tours around 1465. One architectural border in a Lyons Book of Hours of about 1480–90 (sold at Sotheby's in 1977) is copied from a pattern used in the Hours of Isabella Stuart of about 1417–18 and repeated in the Rohan Hours of about 1420 (Cambridge, Fitzwilliam Museum, MS. 62, fol. 141v, and Paris, B.N., ms. lat. 9471, fol. 94v). The calendar of the *Très Riches Heures* entered the pattern-books of the Ghent/Bruges illuminators of the early sixteenth century and recurs in the Grimani Breviary and in the December miniature by Simon Bening in B.L., Add. MS. 18855, fol. 108v. Many Rouen Books of Hours of the 1460s to 1480s mirror each other so exactly that one must visualize some kind of production line to multiply almost identical illuminations at great speed (PLS. 177–80). We find the same in Paris in the last quarter of the century. The most extreme instances of duplicating miniatures are in the Ghent/Bruges Books of Hours of around 1500. Manuscripts like the Hours of James IV, the Spinola Hours, the Hours of Eleanor of Portugal, the Rothschild Hours in the

177–180 *Below (left to right)*

Paris, Bibliothèque de l'Arsenal, ms. 562, fol. 41v, detail

Paris, Bibliothèque Nationale, ms. lat. 13277, fol. 49r, detail

Oxford, Bodleian Library, MS. Douce 253, fol. 50r, detail

Waddesdon Manor, National Trust, James A. de Rothschild Collection, MS. 12, fol. 49r, detail

Books of Hours produced in Rouen in the second half of the fifteenth century often resemble each other very closely and the compositions of miniatures were virtually duplicated from one manuscript to another. These four miniatures show the opening of Prime in four different Rouen Books of Hours of about 1470.

British Library (PL. 182), a fine Book of Hours in Sir John Soane's Museum (PL. 181), and a whole shelf of lesser Flemish manuscripts all have miniatures and borders which must have been reproduced from almost identical patterns. What may be one of these actual model sheets is now in the École des Beaux-Arts in Paris: it shows a typical high-quality Flemish border with scenes from the life of David (this is to illustrate the Penitential Psalms), and versions of it reappear in the Spinola Hours and elsewhere. Clearly, the public appetite for Books of Hours was so huge that the mass multiplication of miniatures was regarded as quite ethical, being the only way to meet the demand.

If the evidence of the bulk production of miniatures tends to undermine our image of the artists as the original geniuses that we once thought, we must remember that it was not the artist who designed the book. He was merely a sub-contractor in the business. It was the keeper of the bookshop who dealt with the public and who invested money (and therefore responsibility) in the manufacture of Books of Hours. The sending out of written leaves to be illuminated was only part of the business of assembling and selling

manuscripts. In Flanders the two operations were so clearly distinct that very many miniatures for Books of Hours were actually painted on separate single leaves, blank on the back, that could be made quite separately and only afterwards purchased by the bookseller and bound into Books of Hours. In 1426 the professional association of the Bruges illuminators, the Guild of St Luke, attempted to legislate against the booksellers' common practice of buying up and selling among themselves separate miniatures made in Utrecht over a hundred miles away. If you peer into the sewing of a Bruges Book of Hours you can easily see how the miniatures have been inserted by wrapping the stub around the back of the quire.

The bookseller was usually responsible for binding the Book of Hours. While Books of Hours survive in such large numbers that we can study their contents minutely, it is much more difficult to make a realistic survey of their outsides because, like all books which have been enjoyed in private hands, Books of Hours have often been rebound many times in their lives. Surviving medieval bindings of Books of Hours are usually of wood, and in French manuscripts are often covered with tanned leather stamped with

neat rows of small rectangles of animals or flowers. Often the edges of the pages are gilded and painted with designs of multi-coloured flowers or acanthus leaves, like the borders inside the book. Such paintings are lost, of course, if the edges of a book are trimmed in rebinding, and their loss has deprived us of an important aspect of the original ornamentation of Books of Hours. Around the outside of the bindings again were very often large chemise covers of coloured textile, extending far beyond the edges of the pages and sewn with weighted corners, so that when the Book of Hours was closed up the wide edges could be wrapped around, enclosing the manuscript in a coloured parcel. Needless to say, such chemise covers very seldom survive (PL. 147). They can be seen in very many medieval pictures of people using books of private devotion, either unfolded to form a kind of table cloth on which the book rested when laid open on a prayer desk (as in PL. 174, for example), or dangling down from the edges when a book was picked up in the hands (PL. 3).

Occasionally we can recover isolated details about bookshops where Books of Hours were purchased. One in Lyons was perhaps

owned by Guillaume Lambert as there is a Book of Hours (until recently privately owned in France) with several inscriptions saying it was written in Lambert's house by the gate in 1484, and there is a Missal still in Lyons (Bibliothèque Municipale, ms. 516) which Guillaume Lambert wrote in 1466. His house was near the gate ('*près le portal*') which may be a city gate, a good place for trade, or the great triple door of Lyons Cathedral. In Rouen the bookshops were certainly around the cathedral, as they had been in Paris, and the courtyard by the north door of Rouen Cathedral is still called the Portail des Libraires, a name already in use by 1479. We know the names of some booksellers who rented their shops from the cathedral in Rouen: different members of the Coquet and Boyvin families, for instance, were in the bookselling business there throughout much of the fifteenth century. We should be looking to these kind of people to understand the manufacture and marketing of such vast numbers of Books of Hours. The customer paid a lot of money and a Book of Hours was specially made for him. The customer paid less money and bought a little one ready-made or a second-hand copy. So appealing were these manuscripts that every moderately well-to-do person in Europe in the fifteenth century seems to have walked out of some bookshop with a Book of Hours under his or her arm. One owner of an English Book of Hours was so proud of his new manuscript that he wrote on the flyleaf: 'He that stelles thes boke he shal be hanked upon on hoke behend the kechen dor.' In the little domestic world of the owner, to hang a thief on the hook behind the kitchen door was the most awful threat imaginable. The Book of Hours was a very precious possession in that household. It was probably their only book.

181 *Right*

London, Sir John Soane's Museum, MS. 4, fol. 23v

This Book of Hours was painted in Ghent or Bruges in the very early sixteenth century. The miniature here shows the Entombment of Christ at the opening of Compline.

182 *Opposite*

London, British Library, Add. MS. 35313, fol. 31r

The same composition occurs in the Rothschild Book of Hours illuminated at about the same date by the Master of James IV (cf. PL. 148). Not only is the design nearly identical, but even many of the colours must have been recorded on the pattern sheet.

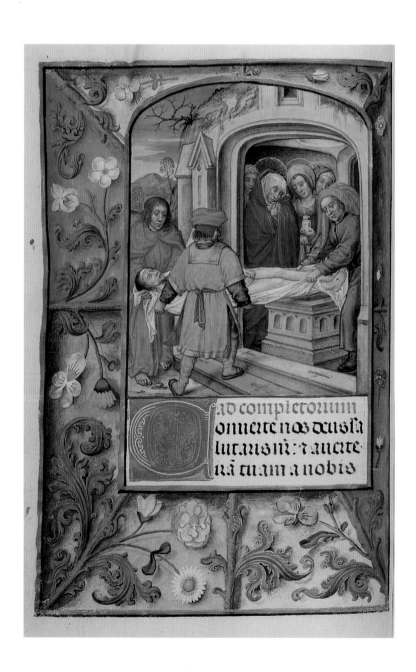

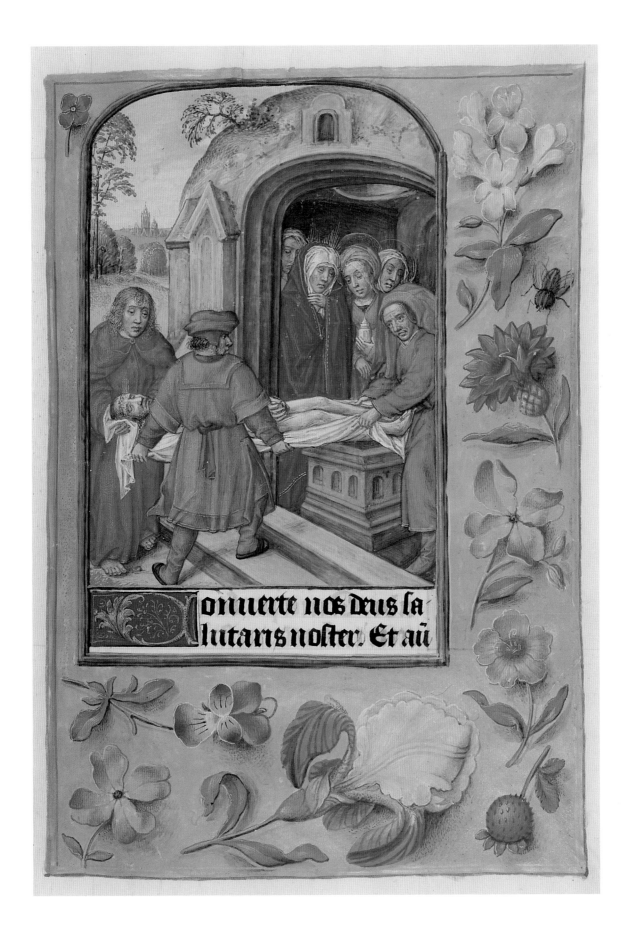

Books for Priests

More manuscripts have come down to us from the Middle Ages than anything else, but the most visible survivals of the period are the parish churches. The rural landscape of Europe is still dotted with towers, steeples and onion-shaped domes, and it is easy to picture the old arrangement of village houses clustered around a parish church. The rebuilding and furnishing of churches was a constant activity in the Middle Ages (PL. 184). Anyone entering one of these churches today will see many books: a shelf of hymn books by the door, prayer-books and perhaps a rack of general Christian literature. There may be guidebooks to the building and parish newspapers. By the chancel steps there will probably be a lectern with a large Bible opened for the daily reading. Modern church pews have a ledge where members of the congregation place their books to participate in the service. Books are very visible in modern churches. In the Middle Ages it would certainly have been different. There were no pews (people usually stood or sat on the floor), and there would probably have been no books on view. The priest read the Mass in Latin from a manuscript placed on the altar, and the choir chanted their part of the daily office from a volume visible only to them. Members of the congregation were not expected to join in the singing; some might have brought their Books of Hours to help ease themselves into a suitable frame of mind, but the services were conducted by the priests.

The local priest was often a man of some status in the village, assumed to be moderately well educated and reasonably articulate. He supervised the spiritual life of the parishioners: he preached the Christian faith, taught reading and writing, visited the sick, prayed in time of tribulation and led the services of thanksgiving, he heard confessions, conducted baptisms, marriages, funerals and burials, and maintained the constant round of liturgical worship.

Most medieval priests probably had a number of manuscripts. The most important were used regularly in church. It is a paradox that the obsolescence of service-books has caused many liturgical fragments to survive. A Breviary goes out of date quite quickly: as new festivals are introduced and liturgical practices are modified, the old book is discarded. Pages can work loose and tend to fall out of manuscripts handled frequently, and the whole volume becomes unusable and is laid aside. The Reformation caused the disposal of vast numbers of obsolete Romish service-books. Because of the wear and tear to which liturgical books are likely to be subjected, they had usually been written on vellum rather than on paper, and discarded sheets of second-hand vellum were always useful. Leaves from medieval service-books were reused as flyleaves and to strengthen the sewing in sixteenth-century bookbindings, and as folders for documents, for patching windows, lining walls, covering jam jars and other domestic uses, and single leaves from medieval Missals, Breviaries and liturgical music manuscripts are really quite common (PL. 186). This chapter will examine these manuscripts, and consider how the priest had used them.

First of all, it should be remembered that the church year is based on two simultaneous cycles of services. The first is the Temporal, or Proper of the Time, which observes Sundays and festivals commemorating the life of Christ. It opens with the eve of the first Sunday in Advent, which the Sunday closest to 30 November (PL. 185), and continues with Christmas (including

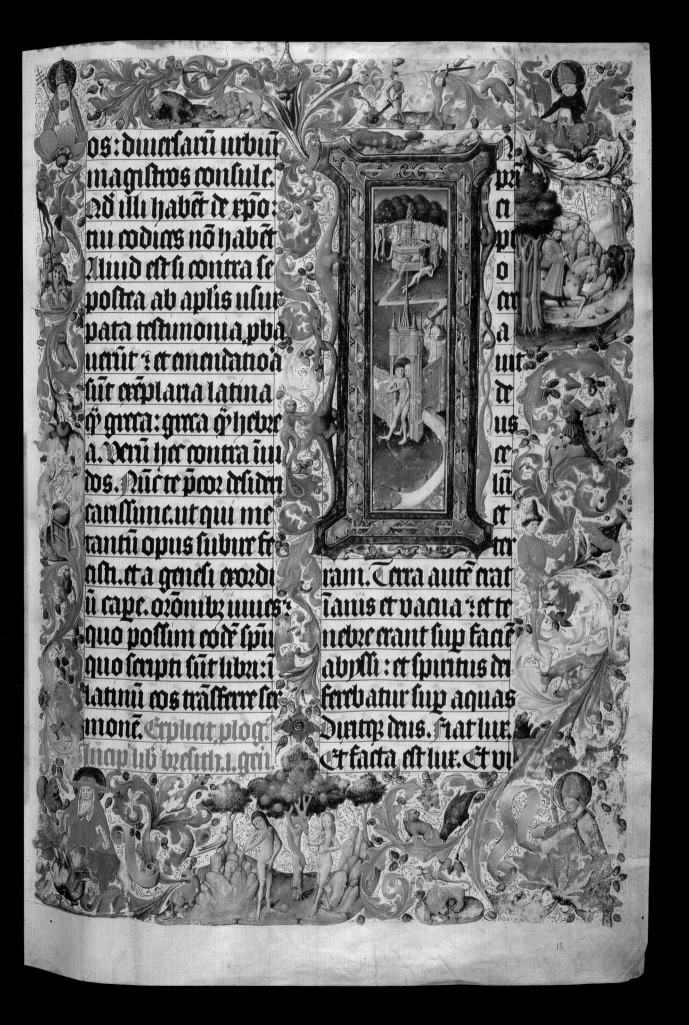

os: diuersarū urbiū
magistros consule.
nd illi habēt de xpo:
tū codices nō habēt
Aliud est si contra se
postea ab aplis usur-
pata testimonia, pba-
uerūt: et emendatioa
sūt exēplaria latina
q̄ greca: greca q̄ hebre
a. Verū hec contra iuu
dos. Nūc te precor desidi
carissime. ut qui me
tantū opus subire fe-
cisti. et a genesi exordi
ū cape. orōnibus iuues:
quo possim eodē spū
quo scripti sūt libri:
latinū eos trāsferre ser
monē. Explicat ploḡ.
Incip lib bresith.i. gen.

uī
ci
p
o em
a
de
us
ce
lū
et
tr
ram. Terra autē erat
inanis et vacua: et te-
nebre erant sup faciē
abysli: et spiritus dñi
ferebatur sup aquas
Dixitq̄ deus. Fiat lux.
Et facta est lux. Et vi

Epiphany, the Twelfth Day of Christmas), Lent, Paschal Time (from Easter to Ascension eve), and the season of the Ascension (which includes Pentecost, Trinity Sunday, Corpus Christi, and the Sundays after Pentecost). Christmas, of course, is a fixed feast and is always celebrated on 25 December, whether it is a Sunday or not. Easter, however, falls on the Sunday after the first full moon following the spring equinox and it varies considerably, thus changing the dates of other feasts calculated from Easter, such as Ascension Day, which is forty days later, and Pentecost, which is seven weeks after Easter. These are movable feasts. The second quite distinct cycle of the church year is the Sanctoral, or Proper of the Saints. This celebrates the feast days of saints, including those of the Virgin Mary, and it usually opens with St Andrew's day (30 November). Some saint's name could be assigned to every day of the calendar year. Local observances varied from place to place, and the calendars in liturgical manuscripts classified or 'graded' saints' days according to the importance to be given to them: ordinary days, important or *semi-duplex*, and of exceptional importance or *totum duplex*. The greatest feasts of the Sanctoral, like the Annunciation on 25 March and Michaelmas on 29 September, are ranked with Christmas Day and Trinity Sunday in the Temporal among the most honoured days of the religious year.

The Sanctoral and the Temporal were kept quite distinct in medieval service-books and sometimes even formed separate volumes. A medieval priest would not confuse them. It should be quite straightforward, in examining a page from a liturgical manuscript, to assign it to one or the other. The Temporal will have the services with headings such as *Dom. ii in xlᵃ·* (second Sunday in Lent – or *Quadragesima* in Latin) and *Dom. xiii post Pent.* (thirteenth Sunday after Pentecost), but the Sanctoral will refer to saints' names, *Sci. Hilarii epi. et conf.*, St Hilary (14 January), *Decoll. sci. Joh. bapt.*, the Beheading of St John the Baptist (29 August), and so on.

An even more fundamental distinction in the services of the late medieval Church is between the Mass and the daily offices. These were completely different in function and in form. The Mass is the communion service or Eucharist, one of the most solemn and important Sacraments of the Church, instituted by Christ at the Last Supper and consisting of consecrating and partaking of the bread and wine which represent the Body and Blood of Christ. It was celebrated at the altar, and its service-book was the Missal. The Mass is not to be confused with the daily services performed in the choir: Matins, Lauds, Prime, Terce, Sext, None, Vespers and Compline. We discussed the shortened versions of these offices in the chapter on Books of Hours. They are not sacramental services, but are basically prayers and anthems in honour and praise of Christ and the saints. Their service-book was the Breviary. In the eighteenth and nineteenth centuries, antiquarians used to call any medieval liturgical manuscript a 'Missal' (be cautious therefore of titles added on the spines of manuscripts), and

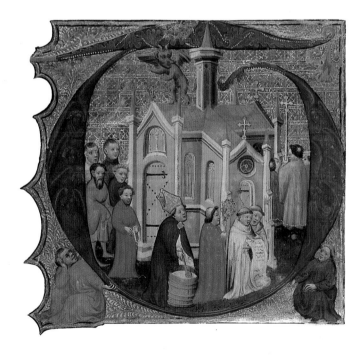

183 *Previous page*

Rome, Biblioteca Casanatense, MS. 4212, fol. 15r

This is the opening of Genesis in a vast lectern Bible commissioned by a Dutch priest, Herman Droem, canon of Utrecht from 1425 and dean of Utrecht from 1458 until his death in 1476. The manuscript was intended for use in church.

184 *Left*

London, British Library, Add. MS. 29704, fol. 68v, detail

The dedication of a church is shown in this miniature from the Carmelite Missal illuminated in London in the late fourteenth century. As a procession walks chanting around the outside of the building, a bishop sprinkles the church with holy water in order to drive out the devil, who can be seen leaping from the roof.

185 *Opposite*

Private collection (formerly the library of Major J.R. Abbey, JA.7209), fol. 7r

This is the opening of the Temporal in a manuscript Breviary made in Ferrara about 1480. The heading reads, in translation, 'In the name of the Lord Jesus and his Virgin Mother, here begins the order of the Breviary according to the Use of the holy Church of Rome. On the first Saturday in Advent, at Vespers.'

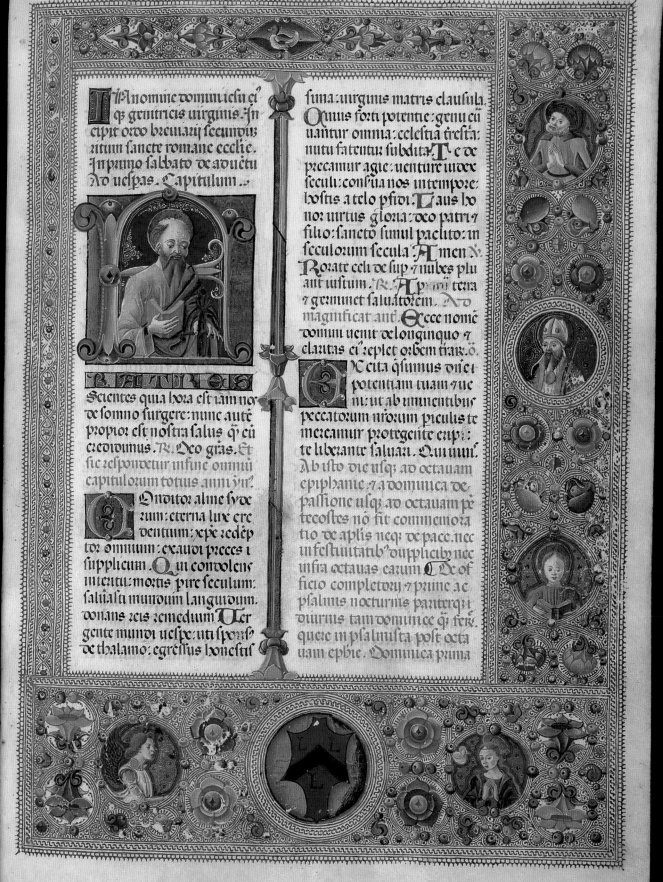

186 *Left*

Private collection, s.n.

At the Reformation in England in
the 1530s, all service books in use
in churches were declared obsolete
and were ordered to be destroyed.
Many of them had been written on
vellum and leaves from the discard-
ed manuscripts were sometimes sal-
vaged for reuse in strengthening the
inside of bookbindings or as folders
or wrappers. In this way one can
sometimes recover pieces of lost
English liturgical manuscripts.

even now cataloguers sometimes confuse Breviaries and Missals. To the medieval mind, this would be unthinkable. The Mass is on an altogether different level from the eight offices, and the words of the service were in quite distinct manuscripts.

Having distinguished the Temporal from the Sanctoral and the Missal from the Breviary, one can see how these would slot in together throughout the church year. On an important feast day in the Temporal or Sanctoral, the priest would celebrate Mass at the altar (PL. 187). Further down in his church in the choir he would usually also recite two or more of the offices, at least Matins and Vespers (PL. 189). The basic shape of these services would remain the same throughout the year but could be adapted according to the progress of the Temporal and the coincidence with the feasts in the Sanctoral. Special prayers could be inserted for the day appropriate within each cycle. Thus, for example, St Mark's day (25 April) might one year happen to be on the second Sunday after Easter, but in the next year on the Tuesday after the third Sunday after Easter. The liturgy would therefore be different. In this way, the round of services, though fundamentally the same year after year, was capable of considerable variation.

Let us now suppose we are examining a manuscript Missal. Sometimes the bindings were fitted with great metal bosses, for this is a book which was kept on the altar. A few moments glancing at the rubrics inside the manuscript will confirm that it is indeed a Missal, not a Breviary, as it includes headings like *Introitus* (PL. 188), *Secreta*, *Communio* and *Postcommunio*, which would not be found in a Breviary. (A Breviary, by contrast, would have headings such as *Invitatorium*, *Hymnus*, *In primo nocturno*, *Lectio i*, *Lectio ii*, *Lectio iii*, *In secundo nocturno*.) The Missal will probably open with a Calendar. It is then likely to contain the Temporal (starting with the Intoit, or opening words, 'Ad te levavi animam meam' for the First Sunday in Advent, PL. 190), consisting of those words in each Mass which vary from day to day: the Introit (sung), the collect or prayer for the day, the appropriate readings from the New Testament Epistles and from the Gospels (with a sung Gradual verse between them), the Offertory or scriptural quotation read or sung before the collection, and the Secret, which is read quietly after the offerings have been received, with the communion verse from the Bible and a short prayer used after the communion. These are all quite short. The Masses itemized in the Temporal repeat these sub-headings over and over again as the section runs through the whole church year from the beginning of Advent to the last of the many Sundays after Pentecost.

The Missal will then have the central core of the Mass itself, more or less in the middle of the volume. This will be the most thumbed section in a manuscript. It is the unchanging part which the priest read at every Mass, inserting the daily variations where appropriate. There will be some short prayers and the Common Preface ('Vere dignum et justum est') and the Canon of the Mass ('Te igitur clementissime pater') and the solemn words

187 *Above*

London, British Library, Add. MS. 35254, cutting Q

This is Paul IV, pope 1555–9, celebrating Mass from a manuscript held open for him by two cardinals. It comes from a series of cuttings from the sixteenth-century service books of the Sistine Chapel, which were stolen during the Napoleonic upheavals of the very end of the eighteenth century and found their way on to the market in England in the 1820s.

188 *Opposite*

Malibu, J. Paul Getty Museum, MS. Ludwig V.6, fol. 110r, detail

The initial here marks the opening of the Easter Mass in a Missal probably made in Vienna, *c.*1425. The heading above the initial, '*In die sancto*' (on the holy day) is followed by '*introitus*', the Introit, telling us that this is indeed a Missal.

Cum rex glorie xpūs triūfaret de

batica dūi dro puia cantet

Salue festa dies dūi reliquis

dū die sancto marutiis :·

Clauxi
et ad hūc
tecū sum
alla po
situsti su
per me
manū
tua: alla
nuabit

lis facta est scientia tua alletua

alla pis Dorie plobasti me et

cognouisti me cū cognouisti se

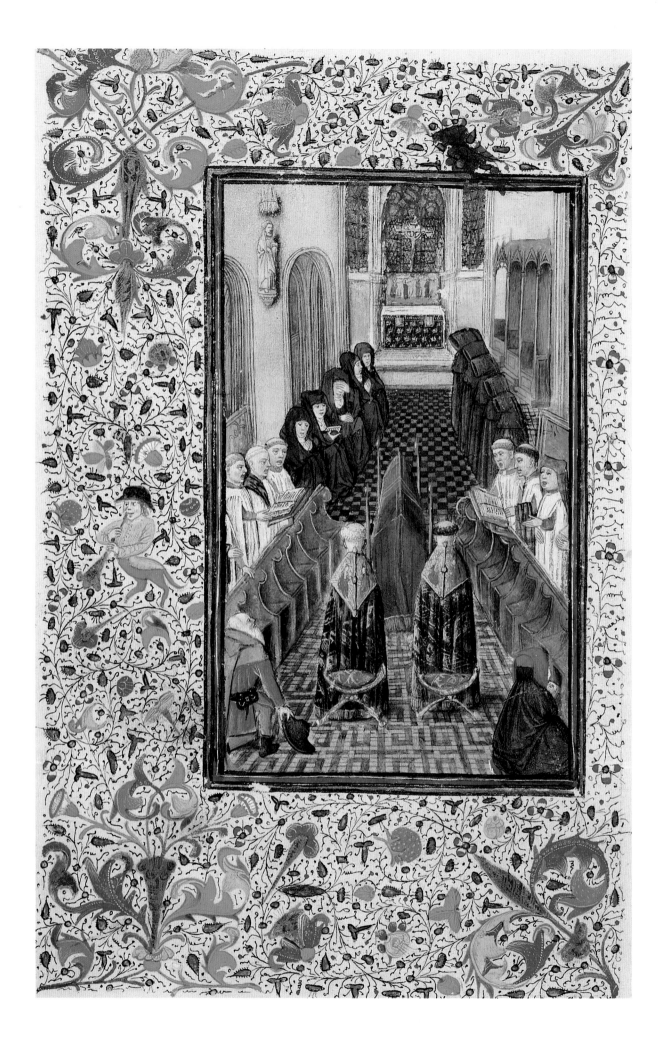

of consecration followed by the communion itself. It was sometimes written out in a larger script, perhaps because the priest used both hands for the acts of consecration and would at this point leave the manuscript open on the altar or hand it to an acolyte with the result that he now needed to read it from a greater distance than if he held the book himself.

The script will then return to the smaller size for the beginning of the Sanctoral which, in the manner of the Temporal just described, gives the variable sections of the Mass for saints' days of the whole year. This takes up most of the rest of the volume. It will be followed by the Common, comprising Masses which can be used in honour of saints not included by name: for an apostle, a confessor bishop, a virgin martyr, several virgins, and so on. If an officiating priest wanted to celebrate a Mass for a local saint not named in the Sanctoral, he would select the appropriate category from the Common. Finally, a manuscript Missal usually concludes with special sections of votive Masses (against the temptations of the flesh, for travellers, for rain, for good weather, and others for similar special occasions) and probably the Mass for the Dead.

This is a very brief summary, and of course manuscripts differed from each other in their exact contents. The Temporal, like a Book of Hours, might vary according to the liturgical 'Use' of a diocese or region. Feasts for different saints followed local venerations. Are Masses for rain rarer in Missals from England than from Italy? Almost certainly. The most solemn part, it must be stressed

again, is the Canon of the Mass. It never varied. This is the page where a typical late medieval Missal will now usually fall open of its own accord, partly because the priest needed to read this page every time he used the book and partly because it has the most elaborate illumination in the manuscript and generations of admiring bibliophiles will have sought out this opening first of all. Do not be ashamed to be among them. There will generally be one or even two full-page miniatures. We see the Crucifixion, often preceded by a painting of Christ in majesty enthroned in glory between symbols of the Evangelists or presiding over the court of heaven. Often these are splendid pictures, and in the fifteenth century the Crucifixion is sometimes shown with all the crowds and pageantry of a state occasion.

As a generalization (with notable exceptions, like all generalizations), manuscript Missals are not elaborately illustrated. The Canon miniatures are normally the only large pictures in the book. Their subjects symbolize the text: the Crucifixion, the actual sacrifice of Body and Blood, and God the omnipotent Father who (according to the Common Preface) should now be glorified. 'Holy, holy, holy', the priest recites at this point, 'Lord God of hosts – heaven and earth are full of your glory.' The Missal paintings are devotional images representing just this: the glory of God in heaven and the glory of the Son on earth at the most glorious moment of the Crucifixion (cf. Frontispiece). Sometimes God is represented holding the orb made of heaven and earth together.

189 *Opposite*

Malibu, J. Paul Getty Museum, MS. Ludwig IX.7, fol. 131v

Though it comes from a Book of Hours, this is a good illustration of priests in their stalls in the choir of a medieval church. They are singing Vespers of the Dead and up to three clerics are sharing each Breviary. This is not a Mass, for it is not taking place by the altar and the priests' chairs to the right of the altar are left empty. The miniature was painted in Ghent or Bruges, *c.*1450.

190 *Left*

Private collection, s.n.

Ad te levavi animam meam, To you I have lifted up my soul (Psalm 24:1). This is the Introit for the First Sunday of Advent, and these are the opening words of almost every medieval Missal or Gradual. The initial here, painted perhaps in Ferrara, *c.*1470, shows the psalmist literally lifting up his soul in the form of a tiny baby.

It is very difficult, without getting entangled in theology, to explain the full-page miniatures in a Missal in the traditional terms of art history. Elsewhere we have tried to understand the purpose of illumination in different kinds of manuscript: educative, explanatory, decorative, entertaining, and so forth – all recognizable functions of art and presupposing a medieval reader who uses illustrations as part of the business of reading. But a Missal is a unique kind of book. It is the vehicle for a Sacrament. Pictures cannot be strictly illustrative in a text which, taken on its own terms, is not for the use of a reader as such, but rather to re-create the most holy moment of religious worship. Already this explanation is beyond the framework of secular science and, to those to whom the Eucharist is unfamiliar, it must seem complicated. Perhaps a comparison is possible between Missal paintings and icons. An icon is itself regarded as the holy object it represents. The subject and the medium become indistinguishable in the eyes of the believer. The bread and wine in the Eucharist are, at that moment, the Body and Blood of Christ. On an infinitely lower level, the images of Christ on the Cross and of the Father in majesty become part of the presence of God in the Sacrament. At any other time they would just be paintings; but as the priest was reciting the Canon, these miniatures were the subjects of literal veneration. The picture of Christ on the Cross was kissed devoutly by the priest. With the late medieval mingling of spirituality and common sense, artists realized that frequent kissing smudged a fine painting, and so they sometimes illustrated a second much smaller Crucifix or a Cross in the lower margin of a Canon miniature so that it could be physically venerated without damage to the main composition.

Because the Canon had the richest decoration in a Missal manuscript, it is on these pages that we most often find representations or coats-of-arms of the original owners (PL. 192). One sees medieval priests or laity depicted beside the Crucifixion or in the illuminated margins. Patrons were no more bashful about having their names and portraits inserted in the most holy part of a Missal than they were about being commemorated on a monumental brass before the altar in the chancel of a church, and the same kind of images

appear with kneeling figures holding scrolls commending posterity to pray for them. Volume III of Leroquais's *Sacramentaires et Missels*, 1924, describes about 350 late medieval manuscript Missals in public collections in France: of these, just over 100 contain original coats-of-arms or other explicit indications of the original patrons. It is a high proportion. Though this may not be a statistically random survey, it shows between a quarter and a third of fifteenth- or early sixteenth-century French Missals having been commissioned by individuals who wished to be remembered as donors.

These patrons varied considerably. Many were bishops, and some of the grandest surviving Missals were illuminated for the use of prelates of the Church, the high priests. However, since episcopal visitations of parish churches included an inquiry as to whether a church had an accurate and usable Missal, a bishop's coat-of-arms in a Missal might simply indicate that he had made up a deficiency himself. It would be a very worthy thing to do. There survives a contract for the illumination of a Missal in 1448 for Jean Rolin II, bishop of Autun 1446–83 and chancellor of Philippe le Bon. The manuscript in 1448 had evidently already been written, copied by Dominique Cousserii, a Celestine monk, and the artist Jean de Planis now contracted to supply the bishop's new book with illuminated initials at the rate of a gold *écu* per hundred and miniatures at the price of 15 *gros* each, in accordance with a specimen which the bishop has approved. There survive at least seven Missals with the arms and devices of the same Jean Rolin, and some are very splendid and famous indeed, mostly illuminated by an anonymous artist known as the Master of Jean Rolin II (Autun, Bibliothèque Municipale, mss. 131, 133–6 and 138, and Lyons, Bibliothèque Municipale, ms.517, PL. 191). There is not enough evidence to risk identifying the Master with Jean de Planis since the bishop evidently commissioned many Missals, and purchased others (such as Autun, ms. 141), which he gave to churches and chapels of his diocese.

Often the donors were the local priests or the parishioners themselves. One Missal was written by brother Yvo in 1441, according to a note at the start of the Canon (Paris, B.N., ms.

191 *Opposite*

Lyons, Bibliothèque Municipale, ms. 517, fol. 8r

The first page of the Missal of Jean Rolin II announces the text as being of the Use of the Cathedral of Autun. The miniature shows Mass being said. In the margins of the page are the arms and devices of Jean Rolin, bishop of Autun 1446–83, who paid for the book and who is recorded in a contract of 1448 as commissioning a Missal from the scribe Dominique Cousserii and the artist Jean de Planis.

Incipit missale secundum
usum ecclesie cathedralis e
duenlis. Dominica prima
in aduentu domini. Ad mis
sam introitus.

d te leuaui a
nimam me
am deus me
us in te con
fido non eru
bescam neqz urideant me ini
mica mea et etiam uniuersi qui
te expectant non confundent.
Ps. Vias tuas dne. euonac.
xcita domine que ojo.
simus potenciam tuam

et uenu: ut ab imminentibz
peccatorum nrorum pericu
lis te mereamur protegen
te eripi: te liberante saluan.
Qui uiuis. ad romanos.
ratres: Scientes qui
a hora est: iam nos
de somno surgere: Nunc eni
propior est nra salus: qua
cum credidimus: Hox pre
cessit: dies aute appropin
quabit. Abiciamus ergo
opera tenebrarum: et indu
amur armis lucis haut i
die honeste ambulemus:
Non in commessationibz
z ebrietatibus: non in cu
bilibus et inpudicicijs: n
incontentione et emulatio
ne. Sed induimini: dnm
ihesum xpm. R. Anima ti
qui te expectant non confund
tur domine. V. Vias tuas dne
notas fac michi z semitas tu
as edoce me. Alleluya. V. Oste
de nobis domine miam tuam z

nouv. acq. lat. 1690, fol. 228r), on the commission of Hugues de St-Genèse, then vicar of the parish church of Bassan (in the diocese of Béziers, in the far south of France), 'cuius anima requiescat in pace, Amen'. Another Missal was made in 1451 for presentation by the priest Guillaume Jeudi, rector of the parish church of Notre-Dame d'Olonne (in the diocese of Poitiers), for the commemoration and salvation of his own soul: this is all recorded in a scroll at the foot of the Canon miniature which includes a picture of the donor asking the Virgin and Child to remember him (Paris, B.N., ms. lat. 872, fol. 156v). There is a long and complicated inscription at the end of a Missal of 1419, now in Avallon (Bibliothèque Municipale, ms. 1, fol. 257r), recording that it was made by Bernard Lorard in the town of Villaines-les-Prévostés (Côte-d'Or) while Jean Odini de Reomo was curate of the church there, and that the parishioners paid Bernard forty crowns for his labours and that, when Bernard himself made a personal contribution to the cost, they awarded him a supply of red wine. The manuscript sparkles with little miniatures of grotesque animals and faces, and (unusually for a Missal) it has twelve Calendar scenes. It cannot have been simple to make. Probably very local Missals like these were hardly professional products in the normal sense. In a provincial village the priest himself must often have been almost the only person who could write. A Missal made in 1423 for the church of St-Sauveur, diocese of Aix, is signed by the scribe Jacques Murri, 'clericum

beneficiatum' (Aix, Bibliothèque Municipale, ms. 11, p. 829), and another Missal, paid for by the vice-chancellor of Brittany in 1457, was written out by Yves Even, parish priest of the village of Troguéry in the north Breton diocese of Tréguier (Paris, B.N., ms. nouv. acq. lat. 172, fol. 266r). Writing books may have helped supplement a clerical stipend. The first of these two manuscripts has many small miniatures but they are not well executed and may have been made at home. A century earlier there is a colophon in a Flemish Missal completed in Ghent in 1366 by Laurence the illuminator, priest of Antwerp (The Hague, Rijksmuseum Meermanno-Westreenianum, MS. 10.A.14), and probably the priest both wrote and decorated it.

Next to the Missal, the book which a priest would need most regularly in his church was the Breviary. This too must sometimes have been made by the priest himself. A hastily written Breviary in Brussels (Bibliothèque Royale, ms. 3452) is signed by the scribe Hugues Dubois ('de Bosco'), priest in the diocese of Amiens, who records on fol. 156v that he finished copying it from the exemplar owned by Pierre Alou, priest of the church of St-Éloi in Abbeville, in 1464 on 6 November, 'hora secunda post prandium' – at two o'clock, after lunch. A Breviary, as we have seen, was not a book for use at the altar. Its dimensions are often smaller than those of a Missal, and it is usually a squat thick volume (PL. 193) or is divided among several small volumes. In medieval England a Breviary was

generally called a 'portiforium', a book which a priest carried outdoors ('portat foras'), the term reflecting its convenience of size. The handwriting was often very small. A Breviary comprises hymns, readings, Psalms, anthems and other prayers for the offices from Matins to Compline and, in the full version, includes the whole Psalter, marked up with rubrics and responses, as well as the appropriate offices to be used throughout the long sections of the Temporal and the Sanctoral.

There is one major problem in considering Breviaries in a chapter called 'Books for Priests'. Not only priests used them. All monks required Breviaries, and some of the finest surviving examples seem to have been used by the laity. Missals are rather different: only an ordained priest could celebrate Mass, and, though many monks and abbots were ordained as well, it is reasonable to consider a Missal as a priest's book even if the priest was also a monk. Many Breviaries, however, were intended simply for monks and nuns, and they, probably more than parish priests, actually read from the volume eight times a day. A priest often recited only Matins and Vespers. One distinction between a 'secular' Breviary (that is, one used in a church) and a monastic Breviary is in the number of lessons or readings in the office of Matins. A parish priest or a friar used nine lessons on Sunday and on feast days and three on ordinary weekdays; monks, by contrast, read twelve lessons on Sundays and feast days and three on weekdays in the winter and one in summer. This difference ought to be reflected in the manuscripts themselves, and the readings are usually numbered *Lectio i*, *Lectio ii*, and so forth, and are not difficult to find. A second method of checking whether a Breviary is monastic or secular is to look through the Calendar. Feast days are 'graded', and so if special honour is given to St Benedict (21 March), for example, and to the translation of his relics (11 July and probably also 4 December), the Breviary was presumably intended for use by a Benedictine monk. If the Calendar singles out feasts such as St Bernard (20 August), St Robert of Molesmes (29 April), St Peter of Tarantaise (8 May) and Edmund of Abingdon (16 November – he died at Pontigny Abbey), then the Breviary is probably

Cistercian. Thus, with the help of a dictionary of saints, it should be possible to say whether a Breviary is Augustinian, Dominican, Franciscan, and so forth. If it was made for a parish church or secular cathedral, it is likely to accord special honour to local saints of the diocese, and it may well have an entry in the Calendar for the anniversary of the dedication of the church itself. A nondescript '*Dedicatio huius ecclesie*' may be of little help, but one can often arrive at a localization by simple deduction. Sometimes the inquiry can take turns in several directions. To judge from the illumination of one Breviary, Besançon, Bibliothèque Municipale, ms. 69, one would have attributed it to Rouen, *c.*1485 (PL. 194). But its Calendar singles out in letters of blue and/or burnished gold the feast of Saints Ferreolus and Ferrutio (16 June), the evangelists of Besançon in eastern France who were martyred *c.*212 AD, far from Rouen, together with the anniversaries of the finding (5 September) and translation (30 May) of their relics. It is quite improbable that one would find such a veneration in anywhere but the region of Besançon. The Calendar then has '*Dedicatio ecclesie*

Sancti Johannis evangeliste' under 5 May, which must be the Cathedral of St John the Evangelist and St Stephen in Besançon itself. Why such a book should have been made in Rouen, nearly 300 miles away, is explained by the arms on many pages. They are those of Charles de Neufchâtel, archbishop of Besançon from 1463, who, after Besançon was conquered by the French from the duchy of Burgundy in 1480, was forced to flee from his diocese and lived in exile in Normandy until his death in 1498. He must have ordered the Breviary during his banishment.

Breviaries were sometimes illuminated for the laity, especially in the late Middle Ages, and some of the very grandest surviving copies are associated with secular aristocrats such as Charles V of France (Paris, B.N., ms. lat. 1052), the Duke of Bedford (Paris, B.N., ms. lat. 17294), the Duke of Guelders-Jülich (New York, Pierpont Morgan Library, M.87, PL. 196), and Queen Isabella of Castile (B.L., Add. MS. 18851, PL. 195). The most famous of all, the Grimani Breviary in Venice (Biblioteca Nazionale Marciana, MS. lat. I.99), was not designed for Cardinal Grimani

194 *Opposite*

Besançon, Bibliothèque Municipale, ms. 69, p. 485, detail

This Breviary was intended for the Use of the cathedral church of Besançon, and has the arms of Charles de Neufchâtel, archbishop of Besançon 1463–98. However, the archbishop was exiled from his diocese in 1480 and fled to Normandy. This manuscript, made soon after 1480, was probably illuminated in Rouen for the archbishop's chapel in exile. The miniature shows the great annual procession of the Holy Sacrament.

195 *Right*

London, British Library, Add. MS. 18851, fol. 348r, detail

The Breviary of Queen Isabella of Castile, the patroness of Christopher Columbus, was probably commissioned by Francisco de Rojas, a diplomat in her service, in about 1497. It was illuminated in Bruges and may have been intended for use in one of the royal chapels. The miniature here illustrates the office of St Thomas Aquinas (7 March), and shows the saint in church with the crucifix which miraculously spoke to him.

ait illis. Venite post me: et
faciam uos fieri piscatores
hoim. At illi continuo relic-
tis retibus: secuti sut eum.
Et, pcedens inde: uidit alios
duos fres. iacobu zebedei
t iohem frem eius in naui
ai zebedeo pre eor z reficien-
tes retia sua: et uocauit eos.
Illi aute stati relictis retibus
et patre: secuti sut eu. Amē.

Te decet. Oratio.
Maiestatem tua dūe
suppliciter exoram?
ut sicut ecclie tue bēs andre-
as apls extitit pdicator et
rector? ita apud te sit p no-
bis ppetuus intcessor. P.
Dicat hec ecia oro. Ad laud. Ad iij.
et ad vespas. Ad vi. Caplm.
Statuit illi dūs testa-
mentū sempitnū:
circūcinxit eū zona
iusticie: et induit eū corona
glē. Do gē. v. Annūc celi.
Ora Adiuuet ecclia tē in cōi.
Corde cr Ad. iť. Cap.
ditur ad iusticiam?
ore aute confessio
fit ad salute: dicit eni scrip-
tura. ois qui credit in illū
non confundetur. Do gē.
v. Nimis horati. Oro. Adiu-
uet. Ad vē a Iurauit. cū cetis
Oro. Maiestate tua dūe. t.

De sca barbā ugine et mur.
Ad vē sup ps. Ant. Vnguē-
tum. Cap. Qui gloriat. fē-
siulate. ħnū xpe redemptor. v.
Adiuuabit. Ad vē a. Accinxit.
Fk oia in cōi. Oro.
Deus amator pudi-
cie. qui ad declaran-
da merita bte barbare ugi-
nis ac mōs tue misdiam?
pplis ipam inuocantibus
pmisisti: concede ppicius?
ut ab hostiu incursu sim?
semp securi. et eius pia in-
tercessione ad gaudia p-
ueniamus eterna. Per.
Dicat hec ecia ad laud. ij. et vē.
ac post euim. lcodes. Inter
parabolas. cc. xli. Ad vi.
Libera nos Oro.
qs dūe a sagitta
dyaboli: qui bte
barbare uirgini ac mīu
tue triūphalem uictoriā
p nobis supplicandi tu

buulti · p · Ad nona · Oro.
mps sempitne ds
tua piam iplora
mus clemenciam;
ut intcedentib; bte barba
re urginis ac mris tue me
nus; a petor pondere et
hostiu insidys absoluti;
mente alacres et ima cula
ti adherere tibi ugiter ua
leamus · p · Ceta oia siaut
deuna ugine in coi.

sut siliter de coi · Smo bn au
gustini epi. lectio i.
Ominus nr ihc xps.
et uenit ad homines.
et abscessit ab homib; et uen
turus est ad hoies. Et tame
hic erat qn do uenit; nec re
cessit qn do abscessit; et ad
eos uenturus est quib; dixit;
ecce ego nobiscu su usq; ad
consumatione scli. Scdm
ergo forma serui qua suscepit pro nobis; quota tpe
natus est et occisus est; et re
surrexit; etiam no morit;
nec mors ei ultra dnabitur.

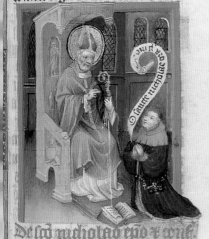

De scd nicholao epo + confe
Ad us laud. iij et ad us.
Eus qui beatum
nicholau ponti
ficem tuu innu
meris decorasti miraculis;
tribue nobis qs; ut eus
meritis et pabus; a gehe
ne incendys + a pntibus
tribulationib; liberemur.
p. Ad vi et iiij si et ba de coi.
Ceta pter leoes que sequitur.

Gaudiu leo ij. Tu at
diuinitate aute qua
equalis est patri; i
hoc mudo erat. et mudus p
ipm facus est; et mudus eum
non cognouit. De hoc audis
tis modo euangeliu qd mo
nuerit nos; cautos nos fa
ciens et uolens esse expedi
tos; et patos ad expetanda
nouissima; que sunt in hoc
sclo metuenda. Succedet req
es que non ht fine; bn qui
ptapes ta fuerit. Erut aute
tuc securi; qui modo non st
securi. Et iteru. Tuc timebut;
qui modo timere noluit. Tu
od hanc expec leo iij.
tatione et ppter hanc
spem; xpiani facti

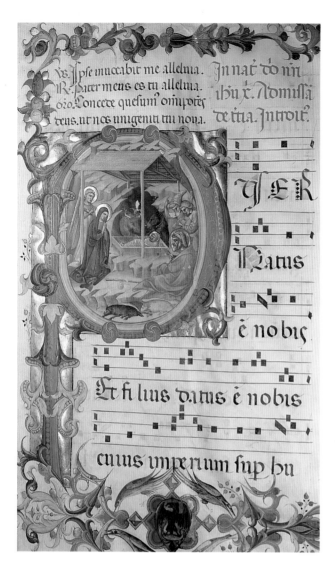

but was bought by him second-hand from Antonio Siciliano, who had been Milanese ambassador in Flanders in 1514. But even these grand books were primarily for use by priests or monks. All princely families had their own private chapels. The splendid Breviaries must often have been chanted by the domestic chaplains rather than by the nobility in person. The aristocrats were the patrons, not the daily readers.

Related to Breviaries are Psalters, and the Psalms arranged liturgically form a principal component of any Breviary. Many parish priests must have owned Psalters, especially in the later Middle Ages when the Psalter often included liturgical elements such as a Calendar, Litany, and the Office of the Dead. By the late Middle Ages such manuscripts were perhaps more common in England than on the Continent (PL. 200). There is an interesting contract for the writing of a liturgical Psalter for the use of a priest in York in 1346. In August that year, Robert Brekeling, scribe, appeared before the Chapter at York Minster to confirm his agreement to make for John Forbor a Psalter with Calendar for which he would charge 5s. 6d., and then, for a further 4s. 3d., to write out, in the same script and in the same volume, the Office of the Dead with hymns and collects. Then there are details of exactly how the illuminated initials were to be supplied. Robert Brekeling was to do the work himself. Each verse of the Psalms had to be given a capital letter in good blue and red. The Psalms themselves were to begin with large initials in gold and colours, and each of the seven liturgical divisions had to be indicated with a five-line initial, except for the psalms *Beatus vir* and *Dixit dominus* (Psalms 1 and 109 – those used at Matins and Vespers on Sundays), which required initials six and seven lines high. All this is carefully specified in the contract. All large initials in the hymnary and collectar, according to the arrangement, were to be painted in gold and red, except those of double feasts, which should be like the big gold initials in the Psalter. For this extra work of illuminating, Robert was to charge an additional 5s. 6d. plus 1s. 6d. for buying the gold. The total comes to 16s. 9d., which was quite a lot of money in the fourteenth century.

A further expense that one sometimes finds in medieval accounts is for the 'noting' of service-books. This means supplying music. Both the Mass and the daily offices contain substantial sections of musical chant. The origins of liturgical music were traditionally said to go back to St Gregory the Great (d.604), who is sometimes shown in medieval art being inspired by the Holy Dove to record the principles of 'Gregorian' chant. As there were two main service-books in the medieval Church, the Missal and the Breviary, so there were two corresponding volumes of music. The Gradual contained the musical parts of the Missal; the Antiphoner contained the musical parts of the Breviary. The difference is as important as that between the Missal and the Breviary, and the same words in the rubrics will distinguish one from the other: headings such as *Introitus*, *Graduale* and *Offertorium* are found in a

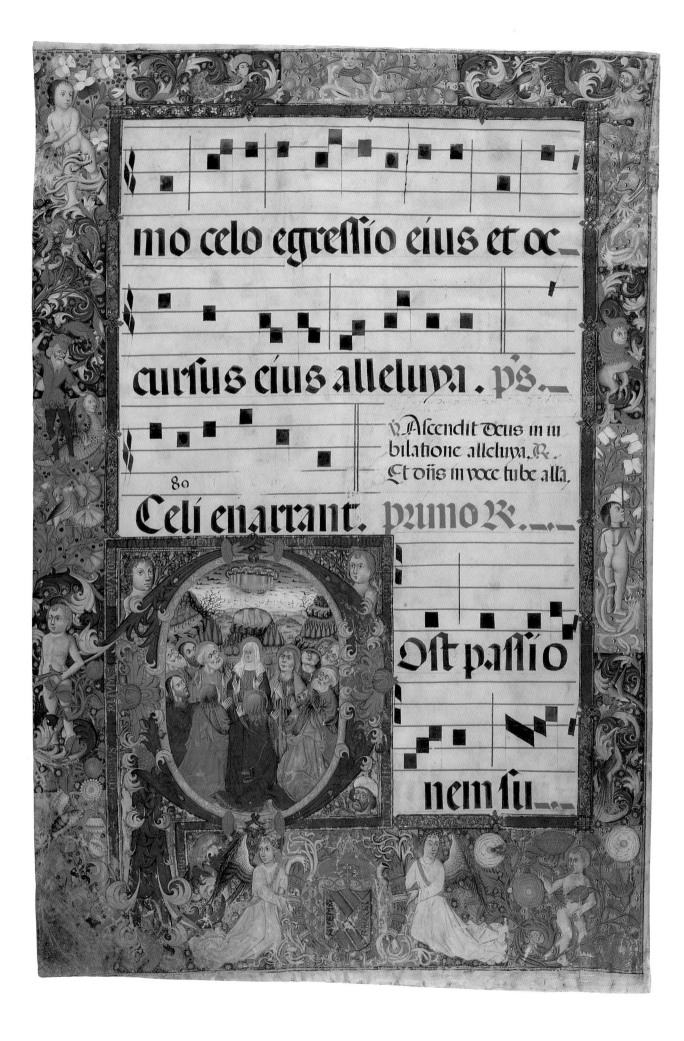

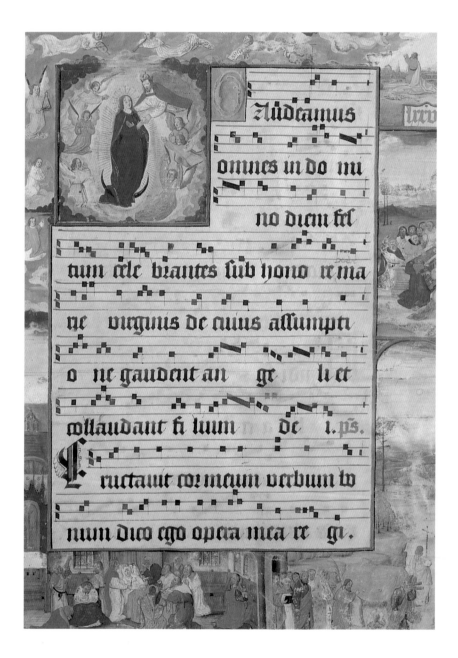

199 *Left*

New York, private collection

This is the Introit for the Mass on the feast of the Assumption of the Virgin (15 August). It is from a Gradual illuminated probably in Bruges in the late fifteenth century. In the miniature at the top left the Virgin Mary ascends to heaven, attended by angels. Around the edges are scenes from her death and funeral with a kneeling figure of St Thomas, who received the Virgin's girdle dropped from heaven as she ascended.

200 *Opposite*

Oxford, Bodleian Library, MS. Liturg. 198, fol. 91v

This is a mid-fourteenth-century Psalter, made in England, perhaps for use in the north-east. The initial here for the Psalm *Cantate domino*, Sing to the Lord, shows a priest and two acolites singing from a manuscript on a lectern in a fantastic Gothic church as a musician plays a viol in the border.

antate domi
no canticum no
num: quia mi
rabilia fecit.
Saluauit sibi
dextera eius: et
brachium sanc
tum eius.

Notum fecit dominus salutare suum: in
conspectu gentium reuelauit iustitiam suam.
Recordatus est misericordie sue: et ueritatis
sue domui israel.

Viderunt omnes fines terre salutare dei:
nostri: iubilate deo omnis terra cantate et ex
ultate et psallite.

Psallite dño i cithara i cithara z uoce psal
mi: i tubis ductilibz z uoce tube cornee.

Iubilate in conspectu regis domini: moue
atur mare et plentudo eius orbis terrarum
et qui habitant in eo.

Gradual (PL. 197), and *Invitatorium*, *Hymnus* and *Responsum* in an Antiphoner (PL. 198). In its original sense, the Gradual comprised the musical response sung between the reading of the Epistle and the Gospel, and the word derives from the steps ('gradus') where the Epistle was read. It came, however, to mean all the sung parts of the Mass. Similarly, an Antiphoner took its name from the short antiphons, verses sung by one choir in response to another at the end of a Psalm, but it was taken to include all musical sections of the offices.

All medieval churches were expected to have a Gradual and an Antiphoner, and all monasteries certainly owned them (PL. 201). Examples from southern Europe – Italy, and more especially Spain and Portugal – are among the most common of all illuminated manuscripts, and there are now vast numbers of framed single leaves from these books, often sixteenth- or seventeenth-century (though dealers may claim them to be earlier). They are usually huge in size because a choir would sing from a single manuscript (PL. 202). One could possibly guess the size of the choir (or perhaps the darkness of the church) by propping up one of these giant choirbooks and experimenting how many people could in practice read it clearly at once. Partly because of the size and partly because every page of music was different, these were complicated books to set in printed type, and so plain-chant manuscripts were still being handmade in the traditional way in south-west Europe for centuries after the introduction of printing.

The music was written in black neumes on staves of four or five lines. It is sometimes asserted that the use of a five-line stave indi-

cates a date of later than the fifteenth century: while in practice this is often true, there are far too many exceptions for it to be an indicator of a manuscript's age. There are examples of five-line staves as early as the thirteenth century. The staves could be drawn with what was called a 'rastrum' (the word literally means a rake), consisting of four or five evenly spaced pens joined like a multi-pronged fork to rule the lines simultaneously across a page. One can see where a rastrum has been used when the scribe has accidentally bumped the implement as he was working and all the parallel lines quiver in unison.

The very earliest manuscript Graduals and choirbooks had no staves at all, and from at least the tenth century simple indications of liturgical music were given by whiskery little neumes written in above the line of text. Several types of Carolingian notation were used, and some of the best-known are associated with St Gall and Lorraine. In their primitive form, these marks look rather as if a spider had trodden in the ink and wandered across the page. In Germany and the Low Countries these zig-zag marks evolved into more angular shapes with linked vertical tails, and, after the stave was introduced in the thirteenth century, they resemble clusters of short nails. Because of this resemblance, the distinctive neumes in German choirbooks are known as *Hufnagelschrift*, which means 'horseshoe-nail writing'. The staves are usually in black ink in German and north Netherlandish manuscripts.

In southern Europe, England, France and Flanders, the stave was usually drawn in red and the neumes are generally without tails. They worked approximately as follows. One of the four or

201 *Opposite left*

Private collection, s.n., upper cover

This is the original decorated binding of a vast manuscript Antiphoner made for the collegiate church of St-Omer, in Artois, about 1520. It is painted in black, red and yellow and was once fitted with metal bosses to support it on a lectern.

202 *Opposite right*

Private collection, s.n., detail

The large choirbooks of the medieval churches were intended to be displayed on a lectern so that a choir could sing from a single manuscript. This detail from a Bolognese Psalter of the early fifteenth century shows a group of Franciscan friars singing from a choirbook.

203 *Right*

Paris, Musée Marmottan, Collection Wildenstein, cat. no. 187

This miniature is from an unusually grand Gospel Lectionary made in the southern Netherlands early in the second half of the fifteenth century. It gives the reading from St Luke's Gospel for the Mass for the dedication of a church. It illustrates the text of St Luke's Gospel, chapter 19, when, despite murmurs of disapproval from the bystanders, Christ dined at the house of Zacchaeus the publican, who stood up during the meal and offered to give half his wealth to the poor.

five lines was marked at the beginning of the row with a clef sign to indicate that a particular line was 'c' or 'f'. These clef marks are derived from the form of the alphabetical letters, 'c' being usually written ▐ and 'f' something like ▜ (or ▜ in eastern Europe). Quite simply, then, the notes on or between the lines of the stave are pitched in accordance with this known note: the neume above 'c' is 'd', the neume below it is 'b', and so on. The clefs can shift up and down, even on one page of a manuscript, and the raising and lowering of the clef allows melodies of different range to be written on a stave of only four lines. There are no bar lines. The faint vertical lines in many manuscripts simply indicate the corresponding division of words in the line of text below. A tick at the end of a line is a silent warning to the singer of what is to be the first note on the following line. The spacing of the neumes indicates the length of the note. Neumes spread out across the page are sung slowly. Two neumes close together, or even contiguous, are sung as quavers. If the neumes are side-by-side ▪▪ , the notes repeat quickly ♫ . If a pair of neumes is written vertically ▪ , the lower note is sung first ♫ . Two neumes joined in their corner thus ◣ are sung in descending order ♪ . These are the simplest forms in medieval choirbooks. There can be many combinations of neumes, or diagonal lines instead of repeated notes, such as ◥ which is ♫ . All these can be interpreted in terms of a modern stave, and enthusiastic medievalists, with a good ear and a little practice, can actually sing straight from a page of a medieval choirbook, re-creating for a few moments the sound of a parish

church or monastery five hundred or more years ago. It can be enthralling to listen to. Some ancient hymn tunes, such as the *Veni creator spiritus* ('Come Holy Ghost'), emerge from the manuscripts almost unchanged from antiquity.

In addition to a Gradual and an Antiphoner, most medieval parishes would have used other liturgical manuscripts from time to time. If there was more than one priest conducting a service, a separate Lectionary might be required with the appropriate Gospel readings (or 'pericopes') of the day (PL. 203). On certain feast days of the year, such as Palm Sunday, a number of Processionals would be needed, with the prayers, hymns and litany to be recited during processions around the church (PL. 204). One such procession is shown in Plate 194. The churchwardens' accounts of St Margaret's church in New Fish Street in London list the books owned there in 1472. Amongst them are six Antiphoners (including 'a gret & a newe Antiphoner covered with Buk skynne ... of the gyft of sir Henry Mader, preest'), five Graduals, ten Processionals (including two given by the priest, Henry Mader), three Manuals (one from Henry Mader's gift again – they were for occasional services such as baptisms, marriages, and visiting the sick), an Ordinal (directions for conducting the liturgy), four Psalters, and a gratifying number of books for simple instruction in the Christian religion: *the Miracles of the Virgin*, in English, a *Catholicon* (this is Balbus's practical encyclopedia of religious knowledge), 'a boke called compendium veritatis theologice' (presumably the popular handbook by Hugo Ripelinus which opens

London, private collection, s.n., fols. 24v–25r

A Processional is a little portable book of chants to be used on the feasts of the year when the liturgy requires the priests and choir to walk in procession singing around the church. This is part of the procession for Palm Sunday from an English manuscript of the fifteenth century.

205 *Opposite*

London, Wallace Collection, inv. M338

It was the hope of every medieval person to die a Christian death with the absolution of the Church and the prayers of a priest. This Bolognese miniature of the late fourteenth century shows the death of the Virgin, with a nun and a priest in the foreground and all the apostles behind. St John has a palm branch brought by Gabriel. St Peter is reading fervently from a manuscript.

'Veritatis theologice sublimitas …'), a tract by St Bernard and the *Prick of Conscience*, both chained in the church, and so forth. The books were not merely for conducting services.

In considering books which a priest would have used, we must not overlook the pastoral side of the parish duties. A priest's occupation included instructing the laity, hearing confessions, comforting the dying and the bereaved (PL. 205), teaching Bible stories to children, and preaching and interpreting the Scriptures. There existed books to assist with all these. These everyday manuscripts are usually unspectacular. Humble little booklets on matters of practical theology were not as impressive as richly illuminated service-books, but they were probably nearly as common in the possession of priests. There is a modern index of the opening words of medieval treatises on the virtues and vices, the fundamental guides

for administering day-to-day religious advice: M.W. Bloomfield, B.-G. Guyot, D.R. Howard and T.B. Kabealo, *Incipits of Latin Works on the Virtues and Vices, 1100–1500 AD*, which was published by the Mediaeval Academy of America in 1979. It cites well over 10,000 surviving medieval manuscripts and more than 6,500 different texts, and it is by no means comprehensive. 10,000 extant volumes is an extraordinary number. For medieval sermons, historians have J.B. Schneyer's monumental nine-volume *Repertorium der Lateinischen Sermones des Mittelalters*, 1968–80, listing very many thousands of sample sermons in vast numbers of manuscripts dating from the two hundred years after 1150; no one has yet tackled the task of recording all the sermons and preaching guides for the fifteenth century. The sheer bulk of surviving manuscripts of pastoral theology is really daunting. Not all these manu-

206 *Right*

**London, British Library,
Add. MS. 16578, fol. 17v**

The *Speculum Humanae Salvationis*, or *Mirror of Human Salvation*, is a popular teaching book in verse which compares events of the New Testament with prefigurations in the Old. Here Christ's Entry into Jerusalem is related to Jeremiah's lamenting over the fate of the city. This manuscript was made by a priest, Ulric of Osterhofen, son of Conrad the public scribe and imperial notary, and was finished on 15 November 1379.

scripts belonged to priests; perhaps the majority were used by friars, and others by monks and literate laity, but they represent a huge body of grass-roots theology in an age when a casual visitor to a church might have thought it bare of books. Two of the most popular handbooks were Raymond of Peñafort's treatise on penance, the *Summa de Casibus Penitentie*, and Guillaume Pérault on the vices and virtues, the *Summa de Vitiis et Virtutibus*, both written by thirteenth-century Dominicans. One of the thirteenth-century *exempla* (or moral tales for use by preachers) tells how a common woman used to lend out separate gatherings of her copy of Pérault's *Summa* for priests to copy, and thus did more practical good to the parishes of her region (the story says) than the masters of theology in Paris ever did. Especially useful were texts like Guy de Montrocher's handbook for priests, the *Manipulus Curatorum*,

Gerson's guide for confessors, the *De Praeceptis, de Confessione et Scientia Mortis*, and the *Compendium Theologice Veritatis*, cited above. At the most basic level, a late medieval priest's teaching of the Scriptures would benefit from using a simple textbook such as the *Biblia Pauperum* (Poor Men's Bible), an album of Bible stories with pictures and quotations from the prophets, and the slightly later *Speculum Humanae Salvationis* (Mirror of Human Salvation), which has nearly 5,000 lines of doggerel Latin verse explaining how the life of Christ was prefigured by the Old Testament. It survives in over 200 manuscripts, of which about half are illustrated with vigorous and dramatic pictures (PL. 206). It was used like the Doom paintings in churches to teach the life of Christ and the inevitability of the Last Judgement.

A perceptive reader will have noticed that there has been no

207 *Right*

Oxford, Bodleian Library, MS. Rawl. G.161, fol. 426r

Folio Latin Bible manuscripts began to return into fashion in the late fourteenth century. This Austrian example was completed by the scribe Vena on 30 April 1399. The page here shows the opening of St Luke's Gospel, preceded by two prologues.

mention so far in this chapter of the one book found in every parish church today – the Bible. Readings from the Bible form an essential part of a Christian service. They were always used in medieval services, but lessons followed a fixed programme which laid down which passage was to be read on each day. It was often much more convenient for the priest to have these readings in a Lectionary or within the Missal or Breviary than to try to find the appropriate passage in a complete Bible which was not, at this time, divided into verses. Those little thirteenth-century portable Bibles were still in circulation, but their microscopic script is not suited to declaiming from a lectern.

Sometime in the late fourteenth or early fifteenth century, the lectern Bible began to return into fashion (PL. 207). It is difficult to know how far this was related to the use of a Bible in church, or for reading during meals in a monastery, or for private study (probably all three, in fact), but it seems to have been a phenomenon of the Low Countries and then later of the Rhineland. From the fourteenth century, the rhyming Bibles in the Dutch language were popular, rather as the *Bible Historiale* was in France, and in the fifteenth century monumental copies of the Dutch vernacular Bible histories were among the finest Netherlandish manuscripts. Nearly forty copies survive, and the two known first owners were both priests: Herman van Lochorst (d.1438, deacon of Utrecht Cathedral) probably owned B.L., Add. MSS. 10043 and 38122; and Evart van Soudenbalch (canon of Utrecht 1445–1503) owned

Vienna, Österreichische Nationalbibliothek, Cod. 2771–2. Similarly, huge Latin Bibles were being written out in the Low Countries in the first half of the century. A good example is Brussels, Bibliothèque Royale, mss. 106–7 and 204–5, a giant four-volume Bible made in Utrecht in 1402–3 by Henricus van Arnhem, presumably a professional scribe since he worked both for the Carthusian Abbey of Nieuwlicht and for Utrecht Cathedral. A three-volume copy is in Cambridge (Fitzwilliam Museum, MS. 289), illuminated with the arms of Lochorst of Utrecht, c.1420. There is a handsome five-volume copy from Liège, c.1430, now in the British Library (Add. MS. 15254, PL. 209). In the Bibliotheek der Rijksuniversiteit in Utrecht (MS. 31) there is a splendid lectern Bible in six volumes written at Zwolle between 1464 and 1476 at the expense of Herman Droem, dean of the Chapter of St Mary's in Utrecht 1458–76. We know that it cost him 500 gold florins to have made. The same Herman Droem commissioned another, even grander, lectern Bible in 17 huge volumes, now in the Biblioteca Casanatense in Rome (PL. 183), which was probably unfinished when Herman died in 1476. These are all very grand and enormous manuscripts, and they are not isolated examples. It is probable that the movements known as the *Devotio Moderna* and the Brothers of the Common Life had something to do with the revival of lectern Bibles. Gerard Groote (1340–84), founder of the movement in the Low Countries, taught a return to the basic teaching of the Bible and initiated a spiritual renewal whose

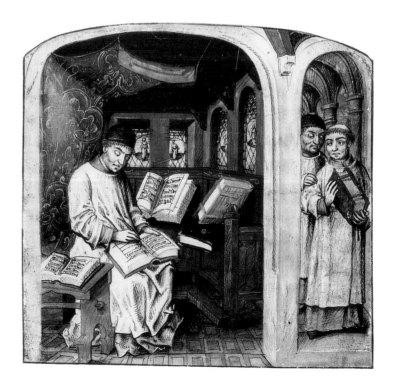

208 *Left*

Vienna, Österreichische National-bibliothek, Cod. 1576, fol. 9r, detail

Thomas à Kempis was a scribe as well as an author. This manuscript of his *Imitation of Christ*, made in Bruges for Baudouin de Lannoy soon after 1481, opens with a miniature of Thomas à Kempis writing out manuscripts in his cell in the monastery of Agnietenberg. Two other canons carry away a manu-script already completed.

209 *Opposite*

London, British Library, Add. MS. 15254, fol. 13r

This is the first page of Genesis in a vast 5-volume Latin Bible illuminat-ed about 1430. It belonged to the abbey of St-Jacques in Liège.

characteristics included lay participation in worship and in practical study of basic Christian books. Thomas à Kempis (1380–1471), author of the *Imitation of Christ*, wrote out a lectern Bible in five volumes between 1427 and 1438 (Darmstadt, Hessische Landes- und Hochschulbibliothek, MS. 324). The chronicler of the monastery of Agnietenberg, near Zwolle, wrote of Thomas à Kempis, 'He also copied our complete Bible and many other books, both for our house and on commission from outside' (PL. 208). Similarly, the Brothers of the Common Life at Deventer made manuscripts professionally, and their fraternity's regulations included a paragraph on the writing of books, giving instructions to show specimens of scribes' hands to potential clients, to make clear contracts before beginning work, and to obtain payment for work done.

It would be interesting to know if there was a correlation between the dissemination of lectern manuscripts in the fifteenth century and the books' most essential equipment – lecterns. These too were dispersed across Europe from the Low Countries and Germany. There are extremely few surviving lecterns in parish churches dating from before the fifteenth century, but late medieval examples are relatively common in the Rhineland and in the southern Netherlands (like one in Tournai dated 1483 and another at Chievres near Ath, dated 1484). Renier van Thienen of Brussels (fl. 1464–94) was celebrated for making brass lecterns and other church fittings. Fifteenth- and early sixteenth-century lecterns from Dinant and Brabant were used as far afield as Edinburgh, Venice and Sicily.

In considering the apparent success of lectern Bibles in north-west Europe in the fifteenth century, one can look briefly at the very first products of the printing press, an invention that has long had a legendary association with the Netherlands but which was brought into practical realization with movable type by Johann Gutenberg and his partners in Mainz in the Rhineland in the mid-

fifteenth century. A fundamental difference between writing by hand and printing (apart from the obvious difference of technique) is that the publisher of manuscripts accepted a commission first and then wrote out a book to order, whereas a printer, making an edition of several hundred copies simultaneously, was obliged to tie up capital in creating a stock which was subsequently marketed. Therefore a printer selected texts which had a certain sale. It is significant to consider what he chose. It will give us an interesting insight into the most secure market for books in the mid-fifteenth century. After experiments with ephemeral pieces, Gutenberg's first major project was a Latin Bible, the celebrated Gutenberg or 42-line Bible (c. 1450–5). It is a typical lectern book in two volumes. Copies were sold across northern Europe, and there are Gutenberg Bibles with original decoration which can be attributed to illuminators in Mainz, Leipzig, Melk, Augsburg, Erfurt, Basle, Bruges (three copies) and London. These books often look exactly like manuscripts, and the Lambeth Palace copy was actually mistakenly described as a manuscript Bible in H.J. Todd's catalogue of 1812 (PL. 210). Quite clearly, the first printer took sensible advantage of a rich and wide market existing for lectern manuscripts.

Other books from the very earliest years of the first printing press in Mainz include a second lectern Bible, a liturgical Psalter, 1457 (not intended for monastic use but for that of a secular church), Durandus's *Rationale Divinorum Officiorum*, 1459 (the basic parochial guide to church services), the *Catholicon*, 1460 and later (we have seen that there was a copy at St Margaret's parish church in London) and, in the early 1460s, St Augustine on the art of preaching.

It may well be, to return to the opening of this chapter, that if one were to walk into a parish church in the fifteenth century there would have been few books on view, but to the calculating printers who looked about them, priests and churches were the greatest users of books.

210 *Opposite*

London, Lambeth Palace Library, MS. 15, fol. 119v

The Gutenberg or 42-line Bible was the first substantial book printed in Europe, completed in Mainz about 1454–5. It was made to resemble a manuscript, with blank spaces left for the illumination. Copies were evidently sent out for sale across Europe, and were decorated on arrival. This copy reached England and was probably illuminated in London. It looks so much like a contemporary lectern Bible that until the nineteenth century it was mistaken for a manuscript.

Books for Collectors

Book collectors have always taken a delight in owning volumes which belonged to famous private collections of the past. The most refined North American society of bibliophiles is called the Grolier Club in honour of the connoisseur Jean Grolier (c.1489–1565), and the possession now of a book from Grolier's own library is considered a mark of great distinction. But Grolier himself owned a volume with an even greater provenance: he had a manuscript of Suetonius which had come from the libraries of Louis XII of France and of the Visconti princes of Milan and, before that, from the collection of Francesco Petrarch (1304–74). It is now Oxford, Exeter College, MS. 186 (PL. 212). It is a challenge to envisage a more ideal association copy for a classical text. The humanist collector Bernardo Bembo (1433–1519) was proud to possess two manuscripts which he wrongly believed to be in Petrarch's own handwriting (now Biblioteca Apostolica Vaticana, MSS. Vat. lat. 3357 and 3354), but he also owned a manuscript which must have the most supreme bibliophilic provenance of all time – the copy of the *Divine Comedy* of Dante which Boccaccio (1313–75) presented probably in 1351 to Petrarch.

The figure of Francesco Petrarch stands as a giant among the founders of Italian humanism and book collecting (PL. 213). It may now be argued that he was not really the first scholar inspired by the love of the classics and that he was following the Paduan tradition led by men like Lovato Lovati (1241–1309). None the less, Petrarch towers above them all as one of the very greatest of writers, poets, classicists, and collectors. He was born at Arezzo during his father's exile from Florence and was brought up in Tuscany and Avignon. While he was still a boy his father gave him a twelfth-century manuscript of Isidore which still exists (Paris, B.N., ms. lat. 7595), and there is a story that the father thought Petrarch was spending too much time on classical verse and that he flung the boy's manuscripts into the fire and then repented, pulling out Virgil and Cicero already smouldering. When he was about 21, Petrarch ordered, with his father's help, a great manuscript comprising Virgil with the commentary of Servius and other texts. It was stolen in November 1326, and when Petrarch eventually recovered it twelve years later, he commissioned a magnificent frontispiece for it by no less a painter than Simone Martini (1283–1344, PL. 214). By his early twenties, Petrarch had begun assembling as complete a text as possible of the works of Livy. One of his exemplars came from Chartres Cathedral and was itself copied from that fifth-century Livy which we mentioned earlier (p. 62) in the possession of the Emperor Otto III. While still based in Avignon, Petrarch searched the old libraries for classical texts new to him and he found Seneca's *Tragedies*, Propertius, and Cicero's *Pro Archia*. He later acquired books from Pomposa Abbey and Montecassino in Italy, and he was overjoyed to discover Cicero's *Letters to Atticus* in 1345 in the ancient chapter library at Verona. He systematically set out to build up a full set of surviving texts by ancient writers. He wrote poetry, fell in love with Laura, climbed mountains, travelled, talked, wrote, studied, and represented to future generations the ideal of the all-round humanist scholar and antiquarian. His library must have been one of the greatest private collections ever put together. In 1362 he offered to bequeath his books to Venice on condition that the city housed

LAVDES BELLICAE

ILIACAS ALII
FLAMMAS THE
BANAQVE FRA
TRVM ARMA,
ET IASONIIS
INSIGNEM HEROIBVS ARGO

Astror cursus & diiis inania regna.
Fidtaq. pierio referant miracula cantu:
Nos proprijs spectanda oculis: nos inclyta dextrae
Facta tuae canimus: quibus aurea sydera viuus
Tangis: & aetherias fama petis arduus arces:
Sed sine te nunq tenues ad carmina tanto
Subsistant uires oneri: tu numine toto
Dexter ades: da maeoniam tua facta canenti
Matthia coruine chelyn: si delphica parent
Templa tibi: sentitq; frequens tua nomina cyrrha
Si musae si phoebus amant: hoc tempore solus
Carminibus si digna facis: quae nulla uetustas

MATHIAS REX VNGARIAE BOHEMIAE

both them and himself during his lifetime. The republic agreed to the proposal, and Petrarch moved into the palace supplied for him. Some years later he left Venice again and apparently considered the bargain void. He lived on and died in his little house not far from Padua on 18 July 1374. Some of his books were scattered among his family. Others went to his last patron Francesco Novello da Carrara and passed into the Visconti-Sforza library. Altogether, some 44 surviving manuscripts from Petrarch's library have been identified. Any one of them would be a relic worthy of veneration by the sect of humanists which flourished after his death.

The direct link between Petrarch and the humanist bibliophiles of the Renaissance is one of shared enthusiasm which was passed on from one person to another. The poet Giovanni Boccaccio in his later life became passionately involved in the circle of poets and

collectors who gathered round Petrarch, and from the 1350s they became close friends, frequently staying in each other's houses (PL. 216). He too had a wonderful collection of books, which he bequeathed to the Augustinian convent of Santo Spirito in Florence, including an autograph copy of his *Decameron* now in Berlin (Staatsbibliothek Preussischer Kulturbesitz, MS. Hamilton 90). Boccaccio knew and encouraged Coluccio Salutati (1331–1406), chancellor of Florence from 1375 until his death, and Salutati's protégés included Leonardo Bruni (1369–1444), Niccolò Niccoli (c.1364–1437), and Poggio Bracciolini (1380–1459). These are important names in this chapter. Their enthusiasm inspired Cosimo de' Medici (1389–1464), and so we are taken into the period of the princely libraries of the Renaissance based on the revival of classical learning and antique art.

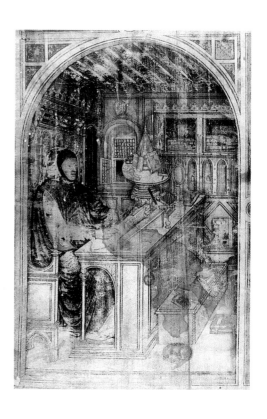

2 I I *Previous page*

Wolfenbüttel, Herzog August Bibliothek, Cod. 85, 1.1, Aug.2°, fol. 3r

This manuscript of a poem by Alessandro Cortesi was prepared c.1485–90 for the royal book collector, Matthias Corvinus, king of Hungary 1458–90. It was written in Rome by the scribe Bartolomeo Sanvito (1435–1511/12) and is painted in a *trompe l'oeil* design, as if an old piece of manuscript was nailed to a classical monument.

2 I 2 *Above left*

Oxford, Exeter College, MS. 186, fol. 24r, detail

The *Lives of the Caesars* by the second-century historian Suetonius is a principal source for Roman history of early empire. This manuscript was acquired by Petrarch between 1345 and 1351. The marginal notes here are in his own hand. The manuscript belonged afterwards to the Visconti dukes of Milan and to the great French Renaissance bibliophile Jean Grolier.

2 I 3 *Above right*

Darmstadt, Hessische Landes- und Hochschulbibliothek, MS.101, fol. Iv

Francesco Petrarch (1304–74) is generally regarded as the founder of Italian humanism. Here, in a late fourteenth-century drawing, Petrarch is shown as the scholar in the ideal study, turning the pages of a manuscript on his desk strewn with books and writing materials. The little room is crowded with manuscripts, on a book stand, in the cupboard, on the chest, and on the floor. A cat sleeps in the foreground.

2 I 4 *Opposite*

Milan, Biblioteca Ambrosiana, S.P. Arm. 10, scaf. 27 (A 49 inf), fol. Iv

In about 1325 Petrarch commissioned a manuscript of Virgil, with the gloss of the fourth-century grammarian Servius Honoratus. The manuscript was stolen in 1326 but Petrarch recovered it in 1338. By then he was living in Avignon and about 1340 triumphantly had this great frontispiece painted for the manuscript by the artist Simone Martini.

Ytala felicibus tellus alis alma poetis/
Oz tibi grecos: redit hic atungeit metas.

Scumus alaloquib rerengens archana maronis.
ve pateant ouibz pastorib; atq; colonis.

Iralia nempe fati tua alba cangine fines/

It is sometimes difficult, in looking at the careers of these early Florentine enthusiasts, to distinguish the love of pure Latin scholarship from the unashamed delight in collecting texts. It has always been possible for satirists to make fun of bibliophiles or collectors of any sort (as did one writer in an otherwise kind review of the first edition of the present book in *History Today*, January 1988), but the gusto and excitement of book acquisition shine through in antiquarians like Coluccio, Niccoli, and Poggio. This in itself represents a major stride into humanism and the Renaissance, and away from the pragmatic book ownership of the Middle Ages. To be a humanist was not a necessary occupation. They bought books because they liked them and enjoyed being surrounded by books. This is a very modern attitude. Like many great collectors today, Coluccio began when quite young. By his mid-twenties he was

certainly buying Latin manuscripts such as his copy of Priscian which is still in Florence (Biblioteca Medicea-Laurenziana, MS. Fiesole 176). Coluccio must have found himself comparing his own life with that of Cicero, his classical hero: a long-serving politician and man of affairs acknowledged to be the centre of a wise network of urbane and civilized friends. Coluccio's famous library came to include Cicero's long-lost *Letters to his Friends* which was discovered in the cathedral library at Vercelli, as well as the oldest complete manuscript of Tibullus and one of the three primary manuscripts of Catullus. All fellow enthusiasts were encouraged to visit his library in Florence, and something like 120 of its manuscripts have survived, including (for example) a signed Seneca entirely in Coluccio's hand (B.L., Add. MS. 11987). They can sometimes be recognized by a distinctive feature which he

215 *Above right*

Private collection, s.n., fol. 1r, detail

About 120 manuscripts still survive from the private library of Coluccio Salutati (1331–1406), many of them already antiquarian books when he acquired them. They can sometimes be recognized by a number which he wrote at the top of the first page – in this instance, 4 – followed by the word 'Carte' and the number of leaves in the book, in roman numerals. This example is from a twelfth-century medical manuscript, the *Liber Passionarii* of Gariopontus, 94 leaves, which Coluccio may have acquired in the 1370s.

216 *Below right*

Paris, Bibliothèque Nationale, ms. lat. 1989, vol. I, fol. 1r, detail

Petrarch and Boccaccio were personal friends. This inscription in Petrarch's hand is on the first leaf of an eleventh-century St Augustine. It reads in translation, 'the great man, Giovanni Boccaccio of Certaldo, poet of our time, gave me this immense work when he came from Florence to visit me in Milan, 10 April 1355.'

added to his books: like many collectors now,¹ he counted the number of leaves in each manuscript and at the top of the first page recorded this number in his own hand (PL. 215).

Niccolò Niccoli was some thirty years younger than Coluccio and he lived until 1437, well into the true Renaissance. He was not a rich man (his father had a cloth manufacturing business), but was wealthy enough to devote his life to collecting. He once sold several farms in order to buy manuscripts, and he died with a superb library and a substantial debt at the Medici bank. He was an austere and rather frightening man. While his friends scattered themselves across Europe seeking out manuscripts, Niccoli stayed in Florence encouraging their expeditions and receiving the treasures they brought back for his approval. There is an irresistible modern comparison with Old Brown, the owl in Beatrix Potter's *Tale of Squirrel*

Nutkin, before whose door the young squirrels in the story have to make presents to gain permission to gather nuts on Old Brown's island. Niccoli was an exacting critic. He lived fastidiously and dressed stylishly, wearing a red gown which reached to the ground. He never married though, as we are told by Vespasiano, whom we shall be meeting soon, 'he had a housekeeper to provide for his wants' (we learn elsewhere that her name was Benvenuta). His manuscripts were superb, and his library became a meeting place for scholars and bibliophiles. It is well known that incipient collectors can be greatly inspired by the infectious example of a persistent enthusiast, and (to judge by the results) the long evenings at Niccoli's house were spent discussing and comparing acquisitions with such excitement and sense of fun that a whole generation of collectors became caught up in the search for books.

217 *Right*

Rome, Biblioteca Apostolica
Vaticana, MS. Urb. lat. 224, fol. 2r

Through life-long energy, persuasive charm and unstoppable enthusiasm, Poggio Bracciolini (1380–1459) brought book collecting into the Florentine Renaissance. His portrait here, painted by the Florentine illuminator Francesco d'Antonio del Chierico about 1470, shows Poggio in old age holding open a manuscript of his own book, *De Varietate Fortunae*.

M.TVLLII. CICERONIS.EP
AD.ATTICVM.LIBER.OC
CIT.INCIPIT.LIBER.NO
ICERO ATTICO SALVTEM

This can be explained in historical terms which define humanism as the love of learning for its own sake (that is certainly true here) and the recovery of classical Latin texts as an academic discipline which required books as working tools, but there is a more fundamental straightforward enjoyment of being a collector.

This *joie de vivre* certainly appears in Poggio Bracciolini, the third of the great Florentine classicists who brought bibliophily to the Renaissance (PL. 217). Poggio arrived in Florence in the late 1390s when he was less than twenty and had just given up law school at Bologna. He had no money and was looking for a job, and he was befriended by Coluccio and Niccoli. Between them they devised a new method of writing out manuscripts (we shall return to this in a moment). Late in 1403 Poggio secured a job as a notary with the papal court in Rome. His real chance for book collecting came in October 1414 when he moved as papal *scriptor* to Germany for the great Council of Constance. The Council sat for four years, and one local chronicler proudly listed the astonishing total of 72,460 people who attended. In such a huge gathering there was inevitably spare time which Poggio used to his very best advantage. He made expeditions to libraries all around Lake Constance and further afield, and he discovered and extracted (where he could) a wealth of new classical texts that really brought the admiration of his bibliophile friends back in Florence. Early in 1415 he came upon the Cluny Abbey manuscript of Cicero's speeches and sent it off to Niccoli. In the summer of 1416 he got into the old monastery library at St Gall where his finds included part of Valerius Flaccus, then unknown, and, for the first time, a complete text of Quintilian. The monks would not let him take their Quintilian (and by good fortune it is still in Switzerland, now Zurich, Zentralbibliothek, MS. C.74a), but he borrowed it and copied it out in full, a task which is variously reported as taking him 32 days or 54 days. In any case it was a big book to transcribe and Poggio must have wished that they would release the original. The next year he and a few friends from the Council went to other monasteries in Germany and Switzerland, and in the summer crossed into France. They turned up copies of Lucretius, Silius Italicus, Columella, Vitruvius, and even more hitherto unknown Cicero. Many of the manuscripts had got there in the first place hundreds of years before when the northern emperors had been imitating ancient Romans with imperial libraries. Now the books began to flow back to Italy again. Poggio did not always find it easy to extract volumes from their 'prisons', as he called them: he described their owners as 'barbari et suspiciosi', and one finds it hard not to sympathize with the monastic librarians face to face with this articulate young Italian determined to talk them into giving up manuscripts.

After the council ended, Poggio visited England (where he said the dinner parties were unbelievably boring) and finally returned to Italy. Here his newly found texts passed into the canon of classical literature. There was a growing band of book collectors

218 *Above*

Berlin, Staatsbibliothek Preussischer Kulturbesitz, MS. Hamilton 166, fol. 96r, detail

This manuscript of Cicero's *Letters to Atticus* was copied out by Poggio himself in Florence in 1408. It is a very early example of the new style of manuscript invented by Poggio and his antiquarian friends, written in a single column in a new rounded clear script, with initials filled with entangled white vine stems. This manuscript probably later belonged to Cosimo de' Medici.

219-220 *Opposite*

London and Oslo, The Schøyen Collection, MS. 668, detail; Berlin, Staatsbibliothek Preussischer Kulturbesitz, MS. Hamilton 125, fol. 136v, detail

The new humanist white vine initials were derived from twelfth-century models. Compare the initial 'V' above, from a Bible made probably in Tuscany in the first half of the twelfth century, with the 'B' below, from a manuscript of Caesar copied by Poggio in Florence probably before 1408. Even the colours are similar.

passionately keen on ancient Roman culture and each was inspired to put together as complete a set as possible of classical Latin texts. If they could not own original Roman manuscripts, which was an impossible hope, they had to make do with copies. The style in which this was done had been thought out by Salutati, Niccoli, and Poggio in Florence around 1400. In short, they introduced humanist script. Precisely how or when this happened is difficult to discover, but it is accepted that the young Poggio was a key figure in the operation. The old-fashioned fourteenth-century Gothic script, full of abbreviations, was not always easy to read. We know of complaints by the elderly Coluccio in 1392 and 1396 that ordinary Gothic writing was too small for his eyes. The collectors had been able to acquire many very old manuscripts from the Carolingian period (in fact, about a third of what survives from Coluccio's library dates from before 1200) and they must have admired the elegant single-column pre-Gothic minuscule in which they found their earliest classical texts. We do not know how good their palaeographical judgement really was: they appreciated that these manuscripts were extremely old, but surely they did not actually think they were Roman books? However, they began to make manuscripts in a version of this old rounded neat script. They were concerned with the whole bibliophilic appearance of the book, giving attention too to the quality of the vellum, the ruling, and the proportions of the pages. One of the earliest specimens of the new style is thought to be a volume of texts by Coluccio himself with corrections by the author (therefore datable to before his death in 1406) and copied out almost certainly by Poggio in 1402–3 before he left to take up his first job in Rome (Florence, Biblioteca Medicea-Laurenziana, MS. Strozzi 36). Another is a Cicero copied by Poggio in 1408 (Berlin, Staatsbibliothek Preussischer Kulturbesitz, MS. Hamilton 166; PL. 218). Already by 1418 they were describing this kind of script as 'lettera antica'. It was a deliberate attempt to revive an old script and they admired it simply because they knew it was ancient. These men were antiquarians, not inventors. They adopted a new kind of decorated initial too. In both the Coluccio book of 1402–3 and in the Cicero of 1408 there are initials with branching entwined vinestems left white against a coloured ground. These initials became typical of Florence in the fifteenth century, but they were quite new in the time of Coluccio, Niccoli, and Poggio. They are formed of what are known as white vines ('bianchi girari' in Italian). The initials look rather like the acanthus foliage which the humanists knew on ancient Roman marble columns, but their actual models must have been the vinestem initials found in many central Italian manuscripts of the mid-twelfth century (PLS. 219–20). Once again they thought they were reviving an old tradition.

This new style of book appealed enormously to the collectors of classical texts in Florence in the early decades of the fifteenth century. Scholars began to practise it themselves and to ask their friends to do it. It was the style used for reproducing the texts

which Poggio and others were finding in ancient monasteries. Giovanni Aretino could write a fine version of this *lettera antica*, for example, and he copied out manuscripts of Cicero (1410), Livy (1412), Cicero (1414 and 1416), Francesco Barbaro (1416), Justinus (1417), and so forth. It was Aretino who wrote out a fine copy of the text of Quintilian which Poggio had recovered from St Gall a year or so before (Florence, Biblioteca Medicea-Laurenziana, MS. 46.13). When Poggio came back to Italy he actually seems to have taught scribes to write in his humanistic minuscule. In June 1425 he wrote to Niccoli to say hè was trying to train a new Neapolitan scribe and, two months later, said the scribe was proving unreliable, fickle, and disdainful, but that a French scribe he had was even worse. There is a marvellous despairing letter from Poggio dated 6 December 1427 recounting that he has spent four months attempting to teach a bumpkin scribe: 'I have been shouting, thundering, scolding and upbraiding', wrote Poggio, now aged nearly fifty, 'but his ears are blocked up – this plank, this log, this donkey …'

The circle of bibliophiles in Florence shared the most common complaint of collectors at all periods: they did not have enough money. They must have been particularly pleased to welcome Cosimo de' Medici into their company. It was like a Getty applying to join a hard-up local arts society. Suddenly there was a collector with really unlimited wealth who paid bills promptly. Cosimo the Elder (1389–1464) was a brilliant banker and a calculating and successful politician. His hobby was book collecting. Niccoli cultivated his enthusiasm. He planned a holiday in Palestine with Cosimo to look for Greek manuscripts, and he got him to buy for the huge price of 100 florins a twelfth-century Pliny which had been found at Lübeck, the first complete copy to reach Florence. Poggio took him exploring in Grottaferrata, Ostia, and the Alban Hills to look for Roman inscriptions. Antonio Mario and Giovanni Aretino wrote out manuscripts for him (PL. 222). Cosimo was enchanted with the delightful and cultivated world of the humanists. After the death of Niccolò Niccoli, Cosimo managed to come to a deal with the executors in 1441 to pay off Niccoli's debts and to acquire his library, which he presented to the convent of San Marco, paying for the installation and chaining of the books. Cosimo's own library increased, and no doubt his obliging scribes and friends did not feel diffident about charging him for their services. It is difficult (and fascinating) to try to detect the moment when the passion for old texts and old books edged from the private interest of an ever-increasing group of enthusiasts into a vast business which could support the professional book trade. This probably happened in Florence about 1440, and the agent who profited most was Vespasiano da Bisticcci (1422–98).

Vespasiano was a bookseller and agent for making humanist libraries (PL. 223). He advised collectors, employed scribes and illuminators when required, and acted as a bibliographical broker for wealthy men like Cosimo de' Medici. We know where he lived, in the via dei Bardi, on the Oltr'Arno, and in one manuscript commissioned through Vespasiano there is a map of Florence showing not only Vespasiano's house, but also his garden allotment beyond the city (PL. 221). At the end of his life Vespasiano wrote a kind of book of reminiscences, *Vite di uomini illustri*, which comprises short biographies of the famous men of the author's lifetime, and the implication (and often the fact) is that Vespasiano knew them and furnished them with libraries. Thus he tells us that Cosimo de' Medici had taken on the expense of building the Badia in Florence: 'and one day, when I was with him, he said, "What plan can you suggest for the formation of this library?" I replied that if the books were to be bought, it would be impossible, for

221 *Opposite*

Paris, Bibliothèque Nationale, ms. lat. 4802, fol. 132v

This manuscript of Ptolemy's *Geography*, made in Florence about 1470 for Alfonso of Calabria, includes a map of Florence. Among the various named buildings of Florence is a tiled house with three windows marked 'Domus Vespasiani', Vespasiano's house, in the centre on the far side of the Arno just to the left of the central bridge, the Ponte Vecchio, and in the far corner, under the city walls below San Miniato, is 'Orti Vespasiani', Vespasiano's gardens or allotment.

the reason that they could not be found. Then he went on, "Then tell me what you would do in the matter." I said it would be necessary to have the books transcribed, whereupon he wanted to know whether I would undertake the task. I said that I would ...' Vespasiano goes on to say that arrangements were made for payment through the Medici bank, and claims that he then employed 45 scribes who completed 200 volumes in 22 months. This was obviously big business. The figures (if true) show that each scribe would have averaged five months to make a volume. No doubt every one of the books was written in the humanistic minuscule and decorated with white-vine initials.

At this period, and really for the first time in the history of medieval books, we begin to know a great deal about some of the scribes who were making manuscripts. Many copyists signed and dated their volumes. Others are identifiable from archival sources and, astonishingly (given the rarity of such information earlier in the Middle Ages), over a hundred have been recognized in actual manuscripts by the determination and watchfulness of A.C. de la Mare, Professor of Palaeography at King's College in London. Well-known Florentine scribes of the fifteenth century include men like Antonio Mario (d. 1461, probably), who signed about 45 surviving manuscripts between 1417 and 1456, and who wrote others which he did not sign. One is shown in Plate 226. He evidently made a speciality of copying historical texts, some of great length. Antonio often added cheery messages at the end of his

books such as 'Good-bye, reader' ('Valeas qui legis') or the names of his clients, like Benedetto Strozzi in 1420 or Cosimo de' Medici in 1427, or notes on contemporary events such as a battle with the duke of Milan in 1425, a plague throughout Tuscany in 1437, the Council of Florence in 1440, or the republic's concern about vexation from the king of Aragon in 1448. There are about 40 manuscripts signed by Gherardo di Giovanni del Ciriago (d.1472), dating from 1447 to the end of his life. He was the son of a Florentine silk dyer. A number of Ciriago's manuscripts were made for Cosimo de' Medici, and in one he says that he wrote it out when he was a notary and scribe to the lords of the municipality of Florence and that he afterwards sold it to Cosimo in 1457 (Florence, Biblioteca Medicea-Laurenziana, MS. plut. 37.16). Two of Ciriago's last manuscripts were made for Federigo da Montefeltro and for Alfonso, Duke of Calabria, 'through the agency of Vespasiano son of Filippo' (writes the scribe in both books, fully aware of who is paying him) 'the prince of all the booksellers of Florence' (Biblioteca Apostolica Vaticana, MS. Urb. lat. 1314; Valencia, Biblioteca Universitaria, MS. 765). Not least among the innovations of Vespasiano is that he was probably the first bookseller to keep a substantial stock of new books on the shelves for customers to come and browse and buy. Many scribes must have owed their livings to him.

Obviously there was money to be made in copying out manuscripts. Very many of the best scribes seem not to have been full-

222 *Left*

Oxford, Bodleian Library, MS. D'Orville 78, fol. 26r, detail

In 1417 Poggio discovered in France a copy of various speeches by Cicero, including the *Pro Caecina* and *Pro Lege Agraria*. This manuscript was written out from the new exemplar probably in 1418 by the scribe Giovanni Arentino for Cosimo de' Medici, whose partially erased name is just visible in the centre of this page.

223 *Opposite*

London, British Library, Royal MS. 15.c.xv, fol. iv, detail

'Vespasiano, Florentine bookseller, had this work copied in Florence': this note on the flyleaf of a manuscript of the *Commentaries* of Julius Caesar attests to the involvement of Vespasiano da Bisticci (1422–98). The manuscript, commissioned through the agency of Vespasiano, was brought probably in 1465 to Exeter College in Oxford by Robert Flemmyng (c.1417–83), who was buying manuscripts in Italy in the late 1440s.

time professionals. They were often notaries, like Antonio Mario and Gherardo del Ciriago, or like Niccolò di Berto di Martino de' Gentiluzzi, of San Gimignano (*c.*1398–1468), who was a minor scholar and translator in his own right (PL. 225). Other scribes were members of the Church, like Piero Strozzi who was a priest in Florence from 1447 to 1491 and (as Vespasiano tells in his book on famous men) supplemented his income by copying manuscripts so that he would not feel dependent on charity (PLS. 224 and 235). Strozzi came from a good family and there was no shame in being a scribe. One reason which turned men to scribal work was that they needed money quickly. A curiously large number of manuscripts were written in *le stinche*, the debtors' prison in Florence. The building is shown in the map of Florence in Plate 221, across the river from Vespasiano's house. Gabriele da Parma wrote a Petrarch there in 1427 (Sotheby's, 21 November 1972, lot 555), Agostino di Bartolo wrote B.L., Add. MS. 8784 there in 1442 (and if he also wrote Biblioteca Apostolica Vaticana, MS. Pal. lat. 1607, was back inside again in 1444), and Andreas de' Medici signed six manuscripts between 1468 and 1472, two of them 'nelle stinche' in 1468. It was probably quite an agreeable way of passing one's time in prison and paying off debts at the same time.

A scribe who is being paid for his work will naturally prefer to work as quickly as possible. The beautiful round humanistic minuscule required care and precision and the pen often had to be lifted as each letter is formed of neat little strokes. Some scribes began to slope their script and join up the letters into a cursive script which must have been much faster to write. It is basically this joined-up script of the humanist scribes which has been revived by calligraphers in the twentieth century and is known as 'italic' from its Italian Renaissance models. One scribe, Giovanni Marco Cinico of Parma, who trained in Florence but worked in Naples, 1458–98, sometimes signed himself 'velox' (speedy) and boasts in manuscripts that he was able to make them in 52 or 53 hours (Florence, Biblioteca Medicea-Laurenziana, MS. Strozzi 109, and the former Dyson Perrins MS. 79, respectively). By contrast, he says in B.L., Add. MS. 24895 that it was written 'tranquille', no doubt meaning that he was working at a more leisurely pace. A copy of Caesar written by a scribe Stephen in 1462 (B.L., Add. MS. 16982) took 38 days, which works out at eleven pages a day. This must have been a much more usual kind of rate. A customer commissioning a manuscript through Vespasiano, for instance, would have to allow time for the book to be written out and illuminated.

William Gray (*c.*1413–78), from Balliol College in Oxford, is a good example of a book collector who seized the chance of a few days in Florence to place an order with Vespasiano that would take several years to fulfil. Gray was a notable English scholar and had been chancellor of Oxford University about 1440. By the end of 1442 he had left on a tour of Europe, going first to Cologne (where he acquired a number of manuscripts such as a Seneca, now Oxford, Balliol College MS. 130), and late in 1444 or early in the

next year he travelled on to Italy, spending time in Padua, Ferrara, and Rome. However, he came first to Florence. Vespasiano includes William Gray among his lives of great men, and says that he was so rich (one can see Vespasiano's eyes flashing with approval) that he had to travel from Cologne in disguise to avoid being robbed on the journey. 'When he arrived in Florence', writes Vespasiano, 'he sent for me and told me about this adventure. He ordered many books, which were transcribed for him, and then left for Padua ...' When Vespasiano says the books were transcribed, he means that they were specially made rather than acquired second-hand or sold from stock. They were still working on the order in December 1448 when Vespasiano wrote to Gray in Rome to say that a Tertullian manuscript had been sent off and that he was waiting for his instructions on the Plutarch and other texts. The scribes employed for this job included Piero Strozzi and

Antonio Mario. Some of the manuscripts themselves survive, mostly still in Balliol College to which Gray bequeathed them many years later. They include a five-volume Cicero (one volume dated November 1445 and another September 1447), Sallust, Quintilian, Virgil, Pliny, and two religious texts, St John Chrysostom and John Climacus (PL. 226), which Antonio Mario signed in most friendly terms in August 1447 and June 1448: 'Lege feliciter, mi suavissime Ghuiglelme' ('Have a nice read, my dearest William'). Obviously the relationship between the bookseller, his scribes, and his customer, was one of cultivated cordiality. It is as if the fellowship of Florentine bibliophiles has temporarily admitted William Gray into their number. When he left Italy finally in 1453, he had much less money and some fine manuscripts. Personal contact and shared enthusiasm are the delight of all collectors, and Vespasiano was a most genial man.

224 *Left*

Florence, Biblioteca Medicea-Laurenziana, MS. plut. 36, 41, fol. 1r

This manuscript of the comedies of Plautus was commissioned around 1450 by Piero de' Medici (1414–69), son of Cosimo the elder. It was written out by Piero Strozzi, a priest who supplemented his stipend by copying manuscripts for Vespasiano, and was illuminated by Ricciardo di Nanni.

225 *Opposite*

Madrid, Biblioteca Nacionale, Cod. vit. 22–11, fol. 1r

This manuscript of St Augustine, in Italian, was copied by the scribe Niccolò di Berto di Martino de' Gentiluzzi, of San Gimignano (c. 1389–1468), notary and translator, for one of Vespasiano's Spanish clients, the Marquis of Santillana (1398–1458), poet and collector of manuscripts in the Italian language.

Reduci libri delle mie confessioni laudano
idio giusto et buono et demie mali et de
mie beni. et commuoueno inlui lointellec
to humano et laffecto. Intratanto quello
che ame appartiene quello inme adoperero
no quando siscriueuano et quel medesimo fanno quando sileg
geno: quello che gualtri ne sentano, essi seluegguno, mentemo
no io so che questi mie libri molto son piaciuti et piaceno a
molti frategli. Dalprimo libro insino aldecimo sono scripti
dime, neghaltri tre delle scripture sancte cominciando daquello
che e scripto, nelprincipio fere idio ilcielo et laterra insino alla
requie delsabbato. Nelquarto libro, quando della morte dello ami
co mio, io confessaui lamiseria dellanimo mio, dicendo che la
nima nostra palcun modo era facta una duie, et pcio dissi che
io temeuo forse dimorire, acio che colui non morisse tutto lo
quale io molto aueuo amato, laquale declamatione ame qua
si leggieri, quanto grieue confessioni pare; benche inqualche
modo sia temperata, p quello che inquesto nonben decto aggiun
to ue forse. Et quello che e scripto nel tredecimo libro, oue io
dissi che lfermamento e facto intralacque spirituali superiori
et trale corporali inferiori, non e decto assai consideratamente
ma quella cosa e molto moscuro. Questa opera comincia co
si. Magno se signore et molto laldabile.

Magno tu se signore et molto lal
dabile. et grande e latua uirtu
et alla tua sapientia non e nu
mero. Et uuole luomo laldarti
ilquale e alcuna parte della tua
creatura. luomo dico loquale
porta dintorno ase lamortalita
sua intestimonio delsuo peccato
et testimonio, percio che tu fai
resistentia asuperbi. Et niente
meno luomo tuuol saluare il
quale e alcuna parte della tua
creatura. Tu commuoui elnostro cuore acio che si dilecti dilodar
ti pcio che tu aifacti noi, att; et non e ilnostro cuor quieto

DE

SERMO SANCTI EFFREM DE PENITENTIA
INCIPIT FELICITER .

226 *Above*

**Oxford, Balliol College,
MS. 78B, fol. 108v, detail**

This is the volume of John
Climacus, *Spiritualis Gradatio* and
other religious texts (that shown
here is by Effrem the Syrian), com-
missioned from Vespasiano in
Florence by the travelling
Englishman, William Gray
(c. 1413–78). It was written out in
1448 by the scribe Antonio Mario,
who ends with a signed colophon
wishing William a pleasant read.

227 *Opposite*

**Paris, Bibliothèque Nationale,
ms. lat. 6309, fol. 1r**

This is a Latin translation by
Giovanni Argyropoulos of the
Nicomachean Ethics of Aristotle. The
manuscript was commissioned in
Florence c. 1480 by Alfonso of
Calabria (1448–1495), son of
Ferrante I, king of Naples, and
a client of Vespasiano. The manu-
script was probably illuminated by
Francesco Roselli.

Good booksellers are brought by their profession into the most
exalted circles. As early as the mid-1460s, the chronicler
Sozomeno of Pistoia declared that Church leaders of East and
West, kings, noblemen and scholars all turned to Vespasiano's
shop. The autobiographies of modern antiquarian booksellers and
art dealers (and there are many such books) always seem to be
filled with accounts of social visits to kings and dukes and million-
aires. It pays to cultivate the very richest people. It is remarkable
how Vespasiano's reminiscences of his clients have exactly the
same theme. His four sections are on popes, kings, and cardinals;
archbishops and bishops; sovereign princes; and men of state and
letters. Vespasiano's most complimentary comment (booksellers
have never changed) is 'he collected a fine library, not regarding
cost'. Like all republicans, the Florentines adored royalty.
Vespasiano goes out of his way to praise the culture of Alfonso of
Aragon (1401–58), king of Naples, but in fact the best he can real-
ly say about the king's scholarship is that Antonio Panormita used
to read Livy manuscripts out loud to him. None the less,
Vespasiano willingly supplied the Aragonese royal library with
manuscripts (PL. 227). Vespasiano had his own name written in the
Thucydides manuscript intended for King Louis XI of France, writ-
ten opposite the opening leaf where the royal reader could not fail
to notice it (Paris, B.N., ms. lat. 5713, PL. 230). When in 1488
the Florentine scribe Antonio Sinibaldi copied out a book for
Matthias Corvinus, king of Hungary (1458–90), he could not resist
name-dropping in signing himself 'formerly scribe and book-agent
to Ferdinand, king of Sicily' (Paris, B.N., ms. lat. 16839; a manu-
script he made for the Neapolitan royal library is illustrated in Plate
238.) Other scribes working for King Matthias often signed their
work (PL. 229). The scribe and illuminator Joachinus de Gigan-
tibus (fl. 1448–85), a German by birth who worked mainly in
Rome with excursions to Siena and Naples, loved to call himself
'royal bookseller and miniaturist on vellum' (as in B.L., Add. MS.
15272). Sometimes Joachinus states in manuscripts that he decorat-
ed them too, as in Paris, Bibliothèque Nationale, ms. lat. 12946,
where he calls himself book supplier and miniaturist to Ferrante
(Ferdinand), king of Naples (PL. 228), and in Rome, Biblioteca
Vittorio Emanuele, MS. 1430, a prayer-book written for Pope
Sixtus IV in 1481, where he added in large purple capitals that he
wrote and painted the book with his own hand. There is no need to
be modest if one wants to come to the attention of popes and
kings. The massive royal and princely orders for manuscripts were
certainly welcomed by the humanist scribes and by booksellers.

This then is the period of the great building of libraries for the
princes of the Renaissance. In the second half of the fifteenth cen-
tury, by no means all rulers bought their books from Florence.
Scribes and illuminators also travelled to the courts where commis-
sions could be found. Great humanist libraries of classical and other
texts were assembled by the Visconti and Sforza dukes of Milan
(PL. 233), by the Este court in Ferrara and the Gonzaga dynasty of

IO ANNIS ARGYROPVLI BI
ZANTII PREFATIO AD MAGNI
FICVM VIRVM COSMAM MEDI
CEM IN LIBROS ETHICORVM AD
NICOMACVM FILIVM EX GRE
CO IN LATINVM PER EVM TRA
DVCTOS INCIPIT FELICITER

IOANNES AR

gyropylus Byzantius magni
fico viro Cosine Medici. S. P. D.
Si ea mihi seruanda sunt erga
te que iam olim institui sapien
tissime Cosma: ea tm sunt a me
tibi offerenda: que preclarissima
rerum esse censentur: nec a qui
busuis hominum offerri facile
possunt. Nam neq tantam uirtutem sine ullis muneribus p
tereundam esse existimaui: & quicquid obtulero muneris
id omne accommodatum esse uirtuti oportere putaui. Nec
enim amor uirtitis unq illud sane pferre posset: & cuiq p
dignitate semp tribuendum ee uidetur iustitie lege: ad qua
omnis res talis omnino est referenda. Q si maxime omnium
ea studioso sunt offerenda: que uehementer ad ipam uirtu
tem felicitatem q pertinent: atq hec sunt sine controuersia
philosophorum maxime libri: presertim diuini hominis A
ristotelis: quem solum omnium ad artes scientiasq tradedas
hominum generi ac modum sciendi: munere quodam diuio

Mantua, by Federigo da Montefeltro in Urbino (PL. 232), and by the popes in Rome, and by the Aragonese kings of Naples (PL. 231). The amount of money spent on manuscripts must have been extraordinary. Vespasiano says Federigo da Montefeltro spent 30,000 ducats on manuscripts, plus the cost of binding. Cardinal Bessarion offered his library to the city of Venice in 1468 at a valuation of 15,000 ducats for 900 manuscripts. In 1481 King Ferrante I of Naples used 266 manuscripts as collateral for a loan of 38,000 ducats. These are all extremely substantial sums. Art is promoted by patronage, and certainly some magnificent and costly books were made. Italian Renaissance manuscripts are very splendid things. The vellum pages are creamy white and open beautifully. The lovely humanistic script is laid out with superbly proportioned margins. Elegant white-vine initials spill over into the borders with charming little *putti*, insects, and butterflies (especially in Florence) or parrots (especially in Naples). The illuminators excelled in the opening pages of manuscripts with full white-vine borders enclos-

228 Above

Paris, Bibliothèque Nationale, ms. lat. 12946, fol. 432r, detail

In this circular colophon, in a book by Cardinal Bessarion, the scribe Ioachim de Gigantibus describes himself as a German, born in Rothemburg, book supplier and illuminator to Ferrante I, king of Naples, and says that he wrote out this book at leisure and painted it in 1476. Ioachim is documented as working for the royal library in Naples from at least March 1471 to November 1480.

229 Right

Vienna, Österreichische Nationalbibliothek, Cod. 22, fol. 1r

Matthias Corvinus, king of Hungary 1458–90, sent to Italy for a humanist library, and many very splendid manuscripts were illuminated for him. This manuscript of Livy's Roman history was made in Florence for King Matthias about 1470, and is signed by its scribe Giovanfrancesco Marzi, of San Gimignano.

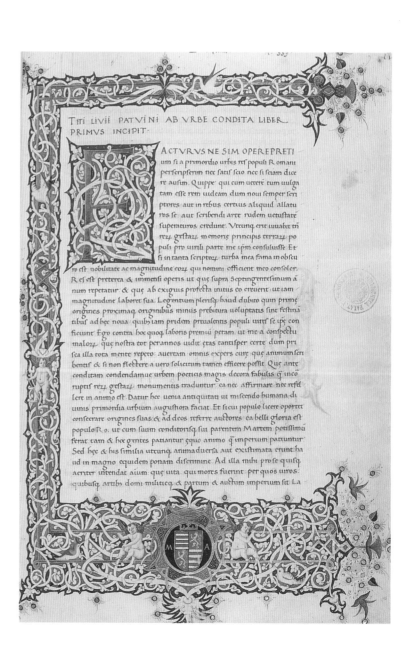

ing vignettes, birds, and coats-of-arms within wreaths. These were the work of great painters like Filippo di Matteo Torelli (1409–68, his friends called him Pippo), Ricciardo di Nanni, and Francesco d'Antonio del Chierico. The edges of the pages are gilded. The books are bound in the smoothest goatskin stamped with arabesque designs, sometimes with gold or painted with the owner's arms (PL. 234). These are treasures for the cabinets of the most refined and princely book collectors.

There is some information about how these rich collections were kept. The library which Malatesta Novello built up for the Franciscan convent in Cesena is still there, in a special upstairs room above the refectory with manuscripts arranged on twenty-nine benches and desks on either side of a central aisle. Piero de' Medici (1416–69) had his manuscripts specially bound according to the way they were to be arranged in his library: theology books were bound in blue, grammar in yellow, poetry in purple, history in red, the arts in green, and philosophy in white. It must have

looked wonderful. Leonello d'Este (1407–50) kept manuscripts in a room decorated with figures of the Muses, and he appears in Decembrio's dialogue *De Politia Litteraria,* where he says that books are less likely to suffer from dust if they are stored in cupboards. Pope Nicholas V (the humanist Tommaso Parentucelli) had his library room painted with portraits of pagan and Christian writers by Fra Angelico in 1449. Federigo da Montefeltro's study at Urbino still has its cupboards with *trompe-l'oeil* inlay work showing tantalizing heaps of manuscripts. These rooms were meeting places too for convivial evenings. 'At your place in Vàrad', wrote a visitor in 1463 to the collections of Janos Vitéz (d. 1472, chancellor to Matthias Corvinus, PL. 235), 'we often sat together with many scholars in your magnificent library, and spent a pleasant and happy time among the innumerable volumes of illustrious men.'

We must now pause to ask a fundamental question. Were the owners true bibliophiles? How is it that the passion for long-lost classical texts among a small group of late fourteenth-century

230 *Right*

Paris, Bibliothèque Nationale, ms. lat. 5713, fol. Ir

Vespasiano was entrusted by Jean Jouffray, cardinal 1461–73, with making manuscripts destined for Louis XI, king of France 1461–85. This copy of Thucydides, in the translation of Lorenzo Valla, has the arms both of the king and of Jouffray. On its flyleaf Vespasiano was unable to resist having inscribed in red capitals, where the king could not fail to notice, 'VESPASIANUS LIBRARIUS FECIT FIERI FLORENTIE', 'Vespasiano the bookseller had this made in Florence.'

S AMARITA

NVS ILLE

PIISSIM

VS SPOLIA

rum uidens hominem / & atrociter sauciatum / miserationis affectu com
patiens medicinam attulit efficacem / qua curatis ipsius uulneribus ac ple
na reddita sanitate / in sui principium / á quo descendens ab hierusalem de
uiauerat / finaliter reducatur. c ista saucii sanatione salubri ac de
uii reductione finali tanq̃ de pedibus sedens super solium excelsum ma
gister in hoc opere finali determinat / ut sicut ex primo & secundo claru
it deum esse alpha tam in se ens sint omnia primum / q̃ omnium aliorū
originale principium / sic ex tertio & quarto appareat ipsum esse & o
tam in se finem ultimum q̃ creature sue per seipsum in seipsum fina
liter reductiuum / Hanc autem reductionem finalem præcedit curatio
semiplena / & plena curatio comitatur. Secundum hanc distinctione
igitur potest diuidi quartus iste / dicendo q̃ magister primo agit de ho
minis saucii curatione salubri. Secundo de hominis de uii reductione fi
nali / Curatur enim homo salubriter in susceptione deuota sacramentorū
ueracium / & reducitur finaliter in perceptione iocunda premiorum cē
lestium. Sacramenta enim disponunt & præparant / premia uero perfi
ciunt / & consumant. Vel potest dici q̃ primo agit de curatione semi
plena / seu dispositiua / & secundo de curatione plena / seu perfectiua / &
utraq̃ diuisio redit in idem. Nam curatio semiplena fit per gratiam
sacramentorum / que sunt medicine salubres / plena curatio / seu fina
lis reductio fit per collationem premiorum / que sunt iocunde refectio
nes. In prima igitur parte agit de sacramentis per que curatur lā
guidus a morbo culpæ. In secunda de premiis perque liberatur a lā
gore pene. Et incipit secunda in principio distinctionis xliii. Post
hæc &c̃. Prima diuiditur in duas. primo namq̃ determinat de sacra
mento in generali / secundo in speciali. Secunda in principio distinctio

231 *Opposite*

**London, British Library,
Add. MS. 15273, fol. 8r**

Both Ferrante I, king of Naples
1458–94, and his sons, Alfonso of
Calabria (1448–95) and Cardinal
Giovanni of Aragon (1456–85),
were notable book collectors. They
ordered books from Vespasiano in
Florence and they employed their
own scribes and illuminators in
Naples. This manuscript of Duns
Scotus was written in Naples for the
king by the royal scribe Pietro
Hippolyto da Luna. The miniature
shows a scribe writing.

232 *Left*

**Rome, Biblioteca Vaticana
Apostolica, MS. Urb. lat. 508, inside
front cover, detail**

Federigo da Montefeltro, lord and
later duke of Urbino 1474–82, built
one of the supreme palaces and
libraries of the fifteenth century.
Vespasiano claimed that Montefeltro
would allow no printed book in his
collection. This dedication miniature
in a manuscript given to the duke
by Cristoforo Landino shows
Montefeltro at a window receiving
the book from its hopeful donor. It
was painted in Florence, c. 1475, by
Francesco d'Antonio del Chierico.

233 *Above*

Private collection, s.n. fol. 26r, detail

Gian-Galeazzo Sforza, duke of Milan
1476–81, was about ten years old
when this manuscript was made for
him before his expulsion by his
uncle, Ludovico il Moro, in 1481.
It is a schoolbook of ducal propor-
tions, a manuscript of Virgil with
the commentary of Servius
Honoratus, perhaps taken directly
from Petrarch's copy (PL. 214). The
boy duke is shown in the lower mar-
gin, above the signature of the court
illuminator, Ambrogio da Marliano.

234 *Above*

**Paris, Bibliothèque Nationale,
ms. lat. 3063, upper cover**

This is the Neapolitan binding of a
manuscript of Duns Scotus, written
in Naples in 1481–2 for Ferrante I
by Pietro Hippolyto da Luna. It was
originally part of the same set of
manuscripts as the volume illustrat-
ed in Plate 231. Gilt tooling of
bookbindings was introduced into
Italy from the Orient during the sec-
ond half of the fifteenth century and
the design here is strongly
influenced by Islamic models.

enthusiasts had moved within eighty years into the business of fur-
nishing princes with packaged culture? It brings us to a definition
of what motivates any collector. There is something fundamentally
human about longing to go out in pursuit of a rarity which can be
acquired and brought home. To some people this instinct is quite
basic; to others (who never collected anything as children) the
desire for possessions is so alien that collecting must be a total
mystery. The real collector knows that, for all his careful rationaliz-
ation, the actual motive is because it is fun. There is something
very exciting and enjoyable about knowing that one is missing a
key item to complete part of a collection and then, perhaps a long
time later, triumphantly finding the longed-for piece. This is just
what people like Coluccio Salutati, Niccolò Niccoli, and Poggio
were doing. Their *desiderata* were the complete works of Latin
authors and they sought them with the passion bordering on mania
which drives on all collectors. They wrote their names in their
books. They exchanged and weeded and upgraded their collec-
tions, like all bibliophiles, and in the 1420s Poggio began replacing
his paper manuscripts with vellum copies. This is not simply the
collecting of a mere reader. The script and decoration devised for
these books is aesthetically very pleasing and appropriate. A well-
made Florentine manuscript of the mid-fifteenth century is a thor-
oughly desirable artefact. Vespasiano claimed, not without some
self-deception, that Federigo da Montefeltro would never allow a
printed book in his house. There are illuminated manuscripts with
their text copied from printed editions (PL. 238). Even the smell
of a clean humanist manuscript is strangely seductive. Owners
often had the illuminated borders of the first pages filled with arms
and devices, richer than at any other period of manuscript making,
attesting to great pride of ownership. The rich princely collectors,
whose needs were met by men like Vespasiano, no doubt respond-
ed in much the same way as we do in handling these beautiful
books, and their instinct for acquisition, once inspired, was no
different from that of the scholar humanists of 1400 or of private
collectors at any time. To allow oneself to indulge this instinct
seriously is peculiarly modern, or humanistic.

One difficulty faced by a modern book collector is that the num-
ber of books is virtually infinite and a new collector benefits from a
classified list or catalogue of items to be sought; this is why stamps
and coins are popular areas of collecting and why catalogues of
them are usually published or promoted by dealers. A great twenti-
eth-century bookseller, Dr A.S.W. Rosenbach, used to specialize
in drawing up for his customers lists of (for example) the hundred
best books in literature or science or American history. This is an
excellent way of crystallizing the collecting instinct. It is therefore
interesting to see Tommaso Parentucelli in 1439–40 compiling a
list for Cosimo de' Medici of the texts he ought really to be collect-
ing for his library in San Marco, and to find Malatesta Novello using
the same list in building up the library at Cesena around 1450.
Vespasiano is revealing in his account of how Federigo da

Montefeltro outfitted his library. 'He took the only way to make a fine library,' writes Vespasiano. What he did was to work from a list of priorities: the Latin poets and commentaries first, followed by the orators and grammarians, the historians (Latin writers and Greek historians translated into Latin), philosophers, theologians, writers on the arts and medicine, and books in Greek and finally in Hebrew. It was a true collection, doubtless giving great delight as the books were unwrapped parcel by parcel into the library in Urbino.

To summarize, then, the style and taste of the humanists of Florence were transmitted by personal enthusiasm and careful cultivation of collectors, and humanistic manuscripts and their white-vine initials were dispersed outwards from Florence to the libraries of Rome and Naples (in particular) and to Ferrara and Milan, and beyond Italy to collections as far distant as those of William Gray in Oxford and Janos Vitéz in Vàrad in Hungary.

We must, however, introduce another development which complicates the story. From the north-east of Italy there came a new style of humanistic manuscript. It is later in development but by the last quarter of the fifteenth century the two types are merging in central Italy. From Verona, Padua, and Venice there came a generation of mid-fifteenth century antiquarians with a passion for ancient Roman culture quite as lively as that of Coluccio, Niccoli, and Poggio. By the 1450s, however, there were fewer manuscripts to rediscover. Perhaps they came to realize too that even the very oldest extant volumes of classical texts were still centuries later than their authors. They therefore began to look at ancient Roman inscriptions on stone: after all, a monumental epigraph is an authentic Latin text and (though less portable) is as near to an original Roman manuscript as anyone can hope to find. They started to make collections of these inscriptions. The self-taught merchant from Ancona, Ciriago (1391–1452, he learned Latin only at the age of 30), travelled extensively in the course of his business and took every opportunity to copy inscriptions he found. He wrote them out prettily in coloured inks. He had a remarkably eccentric young friend, Felice Feliciano (c.1432–80) of Verona. The late James Wardrop describes Feliciano in *The Script of Humanism* (Oxford, 1963) as a totally madcap scribe, antiquary, doggerel poet, painter, alchemist, and immoralist, whose own brother called him a vagabond, who used to disappear into the foothills of the Alps for days at a time and would suddenly re-emerge unshaven like a tramp, a wit, a delightful, amusing, unpredictable, wild eccentric. 'It seems fairly certain there was a screw loose in Felice Feliciano,' observed Wardrop.

None the less, the passion of Feliciano and his friends for ancient monuments had a far-reaching consequence. He used to go on rambles with fellow antiquaries and with the painter Andrea Mantegna to copy out inscriptions. Artists like Mantegna and Marco Zoppo then started to work features of Roman monuments into painting and manuscripts. Illuminators began to rethink the

235 *Above*

Munich, Bayerische Staatsbibliothek, Clm. 15722, fol. 2

Janos Vitéz (d.1472), chancellor to Matthias Corvinus, built up a substantial private library himself. This manuscript of Livy was made for him in Florence and, like the Plautus in Plate 224, was written by Piero Strozzi and illuminated by Ricciardo di Nanni.

white-vine initials which (of course) had nothing to do with ancient writing. They started to paint into manuscripts capitals copied from monuments: narrow-faceted initials shadowed to look like epigraphic letters chiselled on stone. They introduced a punctuation mark which resembles a little ivyleaf and which is copied from Roman tombstones. Above all, they abandoned the white-vine borders of Florence and they painted as realistically as possible the paraphernalia of Roman carvings, military standards, spears, shields, cornucopiae, funerary vases, coins, rams' heads, dolphins, candelabra, and so forth (PL. 236). They even began to paint the opening pages of manuscripts in colour so that the whole of the text looked deceptively like a Roman inscription or scroll. It was a remarkable new style and very characteristic of the north-east of Italy from about 1465.

There was one great scribe and probably illuminator too from Padua who excelled above all others in his splendid script and the *trompe-l'oeil* borders based on classical monuments. This was Bartolomeo Sanvito (1435–1511 or 1512). His script is a most beautiful fluent italic and his elegant coloured capital letters are really admirable. As so often with great Renaissance scribes, Sanvito was not simply a professional copyist. He was an antiquarian and scholarly collector in the circle of the humanists in Padua. One friend for whom he wrote manuscripts was Bernardo Bembo (PL. 237), who even named his illegitimate son Bartolomeo after him. Sanvito's great skill, however, brought him to the papal court in Rome where he is documented from 1469 to 1501 (PLS. 211

and 239). Through him and other north-eastern Italian illuminators, such as Gasparo Padovano, the monumental epigraphic style of manuscripts reached Rome and filtered through to Naples.

In fact this chapter ought to end around the late months of 1464 or spring of 1465 when two Germans, Conrad Sweynheym and Arnold Pannartz, brought their carts trundling down the same road south towards Rome, bringing the first printing press into Italy. The art of printing with movable type was devised in Mainz in Germany about 1450, and its tremendous advantages to publishers and booksellers were quickly realized. The first books printed in Italy were produced anonymously at the monastery of Subiaco near Rome: probably grammar books of Donatus, a Cicero, *De Oratore* (perhaps before September 1465), a Lactantius (29 October 1465) and a St Augustine (12 June 1467). One copy of the St Augustine, now in the Bibliothèque Nationale, has a purchase note dated November 1467 by Leonardo Dati (d.1471), the bishop of Massa who figures briefly in Vespasiano's memoirs as a slightly ridiculous bespectacled papal secretary. It says, 'Leonardo Dati, bishop of Massa, with his nephew Giorgio, bought this book about the *City of God* for himself with his own money for 8 gold ducats and two *grossi*, from those two Germans living in Rome who are accustomed to print not write countless books like this.' Sweynheym and Pannartz moved their press into Rome itself that winter (PL. 240). The innumerable copies of the same book amazed Dati and many other people seeing printing for the first time. In one book of 1472, Sweynheym and Pannartz recorded the

236 *Opposite left*

**London, British Library,
Add. MS. 14787, fol. 6v**

The new north-eastern Italian style
of manuscript illumination was
based on classical monuments which
were rendered three-dimensionally
on the page. This very early exam-
ple is from a congratulatory address
presented by Bernardo Bembo
(1433–1519) to Cristoforo Mauro,
doge of Venice, soon after his elec-
tion in 1462.

237 *Opposite right*

**London, British Library,
Royal MS. 14.C.3, fol. 2r**

Bernardo Bembo was a close friend
of the great scribe Bartolomeo
Sanvito (1435–1511/12). This man-
uscript of the chronicles of Eusebius
of Caesarea was written in the 1480s
by Sanvito for Bembo, whose arms
are at the base of the classical
columns on either side. It was illu-
minated by the Master of the
Vatican Homer.

238 *Right*

**Paris, Bibliothèque Nationale,
ms. lat. 8016, fol. 1r**

This manuscript of Ovid's
Metamorphoses was almost certainly
prepared for Cardinal Giovanni of
Aragon and passed with his manu-
scripts into the royal library of
Naples. It was written by the
Florentine scribe Antonio Sinibaldi
about 1483, and may well have been
copied from the edition of the text
printed in Venice in 1474, of which
the Cardinal already owned a copy.

239 *Above*

**London, British Library,
Kings MS. 24, fol. 23v**

This manuscript of Virgil's *Aeneid*
was written in Rome by Bartolomeo
Sanvito, probably for Lodovico
Agneli, bishop of Cosenza 1497–9.
The miniatures, showing the Trojan
horse and Aeneas carrying his father
Anchises into exile, were very prob-
ably painted by Sanvito himself.

240 *Opposite*

**Oxford, Bodleian Library,
Auct. L.2.2, fol. 6r**

This is a printed book, the *Noctes
Atticae* of Aulus Gellius, printed in
Rome in 1469 by Conrad
Sweynheym and Arnold Pannartz.
The illumination was added by hand
and is by an artist employed regular-
ly by Sweynheym and Pannartz. The
blank space within the wreath at the
foot is so that a customer could have
his own coat of arms inserted.

number of copies they had made of each edition they printed: the
usual print run was 275 and sometimes 300. It had taken Vespas-
iano forty-five scribes and nearly two years to produce fewer vol-
umes than this. The low price intrigued Leonardo Dati too. The
chronicler Hartmann Schedel happens to record the prices which
Sweynheym and Pannartz were asking for printed books in 1470:
St Augustine (1468 edition) has dropped now to 5 ducats; Cicero,
De Oratore, 1469, is only 19 *grossi* (there were 24 *grossi* to a ducat);
Cicero, *De Officiis*, 1469, is one ducat; Caesar, *Commentarii*, 1469,
are 2½ ducats; Pliny's massive *Historia Naturalis*, 1470, containing
378 leaves, is the most expensive at 8 ducats. Compare the prices
at which Vespasiano offered manuscripts of the same texts for sale
in Naples in c.1457: Cicero, *De Oratore*, at 9 ducats; Cicero, *De
Officiis*, at 5 ducats; Caesar, *Commentarii*, at 18 ducats; and in 1463
the secretary of the king of Naples was prepared to pay Vespasiano
up to 60 ducats for a manuscript of Pliny's *Historia Naturalis*. Even
a humble Valerius Maximus manuscript was sold by its scribe in
1440 for 10 ducats (B.L., Add. MS. 14095). The printers could
produce books more accurately and more cheaply for about one
fifth to one tenth of the price of a manuscript. In the event, accura-
cy and price were more important than script and illumination,
and we have been printing books ever since.

Of course this is not the end of making books for humanist bib-
liophiles. Some illuminators decorated printed books to make them
resemble manuscripts. Sweynheym and Pannartz evidently
employed their own illuminator if one can judge from the fine
white-vine initials by the same artist in many of their books.
Especially in Venice, artists who had worked on manuscripts trans-
ferred their skills to illuminating printed books, and the quality is
sometimes breathtaking. In Florence scribes went on copying out
books for special occasions. The great scribe Antonio Sinibaldi
claimed in his tax declaration in 1480 that his work had been
reduced by the invention of printing, but in fact most of his thirty
or so signed manuscripts were made after 1480. Business was not
too bad after all. Texts wanted in fewer copies than a printer found
economical continued to be written by hand for generations: pre-
sentation copies, commemorative addresses, prayers for special
occasions, petitions, commissions issued by the Doge of Venice,
university degrees, unreadable poems, grants of nobility, wedding
presents, maps, and, above all, books which collectors simply
seemed to prefer in manuscript form. They just liked some books
handwritten. Collecting books is not governed by logic. The
human response distinguished Renaissance collectors from previous
generations. It is enough to like a book without having to explain
why. Manuscripts were fine things to collect, and they still are.

Lutarchus in libro qué ο ποσι ψυχων και σωματων ανθρωποισπερι ενφυιαν και αρετην διαφορα. id est quantú inter hoies animi corpisq; ingéio atq; uirtutibus intersit: conscripsit: scite subtyliterq; ratiocinatum Py/thagoram philosophum dicit: in reperienda: moduládaq; status lógitudinis eius pstantia.

Nam quum fere cóstaret curriculum stadii: quod est Pisis: apud Iouem Olympium: Herculem pedibus suis metatum: id q; fecisse longú pedes ducentos: cetera quoq; stadia in terris grecie ab alus postea instituta: pedum quidem esse numero ducentorum: sed tñ esse aliquátulum breuiora: facile intellexit: modú spatiú q; pláte Herculis: róe proportóis habita: tanto fuisse: q̃ aliorum pcerius: quanto olympicum stadium longius esset q̃ cetera. Comprehensa autem mensura herculani pedis: secundú naturalem membrorum omniú inter se competentiá modificatus est. Atq; ita id collegit: quod erat cósequens: táto fuisse Herculem corpore excelsioré: q̃ alios: q̃nto olympicú stadiú ceteris pari numero factis anteiret.

Ab Herode Attico cósulari uiro tempestiue deprompta in quendam iactatum & gloriosum adolescétem: specie tantú philosophie sectatoré uerba Epicteti stoici: qbus festiuiter a uero stoico seiúxit uulgus loquacium nebulonum: qui se stoicos nuncuparent. Caput .ii.

Herodes Atticus uir & greca facundia & consulari honore preditus: accersebat sepe nos: quum apud magistros athenis essemus: i uillas eius urbi pximas: me & clarissimú uirú Seruilianú: complurisq; aliosnostrates: qui roma in greciam: ad capiendum ingenii cultum cócesserant. Atq; ibi tunc quum essemus apud eú in uilla cui nomé est Cephysia: & estu ánt: & sidere autumni fla/grátissimo: propulsabamus caloris incommoda: lucorum umbra ingentiú longis ábulacris: & mollibus: ediú posticú refrigerátibus lauacris nitidis: & abundis: & collucétibus: totiusq; uille uenustate

INTRODUCTION

This is the third bibliography written for the present book. The first, in the edition of 1986, is still largely valid but needs updating. The second, painstakingly compiled for that purpose, was accidentally deleted in its entirety from the Sotheby's computer system on 3 May 1994. This, then, is the third attempt. There are, of course, many books on medieval manuscripts, frequently out of print and sometimes more expensive than a cheap manuscript, and it is difficult to know how to guide the general reader into the literature on the writing and illumination of books in the Middle Ages. I have to acknowledge a vast debt to the Palaeography Room in London University Library, with an open-shelf collection of manuscript reference books which is perhaps as comprehensive as any in Europe. A sound bibliography, with emphasis on script rather than on illumination, is L.E. Boyle, *Medieval Latin Palaeography, A Bibliographical Introduction* (Toronto, 1984). For the decoration of manuscripts there is L. Donati, *Bibliografia della Miniatura (Biblioteca di Bibliografia Italiana*, vol. LXIX), 2 vols. (Florence, 1972). The section *Bulletin Codicologique* in *Scriptorium*, the journal of manuscript studies published twice a year from Brussels, includes brief summaries of recent books and articles, and I have myself attempted a general survey of the literature, especially from England, in the centenary volume of the Bibliographical Society, ed. P. Davison, *The Book Encompassed, Studies in Twentieth-Century Bibliography* (Cambridge, 1992), pp. 37–45.

I think the first books I ever read about medieval manuscripts were catalogues, both of public collections and of manuscripts for sale (probably, if the truth be known, especially for sale, although of course I could not afford them), and I still delight in re-reading catalogues and welcoming new ones to the shelves. The ideal is to be able to sit down with a good catalogue entry and the actual manuscript itself, comparing and checking leaf by leaf. I recall that I took great delight in the popular facsimiles of famous manuscripts such as the *Très Riches Heures* of the Duc de Berry, the *Belles Heures*, the *Rohan Hours* and the *Cloisters Apocalypse*. Such editions usually have introductions explaining the manuscript illustrated. I found John Plummer's *The Hours of Catherine of Cleves* (New York, 1966) particularly useful, and bought J.J.G. Alexander's *The Master of Mary of Burgundy, A Book of Hours for Engelbert of Nassau* on publication in 1970. Facsimiles like this should not be difficult to obtain and can give much pleasure. Exhibition catalogues, sale catalogues and even postcards can provide the nucleus of an inexpensive palaeographical reference library.

I think that F. Madan's *Books in Manuscript* (London, 1893) is still the most readable general account of medieval manuscripts and that D. Diringer's *The Illuminated Book* (2nd edn., London, 1967) is the most unreadable – it aims at comprehensiveness and makes up in telegraphic fact what it certainly loses in narrative. General surveys of medieval manuscript decoration include J.A. Herbert, *Illuminated Manuscripts* (London, 1911, reprinted in 1972), D.M. Robb, *The Art of the Illuminated Manuscript* (Cranbury, NJ, 1973), and the various essays in *Le Livre au Moyen Age,* ed. J. Glenisson (Paris, 1988). Two good field guides through specific types of manuscript and their illustration are R.G. Calkins, *Illuminated Books of the Middle Ages* (New York and London, 1983) and O. Pächt, *Buchmalerei des Mittelalters* (Munich, 1984, translated into English as *Book Illumination in the Middle Ages*, London and Oxford, 1989). All these must now cede precedence to the recent and fascinating book by Professor Pächt's former pupil, J.J.G. Alexander, *Medieval Illuminators and their Methods of Work* (New Haven and London, 1992). I owe much to it, including the illustration of a couple making a *Roman de la Rose* (PL. 130, p. 152 here) and contracts for illuminating manuscripts for Guillaume le Chamois and Jean Rolin II (pp. 188 and 210 here).

For the history of script, E. Maunde Thompson's *An Introduction to Greek and Latin Palaeography* (Oxford, 1912, reprinted in 1975) is the best-known textbook, now splendidly old-fashioned, and Michelle P. Brown, *A Guide to Western Historical Scripts from Antiquity to 1600* (London, 1990) has, to the delight of many, replaced S.H. Thomson, *Latin Bookhands of the Later Middle Ages, 1100–1500* (Cambridge, 1969). The work of the great and late master Bernhard Bischoff appears in his *Latin Palaeography, Antiquity and the Middle Ages* (Cambridge, 1990), which is said to have lost much in translation from the German – I cannot judge with any confidence – but which was useful in revising chapter 2 here in particular. On the mechanics of how script may have been written, an eccentric and engaging book is M. Drogin, *Medieval Calligraphy, its History and Technique* (Montclair, NJ, 1980); it is compulsory reading for all forgers of medieval manuscripts. Many libraries are now involved in a vast international publishing project which goes under the name of *Manuscrits Datés*: they produce volumes or loose packages of plates from medieval books which are exactly dated by their scribes or to which almost exact dates can be assigned from internal evidence. English contributions so far published are for the British Library (London, 1979) and Oxford (Oxford, 1984) by A.G. Watson and for Cambridge (Woodbridge, 1988) by P.R. Robinson, who is now working on the collections in London outside the British Library. Manuscripts with fixed dates are crucial for book historians who must assemble in sequence the vast majority of other medieval manuscripts which contain no explicit clues as to their date or place of origin. A less critical but monumental anthology of inscriptions and signatures by the scribes themselves in the manuscripts they wrote is the huge six-volume *Colophons des Manuscrits Occidentaux des Origines au XVIe Siècle* by the Bénédictins de Bouveret (Fribourg, 1965–82). I read it right through before beginning to write this book, and every chapter is indebted to it.

I BOOKS FOR MISSIONARIES

There are two fundamental reference books for this chapter. The first is the great twelve-volume series *Codices Latini Antiquiores: A Palaeographical Guide to Latin Manuscripts prior to the Ninth Century,* ed. E.A. Lowe (Oxford, 1934–72), with supplement by B. Bischoff and V. Brown in *Medieval Studies*, vol. XLVII (1985). This is an illustrated catalogue of all known Latin manuscripts and fragments earlier than about 800 AD. It is arranged by the countries where the manuscripts are now preserved. The most relevant to the present chapter is vol. II (1935, and a 2nd edn. in 1972) for Great Britain and Ireland, but vols. VIII–IX (1959) include many insular manuscripts taken by the missionaries and others to Germany. The relic label mentioned on pp. 32 and 34 is illustrated in the complementary series for documents, *Chartae Latinae Antiquiores*, ed. A. Bruckner and R. Marichal, vol. I (Olten and Lausanne, 1954), no. 36. The second essential source, at least for manuscripts with illumination, is J.J.G. Alexander, *Insular Manuscripts, 6th to 9th Century* (London, 1978), vol. I in the series *A Survey of*

Manuscripts Illuminated in the British Isles. It briefly describes and illustrates 78 decorated English or Irish manuscripts from the period of the missionaries. Almost every manuscript mentioned in this chapter is listed in *C.L.A.* (as it is usually called) or in Professor Alexander's book, or both, and comprehensive bibliographies are printed there.

The outstanding contemporary source for the period is Bede's *Ecclesiastical History*, which he completed in 731 AD. The quotations in this chapter are from the Penguin Classics edition by Leo Sherley-Price, revised by D.H. Farmer (Harmondsworth, 1990). Historical background to the period can be found in F.M. Stenton, *Anglo-Saxon England* (Oxford, 1947, 2nd edn., 1971). The account here of book production at Wearmouth and Jarrow owes much to articles by T.J. Brown and R.L.S. Bruce-Mitford in *Evangeliorum Quattuor Codex Lindisfarnensis*, ed. T.D. Kendrick, 2 vols. (Olten and Lausanne, 1960) and especially to the Jarrow Lecture by M.B. Parkes, published as *The Scriptorium of Wearmouth-Jarrow* (1982); the quotation in the second column of p. 35 is from this source. I attended Dr Parkes's classes on insular manuscripts in 1972–3 and some lines of inquiry in this chapter are derived from imperfect recollections of those excellent seminars. The Durham Cathedral fragment of Maccabees (p. 21 here) is described by R.A.B. Mynors, *Durham Cathedral Manuscripts to the End of the Twelfth Century* (Oxford, 1939), p. 14 and PL. I, and by E.A. Lowe in his *Palaeographical Papers, 1907–1965*, ed. L. Bieler (Oxford, 1972), vol. II, pp. 475–6. Detailed studies of individual manuscripts include F. Wormald, *The Miniatures in the Gospels of St Augustine, Corpus Christi College, MS. 286* (Cambridge, 1954, reprinted in his *Collected Writings*, vol. I, London and Oxford, 1984, pp. 13–35); T.J. Brown, *The Stoneyhurst Gospel of St John* (Oxford, 1969); the massive analysis of the Lindisfarne Gospels cited above and the much more accessible *The Lindisfarne Gospels* by Janet Backhouse (Oxford, 1981); D.H. Wright and A. Campbell, *The Vespasian Psalter* (*Early English Manuscripts in Facsimile*, vol. XIV, Copenhagen and Baltimore, 1967); E.H. Alton and P. Meyer, *Evangeliorum Quattuor Codex Cenannensis*, 3 vols. (Berne, 1950–1), a full facsimile of the Book of Kells, although readers will not find it as easily available as F. Henry, *The Book of Kells* (London, 1974) and P. Brown, *The Book of Kells* (London, 1980). Each one of these has an introduction as well as many plates, and I have consulted both. On the recommendation of David Ganz, I read M.O. Budny's PhD thesis 'British Library Manuscript Royal 1.E.VI, The Anatomy of an Anglo-Saxon Bible Fragment' (London University, 1984) and hope for its publication.

One of the cheapest monographs ever published on a manuscript is in the series of Pitkin Pictorial Guides and Souvenir Books, *The Lichfield Gospels* by D. Brown, based on work by Wendy Stein (London, 1982); it is excellently produced.

II BOOKS FOR EMPERORS

Except for books like C.R. Dodwell, *Painting in Europe, 800–1200* (Harmondsworth, 1971), which spans the period admirably, most of the literature on imperial manuscripts focuses either on the Carolingian or on the Ottonian period. For the former age, the classic texts include A. Boinet, *La Miniature Carolingienne* (Paris, 1913), A. Goldschmidt, *German Illumination*, vol. I, *The Carolingian Period* (Florence and Paris, 1928), R. Hinks, *Carolingian Art* (London, 1935) and W. Köhler, *Die Karolingischen Miniaturen*, 4 vols. (Berlin, 1930–71). A short but excellent book is F. Mütherich and J.E. Gaehde, *Karolingische Buchmalerei* (Munich, 1976, published the same year in English as *Carolingian Painting*), and Professor Mütherich is now apparently almost at the point of publishing her vast and long-awaited corpus of Carolingian manuscript art. The progress of art history in Germany owes much to vast exhibition catalogues. The huge *Karl der Grosse, Lebenswerk und Nachleben*, 4 vols. (Düsseldorf, 1965–7), forms a great synthesis of scholarship on manuscript studies of the period, especially vols. II, *Das Geistige Leben*, ed. B. Bischoff (including his article on the court library of Charlemagne, pp. 42–62), and III, *Karolingische Kunst*, ed. W. Braunfels and H. Schnitzler; I owe to these catalogues references both to Charlemagne's library catalogue and to his elephant. For Carolingian script, the first generation of the new minuscule is netted within Lowe's *Codices Latini Antiquiores*, and when Professor Bischoff died in 1991 he had completed great portions of a gigantic extension of the work through the ninth century. It is desperately to be hoped that problems surrounding his literary estate will not hinder the publication of as much of this work as possible. I profited from the elegantly written volume by Rosamund McKitterick, *The Carolingians and the Written Word* (Cambridge, 1987) and owe to it, for example, the allusions to the value placed on manuscripts judged by references to thefts (p. 54 here). Older studies include E.K. Rand, *A Survey of the Manuscripts of Tours* (Cambridge, MA, 1929), quoted here on p. 54, and the unusual Lyell lectures of S. Morison, *Politics and Script, Aspects of Authority and Freedom in the Development of Graeco-Latin Script*, ed. N. Barker (Oxford, 1972), selecting the Maurdramnus Bible as the first great imperial book.

At the Ottonian end of the period I feel I should have constantly in mind a reference to the first edition of this book which appears in H. Mayr-Harting, *Ottonian Book Illumination, An Historical Study* (London, 1991): Dr Mayr-Harting points out that what I said about Bamberg 'seems all to be the result of a multiple confusion' (vol. I, p. 216, n. 92), which I hope I have put right now that we have his excellent volumes. I am indebted too to the long article by Florentine Mütherich in *Le Siècle de l'An Mil*, ed. L. Grodecki, F. Mütherich, J. Taralon and F. Wormald (Paris, 1973), pp. 87–188, and helped by A. Goldschmidt, *German Illumination*, vol. II, *The Ottonian Period* (Florence and Paris, 1928), A.R.A. Hobson, *Great Libraries* (London, 1970), esp. pp. 36–43 on the library at Bamberg, and Calkins, *Illuminated Books*, cited above, esp. pp. 119–60. Some of the very great imperial manuscripts are available in luxurious facsimiles, including the Dagulf Psalter, ed. K. Holter (Graz, 1980), the Lorsch Gospels, ed. W. Braunfels (Munich, 1967), the Codex Aureus of St Emmeram, ed. G. Leidinger (Munich, 1921–31), the Gospels of Otto III, ed. F. Dressler, F. Mütherich and H. Beumann (Frankfurt, 1978), the Gospel Pericopes of Henry II (Munich, 1914), and two of the Gospel Books of Henry III, those in Bremen, ed. G. Knoll and others (Wiesbaden, 1980) and in the Escorial, ed. A. Boeckler (Berlin, 1933). For the Gospels of Henry the Lion, we can now consult K. Jordan, D. Kötzsche and W. Knopp, *Das Evangeliar Heinrichs des Löwen* (Hannover, 1984), F.N. Steigerwald, *Das Evangeliar Heinrichs des Löwen* (Offenbach, 1985) and the full facsimile published in the winter of 1988.

III BOOKS FOR MONKS

The writing of this chapter would have been immeasurably more difficult without N.R. Ker's *Medieval Libraries of Great Britain* (2nd edn., London, 1964, with supplement, ed. A.G. Watson, London, 1987). The work is a list of every surviving manuscript which is known to have belonged to any British medieval monastery. It is a fascinating book of the kind in which one cannot look up one reference only: 20 minutes later one is still absorbed, pages from where one started. The entries for Reading Abbey are on pp. 154–8. The library catalogue for Reading, PL. 63, was published by S. Barfield, 'Lord Fingall's Cartulary of Reading Abbey', *English Historical Review*, vol. III (1888), pp. 117–23, and is being re-edited by Richard Sharpe as part of vol. IV of the *Corpus of British Medieval Library Catalogues*. The multiple Reading manuscript in

Chicago, p. 80 here, is described by P. Saenger, *A Catalogue of the Pre-1500 Western Manuscript Books at the Newberry Library* (Chicago and London, 1989), pp. 22–8, and the liturgical fragment at Douai Abbey, pp. 82 and 85 here, is described in N.R. Ker, *Medieval Manuscripts in British Libraries*, vol. II (Oxford, 1977), pp. 418–19. There is a short article by J.R. Liddell, 'Some Notes on the Library of Reading Abbey', *Bodleian Quarterly Record*, vol. VIII (1935), pp. 47–54.

Work on English monastic libraries owes a great deal to the passionate research of M.R. James, writer also of ghost stories, and that of N.R. Ker, both giants in their field. For script and scribal practices in England in the twelfth century, the great seminal book is N.R. Ker, *English Manuscripts in the Century after the Norman Conquest* (The Lyell Lectures, Oxford, 1952–3, Oxford, 1960), a slim folio so concisely written that every reading reveals new facts. It is out of print and second-hand copies are expensive. Supplementing this with C.M. Kauffmann, *Romanesque Manuscripts, 1066–1190* (*A Survey of Manuscripts Illuminated in the British Isles*, vol. III, London, 1975), one can step into Romanesque book production in England with greater confidence than elsewhere in Europe. The Arts Council exhibition catalogue *English Romanesque Art, 1066–1200* (London, 1984) includes many manuscripts in a substantial section by J.J.G. Alexander and C.M. Kauffmann, pp. 82–133.

Certain centres of English Romanesque book production have been studied in greater detail than others. Notable books include C.R. Dodwell, *The Canterbury School of Illumination, 1066–1200* (Cambridge, 1954), which deals primarily with the decoration and iconography of manuscripts, and R.M. Thomson, *Manuscripts from St Albans Abbey, 1066–1235*, 2 vols. (Hobart, 1982), which follows the march of library acquisition and the work of the scribes involved in one of the greatest (and not necessarily most typical) English monasteries. I bought Teresa Webber, *Scribes and Scholars at Salisbury Cathedral, c.1075–c.1125* (Oxford, 1992) too late to have used it in revising chapter III, which was a great error, for it has much on the choice of titles which the canons of Salisbury selected as necessary for their library. Mr Michael Gullick has increasingly emerged as the wandering wise man of English Romanesque books, and, like his fellow magi of the past (Alexander Nequam is one), he is too cautious to publish much of his accumulated experience. If his work on Cirencester Abbey ever appears in print it will surely necessitate corrections to my note on Cirencester scribes on p. 94 and PLS. 77–8. For comments on Norman scribes and English cathedrals on p. 91, I have extensively used M. Gullick, 'The Scribe of the

Carilef Bible: A New Look at some Late-Eleventh-Century Durham Cathedral Manuscripts', in L.L. Brownrigg, ed., *Medieval Book Production, Assessing the Evidence* (Proceedings of the Second Conference of The Seminar in the History of the Book to 1500, Oxford, July 1988, Los Altos Hills, 1990), pp. 61–83. The *De Diversis Artibus* of Theophilus, cited on p. 86, has been edited and translated by C.R. Dodwell, *Theophilus, The Various Arts* (London and Edinburgh, 1961). On the actual making of manuscripts I have myself written a little book in the British Museum's *Medieval Craftsmen* series, *Scribes and Illuminators* (London, 1992). Few individual manuscripts have ever been as thoroughly studied, or over so long a period, as the Winchester Bible was by Sir Walter Oakeshott. His little book *The Artists of the Winchester Bible* (London, 1945) isolated for the first time recognizable personalities among the manuscript's illuminators and introduced painters such as the Master of the Leaping Figures into the canon of English artists. Oakeshott's *Sigena, Romanesque Paintings in Spain and the Winchester Bible Artists* (London, 1972) linked these painters with fragmentary frescoes in Spain, and his huge *The Two Winchester Bibles* (Oxford, 1981) focused on the relationship between the Bible and a second monumental copy, Bodleian MS. Auct. E.inf.2, which the Winchester monks made at the same time. His work is summarized and even extended by Claire Donovan, *The Winchester Bible* (London and Winchester, 1993), with the most beautiful photographs. Articles on English book production in this period include N.R. Ker on Salisbury in *Medieval Learning and Literature, Essays presented to R.W. Hunt*, ed. J.J.G. Alexander and M.T. Gibson (Oxford, 1976), pp. 23–49; R.M. Thomson on Bury St Edmunds in *Speculum*, vol. XLVII (1972), pp. 617–45; J.J.G. Alexander on painted 'arabesque' initials in *Medieval Scribes, Manuscripts and Libraries, Essays presented to N.R. Ker*, ed. M.B. Parkes and A.G. Watson (London, 1978), pp. 87–116; and G. Pollard on the construction of the kind of bookbindings illustrated here in PLS. 90–1, *The Library*, 5 ser., vol. XVII (1962), pp. 1-22.

IV BOOKS FOR STUDENTS

For the early part of chapter IV I have raided my own *Glossed Books of the Bible and the Origins of the Paris Booktrade* (Woodbridge, 1984), especially for the publishing of the Gloss and the works of Peter Lombard. For Parisian illumination of the early thirteenth century I am indebted to F. Avril, 'À Quand Remontent les Premiers Ateliers d'Enlumineurs Laïcs à Paris?', *Les Dossiers de*

l'Archéologie, vol. XVI (1976), pp. 36–44, and to the pioneering book, which is cited on p. 127, R. Branner, *Manuscript Painting in Paris during the Reign of St Louis, A Study of Styles* (Berkeley and Los Angeles, 1977). Like all work which breaks new ground, it will need substantial revision as research progresses, and the fact that it was published after its author's early death means that it is not always free from accidents of proofreading; none the less, it is a remarkable book. The story by Odofredo (p. 108) is taken from Branner, and the chapter owes several illustrations to him. Surprisingly, considering the importance of the subject, there is no standard account of the publication of the one-volume Bible, discussed on pp. 118–23. References can be found in R. Loewe, 'The Medieval History of the Latin Vulgate', in *The Cambridge History of the Bible*, ed. G.W.H. Lampe, vol. II (Cambridge, 1969), pp. 102–54, and in B. Smalley, *The Study of the Bible in the Middle Ages* (Oxford, 1952, reprinted in 1970). For the University of Paris and its curriculum in the thirteenth century, I have used H. Rashdall, *The Universities of Europe in the Middle Ages*, ed. F.M. Powicke and A.B. Emden, vol. I (Oxford, 1936), P. Glorieux, *Répertoire des Maîtres en Théologie de Paris au XIIIe Siècle* (Paris, 1936) and the little Sorbonne exhibition catalogue, *La Vie Universitaire Parisienne au XIIIe Siècle* (Paris, 1974). There is a vast treasury of information on French manuscripts of all periods, including the early Parisian booktrade, in L. Delisle, *Le Cabinet des Manuscrits*, 4 vols. (Paris, 1868–81, reprinted in 1969) and it was valuable here, as always.

I took notes during the Lyell Lectures given by R.H. and M.A. Rouse in Oxford in the summer of 1992 on *Book Producers and Book Production in Paris, 1200–1500*. I am very conscious that they are revising these papers for publication and that I may well have misheard or misunderstood that first performance but I owe too much to the Rouses to let the lectures go unacknowledged. They kindly lent me their typescript of the paper on Nicholas Lombard which allowed me to redraft entirely the paragraph on him, now on pp. 123–4. The practice of copying manuscripts in *peciae*, pp. 130–6, still needs a full-length definitive study by a brave historian. The classic explanation is J. Destrez, *La Pecia dans les Manuscrits Universitaires du XIIIe et du XIVe Siècle* (Paris, 1935) and there is an account of Destrez's work by his pupil G. Fink-Errera in *Scriptorium*, vol. XI (1957), pp. 264–80. A list of surviving university *pecia* exemplars is given by Destrez and M.D. Chenu in *Scriptorium*, vol. VII (1953), pp. 68–80. A lecture by Graham Pollard (with whom I had many discussions of the early booktrade) was printed posthumously, 'The *Pecia* System in the Medieval Universities', *Essays pre-*

sented to N.R. Ker (1978, cited above), pp. 145–61. The article by P.-M.J. Gils, mentioned on p. 134, appears as 'Pour une Étude du MS. Pamplona, Catedral 51', *Scriptorium*, vol. XXXII (1978), pp. 221–30. Once more, for correcting several mistaken impressions I had on *peciae* and for first identifying the bookshop in the Rue St-Jacques, I am most grateful to R.H. and M.A. Rouse for advice and for their article, 'The Book Trade at the University of Paris, c.1250–c.1350', *La Production du Livre Universitaire au Moyen Age: Exemplar et Pecia* (Actes du Symposium tenu au Collegio San Bonaventura de Grossaferrata en Mai 1983, ed. L.J. Bataillon, B.G. Guyot and R.H. Rouse, Paris, 1988), pp. 41–123. The extracts from the tax rolls, cited on p. 137, are taken from Françoise Baron, 'Enlumineurs, Peintures et Sculpteurs des XIIIe et XIVe Siècles d'après les Rôles de la Taille', *Bulletin Archéologique du Comité des Travaux Historiques et Scientifiques*, n.s., vol. IV (1968), pp. 37–121.

This chapter has been mainly concerned with Paris. Investigations on manuscript illumination in Bologna include E. Cassee, *The Missal of Cardinal Bertrand de Deux, A Study in Fourteenth-Century Bolognese Miniature Painting* (Florence, 1980), A. Conti, *La Miniatura Bolognese, Scuole et Botteghe, 1270–1340* (Bologna, 1981), and P.M. de Winter, 'Bolognese Miniatures at the Cleveland Museum', *Bulletin of the Cleveland Museum of Art*, vol. LXX (1983), pp. 314–51. We expect much from the current work by Dr Robert Gibbs. The pioneer work on the medieval booktrade in Oxford was by G. Pollard (such as his 'William de Brailes', *Bodleian Library Record*, vol. V (1955), pp. 202–9) and I owe my reference to Reginald (p. 140) to notes Mr Pollard kindly lent me in 1974.

V BOOKS FOR ARISTOCRATS

Probably few subjects in the humanities have produced more extensive writing than literary criticism has done. To many readers, medieval manuscripts are of value primarily as vehicles of literature. This chapter comprises a necessarily superficial survey of medieval vernacular writing, and I am aware of the dangers of trying to balance literary importance with medieval circulation judged from surviving manuscripts: *Beowulf* and Malory's *Morte D'Arthur*, for example, have come down in only one manuscript each and yet no one would doubt their significance over Petrus Riga's *Aurora*, for example, which survives in very many hundreds of copies. In compiling this chapter I looked at general books on literary history and tried to bear in mind what kind of manuscripts one might actually expect to find in a library or

museum. I used R.S. Briffault, *The Troubadours* (Indiana, 1965), E. Rose, *A History of German Literature* (New York, 1960), J.H. Whitfield, *A Short History of Italian Literature* (London, 1960) and E.H. Wilkins, *A History of Italian Literature*, revised by T.G. Bergin (Cambridge, MA, 1974). As a handbook to medieval literary manuscripts, there is still great value in H.D. Ward, *Catalogue of Romances in the Department of Manuscripts in the British Museum*, 3 vols. (London, 1883–1910, reprinted in 1961) and the historian of French manuscripts will need R. Bossuat, *Manuel Bibliographique de la Littérature Française au Moyen Age* (Melun, 1951, with supplements in 1955, 1961, etc.). A useful book, not as narrow as its title suggests, is R. Lejeune and J. Stiennon, *La Legende de Roland dans l'Art du Moyen Age*, 2 vols. (Brussels, 1966).

The thirteenth-century Canticles of Alfonso the Wise (pp. 148–9) are discussed in J.G. Lovillo, *Las Cántigas, Estudio Arqueológico de sus Miniaturas* (Madrid, 1949), and in J. Domínguez-Bordona, *Spanish Illumination*, vol. II (Florence and Paris, 1930), pp. 38–42. Manuscripts of the Lancelot romances (pp. 149–50) are described by Alison Stones in 'Secular Manuscript Illumination in France', *Medieval Manuscripts and Textual Studies*, ed. C. Kleinhenz (Chapel Hill, 1976), pp. 83–102, and 'The Earliest Illustrated Prose Lancelot Manuscript?', *Annual Proceedings of the Graduate Centre for Medieval Studies in the University of Reading*, vol. III (1977), pp. 3–44. The edition by Elspeth Kennedy, *Lancelot de Lac, The Non-Cyclic Old French Prose Romance*, 2 vols. (Oxford, 1980), uses 44 manuscripts, listed in vol. II, pp. 1–9.

A census of manuscripts of the *Roman de la Rose*, now in need of considerable revision, was published by E. Langlois, *Les Manuscrits du Roman de la Rose, Description et Classement* (Lille and Paris, 1910); a fluent English edition of the *Romance of the Rose* is by C. Dahlberg (Princeton, 1961). Various scholars are currently working on the complex iconography of miniatures of the *Roman de la Rose* and one of the first into print, as often, is E. König, *Der Rosenroman des Berthaud d'Achy, Codex Urbinatus Latinus 376* (Zurich, 1987). The enchanting little detail of a man and a woman making manuscripts, PL. 130 here, has been reproduced several times recently, but the first person to identify the couple shown (at least in print) was M. Camille, *Image on the Edge, The Margin of Medieval Art* (London 1992), p. 147, PL. 80. Many manuscripts of Dante have no illumination, but for those with miniatures there is P. Brieger, M. Meiss and C.S. Singleton, *Illuminated Manuscripts of the Divine Comedy* (New York, 1969). A handsome new book on B.L., Yates Thompson MS. 36, the Dante from which

PL. 113 is taken, is J. Pope-Hennessy, *Paradiso, The Illumination to Dante's Divine Comedy by Giovanni di Paolo* (London, 1993). For Chaucer's *Canterbury Tales* a quite outstanding (if sometimes over-ingenious) list of manuscripts and references to them, such as the wills mentioned here on p. 159, is by J.M. Manly and E. Rickert, *The Text of the Canterbury Tales, Studied on the Basis of all known Manuscripts*, vol. I, *Description of the Manuscripts* (Chicago, 1940). The Glasgow manuscript of Chaucer, PL. 138, is described by N. Thorp, *The Glory of the Page, Medieval and Renaissance Illuminated Manuscripts from Glasgow University Library* (Glasgow, 1987), p. 89, no. 36. For the personnel of the English scribes, illuminators and booksellers, an enthralling amount of information (rarely able to be matched with extant medieval manuscripts in which the tradesmen were involved) is in C.P. Christianson, *A Directory of London Stationers and Book Artisans, 1300–1500* (New York, 1990).

The production and illumination of romances in the fourteenth century is a theme which can be found in M. Meiss, *French Painting in the Time of Jean de Berry, The Late Fourteenth Century and the Patronage of the Duke*, 2 vols. (London, 1967), F. Avril, *Manuscript Painting at the Court of France, The Fourteenth Century (1310–1380)* (London, 1978) and by Avril again in *Les Fastes du Gothique, Le Siècle de Charles V*, exhibition at the Grand Palais (Paris, 1981–2). Manuscripts of the *Bible Historiale* are described in S. Berger, *La Bible Française au Moyen Age* (Paris, 1894), pp. 157–220; Alexander romances and the *Histoire Ancienne* are in D.J.A. Ross, *Alexander Historiatus, A Guide to Medieval Illustrated Alexander Literature* (London, 1963); Anne D. Hedeman has worked on all the manuscripts of the *Grandes Chroniques de France* (dissertation, Johns Hopkins University, 1984); for Vincent of Beauvais, see the note by G.G. Guzman in *Scriptorium*, vol. XXIX (1975), pp. 122–5, and on the translator Jean de Vignay by C. Knowles in *Romania*, vol. LXXV (1954), pp. 353–77.

VI BOOKS FOR EVERYBODY

Despite a welcome number of recent publications, there is still no standard history of Books of Hours. Probably the best is the admirable exhibition catalogue for an equally admirable exhibition at the Walters Art Gallery, R.S. Wieck, *Time Sanctified, The Book of Hours in Medieval Art and Life* (Baltimore and London, 1988). The classic work on the subject is the catalogue by V. Leroquais, *Les Livres d'Heures Manuscrits de la Bibliothèque Nationale*, 3 vols. (Paris, 1927, with a supplement issued in 1943)

with an 85-page introduction defining and describing the contents of a Book of Hours. The first modern historian to treat Books of Hours seriously was L.M.J. Delaissé, who died suddenly in 1972 before his work was complete; posthumous echoes of his teaching are in his article 'The Importance of Books of Hours for the History of the Medieval Book', *Gatherings in Honor of Dorothy Miner*, ed. L. Randall (Baltimore, 1974), pp. 203–25, and in the excessively big *Illuminated Manuscripts* catalogue of Waddesdon Manor (London and Fribourg, 1977). Accounts of Books of Hours, all of which should be easily available, include J. Harthan, *Books of Hours and their Owners* (London, 1977), which must have been the most successful book on manuscripts ever published, Calkins, *Illuminated Books*, cited above, pp. 243–81, and Janet Backhouse, *Books of Hours* (London, 1985). The account here of how to identify the 'Use' of a Book of Hours, p. 180, is mainly based on the extensive tables published by F. Madan, 'Hours of the Virgin Mary (Tests for Localization)', *Bodleian Quarterly Record*, vol. III, 1920–2, pp. 40–4, but one should now add John Plummer's chapter '"Use" and "Beyond Use"' in Wieck, *Time Sanctified*, cited above, pp. 149–52. Because Books of Hours have such popular appeal, as they have always done, publishers of manuscript facsimiles have often chosen this text to reproduce. Editions with especially useful introductions include J. Plummer, *The Hours of Catherine of Cleves* (New York, 1966), J. Longnon, R. Cazelles and M. Meiss, *Les Très Riches Heures du Duc de Berry* (London, 1969), M. Meiss and E.W. Kirsch, *The Visconti Hours* (London, 1972), Margaret Manion, *The Wharncliffe Hours* (London, 1981), D.H. Turner, *The Hastings Hours* (London, 1983), and R. Watson, *The Playfair Hours* (London, 1984); as a manuscript, the latter hardly merited reproduction, but the introduction is excellent and I acknowledge its help in particular for the comparison of statistics of early printed Books of Hours and for the names of those involved in the Rouen book trade (p. 198).

Most studies of late medieval manuscript decoration include many Books of Hours. Parisian illumination in the decades around 1400 is documented massively, and not always uncontroversially, in the well-illustrated series by M. Meiss, *French Painting in the Time of Jean de Berry* (London and New York, 1967–74), including his volume on *The Boucicaut Master* (1968) from which I computed the number of surviving Boucicaut miniatures, pp. 191–2, and learned many other facts used here. Information on the book trade in Paris is given by P.M. de Winter, 'Copistes, Editeurs et Enlumineurs de la Fin du XIVe Siècle: La

Production à Paris de Manuscrits à Miniatures', *Actes du 100e Congrès National des Sociétés Savantes, 1975* (Paris, 1978), pp. 173–98. J. Plummer's Pierpont Morgan Library exhibition catalogue *The Last Flowering, French Painting in Manuscripts, 1420–1530, from American Collections* (New York, 1982) is quite the best guide to localizing Books of Hours from towns in provincial France, supplemented by E. König, *Französische Buchmalerei um 1450, Der Jouvenel-Maler, Der Maler des Genfer Boccaccio, und die Anfänge Jean Fouquets* (Berlin, 1982) for manuscripts from the Loire valley and Brittany, and possibly even eclipsed by the enormous catalogue of the record-breaking exhibition at the Bibliothèque Nationale, F. Avril and N. Reynaud, *Les Manuscrits à Peintures en France, 1440–1520* (Paris, 1993), which I have used in revising both this chapter and the next.

In an earlier exhibition catalogue, *La Miniature Flamande, Le Mécénat de Philippe le Bon* (Brussels, 1959), L.M.J. Delaissé classified provincial Flemish illuminators of the fifteenth century, and for the great period of Ghent/Bruges art of around 1500 the textbook is still F. Winkler, *Die Flämische Buchmalerei des XV und XVI Jahrhunderts* (Leipzig, 1925), updated and extended with more enthusiasm than new research by G. Dogaer, *Flemish Miniature Painting in the 15th and 16th Centuries* (Amsterdam, 1987). Bodo Brinkmann has in recent years become the scholar most suitable to undertake revision of the whole subject. There is a good summary of recent work in the section on 'Flemish Manuscript Illumination, 1475–1550' by T. Kren in the exhibition catalogue he edited, *Renaissance Painting in Manuscripts, Treasures from the British Library* (New York and London, 1983), pp. 3–85. Dutch illuminated manuscripts are described by A.W. Byvanck and G.J. Hoogenwerff, *La Miniature Hollandaise* (The Hague, 1922–6) and are now being comprehensively studied by James Marrow. A glittering foretaste is H.L.M. Defoer, A.S. Korteweg and W.-C.M. Wüstefeld, *The Golden Age of Dutch Manuscript Illumination* (Stuttgart, 1989), with an Introduction by Marrow. With the eventual appearance of Professor Marrow's book, and that of K. Scott on English fifteenth-century illumination, both predicted as imminent in 1986 and still very nearly but not quite published, our knowledge of localizable workshops outside France will become much clearer. On the mechanics of duplicating designs for Books of Hours, by tracing or copying from pattern sheets, an excellent account is in J.D. Farquhar, *Creation and Imitation, The Work of a Fifteenth-Century Manuscript Illuminator* (Fort Lauderdale, 1976), esp. chapter 2, pp. 41–74, and a good part of Alexander's *Medieval Illuminators*, cited above.

VII BOOKS FOR PRIESTS

The most thorough study of liturgical manuscripts is A. Hughes, *Medieval Manuscripts for Mass and Office, A Guide to their Organization and Terminology* (Toronto, 1982), and the most readable, though unashamedly parochial, is C. Wordsworth and H. Littlehales, *The Old Service-Books of the English Church* (London, 1904); I owe to this book my references to English documents on pp. 218, 224 and 226. A clear summary of the different classes of book is *Liturgical Manuscripts for the Mass and Divine Office*, an exhibition catalogue for the Pierpont Morgan Library by John Plummer (New York, 1966). Because the Roman Catholic liturgy remained largely unchanged until recent years, the basic texts of the Missal and the Breviary should be obtainable in Latin from second-hand bookshops. The *Liber Usualis*, edited by the Benedictines of Solesmes, is a handbook of plainchant intended for choristers but is a most valuable tool for medievalists and is indexed by the opening words of antiphons and other chants.

The great catalogues by V. Leroquais of liturgical manuscripts in France formed the basis of my notes here on scribes and patronage in the fifteenth century. The catalogues are *Les Sacramentaires et les Missels Manuscrits des Bibliothèques Publiques de France*, 4 vols. (Paris, 1924), *Les Bréviaires*, 6 vols. (Paris, 1934), *Les Pontificaux*, 3 vols. (Paris, 1937) and *Les Psautiers*, 2 vols. (Macon, 1940–1). The realization that the Breviary of Charles de Neufchâtel is logically from Normandy and not from Besançon, p. 215 and PL. 194, comes from Avril in the exhibition catalogue *Les Manuscrits à Peintures*, cited above, p. 172, and I include it out of piety to Charles de Neufchâtel whose Missal, now in Auckland, was one of the first liturgical manuscripts I ever handled and looked at in detail. The Breviary of Isabella of Castile, PL. 195, is now described by J. Backhouse, *The Isabella Breviary* (London, 1993). The observations on Bibles in the Low Countries, pp. 228 and 231, are derived in part from L.M.J. Delaissé, *A Century of Dutch Manuscript Illumination* (Berkeley and Los Angeles, 1968), S. Hindman, *Text and Image in Fifteenth-Century Dutch Bibles* (Leiden, 1977), and especially from the catalogue *The Golden Age of Dutch Manuscript Illumination*, cited above. For the illumination of Gutenberg Bibles I am indebted to E. König, *Die Illuminierung der Gutenbergbibel*, commentary volume to the facsimile *Johannes Gutenbergs 42-zeiliger Bibel* (Munich, 1979), pp. 71–125, and his 'The Influence of the Invention of Printing on the Development of German Illumination', *Manuscripts in the Fifty Years after the Invention of Printing, Some Papers read at a Colloquium at the Warburg Institute on 12–13 March 1982*, ed. J.B. Trapp (London, 1983), pp. 85–94.

Research on the script and book production of the Italian Renaissance is a curiously recent development. When Sydney Cockerell and the Arts and Crafts connoisseurs began to collect and admire humanistic manuscripts in the early 1900s, their tastes must have been regarded as eccentrically English. It was in England that bibliographers began to look critically at *quattrocento* script, imitating it for their own 'italic' handwriting, and it is still from England and America that much inquiry has been undertaken into the humanists' books. A little publication as recent as the Bodleian guide *Humanistic Script of the Fifteenth and Sixteenth Centuries*, by A.J. Fairbank and R.W. Hunt (Oxford, 1960) was a pioneering work. B.L. Ullman, *The Origin and Development of Humanistic Script* (Rome, 1960) introduced by name many Florentine scribes of the early period, and J. Wardrop, *The Script of Humanism, Some Aspects of Humanistic Script, 1460–1540* (Oxford, 1963), adds some of the most human anecdote and observation ever accorded to medieval workmen; his epithet on Feliciano is quoted towards the bottom of p. 253. Wardrop's book must have given delight to many people. It was he who first identified the importance of Bartolomeo Sanvito, now regarded as the greatest Italian scribe.

The study of Sanvito and of literally hundreds of other Italian scribes is now the territory of Professor A.C. de la Mare, of King's College, London. The early part of this chapter is greatly indebted to the monumental first part of her *Handwriting of the Italian Humanists*, Vol. I, fasc. I (Oxford, 1973) and ever-new information is densely packed, line upon line, in her 'New Research on Humanistic Scribes in Florence', in A. Garzelli, ed., *Miniatura Fiorentina del Rinascimento, 1440–1525, Un Primo Censimento* (Florence, 1985), pp. 395–600. I have consulted L.D. Reynolds, ed., *Texts and Transmission, A Survey of the Latin Classics* (Oxford, 1983). The references to Bembo on p. 232 are derived from C.H. Clough, 'The Library of Bernardo and of Pietro Bembo', *The Book Collector*, vol. XXXIII (1984), pp. 305–31, but would doubtless have been better if I had used N. Giannetto, *Bernardo Bembo, Umanista e Politico Veneziano* (Florence, 1985). The comparison between Niccoli and Old Brown (p. 237) was first made by Nicolas Barker (*The Book Collector*, vol. XXVII, 1978, p. 383) about John Sparrow who taught me bibliophily. The quotations from Vespasiano on pp. 240 and 242 are from the translation by W.G. and E. Waters, *The Vespasiano Memoirs, Lives of Illustrious Men of the XVth Century by Vespasiano da Bisticci, Bookseller* (London, 1926). The map of Florence showing Vespasiano's house is a discovery of Professor de la Mare and is reproduced in her 'A Palaeographer's Odyssey', *Sight and Insight, Essays presented to E.H. Gombrich at 85*, ed. J. Onians (London, 1994), pp. 88, 94. There are accounts of the Medici Library in A.R.A. Hobson, *Great Libraries* (London, 1970), pp. 85–91, B.L. Ullmann and P.A. Stadter, *The Public Library of Renaissance Florence* (Padua, 1972), and F. Ames-Lewis, *The Library and Manuscripts of Piero di Cosimo de' Medici* (London, 1984). The book acquisitions of William Grey are discussed in R.A.B. Mynors, *Catalogue of the Manuscripts of Balliol College, Oxford* (Oxford, 1963), esp. pp. xxiv–xlv, and in the Bodleian exhibition catalogue by R.W. Hunt and A.C. de la Mare, *Duke Humfrey and English Humanism in the Fifteenth Century* (Oxford, 1970), esp. pp. 24–31. The library of the kings of Aragon is presented in a luxurious edition by T. De Marinis, *La Biblioteca Napoletana dei Re d'Aragona*, 4 vols. (Milan, 1947–52, with a supplement in 1969); for the books of Matthias Corvinus, see C. Csapodi and K. Csapodi-Gárdonyi, *Biblioteca Corviniana* (Shannon, 1969); and for those of Cardinal Bessarion, L. Labowsky, *Bessarion's Library and the Biblioteca Marciana* (Rome, 1979). For other identifications of Florentine scribes by A.C. de la Mare, see her 'Messer Piero Strozzi, a Florentine Priest and Scribe', *Calligraphy and Palaeography, Essays presented to Alfred Fairbank*, ed. A.S. Osley (London, 1965), pp. 55–68; *The Italian Manuscripts in the Library of Major J.R. Abbey*, with J.J.G. Alexander (London, 1969); and 'The Florentine Scribes of Cardinal Giovanni of Aragon', *Il Libro e il Testo, Atti del Convegno Internazionale, Urbino, 20–23 settembre 1982*, ed. C. Questa and R. Raffaelli (Urbino, 1984), pp. 245–93.

The illumination of humanistic manuscripts is discussed in O. Pächt, *Italian Illuminated Manuscripts from 1400 to 1550, Catalogue of an Exhibition held in the Bodleian Library* (Oxford, 1948), and by J.J.G. Alexander, both in his share of the Abbey catalogue, cited above (esp. pp. xxxiii–xl), and in his *Italian Renaissance Illuminations* (New York, 1977); his imminent exhibition of Italian manuscript illumination at the Royal Academy will certainly advance the subject significantly. There is a good account in the Bibliothèque Nationale exhibition by F. Avril, *10 Siècles d'Enluminure Italienne (VIe–XVIe Siècles)* (Paris, 1984), esp. pp. 109–79. I owe PL. 219 to the kindness of Mr Martin Schøyen and Mr Richard Linenthal. For Italian Renaissance bookbindings, the magisterial catalogue of surviving examples is T. De Marinis, *La Legatura Artistica in Italia nei Secoli XV e XVI, Notizie ed Elenchi*, 3 vols. (Florence, 1960). On the arrival of printing in Subiaco and Rome, an altogether fascinating little book, filled with observation and humane research, is E. Hall, *Sweynheym & Pannartz and the Origins of Printing in Italy, German Technology and Italian Humanism in Renaissance Rome* (McMinnville, Oregon, 1991).

Index of Manuscripts

AACHEN
Domschatzkammer
s.n., Aachen Gospels *42*; Pl. *35*
ABBEVILLE
Bibliothèque Municipale
ms. 4, St-Riquier Gospels *48*
AIX
Bibliothèque Municipale
ms. 11, Missal *213*
ALBA JULIA (Romania)
Bibliotheca Batthyaneaum
MS. II-1, Lorsch Gospels *48*
AMIENS
Bibliothèque Municipale
mss. 6-7, 9, 11-12, Maurdramnus
Bible *44*
ARRAS
Bibliothèque Municipale
ms. 139, verse lives of saints, etc. *149*
AUTUN
Bibliothèque Municipale
ms. 131, Missal *210*
ms. 133, Missal *210*
ms. 134, Missal *210*
ms. 135, Missal *210*
ms. 136, Missal *210*
ms. 138, Missal *210*
ms. 141, Missal *210*
AVALLON
Bibliothèque Municipale
ms. 1, Missal *213*
AVRANCHES
Bibliothèque Municipale
ms. 159, Eusebius, etc. *105*
BALTIMORE
Walters Art Gallery
MS.W.294, Book of Hours *197*; Pl.*147*
BAMBERG
Staatliche Bibliothek
Msc. bibl. 76, commentary
on Isaiah *66*
Msc. bibl. 95, Gospels of Henry II
64, *66*; Pl. *54*
Msc. bibl. 140, Apocalypse *64*, *66*;
Pl. *56*
BERLIN
Staatsbibliothek Museen Preussischer
Kulturbesitz
Kupferstichkabinett, Min.1233,
Henricus de Allemania *138*; Pl. *117*

MS. Diez B.Sant.66, library
catalogue *49*
MS. germ. 2° 282, Heinrich von
Veldeke, *146*; Pl. *124*
MS. Hamilton 125, Caesar *239*;
Pl. *220*
MS. Hamilton 166, Cicero *239*;
Pl. *218*
BESANÇON
Bibliothèque Municipale
ms. 69, Breviary *215*, *224*; Pl. *194*
BETHESDA, MARYLAND
National Library of Medicine
s.n., Joannitius, etc. *116*
BONN
Universitätsbibliothek
cod. S.526, *Lancelot du Lac 149, 150*;
Pl. *126*
BREMEN
Staats- und Universitätsbibliothek
MS. b.21, Gospels of Henry III, *64*,
71, 89; Pls. *53, 59*
BRESCIA
Biblioteca Civica
Queriniana cod. E.II.9,
Gospel Book *42*
BRUSSELS
Bibliothèque Royale
ms. II.2572, Peter the Archdeacon
49; Pl. *38*
mss. 106-7 and 204-5, Bible *228*
ms. 3452, Breviary *213*
ms. 10175, *Histoire Ancienne jusqu'
à César 165*
ms. 11051, Book of Hours *191*;
Pl. *172*
ms. 18723, Xanten Gospels *42*
CAMBRIDGE
Corpus Christi College
MS. 2, Bury Bible *86*
MS. 4, Dover Bible *77, 106, 232*;
Pl. *62*
MS. 48, St Albans Bible *77*; Pl. *65*
MS. 61, Chaucer, *159*; Pl. *137*
MS. 286, Gospel Book *17*; Pl. *6*
Fitzwilliam Museum
MS. 62, Hours of Isabella Stuart *195*
MS. 289, Bible *228*
Trinity College
MS. B.16.44, Decretals *91-2*
MS. O.4.7, St Jerome *78, 80*;
Pl. *66*
MS. O.9.34, Thomas of Kent *145*;
Pl. *123*
MS. R.17.1, Psalter *89, 94, 106*;
Pl. *61*; map bound in, *82*; Pl. *68*
Trinity Hall
MS. 1 Thomas of Elmham *14, 16*;
Pl. *5*
University Library
MS. Gg.4.27, Chaucer, *157, 159*
CHÂLON-SUR-MARNE
Bibliothèque Municipale
ms. 12, Book of Hours *186*
CHANTILLY
Musée Condé
ms. 14bis, *St Gregory 58, 60*; Pl. *47*
ms. 65, *Très Riches Heures 11, 168,
170, 195*; Pl. *151*
ms. 472, *Lancelot du Lac*, etc. *149*
ms. 1424, Guido da Pisa *157*;
Pl. *136*

CHICAGO
Newberry Library
MS. 12.1, St Augustine *78, 80, 91*;
Pl. *67*
MS. 39, Book of Hours *185*
COPENHAGEN
Kongelige Bibliotek
MS. 4,2°, Bible *86*; Pl. *72*
DARMSTADT
Hessische Landes- und
Hochschulbibliothek
MS. 101, Petrarch *232*; Pl. *213*
MS. 324, Bible *231*
MS. 1948, Gospel Book *63*
DIJON
Bibliothèque Municipale
ms. 34, Ruth with Gloss *111*
ms. 562, *Histoire Ancienne jusqu' à
César 165*
DONAUESCHINGEN
Fürstlich-Fürstenbergische Hofbibliothek
MS. 63, *Nibelungenlied 146, 148*
DOUAI
Bibliothèque Municipale
ms. 1171, Gradual *222*; Pl. *197*
DOUAI ABBEY, BERKSHIRE
MS. 11, fragment of service-book
82, 85
DUBLIN
Royal Irish Academy
s.n., Cathach of St Columba *22, 38*;
Pl. *12*
Trinity College
MS. A.I.6, Book of Kells *11, 24, 28,
37, 40*; Pls. *17, 18*
MS. A.I.15, Book of Mulling *22, 38*
MS. A.IV.5, Book of Durrow *22, 24,
38, 40*; Pls. *13, 15*
MS. A.IV.23, Book of Dimma *22*
DURHAM
Cathedral Library
MS. A.I.10, Berengaudus *91, 94-5*;
Pl. *74*
MS. A.I.16, Hugh of St Cher *136*
MS. A.II.1, Bible *105*
MS. A.II.4, Bible *91*
MS. A.II.17, Gospel *32*
MS. A.III.14, Isaiah with Gloss *111,
113*; Pl. *93*
MS. A.III.16, Ecclesiasticus, etc.,
with Gloss *111*
MS. B.II.30, Cassiodorus *18*
MS. B.IV.6, part of leaf from
a Bible *21*
University Library
Cosin MS. V.III.1, Laurence
of Durham *94*
ENGLAND
private collection
s.n., Book of Hours *170, 178*;
Pl.*156*
s.n., Book of Hours *180*; Pl. *158*
s.n., Zacharias Chrysopolitanus *86*;
Pl. *70*
ENGLISH PROVINCE OF THE SOCIETY
OF JESUS
Stonyhurst College
MS. 7, St Gregory *78, 80, 92, 105*;
Pl. *89*
MS. 55 (on loan to British Library),
St Cuthbert (Stonyhurst) Gospel
38; Pls. *27, 28*

ESCORIAL
Real Biblioteca de San Lorenzo
Cod. T.j.I, Cántigas of Alfonso X
148-9; Pl. *127*
Cod. Vitr. 17, Golden Gospels
of Henry III *71*
FLORENCE
Biblioteca Medicea-Laurenziana
MS. 46.13, Quintilian *240*
MS. Am. I, Codex Amiatinus, Bible
19, 21, 22, 38, 77, 89; Pls. *9, 10*
MS. Fiesole 176, Priscian *236*
MS. plut. 36, 41, Plautus *243*;
Pl. *224*
MS plut. 37, 16, Silius Italicus *242*
MS. Strozzi 36, Coluccio Salutati *239*
MS. Strozzi 109 Bartolomeo Facio
243
MS. Strozzi 152, Dante *157*
Biblioteca Nazionale
MS. L.F.22, Visconti Hours *170,
184*; Pl. *161*
MS. Palat. 313, Dante *157*
FRIBOURG
Bibliothèque Cantonale et Universitaire
ms. L.64, Breviary *213*; Pl. *193*
FULDA
Landesbibliothek
Cod. Bonifat. I, Gospel Harmony *34*
GENEVA
· Bibliothèque Publique et Universitaire
MS. fr. 178, *Roman de la Rose 150*;
Pl. *129*
GIESSEN
Universitätsbibliothek
cod. 945, *Codex in French 149*
GLASGOW
University Library
MS. Hunter 409, Chaucer *159*;
Pl. *138*
HAGUE, THE
Koninklijke Bibliotheek
MS. 76.D.45, Book of Hours *188*
MS. KA.XX, Vincent of Beauvais
165, 167; Pl. *145*
Rijksmuseum Meermanno-
Westreenianum
MS. 10.A.14, Missal *213*
MS. 10.B.23, *Bible Historiale 162*;
Pl. *121*
MS. 10.F.33, Book of Hours *186*
HEIDELBERG
Universitätsbibliothek
Cod. Pal. germ. 848, Manasse Codex,
songs in German *148*; Pl. *125*
JAPAN
private collection
s.n., Book of Hours *170, 191*; Pl. *152*
KINGSTON LACY HOUSE
Banks Collection
s.n., Bible fragment *21*; Pl. *11*
LEIPZIG
Universitätsbibliothek
MS. Rep. I.58a, Gospel Book
fragment *32*
MS. Rep. II.35a, Gospel Book
fragment *32*
LICHFIELD
Cathedral Library
MS. 1, Book of St Chad (Lichfield
Gospels) *24*; Pls. *14, 30*
MS. 29(2), Chaucer *159*; Pl. *135*

LIÈGE
Bibliothèque de l'Université
ms. 499, Gratian *116*
LINCOLN CATHEDRAL
MS. A.3.17, St Augustine *78, 80, 91, 101*; Pl. *83*
LONDON
British Library
Add. MS. 1855, Calendar miniatures *195*
Add. MS. 8784, Arithmetic *243*
Add. MS. 10043, Bible in Dutch *228*
Add. MS. 11987, Seneca *236*
Add. MS. 14095, Valerius Maximus *256*
Add. MS. 14787, Bernardo Bembo *254*; Pl. *236*
Add. MS. 15254, Bible *228*; Pl. *209*
Add. MS. 15268, *Histoire Ancienne jusqu' à César 165*
Add. MS. 15272, Johannes Scotus *246*
Add. MS. 15273, Duns Scotus *248*; Pl. *231*
Add. MS. 16578, *Speculum Humanae Salvationis 227*; Pl. *206*
Add. MS. 16982, Caesar *243*
Add. MS. 18851, Breviary of Isabella of Castile *215*; Pl. *195*
Add. MS. 21212, Chronicle *149*
Add. MS. 22399, Gilles de Paris *116*
Add. MS. 24189, Sir John Mandeville *152*; Pl. *131*
Add. MS. 24895, Narcissus de Verduno *243*
Add. MS. 29704, Carmelite Missal *200*; Pl. *184*
Add. MS. 35216, Book of Hours *180*; Pl. *157*
Add. MS. 35218, Book of Hours *180*
Add. MS. 35254, MS. cuttings *206*; Pl. *187*
Add. MS. 35313, Rothschild Hours *170, 195-6*; Pl. *182*
Add. ms. 37768, Psalter *54*
Add. MS. 37777, Bible fragment *21*
Add. MS. 38122, Bible history in Dutch *228*
Add. MS. 45025, Bible fragment *21*
Add. MS. 54230, Judges with Gloss *78*
Burney MS. 275, Aristotle *128*; Pl. *92*
Cotton MS. Claudius B.II, John of Salisbury *98*; Pl. *85*
Cotton MS. Claudius E.V, Pseudo-Isidore *92*; Pl. *79*
Cotton MS. Nero D.IV, Lindisfarne Gospels *11, 24, 28, 30, 37, 40*; Pls. *4, 19*
Cotton MS. Nero E.II, *Grandes Chroniques de France 165, 191-2*; Pl. *143*
Cotton MS. Vespasian A.I, Vespasian Psalter *16, 24*; Pl. *7*
Egerton MS. 2204, Bede *106*
Egerton MS. 3031, Cartulary of Reading Abbey *77*; Pl. *63*
Harley MS. 531, Sacrobosco *140*
Harley MS. 1758, Chaucer *159*
Harley MS. 2788, Golden Gospels *48*
Kings MS. 24, Virgil *254*; Pl. *239*

Lansdowne MS. 782, *Chanson d'Aspremont 145*
Royal MS. 1.A.XX, *Bible Historiale 162*
Royal MS. 1.B.XI, Gospel Book *101*; Pl. *87*
Royal MS. 2.A.X., Breviary *82*; Pl. *69*
Royal MS. 3.E.V, Bible with Gloss *140*; Pl. *120*
Royal MS. 10.E.IV, *Decretals 140*
Royal MS. 14.C.3, Eusebius *254*; Pl. *237*
Royal MS. 15.C.xv, Caesar *240*; Pl. *223*
Royal MS. 15.D.111, *Bible Historiale 162*; Pl. *139*
Royal MS. 19.D.11, *Bible Historiale 162*; Pl. *141*
Royal MS. 20.D.IV, *Lancelot du Lac 149*; Pl. *128*
Yates Thompson MS. 3, Hours of Jean Dunois *194*
Yates Thompson MS. 36, Dante *157*; Pl. *133*
Lambeth Palace Library
MS. 3, Lambeth Bible *77, 105*
MS.15, Gutenberg Bible *231*; Pl. *210*
MS.110, Exodus with Gloss *92*
MS.1370, Macdurnan Gospels *40*; Pl. *31*
private collection
s.n., Peter Lombard *111*; Pl. *95*
s.n., Processional *224*; Pl. *204*
s.n., St Ambrose *78, 80, 106*; Pl. *91*
Sir John Soane's Museum
MS. 4, Book of Hours *170, 196*; Pl. *181*
Victoria and Albert Museum
Inv. no. 138-1866, Lorsch Gospel cover *50*; Pl. *44*
MS. L.19-1983, Peter Lombard *111*; Pl. *96*
Wallace Collection
inv. M338, miniature *226*; Pl. *205*
Westminster Abbey
MS. 37, Litlyngton Missal *210*; Pl. *192*
LONDON AND OSLO
Schøyen Collection
MS. 258, Peter Lombard *111*; Pl. *98*
MS. 668, Bible *239*; Pl. *219*
LYONS
Bibliothèque Municipale
ms. 516, Missal *198*
ms. 517, Missal *210*; Pl. *191*
MADRID
Biblioteca Nacionale
Cod. vit. 22-11, Augustine *243*; Pl. *225*
Cod. 10069, Cántigas of Alfonso X *148-9*
MAESEYCK
Church of St Catherine, Trésor
s.n., Gospels *32, 37*
MALIBU
J. Paul Getty Museum
MS. Ludwig I.1, Bible *50*; Pl. *39*
MS. Ludwig V.6, Missal *206*; Pl. *188*
MS. Ludwig IX.7, Book of Hours *206*; Pl. *189*
MS. Ludwig IX.8, Book of Hours *170, 184*; Pl. *160*

MS. Ludwig XI.6, Book of Hours *174, 194*; Pl. *176*
MS. Ludwig XV.5, *Roman du Bon Chevalier Tristan 149*; Pl. *2*
MANCHESTER
John Rylands University Library
MS.Lat. 98, Gospel Book *60*
MS.Lat. 164, Book of Hours *190*; Pl. *168*
MILAN
Biblioteca Ambrosiana
MS. C.5.inf., Bangor Antiphonary *22*
MS. S.45.sup., St Jerome *38*
S.P.Arm. 10, scaf. 27(A49 inf), Virgil with commentary of Servius *232*; Pl. *214*
Biblioteca Trivulziana,
MS. 1080, Dante *157*
MUNICH
Bayerische Staatsbibliothek
Clm. 4452, Gospels of Henry II *64, 66*; Pls. *52, 55*
Clm. 4453, Gospels of Otto III *60, 62*; Pls. *32, 49, 50*
Clm. 4456, Sacramentary of Henry II *63-4*; Pl. *51*
Clm. 14000, Codex Aureus of St Emmeram, Gospel Book *54, 57, 63*; Pl. *45*
Clm. 15722, Livy *243, 249*; Pl. *235*
Clm. 30055 (jointly owned by Wolfenbüttel, Herzog August Bibliothek, Cod. Guelf. 105 Noviss. 2°), Gospels of Henry the Lion *71, 146*; Pls. *58, 60*
Schatzkammer,
s.n., prayer-book of Charles the Bald *51*
NETHERLANDS, THE
private collection
s.n., Book of Hours *197*; Pl. *3*
s.n., Book of Hours *175, 185*; Pl.*155*
NEW YORK
Metropolitan Museum of Art
Cloisters Collection, Acc. 54.1.2., Hours of Jeanne d'Evreux *170, 184*; Pl. *162*
Robert Lehman Collection, Acc. 1975.1.2.2487, self-portrait of Simon Bening *185*; Pl. *164*
Robert Lehman Collection, M. 194, single leaf from Hours of Étienne Chevalier *190*
Pierpont Morgan Library
G.37, Tree of Consanguinity *124*; Pl. *107*
M.81, Bestiary *98, 101*; Pl. *82*
M.87, Breviary *215*; Pl. *196*
M.161, Book of Hours *195*
M.289, Dante *157*
M.358, Book of Hours *191*; Pl. *169*
M.736, life of St Edmund *101*
M.945, Hours of Catherine of Cleves *170*; Pl. *149*
private collection
s.n., Gradual Pl. *199*
NORTH AMERICA
private collections
s.n., Antiphoner *222*; Pl. *198*
s.n., Bible *120*; Pl. *103*
s.n., Sacrobosco *127*; Pl. *109*

NUREMBERG
Germanisches Nationalmuseum
MS. 20.156.142, Codex Aureus of Echternach, Gospel Book *71*
OSLO
London and Oslo, Schøyen Collection
MS. 258, Peter Lombard *111*; Pl. *98*
MS. 668, Bible *239*; Pl. *219*
OXFORD
Balliol College
MS. 78B, John Climacus *242, 244*; Pl. *226*
MS. 130, Seneca *243*
Bodleian Library
MS. Ashmole 1431, herbal *101*; Pl. *84*
MS. Auct. D.1.13, Epistles of St Paul with Gloss *78, 105, 106*; Pl. *86*
MS. Auct. D.3.12, Leviticus with Gloss *78*
MS. Auct. D.3.15, Books of Kings with Gloss *78*
MS. Auct. D.4.6, Psalter with Gloss of Gilbert de la Porrée *78*; Pl. *64*
MS. Auct. D.11.14, Gospel Book *17*
MS. Auct. L.2.2., Aulus Gellius *254*; Pl. *240*
MS. Bodley 130, herbal *101*
MS. Bodley 264, Marco Polo *142*; Pl. *122*
MS. Bodley 494, Richard of St-Victor *101*
MS. Bodley 717, St Jerome *78, 80, 91*; Pl. *75*
MS. Bodley 810, Lanfranc *91*
MS. Digby 23, *Chanson de Roland 145*
MS. Digby 148, Hugh of St-Victor *86*
MS. D'Orville 78, Cicero *240*; Pl. *222*
MS. Douce 144, Book of Hours *188*; Pl. *167*
MS. Douce 253, Book of Hours *195*; Pl. *179*
MS. Hatton 48, Rule of St Benedict *21*; Pl. *8*
MS. Holkham misc. 49, Boccaccio *157*; Pl. *132*
MS. Lat. bibl. e.7, Bible *140*
MS. lat. th. b.4, *Decretals 138*; Pl. *119*
MS. Laud Misc. 409, Hugh of St-Victor *106, 108*; Pl. *94*
MS. Liturg. 198, Psalter *218*; Pl. *200*
MS. Rawl. G.161, Bible *228*; Pl. *207*
Christ Church
MS. lat. 88, St Augustine *78, 80, 91, 98*; Pl. *73*
Corpus Christi College
MS. 283, Euclid *127*; Pl. *110*
Exeter College
MS. 186, Suetonius *232*; Pl. *212*
Jesus College
MS. 52, Bede *94*
MS. 53, Bede *94*; Pl. *77*
MS. 62, Orosius *94*
MS. 63, Egesippus *94*
MS. 67, Bede *78, 80, 94, 111*; Pl. *78*
MSS. 53, 63, 68 and 70, bindings from Cirencester Abbey *106*; Pl. *90*
Merton College
MS. 271, Aristotle *128*; Pl. *111*

New College

MS. 121, Thomas Aquinas 130

MS. 288, Thomas Chaundler 140;

Pl. 118

Queen's College

MS. 323, St Luke with Gloss 78

St John's College

MS. 17, Bede, etc. 101

University College

MS. 165, life of St Cuthbert 101

Wadham College

MS. 1, Bible 120, 124; Pl. 104

PAMPLONA

Cathedral Library

MS. 51, Thomas Aquinas 134

PARIS

Bibliothèque de l'Arsenal

ms. 286, Book of Hours 186

ms. 562, Book of Hours 195; Pl. 177

ms. 599, Golden Gospels of

Charlemagne 48

ms. 3337, Roman de la Rose 152

ms. 5059, Bible Historiale 162

ms. 5080, Miroir Historiale 167;

Pl. 146

Bibliothèque Mazarine

ms. 142, Sts Luke and John with

Gloss 116

mss. 131-144, Bible with Gloss 116

Bibliothèque Nationale

ms. fr. 301, Histoire Ancienne jusqu' à

César 165; Pl. 142

ms. fr. 342, Lancelot du Lac 160

ms. fr. 380, Roman de la Rose 152

ms. fr. 782, Benoît de Sainte-Maure

165; Pl. 144

ms. fr. 794, Chrtien de Troyes 146

ms. fr. 2195, Roman de la Rose 152

ms. fr. 5707, Bible Historiale 162

ms. fr. 12595, Roman de la Rose 152

ms. fr. 24766, St Gregory, in French

140

ms. fr. 25526, Roman de la Rose 152;

Pl. 130

ms. fr. 74, Dante 157; Pl. 134

ms. lat. 1, First Bible of Charles the

Bald (Vivian Bible) 50, 54, 57;

Pls. 42, 46

ms. lat. 266, Gospel Book 54

ms. lat. 872, Missal 213

ms. lat. 1052, Breviary 215

ms. lat. 1152, Psalter of Charles the

Bald 51; Pl. 43

ms. lat. 1169, Book of Hours 186

ms. lat. 1989, St Augustine 234;

Pl. 216

ms. lat. 2195, Cassiodorus 50; Pl. 41

ms. lat. 3063, Duns Scotus 249;

Pl. 234

ms. lat. 3107, Thomas Aquinas 134

ms. lat. 4802, Ptolemy 240, 243;

Pl. 221

ms. lat. 5713, Thucydides 246;

Pl. 230

ms. lat. 6309, Aristotle 246; Pl. 227

ms. lat. 7595, Isidore 232

ms. lat. 8016, Ovid 246, 252;

Pl. 238

ms. lat. 8850, St-Médard Gospels 48

ms. lat. 8851, Gospel Book 58

ms. lat. 9085, Martyrology 124

ms. lat. 9383, Gospel Book 51

ms. lat. 9388, Gospel Book 51

ms. lat. 9389, Echternach Gospels

24, 32; Pl. 20, 21

ms. lat. 9428, Drogo Sacramentary

51

ms. lat. 9471, Rohan Hours 195

ms. lat. 9527, St Jerome 32

ms. lat. 9529, St Jerome 32

ms. lat. 9538, St Augustine 32

ms. lat. 10399, fragments 32

ms. lat. 10837, St Jerome 32

ms. lat. 11565, Peter Lombard 111,

113; Pl. 97

ms. lat. 11575, Florus 106; Pl. 76

ms. lat. 11930-1, Bible 116, 118

ms. lat. 12946, Bessarion 246;

Pl. 228

ms. lat. 12950, Aristotle 124

ms. lat. 12953, Aristotle 128; Pl. 112

ms. lat. 13174, Maurdramnus Bible

42

ms. lat. 13277, Book of Hours 195;

Pl. 178

ms. lat. 14563, Richard of Mediavilla

130; Pl. 114

ms. lat. 14706, Thomas Aquinas 129,

132; Pl. 113

ms. lat. 15816, Thomas Aquinas 134

ms. lat. 16200, Ptolemy 116; Pl. 99

mss. lat. 16748-9, Bible 124

ms. lat. 16839, St Jerome 246

ms. lat. 17294, Breviary 215

ms. lat. 17323, Missal frontispiece

ms. nouv. acq. fr. 5243, Romance of

Guiron le Courtois 152

ms. nouv. acq. lat. 172, Missal 213

ms. nouv. acq. lat. 1203, Godescalc

Evangelistary 46, 48, 49; Pl. 37

ms. nouv. acq. lat. 1690, Missal 210,

213

ms. nouv. acq. lat. 3189, Bible 140

Bibliothèque de Sainte-Geneviève

ms. 22 Bible Historiale 152

ms. 75, Acts, Canonical Epistles and

Apocalypse with Gloss 152

ms. 777, Livy 160; Pl. 140

Musée Jacquemart-André

ms. 2, Boucicaut Hours 191

Musée Marmottan

Collection Wildenstein, Cat. no.187,

Gospel Lectionary 224; Pl. 203

Sorbonne

ms. 30, Gratian, 128

PRIVATE COLLECTIONS

(formerly library of Major J.R. Abbey,

JA.7209), Breviary 200; Pl. 185

s.n., Antiphoner 222; Pl. 201

s.n., Bible 120; Pl. 102

s.n., Bible 120; Pl. 105

s.n., Bible 120; Pl. 106

s.n., Book of Hours 168, 170; Pl. 150

s.n., Book of Hours 175; Pl. 153

s.n., Book of Hours 176; Pl. 154

s.n., Book of Hours 174, 184; Pl. 159

s.n., Book of Hours 170, 184; Pl. 163

s.n., Book of Hours 188; Pl. 165

s.n., Book of Hours 191; Pl. 171

s.n., Book of Hours 176, 190;

Pl. 173

s.n., Gariopontus 237; Pl. 215

s.n., Gradual fragment 206; Pl. 190

s.n., Isaac Judaeus 128; Pl. 115

s.n., Psalter 222; Pl. 202

s.n., Virgil with commentary of

Servius Honoratus 246; Pl. 233

RENNES

Bibliothèque Municipale

ms. 255, Lancelot du Lac 149

ROME

Biblioteca Apostolica Vaticana

MS. Barb. lat. 570, Barberini Gospels

32, 37, 89; Pl. 26

MS. Pal. lat. 50, Lorsch Gospels 48;

Pl. 36

MS. Pal. lat. 1607, Giannozzo

Manetti 243

MS. Urb. lat. 224, Poggio Bracciolini

Pl. 217

MS. Urb. lat. 508, Cristoforo

Landino Pl. 232

MS. Urb. lat. 1314, Plato 242

MS. Vat. lat. 120, St Luke with Gloss

118; Pl. 100

MS. Vat. lat. 3354, Petrarch 232

MS. Vat. lat. 3357, Petrarch 232

Biblioteca Casanatense

MS. 4214, Bible 228; Pl. 183

Biblioteca Vittorio Emanuele

MS. 1430, prayer-book of Pope

Sixtus IV 246

San Paolo fuori le Mura

s.n., Bible 51, 54, 77

ROUEN

Bibliothèque Municipale

ms. 96, St Matthew with Gloss 89,

118; Pl. 101

ms. 464, St Augustine 91

SAN MARINO (California)

Huntington Library

MS. EL.26.C.9, Ellesmere Chaucer

157

SARNAN

Bibliothek des Kollegiums

MS. 16, Bible 124

ST GALL

Stiftsbibliothek

Cod. 51, Gospel Book 32; Pl. 23

Cod. 1395, Gospel Book fragment

32; Pl. 22

ST PETERSBURG

Publichnaja Biblioteka

MS. F.v.I.8, Gospel Book 32

MS.lat.Q.v.I.18, Bede 35, 40; Pl. 29

STOCKHOLM

Kungliga Biblioteket

MS. A. 135, Codex Aureus, Gospel

Book, 24; Pl. 16

SWITZERLAND

private collection

s.n., Book of Hours 185; Pl. 166

private collection (formerly Marquess

of Bute MS. 93)

s.n., Book of Hours 174, 194;

Pl. 175

TOURS

Bibliothèque Municipale

ms. 558, Gratian 137, 138; Pl. 116

TRIER

Domschatz

Cod. 61, Gospel Book 34-5; Pl. 25

Stadtbibliothek

Cod. 22, Gospel Book 48

Cod. 24, Gospel Lectionary 58

MS. 171a, St Gregory 58; Pl. 48

TROYES

Bibliothèque Municipale

ms. 175, Peter Lombard 118

ms. 504, St Gregory 14, 16

ms. 1046, Stephen Langton 120, 123

UPPSALA

Universitetsbibliotek

Cod. C.93, Gospel Book 71; Pl. 57

UTRECHT

Bibliotheek der Rijksuniversiteit

MS. 31, Bible 228

MS. 32, Utrecht Psalter 50; Pl. 40

VALENCIA

Biblioteca Universitaria

MS. 765, Cornelius Nepos 242

VENICE

Biblioteca Nazionale Marciana

MS. lat. 1.99, Grimani Breviary

215, 218

VIENNA

Kunsthistorisches Museum

ivory panel ; Pl. 1

Weltliche Schatzkammer,

Inv. XIII.18, Coronation Gospels

42; Pl. 33

Österreichische Nationalbibliothek

Cod. 22, Livy 246; Pl. 229

Cod. 1224, Gospel Book 35

Cod. 1576, Thomas à Kempis 231;

Pl. 208

Cod. 1857, Hours of Mary of

Burgundy 168; Pl. 170

Cod. 1861, Dagulf Psalter 44, 46,

48, 49; Pl. 34

Cod. 1897, Hours of Margaret Tudor

and James IV 170; Pl. 148

Cod. 2315, Constantinus Africanus

128; Pl. 108

Cod. 2771-2, Bible history in Dutch

228

WADDESDON MANOR

National Trust, James A. de Rothschild

Collection

MS. 12, Book of Hours 195; Pl. 180

WINCHESTER CATHEDRAL

MS. 17, Winchester Bible 77, 86,

96, 98, 105, 106; Pls. 80, 81, 88

WOLFENBÜTTEL

Herzog August Bibliothek

Cod. 85, 1.1, Aug. 2°, Alessandro

Cortesi 254; Pl. 211

Cod. Guelf. 105 Noviss. 2° (jointly

owned with Munich, Bayerische

Staatsbibliothek, Clm. 30055),

Gospels of Henry the Lion 71,

146; Pls. 58, 60

WÜRZBURG

Universitätsbibliothek

MS. M.p.th.q.28b, Isidore 32, 34;

Pl. 24

YALE UNIVERSITY

Beinecke Library

MS. 229, Lancelot du Lac 150

ZURICH

Zentralbibliothek

MS. C.74a, Quintilian 238

Aachen *42, 50, 57*; Pls. *33, 36*
Aachen Gospels *42*; Pl. *35*
Abbotsbury, monastery of Sts Peter and
 Paul Pl. *70*
Abelard, Peter *108*
Abingdon, library catalogue *74*
Abulabaz (elephant) *50*; Pls. *41, 42, 44*
'Ada' group of books *48*
Adalhard, Abbot of St Martin, Tours *54*
Adalpertus (monk at St Emmeram) *63*
Adam (scribe) *94*
Adam of St-Michel (scribe) *124*
Aelfred, Aldorman *24*; Pl. *16*
Aeneid (Virgil) *146, 232, 254*; Pls. *214,
 239*
Agneli, Lodovico, Bishop of Cosenza
 Pl. *239*
Agnes, Queen Pl. *57*
Aidan, St *22*
Alan (scribe) *186*
Albans Abbey Bible *77*; Pl. *65*
Albertus Magnus *130*
Albrecht, Cardinal of Brandenburg Pl. *3*
Alcuin *42, 44, 46, 49, 50, 54*
Aldred, Provost of Chester-le-Street *28*;
 Pl. *4*
Alexander the Cantor (scribe) *94*
Alexander the Great *142, 145, 146, 160,
 165*
Alexander of Hales *130*
Alexander (illuminator) *116, 118*
Alexander the Parchmenter *116*
Alfonso V of Aragon, King of Naples *246*;
 Pl. *133*
Alfonso X, King of León and Castile (the
 Wise) *149*
 song book of *148-9*; Pl. *127*
Alfonso of Calabria Pls. *221, 227, 231*
Alfred the Great, King *14, 108*
Almagest (Ptolemy) *116*; Pl. *99*
Alou, Pierre (priest) *213*
Ambrogio da Marliano (illuminator) Pl. *233*
Ambrose, St *78, 80*; Pl. *91*
Andrew, Abbot of Cirencester *94*; Pl. *77*
Angilbert, Abbot of St-Médard *48*
Angilbert, Abbot of St-Riquier *44, 48*
Anselm, St (Archbishop of Canterbury)
 86; Pl. *71*
Anselm of Laon *108*

Antiphoners *13, 82, 92, 218, 222, 224*;
 Pls. *198, 201*
 Bangor Antiphonary *22*
Aquinas, St Thomas *123, 129, 130, 132,
 134, 136*; Pl. *113*
Aretino, Giovanni (scribe) *240*; Pl. *222*
Argyropoulos, Giovanni Pl. *227*
Aripo (monk at St Emmeram) *63*
Aristotle *127, 128-9, 160*; Pls. *92, 111,
 112, 117, 227*
Armagh *see* Book of Armagh
arms, coats of *210, 215, 228, 249, 252,
 256*
Arnhem, Henricus van (scribe) *228*
Arnold of Villeneuve *130*
Arnulf, King of Bavaria *54*
Arnulf, son of Carloman *57*
Arnulfus de Kayo (scribe) *149*: Pl. *126*
Arras, Treaty of *185*
Arthur, King *142, 146, 149*
Artois, Mahaut, Countess of *142, 160*
Artois Pl. *201*
Atalanus, Abbot of Bobbio *38*
Athelstan, King of Wessex and Mercia *40*
'Auct' Bible *77*
Augustine, St *54, 78, 80, 86, 89, 91, 101,
 160, 231, 234*; Pls. *67, 73, 83, 216,
 225*
Augustine of Canterbury, St *14, 16, 17,
 22, 32, 40*; Pls. *6, 7*
Augustinians *85*
Augustus, Emperor *58*
Aulus Gellius Pl. *240*
Auxerre Pl. *105*

Bacon, Roger *123*
Bamberg *64*; Pl. *52, 54*
Bamberg Apocalypse *64, 66*; Pl. *56*
Bangor Antiphonary *22*
Barberini, Ser Francesco di Ser Nardo da
 (scribe) *157*
Barberini Gospels *32, 37, 89*; Pl. *26*
Becket, St Thomas *10, 74, 98, 120*; Pl. *85*
Bede *14, 17, 21, 22, 35, 38, 40, 54, 78,
 80, 94, 111*; Pls. *11, 29, 77, 78*
Bedford, Duke of *184, 215*
Bedford Master *184, 190, 191, 194, 195*;
 Pls. *175, 176*
Bembo, Bernardo *232, 254*; Pls. *236, 237*
Benedict, St *214*; Pl. *8*
Benedict, Abbot of Peterborough Abbey *78*
Benedict Biscop *11, 17-18, 22, 32, 34*
Benedictines *86*
Bening, Simon (illuminator) *185, 195*; Pls.
 3, 164
Berengaudus Pl. *74*
Beringar (scribe) *54*
Bernard, St *96, 176, 214, 226*
Bernard of Parma *138*; Pl. *119*
Bernardinus of Siena, St *184*
Berry, Jean, Duc de *13, 162, 165, 168,
 184*; Pls. *142, 151*
Bersuire, Pierre *165*; Pl. *140*
Bertram of Middleton *136*
Besançon Pls. *158, 194*
Bessarion, Cardinal *246*; Pl. *228*
Bestiaries *98, 101*; Pl. *82*
Bethany Pl. *166*
Bible *14, 16, 118, 128, 228*; Pls. *39, 72,
 102-6, 120, 183, 207, 209, 219*
 Carolingian *44, 51-2, 57, 118*

chapters, division into *120*
Dutch vernacular Bible histories *228*
earliest complete Latin (Codex
 Amiatinus) *15, 21-2, 38, 77*
English *77, 101*
format *77, 101, 118, 120, 138*
42-line *231*; Pl. *210*
French *50, 116-18, 118, 123, 128*
Glossed *78, 111, 113, 116, 118, 124*
Gutenberg *231*; Pl. *210*
Latin *15, 19, 54*
Novem Codices *18*
one-volume (pandect) *18, 116, 118,
 120, 138*
printed *120, 231*
production *86, 89*
rhyming *228*
scholarship *123*
signed *116*
size *77*
text standardization *123*
see also Codex Amiatinus, Dover,
 Lambeth, Maurdramnus, St Albans,
 San Paolo fuori le Mura, Vivian,
 Winchester; Gospel Books
Bible Historiale *162, 228*; Pls. *121, 139,
 141*
Bible Moralisée *167*
Biblia Pauperum (Poor Men's Bible) *227*
Billfrith, the anchorite *28, 37*
bindings *21, 28, 38, 54, 60, 78, 82, 89,
 92, 106, 150, 167, 188, 197, 200, 224,
 249*
 colour *106, 197, 249*
 enamels *58*
 gold and silver *16, 54, 58, 60, 142*
 ivory *50, 61-2*; Pls. *32, 44*
 jewels *54, 58, 60*; Pl. *32*
 materials and techniques *106, 197*
 metal fitments *28, 37, 168, 206*
 tabs *106*; Pl. *90*
 wooden boards Pl. *90*
Bischoff, Professor Bernhard *49*
Blanche de France *160*
Blavius (Paris beadle and bookseller) *116,
 124*
Bloomfield, M.W., et al.
 *Incipits of Latin Works on the Virtues and
 Vices 226*
Boccaccio, Giovanni *10, 157, 232, 234*:
 Pls. *132, 216*
Boethius *66, 129, 160*
Boisil, St *38*
Bonaventura, St *123, 130, 184*
Bondol, Jean (illuminator) *162*
Boniface, St *10, 34, 35, 40, 44*
Bonne of Luxembourg *160*
Book of Armagh *24*
Book of Dimma *22*
Book of Durrow *22, 24, 38, 40, 40*; Pls.
 13, 15
Book of Kells *11, 24, 28, 37, 40*; Pls. *17,
 18*
Book of Mulling *22, 38*
book production *9, 19, 64, 77, 80, 85-6,
 124, 140, 191, 196, 238*
 contracts *218, 231*
 cost *124, 188, 213*
 monastic *12, 85, 116*
 time taken *152, 188*
Book of St Chad (Lichfield Gospels) *24,*

38; Pls. *14, 30*
book trade *92, 108, 140, 196, 240*
 English *159*
 Italian *138, 140, 240, 242-4, 246*
 market for books *13, 18, 185, 231*
 Parisian *123-4, 127, 129, 136-8, 152,
 184*
bookbinders *140*
Books of Hours *10, 13, 37, 168ff., 197*
 dating *184, 188*
 localizing *178*
 national characteristics *184, 185, 198*
 see also Hours of ..., Boucicaut Hours,
 Rohan Hours, Rothschild Hours,
 Très Riches Heures, Visconti Hours
books and manuscripts
 dating *91, 184, 188*
 export and import *19, 34, 35, 54, 60,
 128, 138, 184, 185*
 format *38, 40, 89, 91, 98, 101, 120,
 167, 218, 239, 248*
 grammar *10, 49, 176, 249*
 language *152, 157*
 magic talismans, use as *38, 40*; Pl. *12*
 market for *13, 18, 185, 231*
 monetary value *51, 54, 66, 71, 116,
 124, 152, 159, 160, 162, 168, 188,
 240, 254, 256*
 pattern books *195, 196*
 pattern sheets *192, 194, 195*
 political use *42, 44, 48-9, 54, 71*
 purpose of decorations *40, 98*
 storage *9, 82, 106*; Pl. *90*
 unfinished *101, 148, 159, 170*
booksellers *13, 146, 176, 191, 196, 242,
 246*
bookshops *18, 113, 116, 130, 184, 186,
 188, 197*
borders, ornamental *149, 167*
Botticelli, Sandro *157*
Boucicaut, Maréchal de *184, 191*
Boucicaut Master *184, 190, 191*; Pls. *143,
 152, 165, 167, 171-3*
Bowen, James *80*
Branner, Robert *124*
 *Manuscript Painting in Paris during the
 Reign of St Louis 127*
Brekeling, Robert (scribe) *218*
breviaries *13, 82, 123, 170, 200, 202,
 206, 213, 214, 218*; Pls. *69, 94, 185,
 193, 196*
Breviary of Isabella of Castile *215*; Pl. *195*
Brinchele, John *159*
Brothers of the Common Life *228, 231*
Bruges Pls. *160, 181, 189, 195, 208*
Bruni, Leonardo *234*
Bruno, Archbishop of Cologne *57*
Brut Chronicle 165
Buildwas Abbey Pl. *73*
Burghley, William Cecil, Lord *16*
Burginda (scribe) *37*
Burgundy, John the Fearless, Duke of *184*
Burgundy, Margaret, Duchess of *165*
Burton-on-Trent Abbey *74, 86*
Bury Bible *77, 86*
Buvarelli, Rambertino *148*

Cadmug (scribe) *37*
Calabria, Alfonso, Duke of *242*
Calcagni, Teofilo *157*; Pl. *132*
Calendar

Church *40, 202, 206*
 in Books of Hours *174, 185*; Pl. *159*
Canon Tables Pl. *65*
Canterbury *14, 24, 37, 101*; Pl. *62*
 Christ Church *74, 85, 86, 92*; Pls. *61,
 68, 79*
 St Augustine's Abbey *74, 78*
Canterbury Tales (Chaucer) *157, 159*;
 Pl. *135*
Carloman, King of Bavaria and Italy *44, 57*
Carmelite Missal Pl. *184*
'carpet' pages *22, 40*; Pls. *13, 18, 30*
Carthusians *24, 85, 86*
Cassiodorus *18, 21, 50, 78, 86, 89*; Pls.
 10, 41
catchwords *98*
Cathach of St Columba *22, 38, 38*; Pl. *12*
Catholicon 231
Caxton, William *165, 167*
Celestine II, Pope *108*
Cellach *28*
Ceolfrith, Abbot of Wearmouth *17-18,
 19, 21, 22, 40, 118*; Pls. *9, 11*
chained books *82, 226, 240*
Chanson d'Aspremont 145
Chanson de Roland 142, 145
Charlemagne *10-12, 42, 44, 48, 50-1, 54,
 57, 60, 62, 66, 108, 142, 145*; Pls. *33,
 34, 36, 37, 41*
 library catalogue *74*
 library disposal *51*
Charles I, King of France (the Bald) *51,
 54, 57, 62, 63, 66*; Pl. *43, 46*
Charles IV, King of France *152*; Pl. *162*
Charles V, King of France *142, 160, 162,
 165, 215*; Pls. *121, 140*
Charles Martel *44*
Chaucer, Geoffrey *13, 157, 159*; Pls. *135,
 137, 138*
Chaundler, Thomas (warden of New
 College, Oxford) Pl. *118*
Chierico, Francesco d'Antonio del *249*;
 Pls. *217, 232*
Chrétien de Troyes *146*
Church calendar *40, 202*
 Sanctoral (Proper of the Saints) *202,
 206*
 Temporal (Proper of Time) *202, 206*
church services *214*
Cicero *232, 238, 240*; Pls. *218, 222*
Cinico, Giovanni Marco (scribe) *243*
Cirencester Abbey *92*; Pls. *77, 78, 85, 90*
Ciriago, Gherardo di Giovanni del (scribe)
 242, 243, 253
Cistercians *85, 86, 96*
City of God (St Augustine) *42*
Clémence of Hungary *152*
Cluniac, monastic order *85*
Cluny Abbey *238*
Codex Amiatinus *19, 21, 22, 38, 77, 89*;
 Pls. *9, 10, 19*
Codex Aureus *24*; Pl. *16*
Codex Aureus of Echternach *71*
Codex Aureus of St Emmeram *54, 57, 63,
 66*; Pls. *45, 51*
Codex Egberti *58*
Codex Grandior *18, 19, 21*
Coene, Jacques (illuminator) *190*
Colin le Frutier (scribe) *149*
Collectars *82*
Colman *22*

colour *40, 42, 120, 222, 254*
 bindings *106, 120, 197, 249*
 highlighting text *118, 184, 215*
 initials *98, 105, 118, 239*
 purple grounds *14, 24, 42, 46, 48*; Pls.
 33, 34
 technique *105*
Columba, St *22, 40*
Comestor, Peter *111, 113, 160*
Commentaries (Julius Caesar) *240*; Pl. *223*
compasses, use of *101*
Concordantia Discordantium Canonum
 (Gratian) *138*
Conrad, Duke of Franconia *57*
Constantinus Africanus *128*; Pl. *108*
Corbie Abbey *44, 49, 51, 105*; Pl. *76*
Coronation Gospels *42*; Pl. *33*
corrections *96*
Cortesi, Alessandro *254*; Pl. *211*
Cotton, Sir Robert *16*
Cousserii, Dominique (scribe) *210*; Pl. *191*
crusades *145*
cumdach 22, 38
Cunegund, Queen *66*; Pl. *55*
Cutbercht (scribe) *35, 37*
Cuthbert, St *28, 30, 101*; Pls. *27, 28*

Dagulf Psalter *44, 46, 48, 49*; Pl. *34*
Dagulf (scribe) *46*
Dante Alighieri *13, 138, 148, 157, 232*;
 Pls. *133, 134, 136*
Dati, Leonardo *254, 256*
dating
 Books of Hours *184, 188*
 from script *91, 98*
De Animalibus (Aristotle) *128*; Pl. *111*
De Dietis (Isaac Judaeus) *128*; Pl. *115*
De Differentia Spiritus et Animae (pseudo-
 Aristotle) Pl. *112*
De Interpretatione (Aristotle) *128*; Pl. *92*
De Officiis (Ambrose) *80*
De Politia Litteraria (Decembrio) *249*
De Praeceptis, de Confessione et Scientia Mortis
 (Gerson) *227*
De Varietate Fortunae (Bracciolini) *238*;
 Pl. *217*
De Viris Illustribus (Jerome) *80*
Decameron (Boccaccio) *157, 234*: Pl. *132*
Decretals (Boniface II) *138*
Decretals (Boniface VIII) *138*
Decretals (Clement V) *138*
Decretals (Gregory IX) *138, 140*; Pl. *119*
Decretum (Gratian) *86, 113, 116, 128, 137,
 138*; Pl. *116*
Deodatus (scribe) *94*
Deschamps, Eustache *168*
Destrez, Jean *132*
Devotio Moderna 228
diagrams *101*
Diarmait (scribe) *37*
Dimma *see* Book of Dimma
Divina Commedia (Dante) *138, 157, 232*;
 Pls. *133, 134, 136*
Dominic, St *123*
Dominicans *123*; Pls. *105, 103*
Douai Abbey *82*
Dover Bible *77, 106, 232*; Pl. *62*
Droem, Herman (dean of Utrecht) *228*;
 Pl. *183*
Drogo, Bishop of Metz *51*
Drogo Sacramentary *51*

Dubois, Hugues (scribe) *213*
Dubtach (scribe) *37*
Dunois Master Pl. *168*
Duns Scotus *130, 248, 249*;
 Pls. *231, 234*
Durand of St Pourain *130*
Durham Cathedral *74*; Pl. *93*
Durham Gospels *24, 77*
Durrow Abbey Pl. *13*
 see also Book of Durrow

Eadfrith, Bishop of Lindisfarne *28*; Pl. *4*
Eadfrith (scribe) *37*
Eadwine (scribe) *94*; Pl. *61*
Ebbo, Archbishop of Rheims *50*
Ecclesiastical History (Bede) *40*; Pl. *29*
Echternach Abbey *35, 64*; Pls. *25, 53,
 57, 59*
Echternach Gospels *24, 32*; Pls. *20, 21*
Eckhart *130*
Edilbericht son of Berichtfrid (scribe) *37*
Edmund, St *101*
Effrem the Syrian Pl. *226*
Egbert, Archbishop of Trier *58, 60*; Pl. *47*
Egerton Master *190*; Pl. *139*
Egfrith, King of Northumbria *17*
Einhard *49*
Ekkehard *57*
Ellesmere Chaucer *157*
Enarrationes in Psalmos (Augustine) *234*;
 Pl. *216*
Enart de St-Martin (illuminator) *137*
Enchiridion (Ambrose) *80*
Eneide (von Veldeke) Pl. *124*
Epistolary *60*
Erasmus of Rotterdam *10*
Este, Borso d', Duke of Ferrara *157*
Estienne le Roy (illuminator) *137*
Ethelberht, King of Kent *14*; Pl. *5*
Ethelwald, Bishop of Lindisfarne *28*
Ethics (Aristotle) Pl. *117*
Euclid *127*; Pl. *110*
Eusebius of Caesarea Pl. *237*
Even, Yves (scribe) *213*
exemplars *19, 34, 86, 91, 94, 96, 116,
 130, 134, 188, 213*
Exeter Cathedral Pls. *75, 86*
export and import of books and manu-
 scripts *19, 32, 34, 35, 54, 60, 91, 128,
 138, 184, 185*
Eyck, Jan van *194*
 portrait of Nicolas Rolin *194*; Pl. *174*

Fardulphus, Abbot of St-Denis *50*
Faricius, Abbot of Abingdon Abbey *92*
Fastolf Master *195*
Fécamp Abbey *91*
Feliciano, Felice *253*
Felix *106*
Ferdomnach (scribe) *37*
Ferrante I, King of Naples *248*; Pl. *231,
 234*
Ferrara Pls. *185, 190*
Fingall, Lord *77*
Finnian, St *22*
First Bible of Charles the Bald (Vivian
 Bible) *50, 54, 57*; Pls. *42, 46*
FitzNeal, Richard, Bishop of London *77*
FitzOsbern, Osbern, Bishop of Exeter *91*
FitzStephen, William *98*
Flan, King *22*

Flemmyng, Robert Pl. *223*
Fleury Abbey *50, 51*
Florence Pls. *134, 197, 227*
Florent, Count of Holland *165*; Pl. *145*
Florus *106*; Pl. *76*
Forber, John *218*
42-line Bible *see* Gutenberg Bible
Fra Angelico *249*
Franciscans *123*; Pl. *105, 202*
Frederick I, Emperor (Barbarossa) *71*
Frederick II, Emperor *148*
Fridugisus, Abbot of St Martin, Tours *54*
Fulco (scribe) *94*; Pl. *77*
Fulda Abbey *32, 34*
furniture for books *22, 38, 57, 96, 231,
 249*; Pl. *90*
Fürstenberg, Princes of *148*

Gabriele da Parma (scribe) *243*
Gaddi, Taddeo *192*
Gall, St Pl. *23*
 see also St Gall
Gariopontus *237*; Pl. *215*
Gautier Neron *152*
Gelhi, son of Arihtiud Pl. *14*
Gembloux Abbey *51*
Gentiluzzi, Niccolò di Berto di Martino de'
 (scribe) *243*; Pl. *225*
Geoffroy de St-Léger *152*
Geography (Ptolemy) *240, 243*; Pl. *221*
Gerard, Count of the Sabine *62*
Gerard of Abbeville *130*
Gerard of Cremona *129*; Pl. *99*
Gerbert of Aurillac *60*
Gero, Archbishop of Cologne *63*
Gerson, Jean Charlier de *227*
gesso *124*
Ghent Pls. *181, 189*
Gilbert l'Englais (illuminator) *137*
Gilbert, Bishop of London (the Universal)
 80, 108
Gilbert de la Porrée *78, 108*; Pl. *64*
Gilbertines *85*
Gilles de Paris *116*
Gils, Father P.-M.J. *134*
Giovanni d'Andrea *138*
Giovanni, Cardinal, of Aragon Pls. *231,
 238*
Giraldus Cambrensis *28, 37, 40*
Girart de Biaulieu (scribe) Pl. *129*
Giraut, Pierre (scribe) *137*
Gloss *78, 111, 113*
 see also Bible
Godescalc Evangelistary *46, 48, 49, 49*;
 Pl. *37*
Godescalc (scribe) *48*
gold *11, 48-9, 51, 54, 66, 71, 96, 101,
 105, 124, 168, 174, 184, 188, 218,
 249*
 application *105, 124*
 initials *46, 108, 218*
 script *24, 54, 58, 116*; Pl. *36*
Golden Gospels of Charlemagne *48*
Golden Gospels of Henry III *71*
Gospel Books *10, 17, 22, 28, 30, 24, 32,
 140*; Pls. *6, 22, 23, 25, 57, 87*
 Carolingian *10, 46-54*
 insular *24, 28, 32, 40*
 Ottonian *58, 60, 63, 71*
 use *32, 38*
 see also Aachen, Armagh, Barberini,

Codex Aureus, Coronation, Dimma, Durham, Durrow, Echternach, Golden, Harley Golden, Hereford Cathedral, Kells, Lichfield, Lindisfarne, Lorsch, Macdurnan, Mulling, St-Médard, St-Riquier, Stonyhurst, Vienna Coronation, Xanten
Gospels of Henry II 64, 66; Pls. 52, 54, 55
Gospels of Henry III 64, 71, 89; Pls. 53, 59
Gospels of Henry the Lion 71, 146; Pls. 58, 60
Gospels of Otto III 60, 62, 66; Pls. 32, 49, 50
Gottfried von Strassburg 146
Graduals 13, 82, 92, 218, 222, 224; Pls. 190, 197, 199
Grandes Chroniques de France 165, 191-2; Pl. 143
Gratian 86, 98, 113, 116, 128, 137, 138; Pl. 116
Gray, William 243, 244, 253; Pl. 226
Greenwell, Canon William 21
Gregory I, Pope (St Gregory the Great) 14, 16, 32, 40, 78, 80, 218; frontispiece, Pls. 3, 5, 29, 89
 commentary on Ezechiel 78, 80, 92, 105; Pl. 89
Gregory V, Pope 60
Gregory IX, Pope 127, 138; Pl. 119
Gregory XI, Pope Pl. 92
Grimani Breviary 215, 218
Grolier, Jean 232; Pl. 212
Groote, Gerard 228
Grusch, Johannes (scribe) 124
Guelders-Jülich, Dukes of 215; Pl. 196
Guérin, Abbot of St-Victor 113; Pl. 97
Gui de la Tour, Bishop of Clermont 124
guidewords Pl. 87
Guido of Castello 108
Guido da Pisa Pl. 136
Guido delle Colonne 165
Guillaume d'Avesnes 150
Guillaume de Chamois 188
Guillaume de Lorris 150
Guillaume de Termonde 150
Guioz de Troyes (scribe) 146
Gutenberg, Johann 231
Gutenberg (42-line) Bible 231; Pl. 210
Guy de Montrocher 227
Guyart des Moulins 160
Guyot, B.-G. 226

Hadrian, Pope 48; Pl. 34
Hainault, Jean d'Avesnes, Count of 150
Haincelin, Jean (illuminator) 190
Harley Golden Gospels 48
Haroun-al-Rachid 50
Hartmann von Aue 146
Heinrich von Morungen 148
Heinrich von Veldeke Pl. 124
Helduinus 111
Helmarshausen Abbey Pl. 58
Henri III, King of France 162
Henricus de Allemania Pl. 117
Henry II, Emperor 12, 63, 64, 66; Pls. 51, 52, 54, 55, 56
Henry III, Emperor 71; Pls. 53, 57
Henry I, King of England 74, 85
Henry II, King of England 74, 86, 146
Henry V, King of England 184

Henry the Fowler 57
Henry of Ghent 130
Henry the Lion, Duke of Saxony and Bavaria 12, 71, 146
Heraclius, Patriarch of Jerusalem 74
herbals 101; Pl. 84
Herbert of Bosham 111
Hereford 86
Hereford Cathedral Gospel Book 24
Heribert (chancellor of Italy) 62; Pl. 49
Heribert (monk and scribe of Reichenau Abbey) 58
Herimann (monk at Helmarshausen Abbey) 71
Hexham 17
Hincmar, Archbishop of Rheims 54
Hippocrates 128
Histoire Ancienne jusqu' à César 165, 165; Pl. 142
Historia Destructionis Troiae (Guido delle Colonne) 165
Historia Ecclesiastica (Bede) 35, 40; Pl. 29
Historia Scholastica (Peter Comestor) 111, 113, 160
historiated initials 40, 51, 101; Pl. 102
homoeoteleuton 94
Horace 80
Horenbout, Gerard (Illuminator) Pl. 148
Hort, F.J.A. 19
Hours of Catherine of Cleves 170; Pl. 149
Hours of Charles the Noble 188
Hours of Eleanor of Portugal 195
Hours of Étienne Chevalier 190
Hours of Isabella Stuart 195
Hours of James IV 195
Hours of Jean Dunois 194
Hours of Jeanne d'Evreux 170, 184, 184; Pl. 162
Hours of Maréchal de Boucicaut 184, 191
Hours of Margaret Tudor and James IV 170; Pl. 148
Hours of Mary of Burgundy 168; Pl. 170
 see also Books of Hours
Howard, D.R. 226
Hugh of Lincoln, St 86
Hugh the Painter 91, 92; Pl. 75
Hugh de Puiset, Bishop of Durham 77
Hugh of St Cher 123, 127, 130
Hugh of St-Victor 86, 106, 108, 108; Pl. 94
Hugo Cappellarius (scribe) 128
Humfrey, Duke of Gloucester Pl. 140
Hygebeald, Bishop of Lindisfarne 32

illumination 11, 170
 design sources 192, 194
 fashion for illuminated manuscripts 168
 gold 66, 124
 illustrating contemporary life 185, 190
 originality 194, 195
 prices 210
 purpose 96, 167, 210
 technique 101
illuminators 58, 62, 124, 137, 140, 190
 amateur 186
 classified by style 127
 female 137, 152, 186
 guild 159
 Paris 184
 payment 140, 210
 working speed 192

Alexander 116, 118
Ambrogio da Marliano Pl. 233
Bedford Master 184, 190, 191, 194, 195; Pl. 175, 176
Bening, Simon 185, 195; Pls. 3, 164
Bondol, Jean 162
Boucicaut Master 184, 190, 191; Pls. 143, 152, 165, 167, 171-3
Coene, Jacques 190
Dunois Master Pl. 168
Egerton Master 190; Pl. 139
Enart de St-Martin 137
Estienne le Roy 137
Fastolf Master 195
Gilbert l'Englais 137
Haincelin, Jean 190
Horenbout, Gerard Pl. 148
Hugh the Painter 91, 92; Pl. 75
Jean de Planis 210; Pl. 191
Jehan d'Orli 137
Laurence 213
Laurentius de Voltolina Pl. 117
Lebaube, Gautier 124; Pl. 107
Limbourg brothers 184, 192
Master of the Brussels Initials 190
Master of the Coronation of the Virgin 191
Master of the Dominican Effigies 157
Master of Guillebert de Mets Pl. 166
Master of the Harvard Hannibal 190, 195
Master Honoré 137; Pl. 116
Master of James IV Pls. 148, 182
Master of Mary of Burgundy Pl. 170
Master of the Rolin II 210
Master of the Vatican Homer Pl. 237
Montbaston, Richard and Jeanne 152; Pl. 130
Mouret, Jean 186
Nanni, Ricciardo di 249; Pls. 224, 235
Oderisi da Gubbio 138
Padovana, Gasparo 254
Pucelle, Jean Pl. 162
Reginald Pl. 120
Richard de Montbaston 152
Robert de Derbi 140
Simon Master 105; Pl. 89
Thomase 137
Troyes Master 190
Walter of Eynsham 140
William de Brailes 140
 see also scribes
Imitation of Christ (Thomas à Kempis) 231; Pl. 208
initials 40, 145, 170, 218
 Carolingian 46, 48, 50, 54
 colours 14, 98, 105, 118, 239
 contract for painting 218
 function 98, 118
 gold 46, 108, 218
 historiated 24, 40, 50, 100, 113, 248
 interlaced 22, 24, 48
 Ottonian 62
 white-vine 13, 239, 248, 253, 254; Pls. 218, 219, 220
Innocent V, Pope 130
Institutes (Cassiodorus) 18
insular books and manuscripts 22, 28, 32, 40
Interpretation of Hebrew Names 118
Ioachim de Gigantibus (scribe) 246;

Pl. 228
Iona 28
Isaac Judaeus 128; Pl. 115
Isabella of Castile 215; Pl. 195
Isabelle of Bavaria 176, 188
Isidore of Seville 32, 34, 40; Pl. 24
ivory bindings 50, 61-2; Pls. 32, 44

James of Venice 129
Jarrow 17, 18, 19, 21, 35, 37, 118; Pl. 29
Jean l'Avenant (scribe) 188
Jean de Boucicaut 184
Jean de Meun 13, 150, 157
Jean de Papeleu (scribe) 162
Jean de Planis (illuminator) 210; Pl. 191
Jean de Vignay 167; Pl. 146
Jeanne d'Amiens le Petit (scribe) 149
Jeanne de Belleville 160
Jeanne de Bourgogne, Queen of France 167; Pl. 146
Jeanne of Burgundy 152, 186
Jeanne d'Evreux 160
Jeanne de Navarre 160
Jehan d'Orli (illuminator) 137
Jerome, St 18, 48, 54, 78, 80, 91, 118; Pl. 66
Jeudi, Guillaume 213
jewels 54, 58, 60; Pl. 32
Joannitius, Isagoge 116
Jocelin (scribe) 94
John II, King of France 160, 162, 165, 167; Pl. 141
John, Duke of Bedford Pl. 140
John Climacus 242, 244; Pl. 226
John the Good Pl. 146
John of Sacrobosco 127, 140; Pl. 109
John of Salisbury Pl. 85
jongleurs 142
Josephus 89
Jouffray, Cardinal Jean Pl. 230
Julius Caesar 240; Pl. 223
Jumièges Abbey 91
Juvenal 80

Kabealo, T.B. 226
Kells see Book of Kells
Ker, Dr N.R. 86
Kerad (monk and scribe of Reichenau Abbey) 58
Kilian, St Pl. 24
Kingston Lacy House 21
Konrad (Pfaffe) 146

Lambert, Guillaume (scribe) 198
Lambeth Bible 77, 105
Landino, Cristoforo Pl. 232
Lanfranc, Archbishop of Canterbury 91-2
Langton, Stephen 111, 120, 123, 130
Lannoy, Baudouin de Pl. 208
Latini, Brunetto 152
Laurence, Prior (scribe) 94
Laurence (illuminator) 213
Laurentius de Voltolina (illuminator) Pl. 117
Lebaube, Gautier (illuminator) 124; Pl. 107
Lectionaries 58, 63, 66, 82; Pl. 203
legal books and manuscripts 128, 138, 140
Leo X, Pope frontispiece
Leo, Bishop of Vercelli 62; Pl. 49
Leonardo de Gropius of Modena (scribe)

Pl. 119
Leonello d'Este 249
lettering see script
Letters to Atticus (Cicero) 232; Pl. 218
Letters to his Friends (Cicero) 236
Li Livres du Graunt Caam (Marco Polo) 142; Pl. 122
Liber Passionarii (Gariopontus) 237; Pl. 215
libraries 60, 148, 149, 160, 232, 240, 248
 catalogues 14, 74, 96
 monastic 12, 78, 80, 82, 85, 106
 monetary value 248
 papal 248, 249
 Bessarion 248
 Boccaccio 234
 Cassiodorus 18, 19
 Cesena 249, 252
 Charlemagne 49, 51
 Charles V 167
 Corbie Abbey 49
 Duc de Berry 168
 Durham Cathedral 21
 Este 246
 Ferrante I 248
 Gonzaga 246
 Louis XII 232
 Medici, Cosimo de' 252
 Montefeltro, Federigo da 248, 249, 253
 Niccoli 237
 Otto III 62, 66
 Petrarch 232
 Richard II 159
 St Augustine's Abbey 10
 St Gall Abbey 37, 38, 238
 Salutati 236, 239
 Sforza 234, 246
 Verona 232
 Visconti 232, 234, 246
 Wearmouth 17
 Willoughby 21
Lichfield Gospels see Book of St Chad
Liège Pl. 163
Limbourg brothers 11, 184, 192; Pl. 151
Lincoln Cathedral 74, 101; Pl. 83
Lincoln Pl. 82
Lindisfarne 22, 32
Lindisfarne Gospels 11, 24, 28, 30, 37, 38, 40, 89; Pls. 4, 19
Litlyngton, Nicholas, abbot Pl. 192
Litlyngton Missal 210; Pl. 192
Liuthard (scribe) 54
Lives of the Caesars (Suetonius) 232; Pl. 212
Livy 10, 51, 160, 246; Pls. 140, 229, 235
localization 215
Lochorst, Herman van 228
Lombard, Peter 78, 80, 98, 111, 113, 118, 120, 124, 127, 128, 129; Pls. 95, 96, 97, 98, 114
Lombardus, Nicolaus 123-4
Lorard, Bernard 213
Lorsch 49, 50; pl. 36
Lorsch Gospels 48, 50, 63; Pls. 36, 44
Lothair, King 54
Louis I, Emperor (the Pious) 48, 51, 54
Louis IX, King of France (St Louis) 10, 165
Louis X, King of France 152
Louis XI, King of France 246; Pl. 230
Louis XIII, King of France 162
Louis XIV, King of France 162
Louis the Child, King of the Franks 57

Lovati, Lovato 232
Lowe, E.A. 32
Ludovico il Moro Pl. 233
Lul, Archbishop of Mainz 35
Luna, Pietro Hippolyto da Pls. 231, 234
lunellum Pl. 72
Lupus of Ferrières 54

Macdurnan, Maelbrigt, Abbot of Armagh Pl. 31
Macdurnan Gospels 40, 40; Pl. 31
MacRegol (scribe) 37
Mader, Henry 224
Maerlant, Jacob van 165; Pl. 145
Maeseyck, church of St Catherine 32
Maeseyck Gospels 37
Manasse Codex 148; Pl. 125
Mandeville, Sir John 152; Pl. 131
Manipulus Curatorum (Guy de Montrocher) 227
Mantegna, Andrea 253
Manuals 13
Map, Walter 149
Marco Polo 142, 152; Pl. 122
Mare, A.C. de la 242
Maria, Antonio 240
Mario, Antonio (scribe) 242, 243, 244; Pl. 226
marriage charter of Theofanu and Otto 58
Martini, Simone 232; Pl. 214
Mary of Burgundy 168
Massiot Austin 152
Master Alexander 116
Master Alexander's Bible 118
Master of the Brussels Initials 190
Master of the Coronation of the Virgin 191
Master of the Dominican Effigies 157
Master of Guillebert de Mets Pl. 166
Master of the Harvard Hannibal 190
Master Honoré 137; Pl. 116
Master Hugo 86
Master of James IV Pls. 148, 182
Master of Mary of Burgundy Pl. 170
Master of the Registrum Gregorii 58, 60; Pls. 47, 48
Master of the Rolin II 210
Master of the Vatican Homer Pl. 237
Matthias Corvinus, King of Hungary 246, 249; Pls. 211, 229, 235
Mauleon, Giles (scribe) 186
Maurdramnus, Abbot of Corbie 44
Maurdramnus Bible 42, 44
Mauro, Cristoforo, Doge of Venice Pl. 236
Maximinus, Emperor 48
Mediaeval Academy of America 226
medical books 128; Pl. 115
Medici, Andreas de' (scribe) 243
Medici, Cosimo de' (the Elder) 10, 234, 240, 242; Pl. 218, 222
Medici, Piero de' 249; Pl. 224
Meditations (Anselm) Pl. 71
Mellitus 14
Mendoza, Pedro Gonzales de, Archbishop of Toledo 198
Metamorphoses (Ovid) 246, 252; Pl. 238
Metaphysics (Aristotle) 128; Pl. 113
Middleton, Lord 21
miniatures
 kissing 210

mass multipication 196
 as record of secular life 149
 as subjects for veneration 210
Miroir Historiale 167; Pl. 146
Missal of Jean Rolin II 210; Pl. 191
Missals 13, 49, 82, 92, 106, 200, 209, 210, 213, 214; frontispiece, Pls. 184, 188, 191, 192
Mistery of Stationers 159
Modena Cathedral 145
Moling, St 22
monasteries and monastic orders 85
 book production 85, 116
 books held by 74-85
Montbaston, Jeanne de (illuminator) 152; Pl. 130
Montbaston, Richard de (illuminator) 152; Pl. 130
Montefeltro, Federigo da, Duke of Urbino 242, 252-3; Pl. 232
Moralia on Job (Gregory the Great) 80
Mouret, Jean (illuminator) 186
Mulling see Book of Mulling
Mulot, Johan (scribe) 152
murals 42, 105, 149, 192, 227
Murri, Jacques (scribe) 213
music manuscripts and books 10, 13, 14, 77, 82, 92, 138, 145, 148, 149, 218; Pls. 197, 198, 199, 202, 204
 notation 222, 224

Nanni, Ricciardo di (illuminator) 249; Pls. 224, 235
Nero 48
Neufchâtel, Charles de, Archbishop of Besançon 215; Pl. 194
Nibelungenlied 146, 148
Niccoli, Niccolò 234, 236-9, 252, 253
Nicholas II, Pope 249
Nicholas of Lyra 130
Nicholas the Parchmenter 124
Nicholas of Salerno, Antidotarium 128
Nicholas of Tolentino, St 184
Nicolas (canon of St-Victor) Pl. 97
Nicolas von Firmian 185
Nicomachean Ethics (Aristotle) 246; Pl. 227
Noctes Atticae (Aulus Gellius) 254; Pl. 240
Northumbro-Irish 24, 32
Nottingham Castle 160
Novello, Malatesta 249, 252
Novello da Carrara, Francesco 234
Novem Codices 21

Oakeshott, Walter 105
Oderisi da Gubbio (illuminator) 138
Odini de Reomo, Jean 213
Odo of Châteauroux 130
Odo de Wica (scribe) 94; Pl. 78
Odofredo (lawyer) 108
Origen 78
Orléans 51
Osmund, St 92, 184
Oswy, King 22
Otranto Cathedral 146
Otto I, Emperor (the Great) 57, 58
Otto II, Emperor 57, 58, 60; Pl. 47
Otto III, Emperor 10, 12, 42, 60, 62, 63, 64, 66, 71, 232; Pls. 33, 49, 56
Ottonian renaissance 57
Ovid 246, 252; Pl. 238
Oxford 140; Pl. 118

Padovano, Gasparo (illuminator) 254
paintings 40, 51, 96
panel paintings 18
Pannartz, Arnold 254
Panormita, Antonio 246
paper 159, 200, 252
parchment see vellum
Parentucelli, Tommaso 249, 252
Paris 149; Pls. 99, 100, 101, 103, 106, 107, 108, 109, 111, 112, 113, 114, 129, 139, 140, 150, 152, 156
 Notre-Dame 108, 111
 Sainte-Chapelle 58
 St-Denis 165
 Ste-Geneviève 108, 111
 St-Germain-des-Prés Pl. 97
 St-Jacques 123
 St-Victor 92, 108, 111, 116; Pls. 93, 94, 97, 99, 114
 University 108, 127-8, 138, 140
Parker, Matthew 17
Parkes, Dr M.B. 35
Parzival (Wolfram von Eschenbach) 146
Pastoral Rule (Gregory the Great) 14, 16, 40
pastoral theology 226, 227
Patrick, St 22
Paul IV, Pope Pl. 187
Paul the Deacon 42
pecia system 130, 132, 134, 136, 140
pen flourishers 124
Pepin the Short 44
Peter the Archdeacon 49; Pl. 38
Peter of Blois, Archdeacon of Bath 113, 116, 128
Peter the Chanter 111
Peter of Châteauroux 116
Peter of Pisa 42
Peter of Poitiers 111, 130
Peter of Tarantaise, St 130, 214
Peterborough Abbey, library catalogue 74, 78
Petit Heures of the Duc de Berry 184
Petrarch, Francesco 232, 234; Pls. 212, 213, 214, 216, 233
Philagathos, Johannes, Bishop of Piacenza 60, 62
Philip II, King of Spain 148
Philip IV, King of France (the Fair) 137, 152
Philip the Chancellor 130
Philip the Good, Duke of Burgundy 165, 210
Phillipps, Sir Thomas 80
philosophy 249
Pier della Vigna 148
Pisa Pl. 136
Plautus Pl. 224
plummet 101
poetry 145, 146, 150, 168, 236, 249
Poggio Bracciolini 234, 236, 238, 239, 252, 253; Pls. 217, 218, 219, 222
political propaganda 66
Pollard, Graham 140
Pontigny Abbey 214
Portier, Pierre 188, 191
portiforium 214
prayer-books 51
 vernacular 160
price of books and manuscripts 124, 152, 188, 210, 213, 256

prickings *38, 91*; Pl. *74*
primers Pl. *156*
printing *9, 13, 46, 89, 165-7, 176, 222, 231, 252, 254, 256*
Priscian *127*
Pro Archia (Cicero) *232*
Pro Caecina and *Pro Lege Agraria* (Cicero) *240*; Pl. *222*
Processionals *13, 82*; Pl. *204*
production techniques *86*
Propertius *232*
Psalter of Charles the Bald *51*; Pl. *43*
Psalters *13, 14, 16, 44, 46, 49, 50, 51, 54, 57, 82, 218*; Pls. *43, 61, 64, 200, 202; see also* Dagulf, Utrecht, Vespasian
Ptolemy *116, 240, 243*; Pls. *99, 109, 221*
Pucelle, Jean (illuminator) Pl. *162*

Quentin, Jean *170*
Quintilian *238*

Ralph de Pulleham (scribe) *94*
Ramwold, Abbot *63*
Rand, E.K. *54*
Raoulet d'Orléans (scribe) *188*
Rationale Divinorum Officiorum (Durandus) *231*
Raulinus (scribe) *140*
Raymond of Peñafort *138, 227*
Reading Abbey *77, 118*; Pls. *64, 67*
 library catalogue *74, 77, 78, 82, 86, 92, 98, 106, 111, 129*; Pl. *63*
Regensburg *64*; Pls. *51, 124*
Reginald (illuminator) Pl. *120*
Registrum Gregorii 58, 60; Pls. *47, 48*
Reichenau Abbey *57, 58, 60, 64, 66*; Pls. *49, 50, 52, 55*
Reinmar von Hagenau *148*
Reynoldes, J. *80*
Rheims *50*
Richard I, King of England (the Lion Heart) *145*
Richard de Belmais, Bishop of London *77*
Richard of Mediavilla *130, 130*; Pl. *114*
Richard (monk of Corbie Abbey) *105*
Richard (prior of St-Victor, Paris) *86, 101*
Richildis *54*
Ripelinus, Hugo *224*
Robert of Adington *111*; Pl. *93*
Robert of Courçon *130*
Robert de Derbi (illuminator) *140*
Robert de Marchia (scribe) *162*
Robert of Molesmes, St *214*
Rochester Cathedral *86*; Pl. *66*
 library catalogue *74*
Roger, Abbot of Reading *78*; Pl. *64*
Rohan Hours *195*
Roland *142, 145*
Roland, Abbot of Montiéramey *118*
Rolandslied 146
Rolin, Jean II, Bishop of Autun *210*: Pl. *191*
Rolin, Nicolas *194*; Pl. *174*
Roman books *9*
Roman manuscripts and inscriptions *253*
Roman du Bon Chevalier Tristan 149; Pl. *2*
Roman de Lancelot du Lac 149, 150; Pls. *126, 128*
Roman de la Rose 150, 152; Pls. *129, 130*
Roman de Toute Chevalerie (Thomas of Kent)

145; Pl. *123*
Roman de Troie (Benoît de Sainte-Maure) *165*; Pl. *144*
Romance of Guiron le Courtois 152
Romaunt de la Rose (Chaucer) *159*; Pl. *138*
Rosenbach, Dr A.S.W. *252*
Rossi, G.B. de *19*
Rothschild Hours *170, 195-6*; Pl. *182*
Rouen Pls. *177-180, 194*
Rouse, Professors Richard and Mary *134*
Rudolf von Ems *146*
running-titles *98*

Sacramentaries *60, 63*
 Drogo Sacramentary *51*
Sacramentary of Henry II *63-4*; Pl. *51*
Sacrobosco *140*
St Albans Abbey *77, 86, 101, 108*; Pls. *65, 69, 89, 94*
 chronicle *98*
St Albans Breviary *82*; Pl. *69*
St Augustine's Abbey, Canterbury *10, 17, 74, 78*; Pls. *6, 84, 87, 110*
St Cuthbert (Stonyhurst) Gospel *38*; Pls. *27, 28*
St-Denis Abbey *50, 54*
St Emmeram Abbey *54, 63, 66*; Pl. *51*
St Gall, abbey *32, 37, 38*; Pls. *22, 23*
 chronicle *57*
St-Genèse, Hugues de *213*
St-Hubert, abbey *54*
St James of Compostela *142*
St Martin's Abbey, Tours *50*
St-Médard *48, 50*
St-Médard Gospels *48*
St Petersburg Bede *40*
St-Riquier Gospels *48*
St-Victor, abbey *92, 108, 111, 116*; Pls. *93, 94, 97, 99, 114*
Salisbury *86, 96*
Salisbury, William de Montacute, Earl of *162*; Pl. *141*
Salomo III, Abbot of St Gall *58*
Salutati, Coluccio *234, 236, 238, 239, 252, 253*; Pl. *215*
San Paolo fuori le Mura Bible *51-2, 77*
Sanctoral (Proper of the Saints) *202, 206*
Santillana, Marquis of Pl. *225*
Sanvito, Bartolomeo (scribe) *254*; Pls. *211, 237, 239*
Schedel, Hartmann *256*
Schneyer, J.B.
 Repertorium der Lateinischen Sermones des Mittelalters 226
scientific books *101*
Scot, Michael *129*
scribes *37, 92-6, 140, 231, 240*
 fees *124, 132, 243, 256*
 female *160*
 guild *159*
 illustrations of *92, 94, 152*
 Italy *140, 240, 242-3*
 mistakes made by *94, 96*
 monastic *11, 21, 35, 37, 67, 86, 92-6, 231*
 names *94, 124, 137*
 Paris *116, 118, 124, 137, 140*
 part-time *159, 243*
 professional *64, 92, 94, 116*
 tools and materials *9, 91, 94, 101, 222*
 travelling *86, 92, 140*

working conditions *35, 37, 243*
working speed and time taken *22, 92, 130, 152, 238, 242, 243*
Adam *94*
Adam of St-Michel *124*
Alan *186*
Aldred *28*
Alexander the Cantor *94*
Aretino, Giovanni *240*; Pl. *222*
Arnhem, Henricus van *228*
Arnulfus de Kayo *149*; Pl. *126*
Barberini, Ser Francesco di Ser Nardo da *157*
Beringar *54*
Brekeling, Robert *218*
Burginda *37*
Cadmug *37*
Cinico, Giovanni Marco *243*
Ciriago, Gherardo di Giovanni del *242, 243, 253*
Colin le Frutier *149*
Cousserii, Dominique *210*; Pl. *191*
Cutbercht *35, 37*
Dagulf *46*
Deodatus *94*
Diarmait *37*
Dubois, Hugues *213*
Dubtach *37*
Eadfrith *28, 37*
Eadwine *94*; Pl. *61*
Edilbericht son of Berichtfrid *37*
Even, Yves *213*
Fulco *94*; Pl. *77*
Gabriele da Parma *243*
Gentiluzzi, Niccolò di Berto di Martino de' *243*; Pl. *225*
Girart de Biaulieu Pl. *129*
Giraut, Pierre *137*
Godescalc *48*
Grusch, Johannes *124*
Guioz de Troyes *146*
Heribert *58*
Hugo Cappellarius *128*
Ioachim de Gigantibus *246*; Pl. *228*
Jean l'Avenant *188*
Jean de Papeleu *162*
Jeanne d'Amiens le Petit *149*
Jocelin *94*
Kerad *58*
Lambert, Guillaume *198*
Laurence, Prior *94*
Leonardo de Gropius of Modena Pl. *119*
Liuthard *54*
MacRegol *37*
Mario, Antonio *242, 243, 244*; Pl. *226*
Master of the Registrum Gregorii *58, 60*; Pls. *47, 48*
Mauleon, Giles *186*
Medici, Andreas de' *243*
Mulot, Johan *152*
Murri, Jacques *213*
Odo de Wica *94*; Pl. *78*
Ralph de Pulleham *94*
Raoulet d'Orléans *188*
Raulinus *140*
Robert de Marchia *162*
Sanvito, Bartolomeo *254*; Pls. *211, 237, 239*
Serlo, Abbot of Cirencester *94*
Sigbert *37*

Simon of Cornwall *94*
Sinibaldi, Antonio *246, 256*; Pl. *238*
Strozzi, Piero *243, 244*, Pls. *224, 235*
Thomas *35*; Pl. *25*
Ulric of Osterhofen Pl. *206*
Ultan *38*
Vena Pl. *207*
Walter *94*
Wigbald *37*
William, 'knight of Paris' *124*: Pl. *104*
see also illuminators
script *11, 18, 78, 91, 94, 186, 214, 228, 252*
 Carolingian (Caroline) minuscule *46, 50*
 coloured *96*
 'Corbie a/b' *46*
 dating by *91*
 English developments *91*
 gold *44, 46, 48, 54, 58, 116*; Pl. *36*
 Gothic *46, 239*
 humanistic *239, 240, 243, 248*
 insular *34, 37*; Pl. *28*
 Irish half uncial *24*
 Irish majuscule *22*
 Irish minuscule *22, 24*
 Italian *185*
 italic *243, 254*
 Latin Bibles *77*
 lettera antica 239, 240
 'Luxeuil minuscule' *46*
 minuscule *46, 49, 58, 239*
 Norman *92*
 'Roman' *13, 46*
 Roman inscriptions *253*
 silver *46*
 size *209*
 Spanish *185*
 uncial *11, 14, 16, 21, 24, 35, 37, 58*; Pls. *7, 28*
Script of Humanism, The (James Wardrop) *253*
scriptoria *11, 14, 37, 38, 49, 50, 54*
scrolls *9*
Seneca *80, 232, 243*
Sens family (Parisian stationers) *150*
Sentences (Lombard) *80, 111, 113, 129*; Pls. *95, 96, 114*
Serlo, Abbot of Cirencester *94*
service-books Pl. *69*
Servius Honoratus Pls. *214, 233*
Sforza, Gian-Galeazzo, Duke of Milan Pl. *233*
Sic et Non (Abelard) *108*
Siciliano, Antonio *218*
Sigbert (scribe) *37*
Sigena, Spain *105*
Sigismund, Emperor *165*
Simon, Abbot of St Albans *92, 98*; Pl. *89*
Simon of Cornwall (scribe) *94*
Simon Master *105*; Pl. *89*
Simon of Tournai *130*
Sinibaldi, Antonio (scribe) *246, 256*; Pl. *238*
Sistine Chapel service books Pl. *187*
Sixtus IV, Pope *246*
Sotheworth, Richard *159*
Soudenbalch, Evart van *228*
Sozomeno of Pistoia *246*
Sparwenfeldt, John Gabriel *24*
Speculum Historiale (Vincent of Beauvais)

165; Pls. 145, 146
Speculum Humanae Salvationis 227; Pl. 206
Spieghel Historiael 165, 167; Pl. 145
Spinola Hours 195, 196
Spiritualis Gradatio (John Climacus) 242,
 244; Pl. 226
stationers 123, 130, 132, 134, 136, 140,
 150, 159
Stavelot Abbey Pl. 38
Stephen II, Pope 44
Stoke-by-Clare, priory Pl. 91
Stonyhurst Gospel *see* St Cuthbert Gospel
Strozzi, Benedetto 242
Strozzi, Piero (scribe) 243, 244; Pls. 224,
 235
Suetonius 48, 232; Pl. 212
Summa contra Gentiles (Aquinas) 134
Summa Theologiae (Aquinas) 129, 130
Summa de Vitiis et Virtutibus (Raymond of
 Peñafort) 227
Sweynheym, Conrad 254
Sylvester II, Pope 60
Symeon of Durham 30
Synonyma (Isidore) 32, 34; Pl. 24

techniques 38, 91, 101, 105, 222
 drawing 101; Pl. 169
 drawing circles and curves 101
 use of charcoal 101
Temporal (Proper of Time) 202, 206
Tewkesbury Abbey 85
Text of St Mildrid 14
textbooks 108
Theodulf the Visigoth 42
Theofanu 60
Theologia (Abelard) 108
theology books 128, 249
Theophilus, *De Diversis Artibus* 86
Thomas of Elmham 14; Pl. 5
Thomas à Kempis 231; Pl. 208
Thomas of Kent 145; Pl. 123
Thomas de Maubeuge 152, 160
Thomas (scribe) 35; Pl. 25
Thomase (illuminator) 137
Thorney Abbey 101
Thucydides 246; Pl. 230
Thurn und Taxis, Franz 185
Tibullus 51
Todd, H.J. 231
Toledo Pl. 198
Torelli, Filippo di Matteo 249
Tours 50, 51, 54; Pls. 39, 154
travelling artists 105
Travels (Mandeville) 152; Pl. 131
treasure manuscripts 51
Tree of Consanguinity Pl. 107
Très Belles Heures (Duc de Berry) 184, 188
Très Riches Heures (Duc de Berry) 11, 168,
 170, 192, 195; Pl. 151
Trier 58, 64; Pl. 47
Tristan (Gottfried von Strassburg) 146
Troilus and Criseyde (Chaucer) 159; Pl. 137
Tropers 82
troubadours 142
Troyes Master 190
Tudor, Margaret Pl. 148

Ulric of Osterhofen (priest and scribe)
 Pl. 206
Ultan (scribe) 38
universities 12, 108, 111, 127
 control of publishing 130
 university stationers 130
Use, liturgical 178, 180, 184, 209
Utrecht Pls. 155, 183
Utrecht Psalter 50, 50; Pl. 40

Valerius Flaccus 238
Valla, Lorenzo Pl. 230
Vaudetar, Jean 162; Pl. 121
Vecchietta Pl. 133
Vegetius 160
vellum 9, 22, 32, 38, 42, 48, 91, 118,
 136, 140, 188, 200, 239, 248, 252
 preparation 86, 89, 188; Pl. 72
 reuse 200
 supply 86
 'uterine' 120
Vena (scribe) Pl. 207
Verdun, Treaty of 51
Vespasian Psalter 16, 24; Pl. 7, 16
Vespasiano da Bisticci 237, 240-4, 246,
 248, 252, 256; Pl. 223, 224, 225, 226,
 227, 230, 231, 232
Vienna Pl. 188
Vienna Coronation Gospels 42;
 Pl. 33, 35
Vikings 24, 30
Vincent of Beauvais 165; Pls. 145, 146
Vincent Ferrer, St 184
Virgil 11, 80, 146, 232, 254; Pls. 214,
 233, 239
Visconti dukes of Milan 184; Pl. 161, 212
Visconti Hours 170, 184; Pl. 161
Vitéz, Janos 249, 253; Pl. 235
Vivian, Abbot of St Martin, Tours 54;
 Pl. 46
Vivian Bible *see* First Bible of Charles
 the Bald

Walter of Eynsham (illuminator) 140
Walter (scribe) 94
Waltham Abbey, library catalogue 74
Wardrop, James 253
Wearmouth 17, 18, 19, 21, 35, 37, 40,
 118; Pl. 29
Weltchronik (Rudolf von Ems) 146
Whitby, Synod of 22, 34
Whitby Abbey, library catalogue 74
white-vine initials 13, 239, 248, 253, 254;
 Pls. 218, 219, 220
Wigbald (scribe) 37
Wilfrid, St 22, 40
Willehalm (Wolfram von Eschenbach) 146
William of Auvergne 130
William de Brailes (illuminator) 140
William of Calais, Bishop of Durham 91
William of Champeaux 108
William of Clare Pl. 110
William, 'knight of Paris' (scribe) 124:
 Pl. 104
William of Malmesbury 85
William of Moerbeke 130
William of St Amour 130
William of Trumpington Pl. 94
Willibrord, St 32, 50; Pl. 21
Winchcombe 96
Winchester 85; Pl. 86

Winchester Bible 77, 86, 96, 98, 105,
 106; Pls. 80, 81, 88
Witham 86
Wolfram von Eschenbach 146
women
 illuminators 137, 152, 186
 patronage by 160
 role in promoting vernacular writing
 160
 scribes 160
Worcester, library catalogue 74
Worksop Priory Pl. 82
Würzburg Cathedral 32, 34; Pl. 24

Xanten Gospels 42

Yolande of Flanders 160

Zacharias Chrysopolitanus Pl. 70
Zoppo, Marco 253
Zurich Pl. 125
Zurita, Jeronimo 24

Photographic Acknowledgements
Aachen: © Domkapitel Aachen (photo
Münchow) 35; Berlin: Staatsbibliothek
Preussischer Kulturbesitz, Handscriften-
abteilung 124, 218; Cambridge: The
Master and Fellows of Corpus Christi
College 6, 62, 65, 110, 137; The Master
and Fellows of Trinity College, Cambridge
61, 66, 68, 123; The Master and Fellows
of Trinity Hall 5; Dublin: The Board of
Trinity College Dublin 13, 15, 17, 18;
Durham: The Dean and Chapter of
Durham 74, 93; Florence: photo Donato
Pineider 224; photo Maurizio Schioppetto
161; Glasgow: The Librarian, Glasgow
University Library 138; London: by cour-
tesy of The Dean and Chapter of
Westminster 192; His Grace the
Archbishop of Canterbury and the Trustees
of Lambeth Palace Library 31, 210;
Sotheby's 3, 60, 70, 91, 95, 98, 102, 103,
106, 109, 150, 152, 153, 154, 155, 156,
158, 159, 163, 165, 173, 185, 186, 190,
198, 199, 204, 215, 219, 233; Madrid:
© Patrimonio Nacional 127; Manchester:
reproduced by courtesy of the Director
and University Librarian, The John
Rylands University Library of Manchester
168; New York: Metropolitan Museum of
Art, The Cloisters Collection, 1954
(54.1.2) 162, Robert Lehman Collection,
1975 (1975.1.2487) 164; Oxford: repro-
duced by kind permission of the Principal,
Fellows and Scholars of Jesus College 77,
78, 90; The Warden and Fellows of
Merton College 111; by permission of the
Warden and Fellows, New College 118;
Paris: photo Jean-Loup Charmet 140;
Giraudon 47, 136, 151; Wiesbaden:
© Dr Ludwig Reichert Verlag 53, 59;
Winchester: The Dean and Chapter of
Winchester 80, 81, 88.